PHOTOFINISHING TECHNIQUES
AND EQUIPMENT

PHOTOFINISHING TECHNIQUES AND EQUIPMENT

Jack H. Coote, F.R.P.S., F.B.K.S.

THE FOCAL PRESS
LONDON and NEW YORK

Printed and bound in Great Britain
by A. Wheaton & Co., Exeter

CONTENTS

10

PREFACE

My principal reason for writing a book on photofinishing is that none seems to have been written before. But another reason is that I am particularly interested in the history of the subject and believe that it should be recorded.

Photofinishing is a very unusual kind of activity. Surely no other techno-commercial business deals with hundreds of millions of units of production annually, virtually every one of which is different from the others and almost all of them of considerable personal value to customers who can seldom replace them. Furthermore, most of this work is collected, processed and delivered within forty-eight hours, even though half the turnover of his business may often reach a finisher within two or three months of the year.

Much of my own experience of photofinishing was gained from working in the industry at the time when black and white processing was still dominant but when it was becoming quite clear that the growing importance of colour film processing and printing would involve the finisher in new technology that he would quickly have to master in order to remain commercially successful.

At about this same time the similarities between motion picture processing and photofinishing led a number of motion picture laboratories to become involved in amateur film processing. Technicolor and Pathé in the U.S. and Pathé, Rank and Humphries in the U.K., all entered the new field of colour photo-finishing. Only two of these organisations remain involved today, but I believe that all of them would agree that they found the differences more significant than the similarities between professional motion picture processing and photofinishing for amateurs.

This is not to say that the finisher cannot learn from motion picture laboratory practice. Most of the continuous processors now being used for 126 films are based on designs that were originally developed for the motion picture industry. On the other hand, the colour printers used for motion picture release printing incorporate none of the integrating circuits that are essential when printing from amateurs' negatives.

I have found the photofinisher second to none in his constant search for improved methods and equipment and while he is often prepared to be guided by film and paper manufacturers, he is quite capable of making his own decisions on the basis of observation and practical experience. For the photofinisher is a technologist, and as such is keenly interested in any innovation that can favourably affect the running of his business. He knows that he can no longer depend, as his predecessors did, upon operators working on into the night during times of pressure. Instead, he has to install faster operating, more reliable and more compact plant, and as this generally involves greater capital investment, he must properly understand the advantages and limitations of any new equipment

before he buys it. One of the aims of this book will have been achieved if it sometimes assists finishers to reach satisfactory decisions of this kind.

Many people and organisations have helped during the preparation of this work and I would like to thank them all. I am particularly grateful to those who repeatedly supplied me with information and illustrations, among them; Mr. H. J. P. Arnold of Kodak Ltd. and his colleagues in the Eastman Kodak Company, Dr. B. Fergg of Agfa Gevaert Camera Werk, Dr. W. Grossmann of Gretag, Mr. Alan Gundelfinger of Technicolor, Dr. Kurt Jacobson, Mr. A. R. Kennington and the late Professor Lloyd Varden, who first showed me a modern colour photofinishing laboratory in New York in 1948.

Others to whom I am grateful, for letting me visit their laboratories, are: Mr. Bob Bremson of Bremson Photo Industries (Kansas City), Mr. Sven-Eric Egerborn of Linkopia (Linköping), M. Roger Hamelle (Paris), Herr Herbert Heinze of Foto Heinze (Gelsenkirchen), Mr. Charles Plant of N.A.P. (Chester), Mr. Sam Simon of Berkey Photo Inc. (New York), Mr. Iain Tait of Hamilton Tait Limited (Edinburgh), and Mr. Milton Zugerman of the Film Corporation of America (Philadelphia).

Finally it is a pleasure to record my thanks to two of my colleagues—Philip Jenkins and David Paskin. Their willingness and competence to discuss any aspect of photofinishing during the preparation of the book not only limited the number of errors it contains but made my task both easier and more satisfying.

12

I. OUTLINE HISTORY OF PHOTOFINISHING

Photofinishing really began in 1886 when *George Eastman* coined his famous slogan, "You press the button—we do the rest". Prior to that time, photographers developed their own plates and made their own prints, so that only those who were prepared to stain their fingers made photography their hobby.

Eastman's first box camera sold at twenty-five dollars and contained sufficient film for one hundred exposures. In fact the "film" was paper from which the gelatine emulsion had to be stripped and transferred on to a transparent support before printing. All this manipulative work—representing the very beginning of photofinishing—was done by the Kodak companies at Rochester in the United States and Harrow in England.

Early Eastman Processing

A description of *Eastman's* early processing operation was given in *Wilson's Photographic Magazine* in October, 1889:

> Each dozen (negative) pictures are mounted together on one large skin and printed in an airy printing room on the roof, which looks out on the Genesse Valley, and where quick-fingered girls fill the empty frames in the long racks down its sides. The hundred pictures are probably reduced by a few, for accidents must decidedly happen in photography, and the foreman who inspects them finds woeful evidence of fog and double exposure and other ills amateur work is heir to—but very seldom is any fault due to defects in camera mechanism or in the paper. As a rule, the staff handle the contents of from sixty to seventy-five Kodaks a day—anywhere from six to seven thousand negatives.

Eastman quickly saw how important it was to find some way of making a transparent flexible material on to which he could coat emulsion and thereby obviate the necessity of transferring the negative image before printing.

By 1896 the sale of Kodaks (as the cameras were called) had reached 100,000, and factories in Rochester and Harrow had a monthly output of three to four hundred rolls of film and paper. Other film developing and printing factories were established in England, France, Germany and Hungary. Cheaper cameras were also introduced at twelve dollars and five dollars, and the number of exposures was reduced to twelve. Even in those very early days of developing and printing, the problems of service time had already begun to concern *George Eastman*, who in reply to criticism by a correspondent in the *New York Evening Post*, wrote—

> The letter published under the heading "A Painful Pleasure" in your paper of August 15th (1890), does this Company very great injustice, implying as it does, that this Company requires four weeks to fill its orders for developing Kodak films. At the present writing we

have only five orders on our books for developing that are older than August 7th (twelve days). Our orders are usually fulfilled within the limit of time given in our advertisements—ten days.

In 1891 a paper backed daylight-loading roll film was developed, and after this there was no longer any need to return the whole camera to Eastman for removal of the film and reloading. This meant that any box camera user who wished to do so could set about processing and printing his own film. In due course, professional photographers and chemists who were selling films came to realise that they could profitably offer a developing and printing service to their customers. This was the point at which independent photofinishing activity began.

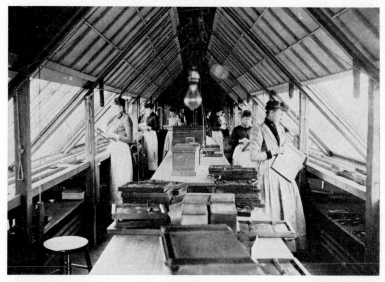

Fig. I In the 1890's Kodak negatives were printed in contact frames and exposed by daylight. A print could be made in a minute or two, except in cloudy weather when ten minutes was the average

Early D and P Service

In Great Britain it seems likely that the chemists or pharmacists began to provide a developing and printing (D and P) service as a natural outcome of occasionally obliging local amateur photographers by obtaining and weighing out the chemicals they required to compound their developers. In most cases the chemist probably began by doing the work himself in his own darkroom, but as time went on and the volume of work increased, many chemists preferred to hand the films over to a local D and P works or wholesale photofinisher, who would be better equipped than most pharmacists could hope to be.

14

To suggest that the photofinishers of the early 1900's were well equipped is merely to indicate that they would be able to handle large quantities of work and, unlike the chemist, were able to give such work their undivided attention. Looking back from this distance the early methods of developing and printing amateur roll films seem crude in the extreme. But we must remember that little or no equipment was being made specifically for either developing or printing large

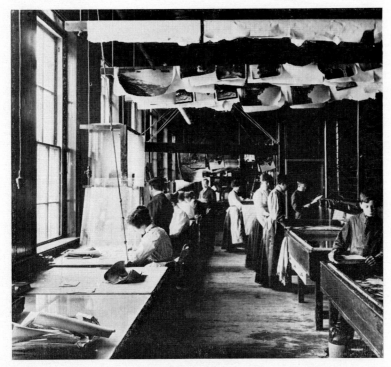

Fig. 2 The Harrow Works of Kodak Limited, during the 1890's processed and printed films from Great Britain and Europe and from as far afield as Singapore

numbers of films, and consequently there was much improvisation in those early days.

Primitive Equipment

A popular method of constructing deep tanks in which to suspend batches of roll films for developing, washing and fixing, was to use large diameter porcelain drain pipes sealed off at one end with a cemented slate.

All printing was done by contact on to separate sheets of paper and this could be carried out on the simplest of home-made printing boxes. Print processing

15

basically required nothing more than a series of capacious tanks—often constructed of wood and lined with roofing felt.

Negative Processing Problems

Manual processing with doubtful or non-existent temperature control and no proper system of chemical replenishment was enough to cause gross variations in negative quality, but additionally the pioneer finisher had to deal with a very large number of different makes of roll film. For example, in Britain during the 1920's, films were being made or sold by Agfa, Ansco, APM, Criterion, Houghton, Gem, Goerz, Ilford, Illingworth, Imperial, Kodak, Kosmos, Rajar and Wellington—all of which were on sale at the same time!

Besides having widely different speeds in the camera, these films often had quite different processing characteristics, so that when they were batched together for common treatment in the developer, the resulting negatives were far from uniform in either density or contrast.

Printing Problems

For this reason it was essential for the finisher to have a number of different contrast grades of printing paper available. Typically, four grades from one manufacturer would be called Contrasty, Vigorous, Medium and Soft. The type of printing paper used at that time was known as Gaslight and this was usually coated with a chloride or chloro-bromide emulsion that allowed sufficiently short exposures to be made by contact, and then permitted the use of quite bright safelighting during print processing. Prints were usually developed in thirty seconds or so, but as the progress of development was judged by inspection, the development latitude of the paper was often utilised to the full.

View Card Printing

When considering the history of photofinishing it is necessary to draw a distinction between the multiple printing of view postcards and the production of prints from amateur films. In viewcard publishing, large numbers of prints are required from each negative, while in photofinishing for amateurs, it is usual to make only one print from every printable negative.

There is abundant evidence that the somewhat simpler problems associated with viewcard production had led to the use of automatic printing and processing methods by the turn of the century. *Graber*[1] in Britain and *Dye*[2] in the US were certainly making and selling printers and processing machines for view-

16

card production in the early years of the century, while in Berlin, Die Neue Photographische Gesellschaft were operating their "rapid automatic" system of developing and finishing.

Barker and Hepworth

Soon after World War I, *Captain Will Barker*, who had been a pioneer in the earliest days of the British motion picture business, entered the photofinishing field by forming the Roll Film Company, first at Ealing and later, in 1928, at Wimbledon. *Cecil Hepworth*, another pioneer in motion pictures, also forsook

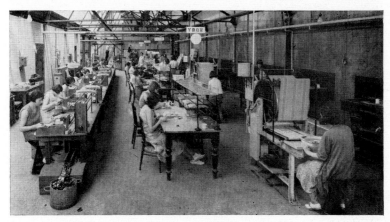

Fig. 3 The Roll Film Company of Wimbledon—one of the largest and most advanced wholesale photo-finishers in the U.K. during the 1930's

that business and entered photofinishing, becoming the first President of the Wholesale Photofinishers Association.

Both *Barker*[3] and *Hepworth* separately designed and built semi-automatic roll film processing machines, one or two examples of which were still in service in 1970. *Barker* also made an attempt to process long lengths of paper on a continuous machine. The separate lengths of paper were joined by stitching, and if this seems a strange way of tackling the problem it should be remembered that years later it was proposed that motion picture film should be joined by stitching prior to processing.

In order to supply his paper processing machine with continuous lengths of paper, Barker also had to have a printer that would use continuous rolls of paper. This printer, besides having automatic paper transport, incorporated a simple photo-electric exposure estimating device—perhaps the first of its kind in photofinishing.

From the illustration of the *Barker* print chopper, it can just be seen that two

17

small round holes were punched in the space between each pair of prints, and these holes were used in conjunction with a claw mechanism (motion picture influence) to transport and locate the paper in the printer and subsequently in the chopper that also formed part of *Barker's* system.

The illustration shows how each picture was cut out of the roll to leave a print with rounded corners and no evidence of the punched holes. The same technique was used much later by both Kodak and Pavelle when making colour prints by reversal—when margins became black and were therefore removed.

According to *Barker*, his attempts to handle paper in continuous lengths failed not because of mechanical difficulties, but because of crossovers. A

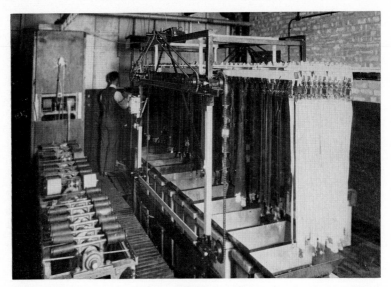

Fig. 4 Barker designed and built a roll-film developing machine and a continuous paper processing machine in the early thirties. Some of the roll-film machines were still in service in 1970

crossover is an ever present hazard of photofinishing, and results in the return of two or more films to the wrong customers.

Glen Dye

The founder of the Pako Corporation—*Glen M. Dye*, was the American counterpart of Barker in Britain. By 1909 *Dye* was building motorised printing machines for viewcard production, and in 1918 he produced a motor driven rotary drum dryer to speed up the print drying operation.

By the early twenties, *Dye* had already appreciated the necessity for equipment that would enable the finisher to mechanise as much of his work as

18

possible. In one of his patents[4] of that period, *Dye* outlined a problem that has continued to hold the attention of all photo-finishers:

It is common practice for amateurs to take their film to a commercial developing and printing establishment to have the prints developed and finished. Such establishments now in large cities handle a large amount of such business, and the volume of this business varies greatly from day to day and week to week. In certain periods during the summer the volume will be large and at other periods the volume will be quite small. It is difficult for the developing and printing establishment therefore, to properly regulate the number of employees for handling the work. If a sufficient force is maintained to handle the work during a week of large volume the same force will not be kept busy during a week when the volume of work is small and the establishment will thus have a heavy payroll for which it receives no return. It is quite desirable therefore to provide automatic or mechanical means for handling the prints during the developing, fixing and washing stage as well as during the drying and glazing stage. With such a mechanical means, once the developing and printing establishment has invested in the same, it can take care of a large volume or small volume of business without any change in its operating force.

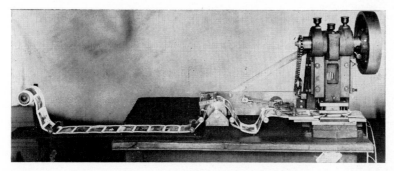

Fig. 5 The Barker automatic print cutter used an intermittent movement working on perforations punched between successive prints. The perforations were removed when the pictures were punched out of the roll

From this it is clear that the problems of fluctuating and seasonal work loads were already taxing photofinishers' ingenuity in the 1920's.

The print processing device *Dye* patented in 1924 was the first of the so called Doper Machines in which prints were progressed, image upwards, on a conveyor while being successively sprayed with developing, rinsing, fixing and wash solutions, the developer and the fixing and washing solutions being separate during application and collected separately after use.

Pako Doper

This early form of Doper was superseded around 1940 with an improved design.[5] This later Pako machine comprised a long shallow tray incorporating a rotating rubber bladed paddle wheel at one end. The paddle or ducker

19

automatically submerged each print as it was fed into the developer. Continuous rotation of the paddle provided a flow of developing solution so that the prints moved slowly along in the tray and, because they were all face upwards, the progress of their development would be seen at a glance. While the prints passed in front of the operator, she watched as each of them reached correct density and then transferred them one by one either into an ordinary fixing bath or into the first section of a Pako Printmachine.

Pako Printmachine

The Printmachine, another of *Dye's* inventions[6] is a machine into which developed prints are placed before being transferred automatically at regular intervals through stop-bath, fixing bath, and washing sections to be deposited on a draining board ready for drying. After processing, prints were usually dried and glazed on hot chromium-plated drums—at first by using gas and later by electrically heated water. While cut-sheet printing was in vogue, every print had to be positioned on the slowly moving apron of a glazing machine, or even on to separate ferrotype sheets.

Dye like *Barker*, soon turned his attention to the automatic processing of amateur roll films and obtained a patent[7] in 1932 for a machine that was the fore-runner of a whole line of automatic film processors later to be known as Pako Filmachines.

The mechanised processing of roll films not only speeded up the job but resulted in better and more consistent negative image quality. In turn this led to a search for satisfactory means of replenishing developing and fixing solutions. *Barker*, with his motion picture experience to help him, saw the possibility and the advantages of keeping a developer in service for long periods of time, and in 1933 published details[8] of his formulae and methods.

Barker's formulae were for a developer as is made up for filling the machine tanks and a "strengthener" or replenisher "for addition from time to time". By working with the *Barker* system it was claimed that the developer could be kept in constant use for a long period—"sometimes as long as three or four years"— a quite revolutionary idea for those days.

By the middle thirties the progressive finisher had mechanised his roll film processing and had begun to use some degree of mechanisation in his print processing, but was still making prints by contact on very simple equipment.

Early Contact Printers

The contact printers used by finishers were for the most part simple machines operated either by hand or by means of a foot treadle. In the thirties some of the

most popular types in the US were the Pako Junior and Model B Printers and the Automatic and Service Printers made by Eastman Kodak; in the UK, the Kodak A and B machines and the Ensign-Keen Printers were the most popular. Most of these were simple printing boxes with hand or treadle operated platens and they all used cut-sheet paper. A printer of this general type would have cost about £20 in 1935, although Eastman Kodak's Automatic printer

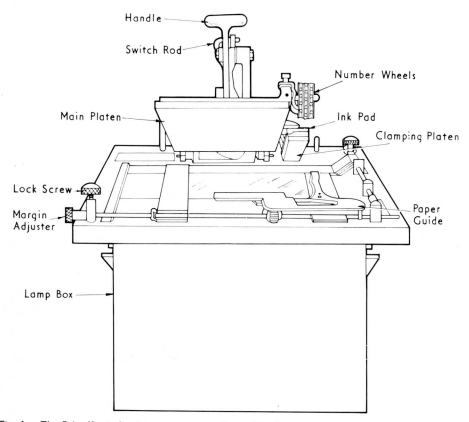

Fig. 6 The Pako 'Junior' printer was commonly used by finishers in the U.S. during the nineteen twenties and thirties

was more complicated and certainly cost more. The Automatic printer, first introduced in 1932, used the fixed-time variable intensity principle of exposure, thereby eliminating any problems that might have resulted from failure of printing papers to comply with the reciprocity law. The voltage on the exposing lamp and therefore the effective exposure, was varied by means of a set of nine keys or press buttons and an accurately timed shutter prevented either pre-glow or after-glow of the lamp from affecting the print exposure.

21

In the late thirties *Barker* made and used contact printers incorporating photo-electric means for indicating the exposure and contrast paper grade likely to suit individual negatives. The arrangement was simple; with a negative in position in the printer and before a sheet of paper was placed in contact with

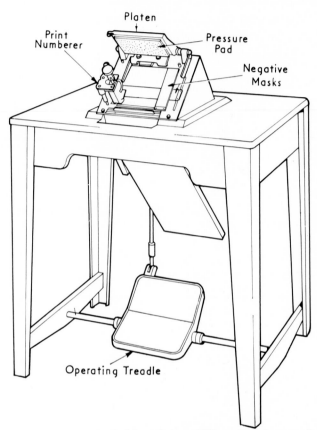

Fig. 7 The 'Finisher' printer sold by Kodak until about 1950, typified the type of printer used in the U.K. up to that time

it, some of the light transmitted by the negative was collected by a selenium photo-cell located in a hood above the printer table. The output from the cell was used to drive a meter, which was scaled in terms of relative exposure and contrast grades of paper. The operator, having noted the meter reading proceeded to choose the appropriate grade of paper and give the indicated exposure.

In Britain before World War II, the only commercial printers incorporating semi-automatic photo-electric exposure control were the Kodak Velox Auto-

metric, which became available in 1937, and the Ensign-Keen Photo-electric Printer (1938). The Autometric was a fixed-time constant-intensity printer with an exposure of one second for all negatives and grades of paper. The average (integrated) density of each negative was measured by means of two Weston Photronic Cells and the resulting meter reading was used as an indication of which of ten lamp voltage control buttons was to be depressed. Choice of paper grade was based on the simple principle that on the whole, dense negatives have high contrast and thin negatives are flat. Thus a high meter reading resulting from an under-exposed negative was taken to indicate that a contrasty or vigorous grade of paper should be used; conversely, a low meter reading from a dense negative was taken as indicating that a soft grade of paper should be chosen. The meter scale, was in fact, divided into four grade sections in this way.

The Ensign-Keen printer worked in a somewhat similar manner except that a sliding resistance scale was used instead of push-buttons to relate lamp-voltage to meter reading.

It would seem that the British-made Autometric printer was in some respects based on a patent[9] of *Tuttle* and *Young*.

The Durkopp 'Seeing' printer was used in Germany and to a limited extent in Britain during the thirties. This photometrically operated contact printer required that the printer lamp brightness be set in accordance with the minimum density of each negative, while paper grade was determined by a highlight or maximum density comparison. These operations involved visual judgement, and were time-consuming. This prevented the Durkopp printer from becoming really popular outside Germany.

Velox Rapid Projection Printer

In the US, the Velox Rapid Projection printer began life in 1937 as a simple manually operated cut-sheet projection printer with which exposures had to be determined by visual assessment. The purpose of the printer was explained in these terms:

> This new Eastman printer opens new avenues for increased photofinishing business by making fixed magnification enlargements from miniature negatives on Velox Rapid paper.

By the early 1940's Eastman Kodak had modified the Velox Rapid printer to include a photo-cell system of exposure control. This printer—undoubtedly the first commercial machine of its kind to be made generally available to finishers, was known as the Velox Rapid Printer Photo-Cell, Model A, and was followed by a whole series of printers based on the same design.

Printing on to continuous rolls of paper—albeit to cut the prints from the roll immediately after exposure—came about in the US around the late 1940's and

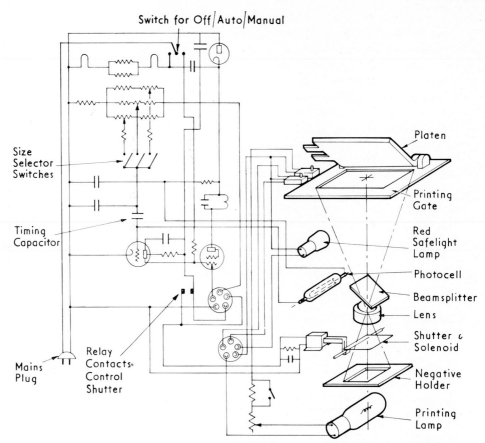

Switch for Off/Auto/Manual

Platen

Printing Gate

Red Safelight Lamp

Photocell

Beamsplitter

Lens

Shutter & Solenoid

Negative Holder

Printing Lamp

Size Selector Switches

Timing Capacitor

Mains Plug

Relay Contacts Control Shutter

Fig. 8 This schematic drawing illustrates the method of integrated exposure estimation on a projection printer. The Velox Rapid Printer Photo-Cell Model A, represented by the diagram, was the first of its kind to be designed for photofinishing

early 50's. At first, roll-head conversion kits for Velox Rapid printers were offered by independent equipment suppliers such as Fotopak and later by Kodak themselves.

Kennington Synchromat

In 1952 *Kennington* and *Bourlet* introduced the first commercial roll-paper photo-electric projection printer to appear in Britain. The Synchromat produced prints that were the same size as the negative. At that time in Britain, the idea of projection printing of negatives to make enlargement prints had not yet been accepted. Furthermore, because very few photofinishers at that time were convinced that all their printing could be done on a single contrast grade of

24

paper, the Synchromat incorporated a device that provided a choice of effective print contrast equivalent to rather more than the difference between two grades of paper. This contrast control was achieved by using the Callier effect that results from printing with light that varies widely in the extent to which it is diffused. To achieve this the Synchromat had two separate light sources, one of which would be chosen to suit the contrast of the negative being printed.

As we have seen, for some years all prints from 35 mm. negatives were made on manually operated enlargers—a time consuming and uneconomical method of producing large numbers of small prints. Attempts to speed up print production from 35 mm. negatives led to the introduction of several forms of enlarger-printer or En-printer as such machines came to be called in Britain.

The fixed focus Kodak En-printer introduced in Britain in 1950 was a counterpart of the Kodabromide Types III and IV in the US. These projection printers were designed "to produce swiftly and economically bigger-than-negative-size prints from miniature negatives for small volume finishers".

A rather more elaborate printer with automatic focusing was patented[10] and manufactured by Johnsons in Britain.

Pakomatic Printer

Pako's Pakomatic printer could be distinguished from many subsequent fixed-focus photofinisher printers in that both lens position and paper plane were adjusted automatically to allow prints to be made from a wide range of negative sizes without the necessity for changing lenses. The Ilford N printer, produced in England in 1956 was also based on this same autofocus principle.

Continuous Paper Processing

By 1950 Pako in the US were sufficiently aware of the direction in which photofinishing was headed to launch their Pakoline system.[11] This comprised a roll-paper attachment for their Pakomatic printer, a continuous roll-paper processor and an automatic roll-paper cutter.

But because of the rather large investment involved in buying and installing a continuous paper processing machine, the British finisher converted more slowly from cut-sheet to roll printing. As a result of this caution, for a period of a few years in the early fifties an unusual type of printer emerged and became popular in Britain. Both the Ilford Roll-Head printer and the Kodak Auto-Velox printer were contact printers incorporating photo-electric integrating methods of exposure determination and producing lengths of exposed paper equivalent to the prints belonging to one roll of film. The exposed lengths were processed manually in narrow dishes.

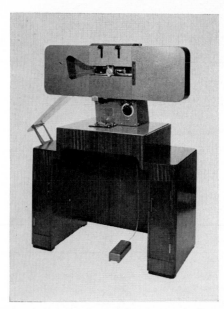

Fig. 9 The Kennington Synchromat produced prints the same size as the negatives by projection on to a roll paper, from which each print was cut immediately after exposure

Fig. 10 The first continuous roll paper processing machine for the British photofinisher, the single-strand Trimatic, became available in 1956

This system of contact printing on to short strips of paper did not survive for many years. For one thing, it was no use for dealing with the increasing number of small format negatives that the finisher now had to print. Projection printing provided the only solution to that problem, and in 1954 the first Kennington Kenprinters and Kodak Velox Projection printers began to appear.

Once a finisher had taken the decision to print on to long rolls of paper, he had to buy a continuous roll paper processor. In 1948 Eastman Kodak introduced the first of their paper processing machines—the Model I. A little later, Pako announced the Pakoline machine using an endless leader band. In Britain it was 1956 before Associated Cine Equipment Limited produced a small single strand continuous paper processor—the Trimatic. Shortly afterwards, both Williamson and Kennington produced paper processors and Kodak Limited began to make machines that were the counterpart of the Eastman Kodak Model I paper processor, with an output of 15,000 prints a day.

Broadly, this was the position in black and white photofinishing in 1960; by which time colour was clear enough on the horizon for most finishers to become cautious about investing in additional equipment for handling black and white films and papers.

Colour Photofinishing

If the processing of amateur movie films is accepted as part of photofinishing, then colour finishing began in 1935 with the launching of the first Kodachrome film in 16 mm. size for use in amateur cine cameras. Because the Kodachrome process was so complex[12] in its original form, there could have been no possible choice for Eastman Kodak but to undertake to process the film themselves. Later, although the process was simplified and extended to include the 35 mm. size, it was still thought by Kodak to be outside the scope of independent photofinishers and they continued to retain the processing of Kodachrome until 1955. After that, Eastman Kodak signed a Consent Decree under the terms of which they agreed to sell Kodachrome films without the cost of processing included and to release processing formulae and know-how to bona-fide finishers.

A decade later, the Wholesale Photofinishers Association appealed to the Monopolies Commission in Britain to instruct Kodak Limited to release the processing of Kodachrome to British finishers. In their report[13] the Commission not only complied with the request of the W.P.F.A., but also recommended that both the film manufacturers and the photographic dealers should reduce their margins of profit. In the event, only two independent photofinishers installed a Kodachrome processing line, and by 1970, only one of these was operating.

Although colour reversal films preceded colour negative films in their use by

27

amateur photographers, it is possible that the era of the colour transparency will yet be seen as something of an anachronism in the history of photography.

To the true snapshot amateur, photography has always meant prints, whether they be in colour or black and white. But the problems that had to be solved before a reasonably good colour print could be made reliably enough and cheaply enough were very many. This is why the colour transparency achieved such popularity after the introduction of Kodachrome and Agfacolor in 1936. At that time it proved a great deal easier for the manufacturer to produce a high quality 35 mm. reversal transparency film than to devise both colour negative and colour papers and the intermediate printing systems that must link the two products.

Launching of Kodacolor

Processing of amateurs' colour negative films was first carried out by Eastman Kodak in 1942, when the Kodacolor process was launched in its original form. Little is known of the methods that Kodak used for processing the exposed films at that time—but we can assume that rack and tank machines were used, because Kodacolor was available in all roll film sizes except 35 mm. and continuous processing machines would not have been suitable.

With the signing of a Consent Decree in 1955, Eastman Kodak set out to provide the information and equipment that photofinishers would need to handle Kodacolor processing and printing. This they did in a remarkably successful manner, so that within a few years Kodacolor films represented an extremely important part of most finishers' intake of work. Furthermore, since that time the processing and printing of Kodacolor films has become the dominant concern of the majority of photofinishers throughout the world. So unprecedented is this position that it deserves closer examination. Certainly there is no parallel in black and white processing, where films of many different makes are sold by dealers and accepted by finishers to be given common treatment. The almost exclusive use of Kodacolor negative film throughout the US and its dominance in most other countries, springs at least in part from the fact that it is a better economical proposition for a photo-finisher to concentrate on the efficient handling of one type of colour negative film than it is to attempt to process and print several types. Manufacturers and finishers in some countries have been reluctant to recognise this, and the reputations of both have sometimes suffered from unsuccessful attempts to establish additional colour negative processes.

The position in Germany and perhaps in certain other European countries may be somewhat different because Agfa's colour negative films were reasonably well established before Kodak challenged with Kodacolor. With the share of a market fairly equally divided between two films it is possible for a finisher to handle both.

28

Frequently, finishers ask why it is not possible for manufacturers to produce compatible colour films, by which they generally mean films that could be processed satisfactorily in Kodacolor solutions. Some manufacturers have set out to do just this—among them Ansco in the US and Fuji in Japan. But it is not often realised that processing compatibility alone—difficult as this must be to achieve—is not sufficient to render one make of colour film truly compatible with another. The two films must yield equally good results when they are printed on the same colour printer, without the printer requiring to be

Fig. 11 In 1945, Pavelle designed special printers for making colour prints from transparencies by direct reversal on Ansco's Printon material

adjusted other than to suit Kodacolor negatives. This second form of compatibility—printing compatibility—is often not properly understood, but its achievement is essential before one film can be considered truly compatible with another.

Colour Prints from Transparencies

Printing from colour negatives has not always seemed to be the most sensible way for an amateur to obtain his colour prints. In 1945 Ansco (now GAF), entered into an arrangement with Pavelle, a photofinisher in New York, to establish a transparency printing service using Ansco's Printon material, and Pavelle Color Incorporated was formed. The service started in 1946. *Pavelle* and *Varden*[14] have described the operation and the original design and engineering work which went into the Pavelle processing and printing equipment.

It should be remembered that apart from Eastman Kodak, who at that time had revealed little of their operations, no photofinisher had tackled the problem of colour printing for the mass amateur market. *Varden* and *Krause*, both of whom had been with Ansco, joined Pavelle in New York and have reported[15] on their search for the best way of automatically determining the printing exposure required for colour transparencies. The printers that Pavelle designed and built were used in conjunction with pre-coders. Each transparency was coded to indicate the relation between the amount of light transmitted by the important subject area and the total integrated light transmitted by the transparency. After exposure the Printon material was processed on a continuous machine running at twenty feet per minute and taking two parallel strands.

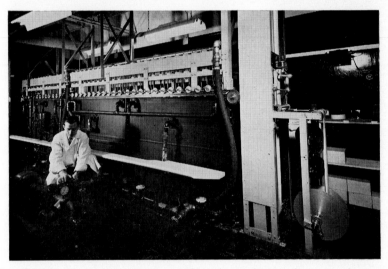

Fig. 12 One of the first continuous processing machines for producing colour prints for amateurs was installed in the Pavelle plant in New York in 1945

Glazing was unnecessary because of the glossy surface imparted to the finished prints by the smooth white pigmented acetate film base of the Printon material.

One other large scale attempt to satisfy the growing demand for colour prints from colour transparencies was launched by Ilford Limited in Britain in 1954. Ilford had developed a reversal colour print material based on the silver dye-bleach system typified by the Gasparcolor process. This material was like Ansco's Printon in so far as its emulsion layers were coated on a white pigmented acetate film base—but there the similarity ended, for the processing of the two materials was quite different. Exposure of any silver dye-bleach material is a problem because of the very low sensitivity that results from the inclusion of complementary coloured dyestuffs into each of the three colour-sensitive emulsion layers. *Coote* and *Jenkins*[16] have described the steps that were taken to achieve high printing rates by using powerful Xenon light sources.

30

In Europe Kodak did not introduce colour prints from transparencies until 1955 and then they used a paper based material employing couplers of the Ektachrome rather than the Kodachrome type. This was the first reversal colour print material to be made on a paper base and the research leading to it was mainly carried out by Kodak Pathé in France. Material of this general type was subsequently produced by Eastman Kodak and was known as Type 'R', later becoming Ektachrome Paper.

Additionally, Kodak offered photofinishers an internegative film with which to produce colour prints from transparencies without duplication of their colour printing or print processing equipment. With this material quite small photofinishing operations were able to offer a transparency printing service.

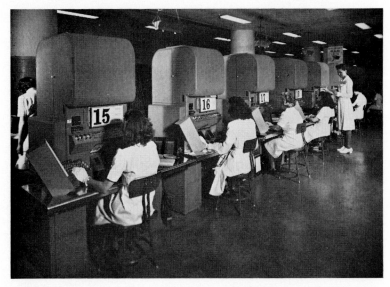

Fig. 13 By 1947, large numbers of Type 1599 colour negative printers were being used by Eastman Kodak in their Rochester plant. Some of these machines were still in use in 1969

Kodak 1599 Printer

Returning to Eastman Kodak's activities in the field of colour negative printing; after some preliminary work on printers involving visual comparisons on the part of the printer operator, Kodak, in 1946, standardized on their 1599 machine. The 1599 exposes three rows of prints along a single eleven inch web of paper. Each single print is the product of three consecutive exposures—one each through red, green and blue filters—a procedure that came to be known as additive printing.

In order to avoid the complications that can result from reciprocity failure in

31

Fig. 14 The 1599 printer exposed three rows of colour prints on a roll of paper eleven inches wide
The prints were inspected before they were separated

Fig. 15 Special slitter/choppers were designed by Eastman Kodak to simultaneously slit and separate
the triple-row prints exposed on 1599 machines

32

the emulsion layers of a colour print paper, the 1599 printer used filtered exposures that were always of the same duration, and the intensity of the printing light was automatically adjusted to achieve this.

That the 1599 printer was successful is indicated by the fact that at one time Eastman Kodak used something like a hundred of them, and do in fact still use them in Rochester.

Move from Additive to Subtractive Printing

When Kodachrome and Kodacolor processing and printing were released to independent photofinishers in 1955, Pavelle Color, because they had already worked on the test marketing of Ansco's colour negative—Plenacolor—in 1948/49, were singularly well placed to handle a colour negative film. Within a very short time, Pavelle had installed Arnold and Richter continuous processing machines for Double 8 and 35 mm. Kodachrome, and had built a number of additive exposure integrating printers for handling Kodacolor negatives.

At that time (1955) no colour printing equipment whatsoever was available to the independent photofinisher. Eastman Kodak, as we have seen, had developed the elaborate 1599 printer, but this was for their exclusive use in Kodak laboratories, and in any case was far too costly and complex for it to be offered to outside finishers. Kodak's answer to the finisher's problem—which affected Kodak closely, since they were required by the Consent Decree to assist finishers to become established in Kodachrome and Kodacolor processing—was to convert their Type IV Velox Rapid Roll-Head printer into an additive colour printer. In fact, this conversion proved so satisfactory, that for many years the IVC printer was standard equipment in the US, and was also used in Kodak's processing plant in England.

For a few years thereafter the American finisher had no choice of printer but the IVC, but then, in 1958, Pako produced an entirely new design—the Pakotronic. This was not an adaptation of any previous printer, but an entirely new design incorporating a number of novel features, including daylight operation and white light exposure with subtractive filter termination. Thus, the Pakotronic was the first American printer to depart from the additive form of exposure.

In Britain, when Kodak began to sell Kodacolor film to amateurs in 1957, the films were at first processed and printed by Kodak themselves and for printing they used some Type IVC printers imported from the US, but quickly converted to the use of the British designed and made S1 subtractive printer. The S1 was the printer that Kodak Limited offered to the independent finishers in Britain when in 1958 Kodacolor processing was freed from restriction.

The S4 and S4P printers followed the S1 in Britain while Eastman Kodak made the 5S in the US—all of which were white-light printers using subtractive termination.

33

Agfacolor Negative

After the War, the Agfa factory at Leverkusen took some years to regain a position where they were able to produce both colour negative film and a colour paper to go with it. Prior to 1939 Leverkusen had been concentrating on colour paper and Agfa's colour negative had been made at Wolfen—now Orwo in East Germany.

Even before World War II, Agfa had made considerable progress in developing both reversal and colour negative films. Their reversal film Agfacolor Neue, was first made available to amateurs in 1937, but its processing was retained by Agfa and carried out in their own processing laboratories. Their colour negative film made greatest progress in the commercial motion picture field, where it was used for the production of many German feature films.

Agfa colour negative film was first sold to the amateur around 1950, and this film was processed and printed on a small scale by European photofinishers who at that time had little or no special equipment for the job. In fact, the usual procedure for a finisher in Europe at that time was to make a colour test strip from every negative and to use enlargers, cut-sheet paper and dish development. Colour prints made in this way were expensive and of varying quality and the growth of this branch of photography was consequently slow.

Gevaert Colour Paper

Unlike any other manufacturer, Gevaert (before becoming part of Agfa/Gevaert) concentrated on the production of a colour paper capable of competing with Kodak's Ektacolor paper for printing from Kodacolor negatives. To make a colour paper that is fast enough, sharp enough, consistent enough and cheap enough to be acceptable to photofinishers is no mean task, but Gevaert were second only to Eastman Kodak in doing this.

Realising that colour papers need to be printed on colour printers and processed in continuous paper processing machines, Gevaert entered into an arrangement with Pako to act as distributors for Pakotronic printers and Pakopak processors.

Principle of Integration to Grey

In 1946, *Evans* of Eastman Kodak filed a patent which undoubtedly represents a landmark in the production of colour prints for amateurs. The patent[17] describes the idea of "integration to grey" and it is clear from the claims that the principles discussed were to be used in the printer described in USP 2,566,264 and BP 660,009—which is the 1599 machine. *Evans'* claim is confined to variable intensity printing and the patents therefore did not cover printers using variable exposure times to achieve the object of integrating to grey. This

34

limitation—probably enforced—enabled Agfa to protect the variable time alternative in BP 805,891, the principal claim of which reads:

A process for producing a photographic colour print from a colour transparency, said process comprising three exposures of the printing material to light of three primary colours, each of said exposures being controlled by a photo-electric regulating device which includes a photo-electric cell and is influenced by printing light rays coming from the colour transparency during the exposure of the printing material and each exposure being interrupted by said regulating device after a pre-determined quantity of printing light of the corresponding colour has fallen on to said photo-electric cell.

This patent of Agfa's was first applied for in France in April, 1954 and whether the printers used by Pavelle in the US at about that time, or the Kodak IVC printers that were generally available in 1946, may have anticipated it is a point which has been much discussed.

Modern Trend to Colour Prints

Between 1955 and 1960, photofinishers, first in the US, and a little later in Europe, took their first steps towards involvement in colour processing and printing. Some of them went in boldly, some were hesitant, and others were frankly sceptical of the future for the finisher in colour. Nevertheless, the decade that followed proved to be a period during which manufacturers and finishers successfully worked together to convince the public that colour prints were good value for money. Quality, service and the yield of prints per roll of film were all improved while prices were effectively reduced.

But the growth in sales of colour negative films and colour prints really gained momentum when Kodak launched their Instamatic system in 1965. The true impact of 126 cartridge film on photofinishing was only slowly realised by some finishers, but by the end of the decade they were all well aware of the economical implications of continuous film processing and fully automatic printing at rates of three or even four thousand exposures an hour.

REFERENCES

[1] BP 18,852 (1913).
[2] USP 18,867 (1911).
[3] BP 371,089.
[4] USP 1,624,781.
[5] USP 2,362,587.
[6] BP 381,636.
[7] BP 390,335.
[8] *B.J. Phot.* January 1933, pp. 13–16.
[9] USP 1,987,032.
[10] BP 642,883.
[11] COOTE, J. H. "Mechanisation in the Photo-Finishing Industry". *Brit. J. Almanac* 1953, pp. 141–153.
[12] USP 2,113,329.
[13] "A Report on the Supply and Processing of Colour Film" by the Monopolies Commission. H.M.S.O. 1966.
[14] PAVELLE, L. AND VARDEN, L. "Ten Years Experience in Colour Photo-Finishing". *Photo Development*, October, 1956, pp. 25–27.
[15] *Am. Phot. Annual* 1950 pp. 30–41.
[16] COOTE, J. H. AND JENKINS, A. P. "A Machine for High Speed Printing from 35 mm Colour Transparencies". *J. Phot. Sci.* Vol. 8, pp. 102–105, 1960.
[17] USP 2,571,697.

II. BLACK AND WHITE FILM PROCESSING

Although film may be processed in a variety of ways, in practice there are three basic methods by which roll, cartridge and 35 mm. films from still cameras are developed.

When the number of films is small they can be processed while contained in grids in which the films are held in a spiral configuration. Alternatively, and more often, films are suspended vertically in deep tanks and transferred either manually or automatically through the necessary series of solutions. When the volume of work is sufficient and the width of the film is uniform, as for example 35 mm. and 126, the films can be joined end to end before being transported by continuous movement through an automatic processing machine.

Spiral Tanks

The earliest form of spiral processing was introduced as part of the Leica system around 1931. At that time the 35 mm films used for amateur cameras were generally rather coarse grained, and were capable of giving satisfactory negatives for enlargement only if they were treated in fine-grain developers rather than in the tank developers used by D and P houses for the bulk of their amateur roll-film processing.

The Correx system sponsored by Leitz involved the use of a length of clear plastic "apron" with dimples embossed along both edges. This apron was wound up spiral fashion with the film to be processed, and both apron and the film were contained within the flanges of a Bakelite spool. The spool was loaded in the darkroom and then, after it had been placed in a Bakelite tank with a light-tight lid, all subsequent processing operations could be carried out in room light. The necessary solutions were poured into and out of the tank through a light-tight inlet and outlet.

After the Correx tank with its apron came tanks with plastic spools that were moulded with matching spiral grooves into which a length of film could be pushed to load the spiral before processing. Similar spiral-form grids are also made from stainless steel wire but the principle is the same. Typical of this form of construction is the Nikor spool and tank.

Because of the time involved and the difficulties that sometimes arise in loading film into spools, this method is not used much by photofinishers, although spiral grids are still sometimes employed for processing reversal colour films such as Ektachrome. Frequently the intake of such films does not justify the considerable expense of keeping a set of deep tanks filled with correctly maintained colour processing solutions.

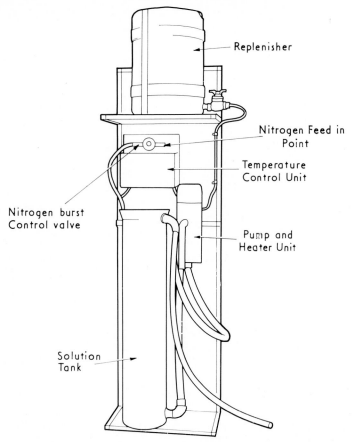

Replenisher

Nitrogen Feed in
Point

Temperature
Control Unit

Nitrogen burst
Control valve

Pump and
Heater Unit

Solution
Tank

Fig. 16 A simple tank unit such as the Pavelle FPT2 can be fitted with temperature control, solution
circulation and gas agitation, as well as replenishment facilities

Deep Tanks: Manually Operated

From the early days of photofinishing, deep tanks have provided cheap and
reasonably satisfactory means of processing relatively large numbers of amateur
films of different sizes.

A typical D and P tank is four feet deep and has a surface area of about one
square foot. Such tanks used to be made from glazed earthenware, but in
recent years rigid polyvinyl chloride or similar plastic materials are more fre-
quently used, as for example Pavelle's model FPT2 tank. This circular PVC tank
will take 12 films at a time, and can be supplied with a circulation unit contain-
ing a heater/thermostat, a replenisher tank, and provision for nitrogen burst
agitation (Fig. 16).

Films are suspended in deep tanks by means of a rod and a clip at the top and a weighted clip at the bottom. The top clips and rods are of stainless steel and the top clips must be self draining, while the bottom lips are used as weights to keep films fully extended; these are made from stainless steel, usually loaded with small lead castings.

Sometimes, with the larger D and P establishments, a degree of mechanisation was introduced by suspending batches of films from a frame that could be hoisted out of a tank by a simple system of pulleys and then moved along an overhead rail before being lowered into the next tank.

A 36-exposure length of 35 mm. film is about $5\frac{1}{2}$ feet long and cannot therefore be suspended like a roll film in a tank that is no more than four feet deep. The solution is to loop 36-exposure lengths so that the depth of tank required is halved. The simplest device for forming a loop is a stainless steel ring, but because the film then has to bend rather sharply, there are sometimes difficulties in drying and a marked negative can result from contact with the ring.

A better method is recommended by Pako who supply a plastic spool and metal weight that ensures uniform development and drying along the whole length of a 36-exposure 35 mm. film. The spool is concave so that the film touches it only at the edges. This method of looping the film at the top eliminates the risk of water marks, which often occurred with the older methods of looping films.

One of the difficulties always associated with the manual or semi-automatic introduction and transfer of batches of roll films from tank to tank during the sequence of processing steps is the relatively high rate of physical damage that occurs to the surfaces of the films. Inevitably at a busy time there is a tendency to accommodate more and more films in a tank in order to increase the processing output. This of course, also increases the risk that some of the films will become damaged.

A further disadvantage that relates to all forms of manual processing is the difficulty of ensuring accurate and consistent operator performance.

Film Identification

As soon as more than one film is to be processed in the same tank at the same time, problems of identification begin. Crossovers, or misdirected orders, have always concerned the photofinisher and one of the most important steps towards eliminating such mistakes was made with the introduction of the double-clip system. A double-ended stainless steel clip has jaws which effectively hold a film by its extreme end, while at the other end flat spring jaws are able to hold the folded order corresponding to the film. The film and order form are thus kept together throughout the processing, drying and printing stages and both special numbering and laborious sorting are avoided.

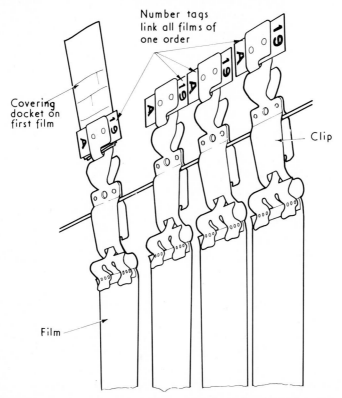

Number tags
link all films of
one order

Covering
docket on
first film

Clip

Film

Fig. 17 The Kodak double-clip provided an ingenious way of ensuring that each customer's film would remain with its corresponding order docket throughout the processing and printing operations

Although the double-clip system of film identification has served the photo-finisher well, it necessarily depends upon the film and order form remaining together at all times during the progress of the film through the plant. Once continuous processing of negatives is adopted, it is no longer possible to follow the same procedure and instead, the film itself must bear some readily distinguishable and adequately resistant form of numerical identification. This is not a big problem in black and white processing because few finishers are equipped to process black and white films continuously. The problem will therefore be considered more fully in the chapter dealing with colour film processing.

Deep Tanks: Automatically Operated

The difficulties associated with manually operated processing eventually led pioneers like *Barker* in Britain and *Dye* in the US, to design and construct

automatic machines for transferring roll films from one solution tank to another. These rack and tank machines are often known as "dunkers"—an apt description.

BARKER'S MACHINE The invention[1] was described as follows:

An improved method of automatically developing, fixing and washing or otherwise treating photographic films, plates, or the like, by suspending them in developing, fixing, washing and other baths arranged in the desired sequence, which consists in assembling the photographic films, plates, or the like and suspending them in groups and simultaneously loading such groups into and retaining them for a given period in developing, fixing, washing and other baths, each bath being adapted to receive one such group, and each group being lifted bodily out of one bath, carried forward and lowered into the next at predetermined intervals of time.

It will be noted from this description of its mode of operation that the Barker machine handled films in groups. Each group or rack contained twenty films in five rows, and a typical transport cycle time was five minutes, which meant that development time had to be either five or ten minutes—preferably five minutes, because ten would involve the transfer of partially developed films from the first tank to the second.

The mechanical operation of a Barker machine is quite simple and can be easily understood with reference to the drawing. In fact more than five rows of film are shown on one rack in the drawing, but in practice such close packing of the films would certainly give rise to trouble.

In order to ensure that on their downward path towards the solution tanks none of the films were caught up on the edges of the tank, tapered chutes were fitted to the tanks to guide the films into each bath. To ensure that each rack of films would be deposited accurately into each tank, pegs were inserted into the lifting arms at equally spaced intervals and these, being tapered, entered corresponding holes in each side of the film rack so as to correct any small misalignment that may have occurred in the position of the rack.

The interval at which the lifting cycle operated was generally adjusted by means of a timer connected through a relay to the driving motor which would drive the lifting arms through one complete cycle at each switching.

A limitation of the Barker machine is that it provides an equal dwell in every solution so that no short immersions in stop baths or rinses are possible. Nevertheless, it worked very satisfactorily, as is evidenced by the fact that several machines were still in operation more than thirty years after they were first installed.

DYE'S MACHINE. Soon after *Barker* had patented his machine, *Glen Dye*, working in America, was granted a patent[2] for his version of an automatic film developing machine that came to be so well known as the Pako Filmachine. The most important distinction between the Dye and Barker machines is that *Dye*

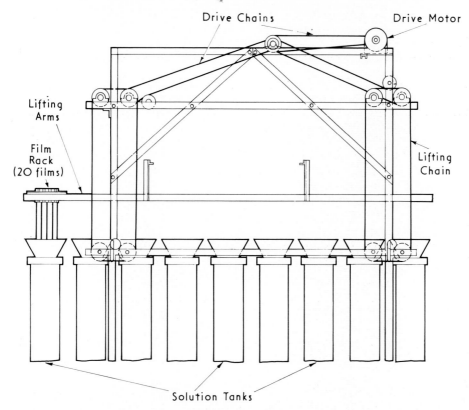

Fig. 18 The Barker roll-film 'dunking' machine automatically transferred racks of twenty films from tank to tank at predetermined regular intervals of time

arranged his films in single rows on rods that reached across the lifting bars, but which rested on two continuously moving chains at all times, except during transfer. This means that when a row of films is deposited in the first tank, the ends of the rods come to rest on moving chains that slowly transport the rod and its films from the front to the rear of the tank until the lifting arms again connect with the rod and transfer it and its films into the next tank.

This particular design allowed *Dye* to use tanks of varying sizes and thereby provide different treatment times in each solution. Furthermore, by changing the speed of the driving motor—a simple matter of changing the belt driven pulleys, the overall times of treatment could be chosen to give a development time of 7, $8\frac{1}{2}$, 10 or 12 minutes—with of course proportionate changes in stop, fix and washing times.

Another feature that *Dye* included in his machine was the provision of an interconnected film drying section in which it was arranged that the film rods would be automatically spaced farther apart than they were during their passage

41

through the wet section of the machine. With the rows of films spaced well apart, they were transported, still on moving chains, beneath fans that propelled gas heated drying air.

In summing up the benefits of his machine *Dye* said in his patent:

> By so handling the films they are very accurately timed in their movements, and scratching and tearing of the films by manual movement is avoided. The machine does the work of several operators who would have to be present to transfer the film from one liquid container to another after a certain time.

METHODS OF MOVING HANGER BARS The Dye machine described above was the first of a line of Pako machines, and it has been explained that the film rods were progressed from each successive solution while supported on a pair of continuously moving chains. Later, *Dye* patented[3] a radically different method of

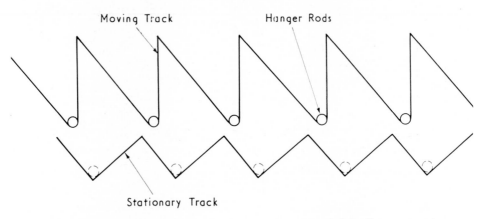

Fig. 19 Film hanger rods are progressed through the solution tanks of a Pako film processor by means of a combination of one pair of moving and one pair of stationary serrated support tracks

moving rods or hanger bars from the solution tanks. This idea depends on the use of two pairs of serrated pick-up arms, the outer pair being periodically reciprocated in a vertical plane. The relative disposition of the two pairs of pick-up arms or plates is such that when a rod is placed on the inner stationary pair of plates it occupies the bottom of the recess between adjacent teeth. When the outer pair of plates is moved upwards the ends of the rods are lifted from the inner plates to the outer ones and as they rise and the rod clears the top of the teeth on the inner plates, the rod slips by gravity down the inclined front edges of the teeth on the outer plates, coming to rest in the recess between these teeth. When the moving plates descend, the ends of the succeeding rod contact the forward facing inclined surface of the succeeding pair of teeth in the fixed plates, and the rod slides down these teeth and comes to rest exactly one step further

42

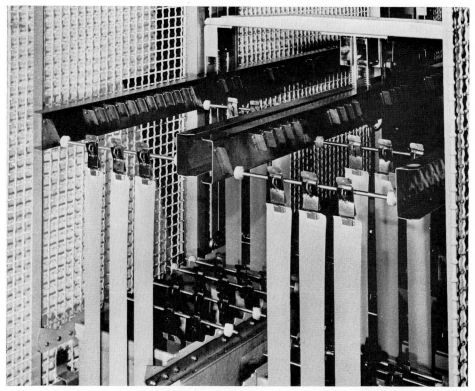

Fig. 20 In the Ilford roll-film processing machine, film hanger rods are transported through the solution tanks by means of regularly spaced inclined plates. This illustration shows a dual-track processor

along the solution tank, the step being equal in distance to the pitch of the teeth cut in the plates. The operation of this form of film transport is more easily understood with reference to the drawing.

Another method of producing a stepwise progression of film hanger rods through processing tanks is used in an Ilford machine.[4] A pair of lifting arms are driven by the usual arrangement of endless chains to provide the tank-to-tank transfer of films. On the inside faces of the two lifting arms there is a series of projecting inclined plates spaced apart by the distance separating the film rods when they are at rest in the processing tanks. Whenever there are two or more rows of films to a tank, the lower end of the foremost inclined plate is bent up to form a hook. None of the other plates relating to any one tank has upturned hooks, with the result that when the lifting arms rise from their lowest position beneath the ends of the film rods, the upper ends of the inclined plates pass between the adjacent rods, but as the lifting arms rise still further, each pair of inclined plates comes into contact with the ends of a film rod, and as the arms continue to rise the plates each push their contacting film rod along the

rails on which they are resting. In fact, the pair of stationary rails on which the rods rest are notched at regular intervals so that as the rods are pushed along the rails by the movement imparted by the inclined plates, the ends of each rod come to rest in the next pair of notches along the stationary rails. This ensures accurate spacing of the rods at fixed points along the machine.

When a rod has been shunted from its first position in a solution tank to its last position in that tank, it is picked up by a pair of hooked plates and then the rod and its suspended films are lifted out of the tank and transferred into the next solution.

SAFETY PRECAUTIONS All the machines described so far have used two parallel lifting arms, thereby effectively enclosing the whole of the solution tank area of the machine. With such machines it is essential to provide both protective guards and cut-out devices to avoid accidents from operators encroaching into the tank area while the lifting arms are in motion.

A number of different approaches have been made to this problem of ensuring safety. Electrical interlocks to prevent the machine from being run whenever all the safety guards are not properly in place, electro-mechanical devices to stop the machine in the case of any obstruction touching a trip-bar attached to the lifting arms and main drive clutches that slip whenever the load on the lifting arm assembly is greater than normal.

One relatively simple way in which some of the risk of damage can be eliminated in a roll film dunking machine is to arrange for the whole of the lifting assembly to be counterbalanced so that the driving chain does not carry any dead weight.

These precautions, while essential for the safety of operators, are also important because they minimise the possibility of serious machine damage. Whenever a film rod accidentally becomes misplaced at some point along a dunking machine, there is a strong possibility that damage will occur to the mechanism and to the rod and its films if the drive to the lifting arms does not stop or slip as soon as it meets any obstruction.

The risk of accidents to operators is greatly reduced when cantilever film support arms are employed so that all the lifting mechanism can be located at the back of the machine. Not only is this type of machine safer, but it leaves the front more open for inspection and for emergency operation by hand in the event of mechanical or power failure.

The Pako Filmachine[5] makes use of cantilever arms for lifting the film hanger rods, and the form of its construction can be seen from the diagrams. A combination of fixed and vertical reciprocating notched side plates is used to move the rods of films through each processing tank as in Pako's earlier machines. A central vertical column at the rear of the machine supports the chain and wheels that impart the transfer motion to a single horizontal elevator bar.

44

With some earlier types of automatic rack and tank machines it was impossible to remove any of the solution tanks without first undertaking considerable dismantling, but *Nottaris* and *Wagner* patented[6] a design that does permit tank removal without disturbance of the rest of the machine.

Limited Operating Speed of Dunking Machines

Typically, about a minute is required to transfer films from one tank to the next on a dunking machine, and because it is undesirable to have partially treated films exposed to air for any longer than necessary during processing, attempts have often been made to speed up the transfer operation. The difficulty that immediately arises is that the horizontal component of the processing cycle, if carried out too quickly, imparts a considerable swinging motion to the suspended films, and this in turn can easily result in the films either touching each other or failing to descend accurately into the next tank.

One method[7] of transferring films from one processing tank to another makes the rate of movement of each rod or rack of films greater during the vertical component of the transfer movement than during the horizontal component. In other words, the films are lifted and lowered quickly, but moved more slowly in the horizontal direction. In the machine proposed by Donka, the two speed drive is obtained by introducing a differential gear and a simple system of changeover switching, with the result that the lifting arm or arms can be made to move vertically at say, six times the speed of the smaller, horizontal movement required to move the films along the machine before lowering them, again at high speed, into the next solution.

Pavelle's automatic roll-film processing machine also uses dual speeds to reduce transfer time to about 30 seconds; but in their case they merely change the voltage supplied to the maindrive motor during the horizontal component of the transfer cycle. This is accomplished by causing the carriage itself to operate a micro-switch when it has almost reached the top of its vertical travel and then, after the carriage and the films have moved horizontally, to operate a second switch that causes the main drive motor to revert to full speed during the descent of the carriage and reimmersion of the films.

Another approach to the problem was adopted by Ilford Limited who designed and constructed a machine capable of processing colour negative films at the rate of 900 an hour. All the films are held in rigid frames—five films to a frame—and the speed of the transfer movement is arranged to be fast throughout both vertical and horizontal components.

The film racks on this Ilford machine are prevented from swinging by means of fork-ended arms which automatically swing into position to guide the racks whenever they start on their upward travel. The forked arms engage slideably with one side of each film rack and serve to restrain it throughout the whole

processing cycle. Only when the racks are back in the tanks are the forked arms automatically retracted and returned laterally ready for the next rack ascent.

Some rack and tank machines dispense with the chain and sprocket system that is normally employed to effect the movement of lifting arms from one tank to the next. A machine made by *Mullersohn* for example, imparts a strictly linear vertical reciprocating movement to the film lifting assembly and depends upon a series of overhead angular cams to shunt the film rods along the rails of the lifting assembly before the films descend.

Wainco[9] have described a hydraulically driven lifting mechanism in place of chains and sprockets. This patent also describes hydraulic means for moving the lifting assembly laterally when it reaches the top of its travel, as well as for reciprocating the movable pair of serrated plates used for moving the films through the solution tanks.

Rack Loading Systems

Daylight rack loading systems have been developed because it is easier and cheaper to do as much preparatory work in white light than it is to have an operator do it in complete darkness. This becomes particularly important when the capacity of an automatic rack and tank machine is large and the preparatory work required to load racks with film is too great for one operator to keep pace with the machine unless as much as possible is done for him before the films reach the dark room.

One way of improving efficiency in film preparation is to use film racks that incorporate clips to hold rolls of film from which the sealing bands have been removed and the backing-papers turned back. This type of hanger can be loaded with its full complement of films and their order dockets before being transported to the darkroom. Pako and Hostert both make hangers of this kind.

Refrema Daylight Loading System

In most photofinishing works, rolls of film for processing are prepared as far as possible in white light before being transferred in batch boxes or trays into a darkroom where the backing papers are stripped from them and the films suspended from hangers with bottom clips attached.

Refrema have designed a film transport system to provide a more efficient means of feeding films to the starting point of their roll-film dunking machine. The system enables an operator working in white light to remove the wrapper label, fold back the end of the backing paper and place the roll in a film clip that is itself attached to a machine hanger. On a signal from the darkroom operator, the hanger bar with its full complement of films can then be transferred from

46

the light room into the darkroom, where it is deposited into a convenient position for stripping its backing papers away. After stripping, the hanger is transferred by the darkroom operator into the magazine or reservoir of the processing machine. The next hanger is then transported from the light into the darkroom stripping position. Considerable saving of valuable time is achieved by this arrangement and the dunking machines can often be operated at speeds that would not be possible if all the usual preparatory work were required of the darkroom operator.

Devomat Overhead Hoist Method

So far machines have been considered in which the racks or rods holding the films are intermittently transferred from one tank to the next by means of a moving lifting mechanism which alternately engages and disengages the film hangers. It is also possible to raise and lower a group of films on a rod or rack by means of an overhead hoist that winds up or unwinds a cable from which the racks of film are suspended. The winding mechanism can obviously be arranged to travel predetermined distances along overhead rails so that when it is required to transfer films from one solution to another, the hoist first lifts the rack out of the first tank and then, after the movable hoist assembly has been driven an appropriate distance along its rails, the hoist motor can come into operation again to lower the films into the next tank. A machine of this type, called Devomat, is made by Photals Sacap in France.

Colortron Circular Machine

The same principle of hoisting films out of a tank and then, after advancing an overhead carriage, lowering them into another tank, can be adapted to operate with a circular overhead rail and a corresponding circular disposition of tanks.

A Colortron (UK) machine worked in this way, and each overhead carriage incorporated a pick-up coil to receive a signal as soon as the carriage was directly above one of the tanks. The signal operated a relay to stop the carriage and then lower the films into the tank. At the end of the required treatment time a further signal caused the carriage to hoist the films out of the tank and move on to the next position. A simple timing circuit controlled the dwell in each solution and it was possible to use the machine for different processes (e.g. black and white and colour negative) by providing extra tanks and programming the carriages to pass those solutions not required.

Another machine of this type is made by Kampovsky of Kiel. Their NA200 Automatic Rotary machine develops and dries films at the rate of 200 an hour.

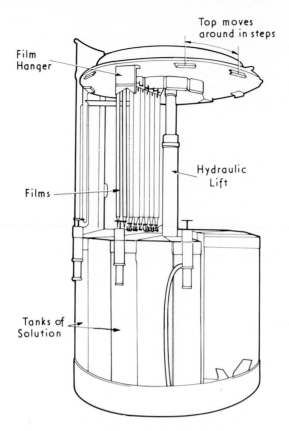

Film
Hanger

Top moves
around in steps

Films

Hydraulic
Lift

Tanks of
Solution

Fig. 21 When space is restricted, a circular roll-film processing machine such as the Kampovsky NA200 can sometimes be used instead of the more orthodox 'straight-line' arrangement of tanks

The operation of this rotary machine is different from the Colortron in that the whole of the upper film rack support assembly not only rotates but ascends and descends on a hydraulically operated central pillar. In this way, while the films are immersed in the solutions, they are closely covered by the lid or roof of the whole assembly.

Horizontal Machines

By reason of its method of operation, any dunking machine in which the films are hanging vertically must require an operating height more than twice the length of the longest film. In practice about eight feet of head room is required, and obviously there are some locations where this is not available. In such cases, it is sometimes possible to instal a type of machine designed to process

48

films while they are held in a horizontal instead of a vertical plane. Both *Hostert* and *Williamson* have made machines that transport films through processing solutions while they are stretched horizontally in frames. But there are some disadvantages associated with this type of dunking machine. Their output is limited because only one film is held in each rack, and it is more difficult to deal with varying lengths of film than it is when they are merely suspended in a tank.

There still remain one or two other ways in which roll films can be treated with processing solutions. Early in his career, *Dye* patented a machine in which films were suspended—at about waist height—on a horizontally moving chain so that they travelled through an elongated "U" shaped path and were successively sprayed by a sequence of treatment solutions—developer, rinse water, fixer and washing water. At the time this idea was propounded, too little was known about the ways in which developers can be made to withstand their tendency to oxidise when used in the form of a spray. However, just as it is now practicable to develop black and white motion picture films in spray processors, so it would undoubtedly now be possible to adopt *Dye's* procedure for processing amateur black and white roll films.

A somewhat similar method of processing films has been adopted by both Ritter and Kampovsky in Germany, and Eiri (Eino Riihelä Ky Kisällinkatu) in Finland.

Single-Tank Processors

The Eiri single tank processing machine requires a floor area approximately 2 ft. × 2 ft. and a height of 4 ft. The output is said to be forty-five 126 or 35 mm. (20 exposure) films per hour, and the power consumption of the machine including heat for the solutions, is one kilowatt.

The operating procedure is quite simple; the films are suspended in a rack and placed in the single processing tank, after which a light-tight lid is closed and subsequent operations can proceed in room light. The required sequence of treatment times having been set on a panel of timers, the starter button is pressed and developer is rapidly pumped into the tank. Development then continues for the chosen time, after which the developer is automatically returned to its container and water is introduced into the processing tank to rinse the films. Fixing solution is then pumped in, and after the required fixing time this too is returned to its storage tank and replaced in the processing tank by washing water. Provision is also made for a final rinse containing wetting agent.

The SWN 100 made by Ritter and the NA 36 made by Kampovsky are similar to the Eiri in both design and operation. With the Ritter machine replenishment is automatic and the replenisher is fed directly into the working tank.

49

Continuous Machines

From time to time attempts have been made to design continuous machines that would be capable of processing the short lengths of film of differing widths that are used by amateurs.

Barker, as we have seen, made an attempt to do this by joining the films end to end and then leading them through the processing sequence on rollers in the normal way. It seems likely that this method would prove unsatisfactory because of the damage to the negatives that must inevitably occur.

Fader,[10] proposed to tackle this problem in a different way and in fact, the type of machine he described was subsequently used by Agfa for paper processing. Fader's machine was intended:

> For use in effecting liquid treatment of cut lengths of paper and/or film wherein means are provided to attach the cut lengths in approximately parallel relationship to and between oppositely disposed and parallely arranged endless chains. The said cut lengths of paper and/or film being the same or different lengths and the attachment or detachment of the paper strips and/or films being effected whether the machine is running or while the machine is stationary.

There is no evidence that any machines were built to *Fader's* design, or, if they were built, how successful they were, but the concept of an endless chain or belt to which attachment arms can be clipped to lead lengths of paper or film through a machine and the way in which the arms can be made to detach themselves automatically from the chain or belt is basically the same as employed on Pako's continuous paper processors.

More recently, *Hostert* has demonstrated a continuous film processing machine which depends upon two endless rubber belts running parallel through the machine and having inward facing slots into which films of a standard width can be fed in order to be carried through the processing sequence.

It can be argued that because the growing tendency is to join films—particularly 126 and 135 films—before printing, the joins may as well be made prior to processing so that the processing can be done on an orthodox friction-drive, helical-path processing machine. If this is so, then the value of a machine which accepts unjoined lengths of film and must transport them in a straight sinusoidal path has limited advantages to offer.

In fact it seems rather unlikely that any black and white amateur films have been or ever will be processed on continuous motion-picture-style processing machines, although such machines are now rapidly becoming commonplace for processing 35 mm. and 126 size colour negative films. Detailed consideration of continuous processing machines will therefore be deferred until a later chapter.

In the same way, although it is certainly possible to process roll films in roller type machines such as those used for X-ray and graphic-arts films, it is unlikely that photofinishers will ever now consider it economically viable to invest in

50

such equipment when the volume of black and white finishing is steadily declining.

Processing Control

There is little doubt that the standards of control in processing colour films and papers now achieved by most photofinishers are higher than they ever were when finishers were dealing only with black and white films. Nevertheless, with the help of film manufacturers, who also have an interest in seeing that the consumer is well served, useful progress towards better control of black and white processing quality had been made by the time colour arrived to demand so much of finishers' attention.

Variables Affecting Processing Quality

The principal variables that must be controlled before uniform processing quality can be achieved are:

1 The rate of solution replenishment. Replenishment is necessary to keep the various solutions at a predetermined level of activity by offsetting any change in the chemical composition of the solutions brought about by treatment of the films passing through them.
2 The time of immersion of the films in the various solutions—usually governed by the speed of operation of the machine.
3 The temperature of the solutions—important in determining the rates at which the processing reactions take place.
4 The agitation of the processing solutions and/or the movement of the films in the solutions, both of which affect the uniformity and speed of the processing reactions—particularly development, which is usually not carried to completion.

Developer Replenishment

In the previous chapter, reference was made to the early proposals of *Barker* for the replenishment and continuous use of a developer in his roll film processing machine. At that time, in the early thirties, the normal procedure in a D and P works, was to use one or other of the commercially available long-life tank developers which were replenished by topping up the developing tank to compensate for the solution that was carried over by developed films.

This simple procedure worked reasonably well, but even so, the chemical manufacturers usually recommended that the developer should be discarded

51

when the initial quantity of replenisher had been used. This was not too serious when tanks were relatively small and when the inevitable changes in negative contrast could be accommodated by choice of a different paper grade. But as soon as black and white printing had to be carried out on continuous rolls of paper it became essential to maintain a uniform negative quality at all times and very undesirable to discard a seasoned developer.

When the concentration of a replenisher cannot be adjusted to keep activity constant by adding just sufficient of it to replace the developer that is carried

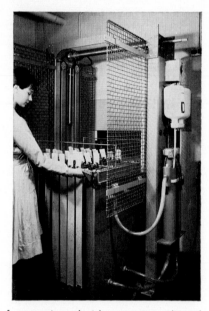

Fig. 22 The simplest type of automatic replenishment system depends upon the maintenance of a constant level of developer in the working tank by means of a self-operating 'chicken-feeder'

over with the film, it is sometimes necessary to run a small but constant amount of working solution to waste in order to make room in the solution system for sufficient replenisher. Replenishing solution can be fed into the working system either in doses or continuously whenever the film is being processed. Because dunking machines necessarily require the arrangement of films into separate groups of rods or racks, it is a relatively simple matter to link the progress of a group of films along the machine with some device that will automatically deliver the required volume of replenisher into the developing and fixing tanks whenever a rod or rack of films passes through.

The make-up of a replenisher depends upon the composition of the original developer, but generally replenishers contain about the same concentrations of sulphite as in the original formula, but rather more alkali and developing agent.

52

Because of the build-up of bromide in the working solution, restrainer is usually omitted from a replenisher formula.

In Britain Kodak have attempted to eliminate the inconvenience and risk of error that attaches to the use of different formulae for starter and replenisher solutions, by devising chemistry (DN-13) that allows replenishment to be carried out with a more concentrated solution of the same stock developer as is used to fill the tanks initially. Correct replenishment rate approximates to the normal carry-over rate and the level in the working tank therefore need only be maintained to achieve uniform performance. In preparing the initial solution for a working bath, a starter solution (DN-135) is added to the diluted developer. No doubt this is to "season" the developer so that its characteristics can be more easily maintained thereafter.

Control of Temperature

Because of the difficulty of installing any form of permanent heating unit within the tanks often used for processing amateur films, the control of solution temperature attained by many photo-finishers was for a long time limited or even non-existent. In cold weather no more was done than to heat the developing solution with a portable electric immersion heater before starting to process. Obviously the temperature, even if correct at the commencement of processing, was unlikely to remain so for very long.

In hot weather, development time was often shortened to maintain reasonable levels of density and contrast. If the necessary reduction in development time was difficult to arrange, as for instance on a fixed cycle dunking machine, then bags of ice might be used to reduce the temperature of the developer before commencement of processing. Generally it was not the resulting increase in negative contrast that dissuaded the finishers from operating at high temperatures, because this could be offset by printing on to a softer grade of paper; but the excessively dense negatives inconvenienced him because they required longer exposure times, which reduced his output of prints.

A change in attitude towards processing variables came about in the early fifties when finishers decided that they could greatly reduce their costs and increase their output by printing all negatives on to continuous rolls of paper. Very quickly after that it was realised that only one contrast grade of paper could be used, and that this apparently serious limitation would be acceptable only if negative quality was much more strictly controlled than ever before.

Heat Exchange

For obvious reasons it is difficult to instal any form of heat exchanger within the working developing tank of a roll film dunking machine. Instead, it has become

common practice either to surround the tank with a thermostatically controlled water jacket or to connect the tank to an auxiliary container through which the developer is continuously pumped for heating or cooling to the desired temperature.

A typical automatic temperature control unit—the Pakotemp—will hold a developing solution to within $\frac{1}{2}°F$ of any desired temperature between 50°F to 90°F. Such a unit can have a cooling capacity of 10,000 BTU's an hour and a heating capacity of 3,000 BTU's an hour and will be contained within a space rather less than one cubic yard.

In recent years the growing tendency to process at higher temperatures in order to reduce the overall time required to carry out a process, has meant that more finishers have been able to dispense with any means of cooling their

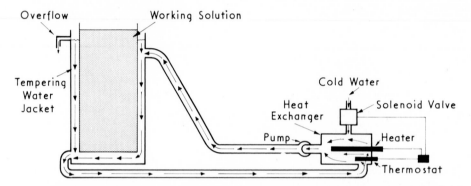

Fig. 23 Most Pako processing machines depend upon water jackets to maintain working solutions at the required temperature. Tempered water is circulated through the jacket by means of a pump

processing solutions—depending instead on the fact that additional heat will be required to raise the developer to the required temperature and hold it there.

Sometimes a heat exchanger is fitted together with a thermostat and a circulating pump to a container that is remote from the processing machine itself. Alternatively a small auxiliary solution container is attached to the side of the machine tank.

Solution Agitation

It is now generally understood that when there is no agitation of a developing solution, a stagnant layer forms adjacent to the surface on any film suspended in it. As development proceeds the solution next to the image is depleted of developing agent and enriched in soluble bromide. Thus the progress of development is slowed down if some way is not found to replace the stagnant layer of solution with fresh developer. In other words the degree of agitation of

54

the developer in a roll film processing tank has a significant effect on the rate and uniformity of development.

For years, finishers made no attempt to create solution movement within their processing tanks. The periodic linear movement that resulted from the immersion and removal of films from a developer in a deep tank, could not be considered a desirable form of agitation because it merely emphasised the streaks that result from accumulated reaction products of development draining down the surface of the film.

While recirculation of a developer by pumping provides a certain amount of solution movement across the surface of the film, the size of the pump and the rate of flow required to effectively disturb the layer of solution adjacent to the film is prohibitively great, except for very large, fast running continuous machines such as those used in the motion picture industry.

As with so many other aspects of photo-finishing, the stricter requirements of colour processing have led to the general adoption of solution agitation by means of gas bursts. Compressed nitrogen is used for developers because this inert gas causes no oxidation, but clean compressed air can be used in wash tanks and certain other solutions.

Continuous bubbling of gas through a solution tends to form regular patterns, so it is preferable to release the gas in short bursts, particularly when, as in the deep tank processing of roll films, there is little or no movement of the film itself.

Recirculation and Filtration

Nowadays, a filter is generally incorporated in a developer recirculation system to remove all but the smallest solid particles from the solution. Disposable filter elements such as those made by Cuno are relatively cheap and should have a pore size of between 25 and 50 microns for use with a developer. The elements can be changed quite easily and regularly.

In small installations it is not generally considered necessary to measure the rate of circulation flow with a flow meter. Instead, the presence of turbulence at the surface of the developing solution is usually considered a sufficiently good indication that circulation is adequate.

Centrifugal sump-type pumps are now generally preferred for solution recirculation because they have no gland to cause trouble from leaking, and as they are mounted in a vertical plane they take up less floor space. The rate of flow can also be adjusted by valves or clamps without changing motor speed.

Fixing

Perhaps it is not surprising that the fixing stage of photographic processing seldom receives as much attention as development. Partly this is because

fixing is carried to completion, and does not therefore have to be such a precise operation as development, but probably also because there may be no immediate evidence of the results of inadequate or faulty fixing.

The fixing process is superficially quite simple but chemically rather complex. In practice three or four conditions must be observed if satisfactory fixing is to be achieved:

1 The required concentration of hypo (sodium/ammonium thiosulphate) must be maintained.
2 The concentration of silver must not become too great in the solution (more than five grams a litre is unacceptable).
3 The pH or degree of acidity must be maintained between fairly narrow limits and never allowed to become alkaline.
4 The hardening effect of the fixing bath must be maintained. This will normally follow from the rate of replenishment required to satisfy (1) above and from the maintenance of the correct pH.

The time required to clear a film in a fixing bath depends on a number of factors:

1 The coating weight of the emulsion and the size of its grains. (Fine grain films fix more quickly than faster films).
2 The type of fixing agent being used—ammonium thiosulphate dissolves silver halides nearly twice as quickly as sodium thiosulphate.
3 The agitation of the fixing bath in terms of dilution (due to carry over) and silver concentration.
4 Physical conditions—such as solution temperature and agitation.

As in development, agitation is extremely important in a fixing bath and because it is often non-existent it is usual to extend fixing time to provide the necessary margin of safety. As a rough guide it is reasonable to assume that a fixing bath remains serviceable as long as the time-to-clear is not more than twice the time that a fresh solution takes to clear the same type of film at the same temperature.

The silver concentration of a fixing bath can be determined with sufficient accuracy for practical purposes by using test papers. Those made by Eastman Kodak in the US and Johnsons in Britain, are probably the best. They cover a range of concentrations between one and ten grams a litre.

Silver Recovery

The recovery of silver from all types of fixing bath has assumed greater importance in recent years during which the price of silver has increased con-

56

siderably. Negative films have relatively high coating weights and the recovery of silver from their fixing baths is therefore well worthwhile. For example, a photo-finisher processing 100,000 rolls of black and white negative film (mostly 126) each year could reasonably expect to recover 250 troy ounces of practically pure silver, while the yield from colour negative films should be almost twice as much.

ELECTROLYTIC SYSTEMS There are various ways in which silver can be recovered from fixing solutions, but probably the most convenient are the electrolytic methods. Of these the so called low current density methods are unsuitable for use in conjunction with the negative processing systems found in photofinishing laboratories. That is because the rate at which silver can be removed from the fixing baths is often much less than the rate at which it is accumulating in the solution, as a consequence a great deal of recoverable silver is lost by being carried over by the film in to the wash tanks or by being bled off to waste to make room for the necessary replenishing solution.

It was with these considerations in mind that Ilford Limited designed a high current density electrolytic silver recovery unit[11] especially well suited to the requirements of photofinishing. It comprises a rotating shaft supporting a helically shaped stainless steel cathode to provide the solution agitation and circulation that is essential if relatively high current density is to be used without silver sulphide being formed and the fixing bath being spoiled. When operated at 4 or 5 amps the Ilford unit is capable of recovering silver at the rate of approximately one troy ounce an hour—sufficient to keep pace with a through-put of some 500 rolls of 126 films an hour. The design intended that the unit should be used overnight by immersing the anode and cathode assembly in the fixing solution in the working tank of a dunking machine. It is also possible to connect the fixer over-flow pipe to an auxiliary container in which the recovery unit is suspended. This arrangement allows the unit to be operated whenever the processing machine is running, and the treated fixing solution, having been almost entirely stripped of silver, can be run to waste through the recovery unit. This system has the merit that if sulphiding should occur there are no adverse effects on the working solution.

The Rotex recovery units made in the US by Snook, and in Britain by PSR Ltd. are similar to the Ilford design except that their cathode plates are flat discs and are not helically shaped.

A comprehensive survey of silver recovery methods has been made by Schreiber.[12]

METALLIC REPLACEMENT SYSTEMS When regular replenishment of a fixing bath is employed and an overflow of used hypo results, the waste solution can be fed through a container in which steel wool is packed. The steel will then be largely replaced by silver without the application of any electrical current. This system

has been adopted in the US by Eastman Kodak with what are called metallic replacement cartridges.

The Kodak chemical recovery cartridge consists of a serially numbered plastic coated drum filled with steel wool. The top or lid of the drum is crimped into place and is not intended to be removed by the user. A so-called circulating unit is used in conjunction with the cartridge, and its primary purpose is to ensure that should a blockage occur in the unit, the flow of waste hypo from the machine is not stopped.

The rate of flow of hypo through a Kodak recovery cartridge should not be

Fig. 24 The high current density electrolytic silver recovery unit supplied by Photographic Silver Recovery Limited in the U.K., uses a set of rotating discs as a cathode in the same way as the Rotex unit made by Snook in the U.S.

more than 500 cc a minute and preferably should be around 250–300 cc a minute. The treatment capacity of a single cartridge is rated as the number of gallons of hypo from which substantially all silver can be removed. This varies according to the concentration of silver contained in the overflowing hypo, but will usually be somewhere between 150 and 250 gallons. When the cartridge is considered to be exhausted it is replaced by a fresh one, and the used cartridge is returned to Eastman Kodak for assay and refining. Kodak's charge for assaying either one or up to ten cartridges from the same customer is 10 dollars, and a further charge is made of approximately one per cent of the value of the recovered silver.

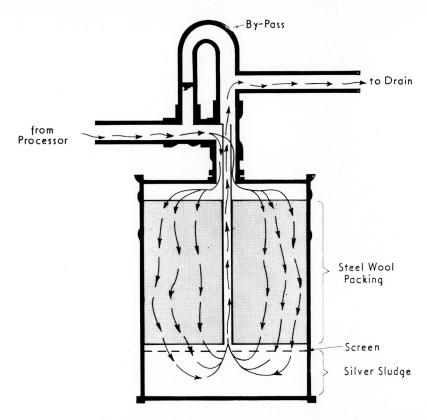

By-Pass

to Drain

from
Processor

Steel Wool
Packing

Screen

Silver Sludge

Fig. 25 The Eastman Kodak Silver Recovery cartridge consists of a five gallon plastic-lined drum charged with steel wool which is replaced by silver when used fixing solution flows through the unit

Washing

Black and white photographic negatives have to be washed after developing and fixing to remove virtually all traces of hypo from the emulsion layer. If this is not done, nothing will happen quickly, but in time the hypo left in the negative may react with the silver image to form yellowish brown silver sulphide. Thorough washing is more important in those climates where the photographic image will be stored in relatively high temperatures and high humidity.

In a sense, all washing of fixed photographic materials is a nuisance, and as the cost of water still increases it becomes an expensive nuisance. In view of this it is rather surprising how little attention the average photofinisher pays to the factors which affect the efficiency of his washing procedures.

TEMPERATURE OF WASH WATER Frequently, little or no attention is paid to the

59

temperature or the rate of flow of water used for washing black and white films. That the temperature of washing water is important may be seen from the fact that film can be washed to a satisfactory standard in 15 minutes in water at 80°F and will require 30 minutes in the same tank when the temperature of the water drops to 40°F.

What usually happens in practice is that longer washing times are adopted in order to provide a margin of safety and consequently a great deal more water is used than necessary—particularly during the summer months.

Even when money is spent on providing a supply of tempered water for washing, care should be taken to see that it is used efficiently. The most effective use of washing water results from the introducing of vigorous gas burst agitation. As with development, the gas bubbles scour the surface of the film being washed, allowing fresh water to get to the emulsion surface so that the hypo can more quickly diffuse out. *Levenson*[13] has shown that given sufficient agitation, it is possible to wash 1,000 feet of 35 mm. motion picture film to archival standards in one litre of water.

Drying

Like washing, the drying of films often receives scant attention, and as a result frequent variations arise to cause trouble. Preferably, films should be dried under closely controlled conditions of humidity, but in practice very little is done about the humidity, and the drying process usually depends upon a somewhat crude system of blowing hot air between the rows of films as they emerge from the wet section of a dunking machine.

Without adequate control of humidity the condition of films may vary from being insufficiently dry to being over dry so that they curl and become brittle. In an attempt to avoid tackiness many finishers tend to over dry their films so that they curl and then prove difficult to handle when printing. Ideally, films should be dry to the touch at the time they are about half-way through the drying tunnel so that during the remainder of the time they can reach equilibrium of the surrounding atmosphere of the laboratory—preferably around 50–60 per cent relative humidity (RH).

Small finishers use drying cabinets in which batches of wet films are suspended so that a draught of warm air can be blown down through them until they are dry. When films are processed in dunking machines it is more usual for the drying to take place in a tunnel forming an extension of the machine itself.

Some dunking machines—the Pako Filmachine for example—are designed so that the rows of films emerging from the wet section of the machine are fed into a drying tunnel and then automatically spaced out so that air can be more effectively circulated between the films. Usually infra-red heat elements are disposed vertically along each side of the drying tunnel while over-head fans

60

draw the hot air past the films. Pako supply a dehydrator for use in conjunction with their dryer and this helps to deal with conditions where increased temperature alone would not result in properly dried films. When humidity is low, say below 25 per cent RH, Pako recommend that the setting of the thermostat controlling the tunnel temperature should be lowered to prevent excessive curling. It may also be necessary to cut down the exhaust flow with some kind of damper. It is sometimes useful to add some moisture to the air in the tunnel and this can be done either by using a humidifier or even, in emergency, by running a damp towel through the drying tunnel ahead of the first hanger of films.

As an approximation it can be taken that a small dunking machine with rods carrying four films and having an hourly output of about 100 films will require some 4 kilowatts of drying heat, while a larger machine handling 250 films an hour will need something like 7 kilowatts.

Film Cutting

Usually, negatives will be cut and put into print wallets together with their order dockets immediately after their first printing, and if any reprinting is necessary the wallet, together with those prints that are satisfactory and all the negatives will come back to the printer who then makes the reprints of the appropriate pictures.

This procedure may persist even when 126-size negatives have been joined prior to processing or printing, but as the proportion of printing from continuous rolls increases, methods will no doubt be devised for the rapid automatic recall of selected negatives for reprinting before the roll is broken down into individual orders. This kind of automation may never be applied to black and white negatives, but some such procedure is likely to be adopted in colour printing.

It is an unfortunate fact that once a roll of negatives has been cut into individual or small groups of exposures, they are never as convenient to handle for printing. Nevertheless, it is usual for all roll-film negatives except 126 and 135 to be cut into individual frames before they are returned to the customer. It has become conventional to cut 12 exposure 126 films into three sets of four negatives while 35 mm. films are usually cut into groups of six.

Automatic Film Cutters

Several attempts have been made to separate processed roll film negatives by automatic cutting. Usually such cutters have depended upon the perforation of

a tiny hole between adjacent negatives at the time of the first printing exposure. The hole can then be used to conduct a spark discharge and trigger a cutting knife. The Eastman Kodak Model 4AK automatic film cutter works in this way, and will cut all standard amateur roll film sizes (except 828) into single frames or strips of two, three or four frames. The film (with the exception of 126) must have been pierced by means of the Kodak film perforator attachment Model 3, which can be mounted on all Kodak roll paper printers.

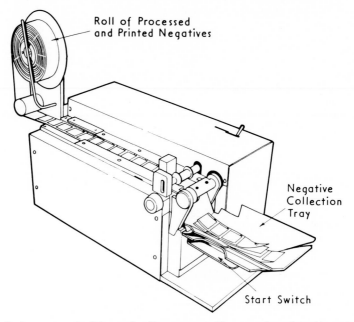

Roll of Processed
and Printed Negatives

Negative
Collection
Tray

Start Switch

Fig. 26 The Berkey automatic 126 negative film cutter typifies a number of machines that will auto-
matically cut rolls of processed negatives into groups of four and stop at the end of each order

Cutting 126 films is of course a much easier job than cutting unperforated roll film, because the rigid relationship between 126 negative images and their adjacent perforations, makes it relatively simple to devise automatic feeding and detection devices to operate a film cutter.

Several manufacturers supply automatic cutters for 126 films that are adjustable for two, three and four negatives per cut and will stop automatically at each join between films. The Berkey Automatic 126 Film Cutter is a typical machine capable of dealing with 500 rolls an hour, cutting either 12-exposure or 20-exposure lengths into strips of four negatives and stopping automatically at the end of each order.

REFERENCES
1 BP 371,089.
2 BP 390,335.
3 USP 2,459,509.
4 BP 934,070.
5 BP 892,003.
6 BP 818,679.
7 BP 981,658.
8 USP 2,823,595.
9 BP 905,944.
10 BP 357,597.
11 BP 817,912.
12 SCHREIBER, M. L. "Present Status of Silver Recovery in Motion Picture Laboratories" *J.S.M.P.T.E.* Vol. **74**, June, 1965, pp. 505–513.
13 LEVENSON, G.I.P. "The Economics of Photographic Washing", *B.K.S.* Vol. **30**, April, 1957, pp. 95–103.

III. BLACK AND WHITE NEGATIVE PRINTING

Although cut-sheet printing may still persist in a few countries, for the most part black and white printing is now carried out on continuous rolls of paper of a single contrast grade. The one commercially significant exception to this being Agfa/Gevaert's Variograd printer and Variolux paper system—which will be dealt with later in the chapter.

Probably the factor that contributed most towards the successful change from cut-sheet printing with several contrast grades to single grade roll printing was the improvement that came about in the standards of roll film negative processing. It is clear now that the necessity for various grades of paper contrast sprang mainly from having to print from an unnecessarily wide range of negative contrasts which in turn were often the result of faulty film processing.

But considerations of labour economy also became very powerful immediately after World War II, and the thinking behind the conversion to roll printing was outlined in 1948 by *Charles Clutz* of Eastman Kodak in his US patent[1] relating to the roll-head conversion of the Kodak Velox Rapid Printer. *Clutz* said:

> In order to speed up the production of these printers it has been suggested that the printing paper be handled in strip form and be automatically intermittently fed into the printing plane in lengths commensurate with the print size desired. Such a procedure eliminates the necessity of the operator having to feed individual sheets of printing paper into the printing plane for exposure and then removing them after exposure, and therefore allows him or her to confine their efforts merely to loading the negatives into the negative carrier. A complete roll of paper, after exposure, can be processed in strip form, thereby cutting down on the processing job ordinarily requiring the handling of individual prints.

In the US the transition from cut-sheet printing to roll printing and the production of "jumbo" prints from all negative sizes took place mainly around 1950. Most photofinishers already had Kodak Velox Rapid Photo-Cell Printers for cut-sheet use and kits were made available for easily converting these machines to roll printing. The first of these roll-head conversion kits were made by independent suppliers such as Fotopak, but Eastman Kodak were soon producing their own.

In 1938 *Glen Dye* of Pako was granted a series of patents relating to a projection printer intended:

> For making over-sized or enlarged prints by means of which various standard sized prints can be produced from different sized negatives and in which single sized prints may be produced from one negative with various magnifications.

This was the forerunner of the very well known Pakomatic printer. At that time it was a sheet-fed printer that did not incorporate automatic exposure determination; but it did have automatic focusing throughout the whole range of negative and print sizes.

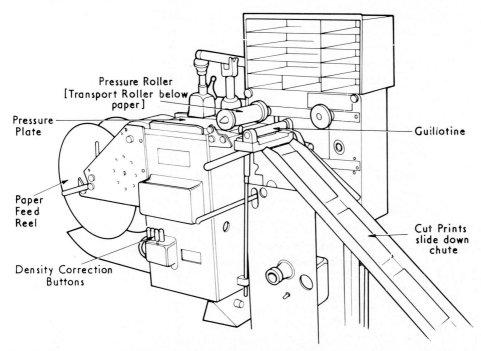

Pressure Roller
[Transport Roller below paper]

Pressure Plate

Paper Feed Reel

Density Correction Buttons

Guillotine

Cut Prints slide down chute

Fig. 27 One of the earliest roll-head adaptor kits for use with the Eastman Kodak Velox projection printer was made by Fotopak. The prints were usually cut from the roll immediately after exposure—continuous paper processing came later

Pako's policy of always making it possible to introduce improvements in their various machines without rendering earlier models obsolete, enabled them later to describe the Pakomatic printer in these terms:

The Pakomatic is a versatile strip-printer for making prints up to 5 × 7 in, using negative sizes from single frame 35 mm thru 116/616. It is available for delivering the exposed paper either in cut sheets or in rolls marked for later cutting by an automatic cutter (using either a slit mark or graphite mark to actuate the cutter). It uses paper from $2\frac{1}{4}$ – 5 in. wide and a maximum roll length of 500 feet. The photo-cell automatically controls exposure but can be overruled by the operator.

Kodak Velox Autometric Printer

In 1937, Kodak Limited launched a printer on the British market that was produced for a year or two before the War, but discontinued thereafter. The Velox Autometric was a cut-sheet printer having certain similarities to the Eastman Kodak Autometric printer that had been used by many finishers in the US since 1932. The Autometric printer assessed the average density of each negative by means of a Weston Photronic cell and a meter. The meter readings

65

could be translated into a series of exposure values in terms of a range of nine push buttons, while the choice of paper contrast was determined from three groups within the nine buttons.

Barker and *Keen* also made printers that worked in much the same way as the Autometric, although the Barker machines were not sold commercially.

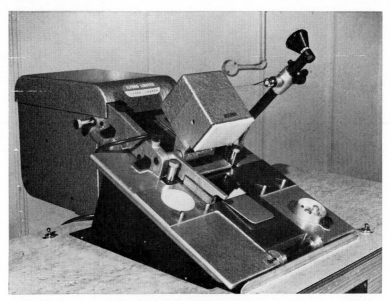

Fig. 28 The Ilford Roll-Head contact printer allowed exposure of a print to be terminated automatically by integrating the light transmitted through both negative and printing paper

Roll Paper Printing

The first roll-head printer to be made commercially in Britain was launched in 1951 and was based on the idea disclosed in a patent[2] granted to Ilford Limited.

The principal novelty of the Ilford roll-head contact printer was that for the first time in Britain the output of saleable prints was determined not so much by photographic skill as by the dexterity of the operator. Basically all the operator had to do was pull down the platen and await the automatic termination of exposure. On this printer, exposure was determined by a photo-electric cell contained in the platen head. Light reached the cell after passing through the negative/paper sandwich and a translucent pressure pad. Paper transport, which was from the back to the front of the machine and at right angles to the negative roll, was quite simply coupled to the movement of the platen operating arm.

At about this same time (1951/2) Kennington & Bourlet produced their

66

Synchromat projection printer which made prints the same size as standard contact prints, on a single grade of roll paper supplied by Ilford Limited. The Synchromat was the first roll-head projection printer commercially available in Britain, and in order to sell the idea of using a single grade of paper it was necessary to incorporate an optical contrast control that provided a choice of print contrast equivalent to at least two grades of paper.

This contrast control was achieved by utilising the Callier effect: two light sources were incorporated in the Synchromat—one, a point source giving specular light and the other an opal lamp providing diffuse light.

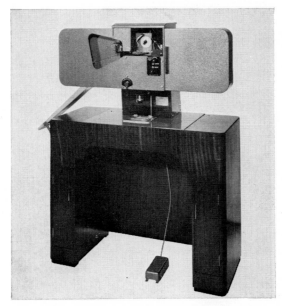

Fig. 29 Kenprinters differed from Synchromats in that they produced 'en-prints' by enlargement from all negative sizes

Soon afterwards, Kodak Limited introduced their Auto Velox printer, another roll-printing machine producing contact prints on a single grade of paper, but cut into short lengths corresponding to the negatives on each roll of film.

But contact printing on to paper in roll form brought with it the problem of handling film sizes other than 120 and 620. As the popularity of smaller negative formats such as 127 and 135 increased, so they became a growing problem to finishers, who either had to deliver very small contact prints or project small negatives to a more reasonable size using sheet-fed enlargers of orthodox type.

The first commercial British machine designed to projection print all negative sizes on to continuous rolls of paper was the Kennington Kenprinter introduced in 1954/5. One of the most valuable features of the Kenprinter was the in-

67

corporation of a plug-in electronic timing unit that could at any time be replaced by a spare with practically no loss of production. This approach to servicing is of course common now, but at the time the Kenprinter was first introduced, the idea was new.

The Kodak equivalent to the Kenprinter in Britain, the Velox Projection Printer, first became available around 1956/7, and with it a finisher could either make en-prints or same size(1:1) prints from 8 on 127, 12 on 120 and 8 on 120 negatives—an indication that the British finisher was yet undecided whether to make enlarged or same size prints. This uncertainty was extended while finishers and dealers chose to ask a higher price for an enlarged print than for a contact or same size projection print.

Optical and Mechanical Layout of Projection Printers

Most black and white roll printers are designed with a lamphouse beneath a horizontally disposed negative carrier, usually located at desk level. The paper plane is generally positioned parallel to and above the negative carrier. Often, the paper platform is fixed, and to change enlargement ratios, the lens and lens position are changed or supplementary lenses are added to alter effective focal lengths. The position of the negative carriers may also be varied in conjunction with the lenses with which they are to be used.

With the Pakomatic printer and the Ilford N-Printer the paper carriage moves in conjunction with automatically adjusted lenses while the negative carriers always remain in the same plane. The Agfa Variograd W76/90 utilises yet another arrangement in which both negative and paper planes remain stationary and the lens and a roof mirror system move in conjunction with each other to provide a range of enlargement ratios.

The printers made by Mullersohn in Germany depart from the more usual disposition of negative, lens and paper, by having the paper plane positioned at right angles to the plane of the negative. Printing is carried out by means of a 45° mirror through which a small proportion of light from the negative is transmitted to the photo-cell that automatically determines exposure times.

The principal advantage of having a vertical paper plane rather than one horizontally disposed directly above the lens, is that there is much less tendency for the dust and fragments that inevitably fall from paper rolls to collect on the upward facing element of the projection lens. This nuisance is avoided when the paper plane is located vertically in relation to the projection lens.

Exposure Determination in Printing

The concept of objective rather than empirical prediction of printing exposure dates back to the turn of the century when *Poliakoff* patented[3] a printer in-

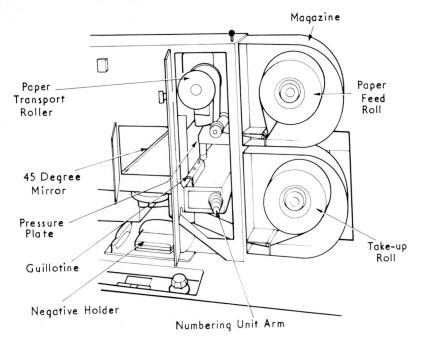

Magazine

Paper
Transport
Roller

Paper
Feed
Roll

45 Degree
Mirror

Pressure
Plate

Take-up
Roll

Guillotine

Negative Holder

Numbering Unit Arm

Fig. 30 Mullersohn printers are generally designed so that the paper exposing plane is vertical. The projected image is diverted via a partially reflecting mirror, while a small proportion of light passed by the negative is transmitted to a photo-cell located above the mirror

corporating a method of exposure determination. In the proposed arrangement light transmitted by a negative was reflected by a mirror on to a sheet of sensitive paper which in its turn reflected light towards a selenium photo-cell. As the paper darkened the current from the cell decreased and at a predetermined value a solenoid closed the shutter. Although rather crude, this idea of *Poliakoff's* showed the way for later workers who refined the method without departing from the principle.

Twyman filed a patent in the US in 1930 in which he described an electro-mechanical method of automatically determining and controlling the exposure of black and white prints made by projection in a variable-time, constant intensity printer.

The means proposed for modulating the effective intensity of the printing light was a rotating metal disc perforated with a multitude of holes of graduated size. Thus, the amount of light transmitted by the disc depended upon the size of the holes in the sector of disc positioned opposite the primary beam of light.

In 1930 *Twyman* disclosed a method of printing exposure determination on which most variable-time integrating printers have subsequently been based. The perfectly practicable printer described by *Twyman* even included means for

dealing with the unfortunate results that spring from using printing materials that depart from the reciprocity law. In other words, he provided means for "slope control" as this form of compensation has come to be known in colour printing.

Twyman's system was simply described in his patent:[4]

> The integrating means preferably comprises a light-sensitive device (e.g. a photo-electric cell) exposed to the influence of light transmitted through the negative, an electric storage device whose charge is adapted to be varied by current under control of the light sensitive device, and an electrical relay adapted to be operated to terminate the printing exposure when the electric storage device is charged to a certain point.

In recognition of the need for some form of compensating device to deal with any printing material that displayed reciprocity failure, *Twyman* explained:

> This may be taken into account by introducing a density wedge into the beam of light proceeding from the negative and entering the photo-electric cell, the said density wedge being moved during the exposure, commencing with the least dense end of the wedge. The density gradient and the rate of movement are adjusted so that the photo-cell is delayed in its process of discharging the condenser to a degree which depends on the length of exposure.

Very shortly after *Twyman* had disclosed his ideas on variable-time integrated exposures for printing, *Denis* of Eastman Kodak patented very much the same procedure.[5] *Denis* in his specification says:

> An object of my invention is to provide an automatic printer in which the discharge of a condenser through an element, the conductivity of which is a measure of the intensity of the printing light falling on the sensitive layer, is utilized to control the duration of exposure.

Integrating timers such as *Twyman* described, depend upon the fact that a capacitor will charge or discharge at a rate that is proportional to the current fed into it. The time taken to charge a capacitor depends on a number of factors:

1 The size of capacitor (S)
2 The current fed into it (C)
3 The initial voltage (V_1)
4 The termination voltage (V_2) and
5 The constant (K)

The equation is:

$$\text{Time} = K \, S \, \frac{(V_2 - V_1)}{C}$$

The initial voltage of the capacitor can be adjusted and is determined by such variable factors as print size compensation, and over-riding density corrections.

In 1932, *Hopkins* of Eastman Kodak patented[6] an electro-mechanical system of controlling printing exposure. He used a circuit-making mechanism in which one contact was driven at a constant angular rate towards another contact—

in effect the indicating pointer of an electrical meter—whose proximity to the continuously moving contact varied in accordance with the density of the negative being printed.

Much attention has been paid by researchers such as *Goldberg*, *Twyman*, *Tuttle*, *Jones* and *Varden* to printing exposure methods based on large area, but not necessarily total negative transmission densitometry. Although primarily concerned with methods of exposure determination for colour printing, a paper by *Bartleson* and *Huboi*[7] includes references to most of the work that has been done in these fields.

Typical of the conclusions reached by most workers were the findings of *L. E. Varden* and *P. Krause*,[8] who felt that the total density concept or the integrated transmission of a negative or transparency, provided the most practical and useful information, but that additional information regarding the relationship of the most important subject area characteristics to the entire negative was desirable. In practice, many printer operators are taught to apply over-riding corrections to automatically determined printing exposure whenever their experience tells them that the negative being printed is anomalous. This rather finely balanced combination of automation and judgment is now accepted by most photofinishers as the best that can be done in an industry that is required to produce millions of low priced prints, almost every one of which is different from the others.

Photo-Cell Optics

Generally, a proportion of light from a main printing beam is deflected to an exposure timing photo-cell by a suitable metallised mirror, the degree of reflectivity depending upon the balance of sensitivities as between the photo-cell and the printing paper. A typical beam-splitter using paper of normal speed might reflect 20 per cent and transmit 50 per cent of the light that reaches it through the negative and the projection lens.

The situation is reversed in the case of printers such as the Mullersohn, where the printing plane is vertical and at right angles to the negative plane so that the larger proportion of light must be reflected to the paper. No beam-splitter is used in a Kenprinter, where a mechanical shutter is manually adjusted to cover more or less of the photo-cell and thereby alter its effective sensitivity.

Light Sources

The problem of obtaining sufficient light at the paper plane of a black and white printer is not as severe as it is in the case of a colour printer. Yet there are many considerations that make the task less than easy.

For example, it is necessary when a printer is to be used for printing a wide range of negative sizes, to ensure that on the one hand there is always sufficient light at the paper plane to result in exposures around one second from normal negatives, and on the other hand, to see that the light is sufficiently diffuse to minimise the evidence of scratches and at the same time achieve reasonable uniformity over the whole of the printed area. This latter requirement is relatively easily achieved when printing from the smaller sizes of negatives, but more difficult when printing from $2\frac{1}{4} \times 3\frac{1}{4}$ in. negatives. Sometimes an auxiliary condenser is swung into position within the lamphouse when printing small negatives, enabling more efficient use to be made of the available light and compensating for the otherwise longer exposure times that would result from the greater degree of enlargement.

In recent years there has been a tendency to use faster printing papers to allow the introduction of a greater degree of diffusion of printing light so as to more effectively suppress the evidence of scratches on negatives.

Velox Projection Printer

Kodak Limited have designed a diffusion kit for their Velox Projection Printer. In this kit a 1,000 watt lamp is used in place of the 500 watt lamp previously employed. A cooling fan, air filter and heat absorbing glass are also fitted to the new lamphouse, the diffuse light from which is said to eliminate the printing of all but the deepest scratches. Using the recommended Velox projection paper (90 Series) the contrast of prints made through the diffusion system is similar to prints made on an unconverted Velox Projection Printer.

Density Correction

No standardisation of density correction values or terminology emerged during the development of black and white printers. The Pakomatic printer employs five modifying keys, with the central number three key being used to print "normal" negatives. If the principal subject is darker than the rest of the negative, then either key 4 or 5 is used, while if the significant part of the subject is lighter than the rest, either key 1 or 2 is used. In extreme cases when the use of number 5 key would not provide sufficient exposure to adequately print some important (dense area of a negative) then two (4 + 5) or even three (3 + 4 + 5) keys can be used in combination.

Overriding adjustment of automatically determined exposures has to be based on operator judgement, and is usually effected either by the push-button introduction of a suitably chosen series of auxiliary capacitors, or by controlling resistances in the timing or trigger voltage sections of the circuit.

The operator must of course be sufficiently knowledgeable to understand that no modification of exposure is necessary when the entire negative is lighter or darker than average.

Variable Contrast Printing

Some continental countries, particularly Germany, have a reputation for high quality black and white photofinishing and therefore it is not surprising that some German finishers have been reluctant to accept the restrictions that result from the adoption of single grade roll-paper printing. They feel—with some justification—that provided the skilled labour is available, some black and white negatives can be made to yield better prints when there is a choice of contrast in the paper on which they are printed. Clearly this choice cannot come from changing rolls, but it has been found possible to alter the effective contrast of a single grade of paper by using a controlled amount of pre-flashing.

AGFA VARIOGRAD When used with Agfa/Gevaert Variolux or Varitex Rapid or equivalent papers, Variograd printers will provide a degree of contrast control that their manufacturer claims ranges from contrasty to extra soft.

The principle underlying the Variograd/Variolux system is that by using a paper that is basically contrasty and giving it a uniform pre-exposure to a regulated level of light, all contrast grades down to extra soft can be obtained on the one paper.

There are two factors that must be taken into consideration when working this kind of pre-flashing system. In the first place negative quality must be under good control so that all negatives are processed to a gamma value between 0·6 and 0·7. Secondly, since pre-exposure increases the effective speed of the paper it is necessary that the main (picture) and the auxillary (flashing) exposures shall always be made in the correct proportions.

The Variograd W76/90 and 76/90 A66 printers like all Agfa printers are designed for daylight operation and use light-tight paper magazines. The optics of these two printers are different and those in the W76/90 are very unusual in that both negative plane and paper plane remain fixed while the lens and associated roof-mirror system are adjusted automatically to give a wide range of enlargement ratios.

In setting up the printer for use with a paper suitable for pre-flashing (e.g. Variolux) a series of exposures is made at various settings of the sensitivity adjustment in order to determine the setting that will need to be used to obtain a satisfactory print from a standard (normal) negative. With the sensitivity setting established it is next necessary to ascertain the maximum permissible pre-exposure by making another series of test prints, using a negative with a sufficiently high subject contrast to require the use of a soft grade of paper if it

73

is to be printed to best advantage. Prints are made from this negative on each setting of the overall fogging adjustment from 0–12 using button one (extra soft) throughout the series.

After developing the exposed paper strip it will be found that the series of prints become increasingly softer until foggng occurs. The first fogged print in the sequence indicates the limit of pre-exposure and the equivalent calibration setting is noted and set accordingly. Thereafter this setting should only be changed when a new batch of paper is taken into use.

Fig. 31 Variograd W76/90 printers are made in England and incorporate an unusual optical system. Both negative and paper planes are fixed, while the lens and associated roof-mirror are adjusted to give the necessary enlargement

Pre-flashing on the W76/90 is for a fixed time at a variable intensity selected by push button, and the pre-flashing exposure is seen by the photo-multiplier so that the greater the amount of pre-flashing the shorter the duration of the image exposure. This method of operation would not seem to comply with the principles outlined by Fabag Fotogewerbliche[9] who questioned the validity of the procedure by suggesting that—

It can be proved by sensitometry that because of the deflection of the gradation (characteristic) curve resulting from strong pre-exposure by the secondary light, the pre-exposed images appear somewhat darker than those images which have not been pre-exposed, when the main light and the secondary light have been equally evaluated by the regulating means. Better results would be obtained if, with increasing pre-exposure the sum of the main light and secondary light were to be somewhat reduced.

74

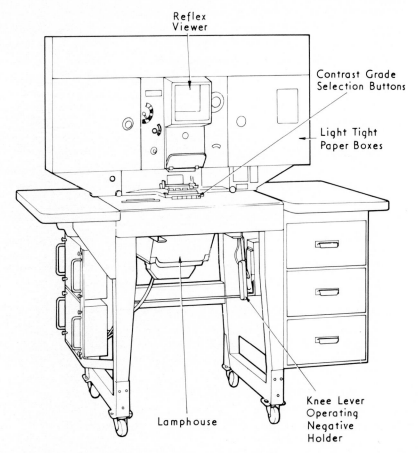

Reflex
Viewer

Contrast Grade
Selection Buttons

Light Tight
Paper Boxes

Knee Lever
Operating
Negative
Holder

Lamphouse

Fig. 32 Agfa's Variograd W76/90 A66 black and white printer is intended for use with a high contrast paper such as Variolux, which can be pre-flashed to a varying degree in order to provide a wide range of effective paper contrasts

In their patent Fabag Fotogewerbliche described means for more advantageously arranging the ratio of main light to secondary light exposure.

VARIOGRAD 76/90A66 The Variograd W76/90 is made in England while the Variograd 76/90A66 is made by Agfa in Germany and looks much more like the other printers produced in Munich. The A66 can be used in daylight and unlike the W76/90 it has the usual Agfa reflex viewing facility.

The assessment and apportionment of exposure as between pre-flashing and image forming is also done differently with the A66. Light transmitted by the negative and by the paper is used to control the length of image exposure, while the amount of pre-flashing exposure is decided by the operator after the examination of each negative and effected by depressing one of a series of six

75

contrast buttons. The pre-flashing lamp is located on the back panel of the printer and its light is reflected upwards to the paper. Because the timing photo-cell uses light transmitted by the paper, it is necessary to adjust its sensitivity when cream (chamois) papers are used.

The tendency for some European, especially German photofinishers to devote greater attention to individual print quality has already been noted, and one of the things that illustrates this is the widely adopted system of recording all exposure information on the backs of prints. For example Agfa supply a Correction Factor Stamping Unit for attachment to the German made Vario-grad printer. Among other things this stamping unit will mark the back of the paper with indications showing the contrast grade and density correction that were used in exposing each print.

Negative Positioning

One of the more frequent and most frustrating causes of "make-overs" in photofinishing is the unsatisfactory positioning of negatives in their carriers at the time of exposure.

In most of the projection printers used by finishers the position of the negative when being printed is at such an angle to the line of sight of the operator that it is usually rather difficult to see precisely how the negative is located in its carrier. This is particularly true in respect of the front edge of the mask—which normally prevents a really clear view of the near side of the negative.

Agfa's approach to this problem has been thorough, and on all but the cheapest of the printers they make, the operator can view the negative on a print-size ground glass screen located vertically at eye level in the front of the operator so that there is much less likelihood of badly positioned negatives.

The advent of 126 negatives with their automatic location by means of a reference perforation and their pre-fogged frame surround, greatly reduced this form of waste for the reasons explained in a relevant British patent:[10]

The prior practice has been to provide spaced metering perforations in the film which co-operate with a metering mechanism in the camera to determine the relation of the exposed areas to the metering perforations. This system, however, is satisfactory only if the metering mechanism of the particular camera employed is designed to accurately meter the film in accordance with the particular metering arrangement employed in the automatic printer. Thus, if the area exposed by the camera does not bear exactly the same relation to its corresponding metering perforation as the area printed by the automatic printer bears to the same perforation, corresponding cropping of the print will occur. One means of avoiding this disadvantage and that which has heretofore been employed, is to print the picture through an aperture which is of smaller size than the camera exposure aperture, but which closely corresponds to the field of view of the viewfinder. This arrangement allows for some deviation in the location of the exposed area with respect to the perforation but has the disadvantage that, when the photographer compares his negative with the finished print, he is apt to note that what seems to be an important part of his picture at the

edge of the negative does not appear on the print. The print area, of course, corresponds in size to the field of view of the viewfinder, but the photographer, nevertheless, has what he considers to be a justifiable complaint. In accordance with the present invention there is provided a photographic roll film having, along its length, spaced light sensitive image forming areas, perforations being provided in the roll film and engageable by a camera metering mechanism to enable each of said areas to be positioned for imagewise exposure in the camera.

The previously determined image forming area on the film agrees in size with the viewfinder but is smaller than the exposure area of the camera so that the entire sensitive area is exposed even if the image forming area is not exactly aligned in the centre of the exposure aperture, and a final print corresponds exactly to the negative. In case of such misalignment, the finished print will not correspond exactly to what was seen through the viewfinder, but the error is negligible. This allowance for the variation in metering mechanisms allows the use of any known form of camera metering means.

Although it is not mentioned in the patent, another very real advantage results from the practice of pre-forming the image frame on 126 films. Whenever an unframed negative, as for instance on an ordinary 620 or 120 roll film is misaligned in the negative aperture of an integrating printer, the light that often leaks between the edge of the image area and the printer aperture is sometimes sufficient to severely distort the photo-cell response with the result that too short an exposure results. This problem is even more serious when colour printing, because with colour masked negatives such as Kodacolor, the spurious light will be orange in colour and thus it will not only affect the density of the resulting print, but will also distort its colour.

Which of these two advantages is the more important is a matter of opinion, but together they certainly represent a significant step towards a higher yield of first-time prints.

Automatic Negative Advance

Although few, if any, photo-finishers are processing 126 black and white negatives in a continuous joined-up form, it is nevertheless worthwhile when the volume is reasonably large, to join 126 films after processing and before printing them. When this has been done the speed at which prints can be made is much higher because transport and location of each negative into its printing position can be made fully automatic.

Auto-advance negative carriers are made to fit their printers by almost all manufacturers including Kodak, Pako, Agfa, Pavelle and Mullersohn, as well as several independent equipment suppliers.

While it is possible to obtain some benefit by joining 35 mm. films before printing, the procedure is not quite so straightforward as it is with 126 negatives because the image spacing cannot be relied upon with some 35 mm. cameras. While many 35 mm negative images are correctly located when transported automatically a distance equivalent to eight perforations, there are many

occasions when the operator is required to manually adjust the position of a negative.

Daylight Printers

Since black and white photofinishing papers are usually sensitive only to blue light, printing is usually conducted in a useful level of orange or yellow safelight, and there has never been any great demand for printers that could be operated in white light or daylight. Nevertheless, Agfa have specialised in making both their black and white and their colour printers so that they can be operated in daylight.

Print Numbering

The practice of having identifying numbers on the back of prints traces back to the time when cut-sheet paper was used and prints had to be sorted after processing in order to marry them with each customer's negatives. As roll printing became more common, so the necessity for print numbering decreased, but as a very strict handling procedure must be established before a finisher can discard print numbers, some forms of print or order marking have persisted.

The procedure that is often followed when numbering is to be used for order sorting, is for the printer operator to manually stamp an identifying number on the customer's order form or envelope that has reached the printer while still attached to its film by means of a double clip. This manual operation simultaneously triggers a second, solenoid operated numberer to imprint the corresponding number on the back of the print about to be exposed. The manually operated numberer can either be attached to the printer in some fixed position, or as with the Agfa Seriotyp, it can be movable so as to be located wherever the operator prefers. In either case the slave or second numberer need only be connected to the first one by means of a cable.

Print Cutting on Printer

For a relatively short time in the early fifties in the US Kodak's Velox Rapid printers were used with roll paper from which each print was cut automatically following exposure. The purpose of this system was to allow those finishers who were not yet equipped with continuous paper processing machines to gain some of the benefits that come from roll-head printing. In Germany, the practice of cut-sheet processing persisted for much longer than elsewhere, and this is

evidenced by a patent[11] granted to Agfa in 1963 for a method of efficiently making changes in print size on a cut-sheet printer.

Automatic Paper Cutting

As the acceptance of continuous roll printing and processing grew, so the need for automatic paper cutting for print separation became obvious. This task has been tackled in a number of ways; by purely mechanical means, such as detecting a slit between prints; by conductivity signals from graphite marks on the back of the paper; and by the photo-electric detection of photographically imprinted marks on the emulsion side of the paper. Generally, one or other of the latter two methods is used today.

The early automatic cutters made by Pako depended on the mechanical sensing of a short slit cut in the centre of the division between adjacent prints. The incision, which was not much more than half an inch long, was made automatically on the printer as part of every print exposure cycle. When the processed and dried roll was to be cut into the separate prints, a quite simple spring-loaded sensing roller riding on the centre of the print roll deflected the paper at the split sufficiently for it to catch on the lower blade of the cutter and cause the paper driving clutch to slip while the knife operated to separate the print. This simple mechanical system worked very well, except that however accurately the line of cut was synchronised with the original slit there was usually some slight evidence of the slit along two opposite sides of the finished prints.

The fact that Pako's latest paper cutters use photo-electric means for detecting graphite, ink or photographic marks is probably because such a cutter is more versatile than one that will only work in conjunction with printers capable of forming a slit between prints.

Some photo-electric paper cutters depend on variations in light reflected from the border of a print roll, in which case they can be made to work effectively only when the indexing mark is either on the front (photographic) or the back (graphite) of the paper, but not both.

The Pako 2–12 paper cutter works with light that is transmitted through the paper base and can therefore detect any kind of mark—graphite, ink or photographic.

Kodak's models 5K and 12K can be used with conductive (graphite) marks which are provided by all Kodak printers or with photo-electrically detected marks. The correct pick-up is required in each case, but when both pick-ups are fitted either can be selected by switch. The Model 5RD-K has a dual reflective pick-up and permits sensing exposed marks on the emulsion side or base side of paper.

With an additional graphite marker in the printer and a second conductivity

pick-up, the Kodak print cutter can be used to sort orders by stopping auto-matically when all the prints for one customer have been separated from the roll.

Printer Attachments for Marking

Because there is still a variety of ways in which prints can be marked for sub-sequent separation on automatic cutters, there are several different devices used in printers to impart the marks at the time of exposure.

The slitter that was originally used by Pako has been mentioned, but this method of indexing prints is no longer as popular as it once was. Graphite marks have been used by Kodak since the days of the Velox Rapid roll-head conversions, and in general they depend on the operation of a rotary solenoid. With the Kodak print marker Model 5, an actuating solenoid serves to move a graphite disc towards the back of the paper, and on contact the disc rotates sufficiently to make the mark dense enough to be detected by the conductivity sensor. The marker is mounted so as to operate at right angles to the direction of paper travel.

Photographic or optical marks are certainly becoming more popular as they are on the whole more reliable than graphite marks—particularly on resin-coated papers. It is not too difficult to arrange for an opening to be cut in the paper mask of a printer or for a separate exposure to be made to provide the mark at a secondary exposing position alongside the printing aperture. If a narrow mark is used, it can be removed completely by using a cutter with a double edged knife that removes the necessary sliver of paper, although this does of course result in a 1 or 2 per cent waste of paper.

Sometimes a photographic cutting mark is located at some point along one of the margins and is left in this visible form on the finished print. When this is done obviously the mark and the exposure necessary to form it, should be kept to a minimum in order to make it as inconspicuous as possible, consistent with reliable detection by the automatic cutter.

Automatic Negative Cutting

Before the days of perforated 126 cartridge film, any attempt to cut negatives automatically from roll-films almost always depended on the detection of a tiny hole that had been pierced in the film at the time of exposure of each negative in the printer. The hole is pierced by a needle operating as part of the printing cycle, and always bears the same relationship to each printed frame. When the roll of negatives is fed into the automatic negative cutter, the pierced holes are detected by a spark discharge that can penetrate the film only at the holes.

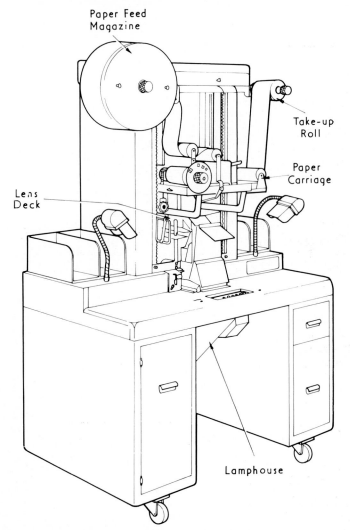

Paper Feed
Magazine

Take-up
Roll

Paper
Carriage

Lens
Deck

Lamphouse

Fig. 33 The Pako Pakomatic enlarger-printer is intended for producing black and white enlargements from all negative sizes up to 5 × 4 inches. The paper plane moves in conjunction with the lens, to retain focus at any enlargement ratio

Enlarging and Enlarger-Printers

Nowadays, almost all photofinishing printing is done by projection, and in that sense all printing is by enlargement. However, the standard sizes of en-prints and jumbo prints produced in volume from black and white and colour negatives are no longer thought of as enlargements. Only when still larger prints are made as re-orders from previously printed negatives does the finisher think of

81

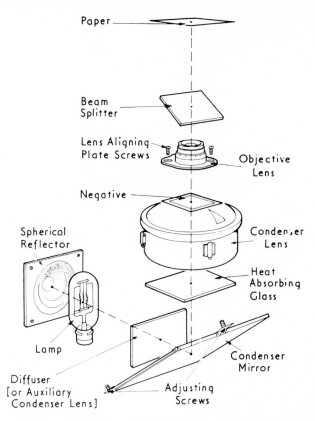

Paper

Beam
Splitter

Lens Aligning
Plate Screws

Objective
Lens

Negative

Spherical
Reflector

Condenser
Lens

Heat
Absorbing
Glass

Lamp

Diffuser
[or Auxiliary
Condenser Lens]

Adjusting
Screws

Condenser
Mirror

Fig. 34 The optical layout of the Pakomatic is typical of many photofinisher printers in which the
lamp-house is located beneath the negative, and the printing beam is directed upwards

the job as enlarging. Even then, enlargements tend to be divided into two
types—those that are made to a set ratio of enlargement from the whole of a
negative and those known as selective enlargements which may be any desired
size from any part of a negative.

The tendency in photofinishing to rationalise as many operations as possible
has led to the use of enlarger printers that are simply bigger versions of the semi-
automatic printers now used by all finishers for their routine production of
en-prints and jumbo prints. Typical of the enlarger-printers used for selective
enlargement are Pako's Pakomatic, and Apeco projection printers.

Enlargers

When greater flexibility is required in enlarging, so that the widest range of
print and negative sizes can be accommodated, there is really no alternative but

to use enlargers of a more orthodox type. At one time, an enlarger operator in a photo-finishing plant was probably the most skilled employee, because the success of his work depended upon his judgment of exposure. But in recent years, much progress has been made with the development of automatic exposure control devices for use in enlarging.

One of the most successful attempts to render enlarging easier was made when Agfa introduced their Variomat system.[12] The Variomat is an enlarging easel within which a photo-multiplier is arranged so as to receive light through the enlarging paper during the course of exposure. As we have seen elsewhere, such a system of non-selective integration has its limitations, but in practice a relatively unskilled enlarger operator can obtain a much higher yield of acceptable prints that would be possible without photo-electric exposure control. So far as the exposure is concerned, using a Variomat easel means that no regard need be paid to the degree of enlargement, the lens aperture, the brightness of the light source or the density of the negative.

The Variomat accepts paper from $2\frac{1}{4} \times 2\frac{1}{4}$ in. (6 × 6 cm.) to $11\frac{3}{4} \times 15\frac{3}{4}$ in. (30 × 40 cm.)—always in cut-sheet form. Successful operation depends upon careful calibration of the Variomat to suit the speed of the paper that will be used.

Roll Paper Easels

To make a sequence of enlargement exposures on to a continuous length of paper, some kind of roll paper easel is required. There are many types available, some manually operated and some motorised, some incorporating exposure control and some even including pre-flashing facilities for contrast control.

A typical roll paper holder capable of giving prints up to 14 × 11 in. is the Model R/11A made by Pavelle. This easel, designed to work with a wall mounted enlarger, has motorised paper transport adjustable in half-inch steps from 2 inches up to 14 inches a print, and the paper roll can be 250 feet in length and up to 11 inches wide. A pair of rigid masks cover the paper while an image is being composed and found.

Pako list a number of different types of roll-paper easels. One of them, the Vanpak, is designed so that the paper plane is moved only one inch above the base board of the enlarger, thereby making it possible for this easel to be used with almost any enlarging equipment.

Contact Strips

There always seems to be some demand for contact or proof strip prints from 35 mm. negatives, and several pieces of equipment have been designed to enable a finisher to produce these. One of the earliest 35 mm. contact strip printers was

made by *Homrich* soon after World War II. This printer was manually operated, but paper transport was automatically effected by the simple operation of raising the paper magazine and lowering it into contact with the next negative. Later models of Homrich strip printers used projection and had motorised paper or film transport.

Agfa makes a simple 35 mm. strip-printer attachment for use on the baseboard of an enlarger so that the enlarger's light source can be utilised for exposing each frame. In this device, negative and paper are transported manually.

The more sophisticated equipment used by Ilford Limited for their 35 mm. colour negative proof-strip system is described on page 210 *et seq.*

REFERENCES

[1] USP 2,541,013.
[2] BP 781,703.
[3] USP 700,083.
[4] USP 1,930,137.
[5] USP 1,973,468.
[6] USP 946,621.
[7] BARTLESON, C. J. AND HUBOI, R. W. "Exposure Determination Methods for Colour Printing". *J.S.M.P.T.E.* Vol. **65** p. 205 1956.
[8] VARDEN, L. E. AND KRAUSE, P. "Printing Exposure Determination by Photoelectric Methods". *American Annual of Photography*, 1950 pp. 30–41.
[9] BP 953,195.
[10] BP 965,532.
[11] BP 943,005.
[12] BP 886,903.

IV. BLACK AND WHITE PRINT PROCESSING

There are still countries—notably Germany, where photofinishing is carried out on a small scale, and black and white prints are made on cut-sheet paper. All print processing was carried out in this way until the early fifties, before which time very few attempts were made to mechanise or simplify the job of processing large numbers of separate prints. Finishers in general accepted as unavoidable the use of dishes in which many prints were handled at the same time.

Pako Doper

In 1924 *Glen Dye* patented[1] a print developing machine that came to be known as the Pako Doper. The Doper, in its later form,[2] was normally arranged to serve two printers. The printer operators would remove their exposed paper from the printer and place the sheets emulsion side up on continuous moving conveyor belts which then delivered them to an inclined oscillating plate intended to ensure that none of the prints stuck or stopped before being deposited into the front end of a long tray of developer.

At the front end of the tray there was also a partially immersed rotating paddle wheel causing the developer to move towards the back of the tray. The prints that were deposited in the tray from the conveyor belts, moved forward towards the paddle wheel, and were then carried beneath the vanes of the wheel to ensure that all parts of the prints were submerged and wetted. The prints passed from the wheel and progressed with the flow of developer towards the other end of the tray.

An operator watched the progress of development of each print and when they were sufficiently developed, removed them and transferred them to a stop or fixing bath near by. Some prints remained in the developer longer than others, and the flow of developer in the Doper was arranged to slow up towards the far end of the tray.

Because they were used mainly in the US, where the temperature can be very high in the summer time, Pako Dopers were sometimes equipped with refrigeration so that the developer could be held at a uniform temperature.

Friborund System

Nothing quite as elaborate as the Pako Doper was ever made for general use in Europe, but the Friborund print developing system has a similar purpose. The Friborund, made by Photo-Union, uses a rotating plastic developing tray about

85

40 in. in diameter and capable of handling prints up to postcard size ($5\frac{1}{2} \times 3\frac{1}{2}$ in) at the rate of 1,500 an hour. The circulating tray is divided into three areas; in the centre there is a circular dish containing a stop bath and outside this there are two separate annular shaped trays containing developer. The whole tray assembly is motor driven and rotates in a period that is adjustable between $1\frac{1}{2}$ and 2 minutes. The operator immerses the prints in the developer and after they have travelled in the dish through 300° or so, they are almost back to their

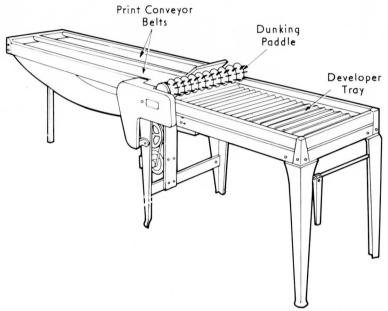

Fig. 35 The first Pako Doper was patented in 1924, and the machine became very popular with photo-finishers in the U.S., until continuous paper processing was generally adopted

starting point, and the progress of development can then be observed. Compensation for incorrect exposure is made by removing the prints from the developer either earlier or later. Fully developed prints are transferred either to the central stop bath or to an automatic fixing and washing machine.

Pako Printmachine

When he had devised his print developing machine, *Dye* realised that he needed to go further and provide means for automatically completing the fixing and washing stages required in print processing. The equipment he designed for this is still made by Pako and is called a Printmachine, which was patented[3] in 1931 and has remained in the Pako catalogue since that time.

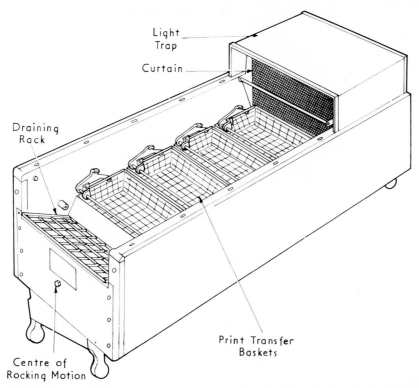

Light
Trap

Curtain

Draining
Rack

Print Transfer
Baskets

Centre of
Rocking Motion

Fig. 36 The Pako Printmachine was originally designed for use in conjunction with the Pako Doper. On completion of development, prints are transferred to the first (stop-bath) section of the Printmachine and thereafter they are automatically transported through the fixing and washing stages of the process

A Printmachine comprises a series of six baskets that are normally immersed in the usual sequence of short-stop, hypo and washing trays. At appropriate intervals the baskets automatically tip their contents into the next section, the last basket finally tipping its prints on to a draining rack to await drying or glazing.

After a Printmachine has been started, developed prints are deposited in the first short-stop basket where they remain immersed for either four or six minutes according to the time setting required. With the standard type of installation a light-trap and curtain, extending over the first two trays, travels along with the short-stop tray basket, thereby keeping the print in safe light until they have been transferred to the first hypo bath. Four (or six) minutes later the first lot of prints are again transferred automatically to the second hypo bath—and so on into the first, second and third wash trays and finally on to a draining rack. The machine accomplishes all this without attention and throughout processing the whole assembly of trays is rocked continuously to ensure that the prints are well separated.

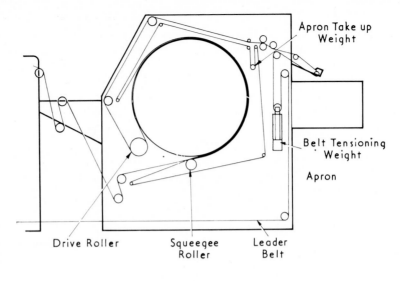

Apron Take up Weight

Belt Tensioning Weight

Apron

Drive Roller Squeegee Roller Leader Belt

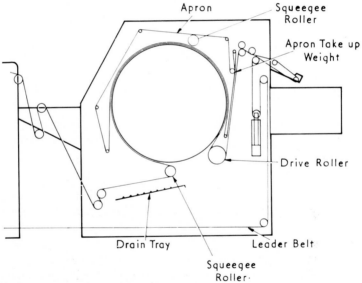

Apron Squeegee Roller

Apron Take up Weight

Drive Roller

Drain Tray Leader Belt

Squeegee Roller

Fig. 37 With an endless leader belt machine of the Pako type, it is possible to glaze or dry prints with a matt surface, according to the way in which the paper, leader belt and apron are led round the drum. The upper diagram shows the arrangement for glazing prints and the other for drying with a matt surface

Several equipment manufacturers have produced their version of the Print-machine. Photo-Union have their Fixwasch, which automatically transfers batches of prints through two fixing and three washing compartments at five or six minute intervals during which agitation is provided by a motor driven

88

mechanism. Similar machines are made by Fabelta in Belgium and by Kindermann in Germany. The Agfa Rotor Fixing Tank incorporates a motor driven circulating pump which runs intermittently—40 seconds on and 20 seconds off in every minute—so that the prints will be prevented from sticking to the walls of the tank or to the baffle which guards the intake of the pump.

Some machines have been made to process cut-sheets or short lengths of paper by attaching them to clips or leader arms that are in turn attached to

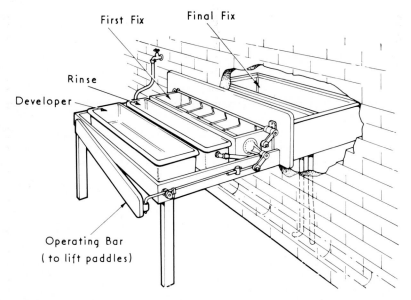

Fig. 38 In the U.K., the output from early roll-head printers, was cut into lengths equivalent to each film, and these paper strips were developed by inspection in tray assemblies of this kind

chains which move continuously through the required sequence of solution tanks. Probably *Fader*[4] in 1930 made the first attempts to work like this but subsequently Agfa also worked this way with a number of their Labormator processing machines. The principal difference between the Fader and the Agfa machines is that the Labormators were designed to handle two strands of paper in the space available between the two endless driving chains. Unlike the endless plastic belt typified by the Pako machine, it is not easily possible to drive chain around a drying or glazing drum and consequently prints processed on a chain type machine have to be dried or glazed as a separate operation.

Continuous Paper Processing

Although viewcard publishers like Graber,[5] in England, had been processing continuous lengths of paper on automatic machines since the early years of the

century, the finisher was not yet ready to convert to continuous paper processing until forty years later. First of all he had to learn to accept the idea of printing on a single contrast grade of paper before he could utilise rollhead printers, and even then for a few years more he either cut the prints into separate sheets before processing, or worked with quite short lengths, processing in long narrow dishes or in reels. But this interim period did not last for very long, and by the early fifties the American finisher was selling his Pako Doper and buying the first of the continuous paper processing machines to become available.

In 1950 *Dye*, *Knudsen* and *Braden* of Pako applied for a patent[6] which disclosed the use of an endless leader belt as a means of guiding either one or two strands of paper through a sequence of processing solutions—a faithful description of the Pakoline model 60 machine which appeared at that time. This invention of Pako's has had far reaching influence on photofinishing, and almost every manufacturer of paper processing machines has since adopted the same endless belt principle.

The original disclosure described a mechanical form of solution agitation in the developing tank. At that time also only one leader belt was visualised and the machine could not therefore handle more than two strands of paper simultaneously.

The paper leading arms in the Pakoline 60 are attached to metal clips inserted at intervals along the leader belt and automatic release of these arms resulted from flexing of the belt around a small roller at the output end of the machine. In 1958 *Dye* and *Miller*[7] described an improved method of attaching paper leading arms to the endless belt as well as an improved arrangement for automatically releasing the arms from the belt at the end of processing. These improvements were adopted in later Pakopak processors and still remain in use.

For the rest, the early machines following both view-card production and motion picture laboratory practice, in that they depended upon leaders and trailers of either paper or film. The operating procedure being to join the leading end of an exposed paper roll to the trailing end of a leader strip already threaded through the processing path of the machine, then, after running the machine until the end of the exposed paper was about to enter the developer, its trailing end was joined to the leading end of another roll of leader paper or film which would remain threaded in the machine after the end of the processed work has emerged.

One of the most important factors determining the suitability of a continuous paper processing machine for the requirements of photofinishing is its ease of threading. This was probably realised by *Graber*[8] in 1912 but was also claimed by *Williamson*[9] in 1944. In the Williamson version of a paper processor the bottom rollers throughout the machine are mounted in such a manner that when lifted they permit unobstructed access for a strand of paper to be introduced from one side of the machine. When the bottom rollers have all been raised they can be locked in position, and by taking the end of a leader band it

can be passed over the upper rollers and then under the rest of the bottom rollers until the leading end can be attached to the last roller in the machine. Then, by pulling further leader off a supply roll, each bottom roller in turn can be lowered and locked into its working position so that the whole machine becomes threaded ready for use.

Paper Leader Systems

Kodak continuous paper processors were first introduced in 1948 and are threaded with paper leader in much the same way as was described by *Williamson*, but one of the features of a Kodak machine is the use of a "turtle-back" over which all the strands of leader paper or exposed paper are drawn before entering the developer tank. The turtle-back is simply a fixed semi-cylindrical stainless steel surface over which the strands of paper are dragged to provide a measure of hold-back against the tension generated by the driving drum at the other end of the machine. Some hold-back is essential to maintain parallel tracking of multiple strands in a pull through type of machine where all the paper rollers are uniform in section and are not driven.

The paper leader supplied by Kodak for threading their paper processing machines is intended to be used only once and then discarded. In this way there is little risk of the leader causing contamination. But if the finisher is to keep all three tracks of a machine constantly threaded either with work being processed or with leader, then the cost of paper leader will be considerable. Consequently some finishers keep their central track always threaded and then manage to attach the leading ends of the outside rolls of exposed paper to the central strand as and when required. This is certainly not a manufacturer's recommendation, but it does emphasise the economic disadvantages of a machine requiring continuous supplies of leader.

On Kodak machines, a heat operated paper splicer is fitted to a joining table designed so that paper-to-paper or paper-to-leader splices can be made quickly and securely. When a roll of paper that is feeding into the machine is nearly exhausted (about ten feet from its end) the remainder is unrolled from its spool and allowed to fall into loose folds in the well of the splicer table, where it serves as a supply reservoir while the splice is being made. Although the recommended Kodak practice is to use heat sealing adhesive tape, there are many pressure sensitive tapes now available that will adhere satisfactorily and are strong enough to serve for joining paper in a processing machine. Metal staples are less satisfactory and certainly cannot be used if the paper is to be led on to a glazing drum.

The paper leader system has few disadvantages where the volume of work being processed is sufficient to ensure that there is little need to cut into the leader strip frequently to get work processed. In other words, when the number

of exposed rolls awaiting processing is sufficient to enable a new roll to be joined on to the end of the last roll of work. Unfortunately, except in the biggest photofinishing organisations this is not the general pattern. A finisher cannot always afford to wait while he accumulates sufficient exposed paper to keep a processing machine continuously filled throughout the day. Certainly when the time comes—often late in the day—for short makover rolls to be processed, then these must have the utmost priority because they contain prints belonging to orders that are held up awaiting the reprints.

Gradually the significance of having paper processing available immediately has led to the wider adoption of machines using endless, permanently threaded leader belts to which paper attachment arms can be fastened to guide rolls of paper through the processing cycle.

Williamson Threading System

Williamson also designed and built a small paper processor[10] for photofinishing that was sold in the US by Pako. This little machine incorporates a form of threading that does not require a leader band. The paper to be processed is drawn from a supply spool by a trolley and led past a series of rollers which feed it through the processing tanks and on to a take-up spool. Before paper is threaded through the machine all the dip or bottom rollers are held out of the processing tanks by a catch attached to two channels running above the tanks. When the threading begins the trolley leader strikes a latch to which the first dip rod catch is connected. This stops the trolley and releases the catch allowing the first dip rod to fall on to the paper and press it down into the processing tank.

When the roller has dropped the predetermined distance into the tank, a notch on the dip rod connects with the catch to lock the rod and roller into their working position, at the same time releasing the trolley from the latch. The trolley is then pulled by a spring into its next position above the next tank where the sequence of operations is automatically repeated.

Paper Driving Methods

Compared with the attention that has been paid to the way in which film is driven through continuous processing machines in the motion picture industry, relatively few attempts have been made to devise any but rather crude methods of driving paper continuously through machines.

Beginning with *Graber's* design, the driving principle of most paper processing machines is quite simple; generally depending upon a controlled-speed, positively-driven first roller followed by friction-driven rollers throughout the

92

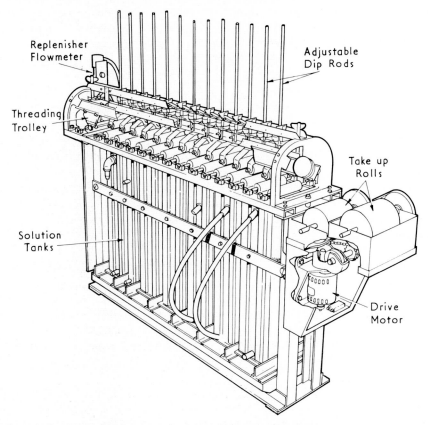

Replenisher Flowmeter

Adjustable Dip Rods

Threading Trolley

Take up Rolls

Solution Tanks

Drive Motor

Fig. 39 The Williamson single-strand processor is threaded automatically once the end of the paper roll has been attached to the threading 'trolley'

rest of the machine. The amount of paper drive coming from the frictionally driven rollers can usually be altered by adjustment of an arrangement of spring loaded friction discs located on either side of a flat faced sprocket which in turn engages with an endless driving chain.

In some cases, as for example, in the small Eastman Kodak Model 4D machines, there is no drive mechanism in the wet section, but the paper is merely pulled through the processor by a glazing or drying drum. This principle is the simplest imaginable but cannot be used when the path of the paper in the processing machine is long, and the paper is to pass over more than about ten rollers. For this reason, Kodak's larger model 4A processor, running at 8 feet a minute and having some 17 racks, is equipped with a pacer drive to pull the paper from the feed roll on to the processor at a constant rate and an auxiliary drive half way along the machine to relieve the tension which would otherwise accumulate on the paper strands between the pacer drive and the drying drum.

What is really needed in a continuous paper processing machine, as in any well designed film processing machine, is some form of compensating drive that locally regulates the tension on the strands. A machine that does this was built by Ilford Limited and is discussed in the chapter dealing with colour paper processors (see page 194) where it is more relevant.

Kennington made a paper processing machine that is threaded in a manner similar to that described by *Williamson*, except that the *Kennington* processor requires no attention whatever once a leader strip has been drawn along the top of the machine and attached to the last roller. To thread paper through the processor it is first necessary to lift all the bottom rollers above the top rollers. The short nylon leader strip is then led along the top rollers and attached to the leading end of the exposed paper roll with a special clip. The first rod is then triggered off and at the set processing speed it falls gradually to the bottom of its travel in the developing tank. When it has reached its lowest position, the next rod automatically starts to fall, and so on, until all the bottom rollers are in their working positions. In the meantime, the paper has been drawn through all the tanks at the correct speed and after the paper has accumulated in loops in the last wash tank, the nylon leader can be removed and the processor left to operate on its own.

The Kenprint processor takes two tracks of paper and the two sets of rollers and rods are quite independent of each other so that a new roll of paper can be threaded on to one track while the other track continues to process another roll.

Paper Reservoir

As the Kenprint processor showed, it is often convenient to leave a quantity of loosely folded paper in the final wash section in order to provide a reservoir of paper between the processing tanks and the drying or glazing drum. The Kodak Model 3 roll-paper processor was designed in this way, and the second wash tank employs the "soak" principle and contraflow of washing water. Of course, a buffer supply of paper can be maintained in the wash tank only if the drive of the glazing drum is isolated from the paper drive through the first part of the processing machines. In the Kodak Model 3 processor the initial drive is applied to the paper by mangle rollers mounted between the first and second wash tanks.

The idea of having a quantity of loosely folded paper travelling through all but the developing tank of a continuous processing machine was patented by *Hollows*,[11] who, like Pako, employed an endless leader band.

A simple way of synchronising the speed of a drying or glazing drum with the output speed of a wet paper processing section, is that employed by San Marco. A paper loop is formed between the tank section and the glazing section of the machine and the shortening and lengthening of the loop is used to operate a

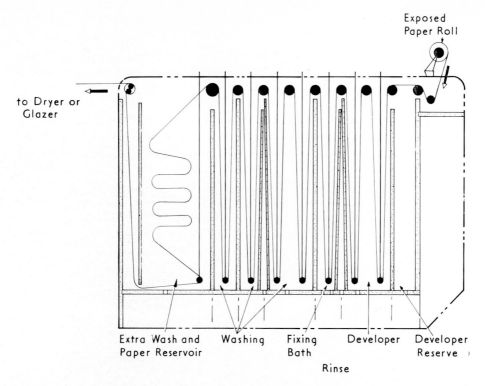

to Dryer or
Glazer

Extra Wash and Washing Fixing Developer Developer
Paper Reservoir Bath Reserve

Rinse

Fig. 40 In order to avoid synchronising processing and drying sections, the Kennington paper pro-
cessor incorporated a large final wash tank in which a reserve of paper could be held as a buffer ahead of
the glazing drum

pivoted arm that is connected to a resistance that in turn adjusts the speed of the
motor driving the glazing drum.

Use of Endless Leader Belts

A Pako patent[12] discloses the special arrangement of rollers that are required on
each shaft of a paper processing machine in which a number of paper strands
can be driven through a series of processing tanks while attached to one or
both of two narrow endless leader belts. The essence of this patent is described
as follows:

> The benefits of the invention can be realised for example in photographic film or paper
> processing apparatus in which the film or paper is transported and guided over rollers
> through processing solutions. In such an apparatus the film or paper can be attached to
> leader belts mounted on driving rollers and following the intended path of the paper or
> film. According to one particular embodiment of the present invention, such a film or
> paper processing apparatus comprises two spaced parallel leader belts disposed side by

side, and guide rollers for film or paper strip are mounted at opposite sides of each belt; the rollers located between the belts are arranged abreast of central rollers so as to form between the belts a roller system capable of carrying two narrow or a single wide strip in accordance with the invention. Such apparatus may be used for conveying four narrow strips, two being attached to each leader belt one each side thereof, or for conveying two narrow strips on the rollers located at the outsides of the belts and one wide strip on the central roller system.

Pako now produce the Hipak line of continuous paper processors. The range consists of 14 models—for black and white or colour, for conventional or R.C. colour paper in 1,000 ft. rolls, for one to four strands and for paper widths from

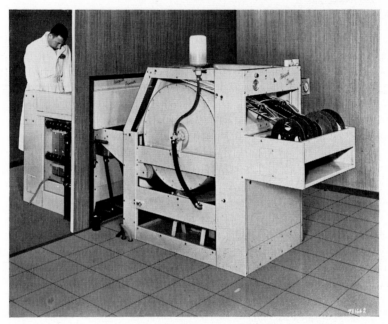

Fig. 41 A Pako Prosser and a Pako Dryer are combined to make a three or four strand paper processor using two endless leader belts

$3\frac{1}{2}$ to 16 inches. Processing capacity ranges from 20 to 100 inches per minute per strand, giving the largest machine an output of more than 30 feet per minute when processing R.C. Ektaprint paper.

The early Pakoline processors used endless leader belts that were driven through their contact with rollers attached to the top shafts of the machine which in turn were driven by sprockets riding on endless chain. The more recent Pakopak processors are designed to use a somewhat different driving system in which the leader belts drive the lower (immersed) belt rollers, which in turn drive the lower paper rollers—to which they are pinned. With this form of drive the belt tension does not affect paper tension. When the paper enters the

96

machine the leader arm pulls it until it goes around the lower roller in the first tank. Once the paper is pulled tight round this roller the roller then drives the paper.

The lower paper rollers are slightly larger than the lower belt rollers and therefore tend to overdrive the paper. Paper feeds through until it becomes slightly slack and drops out of contact with the roller, but as the leader arm continues to move through the machine, the paper is again pulled up into contact with the lower paper roller and is again driven forward. This self adjusting drive operates continuously throughout the machine and tension on the paper strands never becomes excessive.

The overriding advantage to the photo-finisher of a paper processing machine using an endless belt is that it removes any necessity for threading leader. An operator simply has to attach the paper to be processed to a leader arm and then clip the arm to the moving endless belt. After threading itself through the processing tanks and round the drying drum, the leader arm is automatically disengaged and the processed paper is ready for take-up. Short lengths or long lengths of paper are processed in exactly the same way and there is no need for delay between the end of one roll of work entering the developer and the attachment of the next exposed roll. So valuable does the finisher find this convenience that many manufacturers other than Pako now depend upon this form of drive for their paper processing machines. Hostert, Pavelle, San Marco and Kodak, in Britain, all make machines with continuous threading bands.

Labormator Chain Link System

Agfa's Labormator S100 and S200 paper processing machines originally used endless plastic chains to draw paper strands through the solution tanks of the machine, in much the same way as proposed by *Fader*.[13] The chains on these machines pass through a wash water trough on their return under the machine back to the loading point. The irregularly shaped links of a chain do unfortunately carry over a relatively large amount of liquid when the chain moves from one solution to the next. Thus it is quite difficult with a chain link machine to avoid some contamination or at least dilution of solutions. Perhaps for this reason, on more recent Labormator S285 and S4125 machines the chains have been replaced by flexible plastic leader bands with an automatic paper arm release very much like that of Pako. The Labormator S285 is designed like most Agfa printing and processing equipment to be used in daylight.

Pakopak Prosser Belt Transport System

A detailed diagram shows clearly how the belt and paper combination is

P.T.E.—G

transported through a Pakopak Prosser and how the leader belt returns to the feed-on end of the machine.

A chain driven pacer roller (1) at the entrance to the first solution tank determines the speed at which the belt enters the machine. All the other belt rollers (2) along the top of the machine are tendency driven to maintain belt tension while the adjacent paper rollers on the same shafts are idlers, but are crowned to aid paper tracking. The belt rollers on the bottom shaft in the developer (3) are coupled together through one long paper roller between the belt rollers instead of two short ones to keep the belts at precisely the same speed through this important bath. The rest of the bottom rollers (4) are idlers driven by the belt itself while the adjacent paper rollers are pinned to the

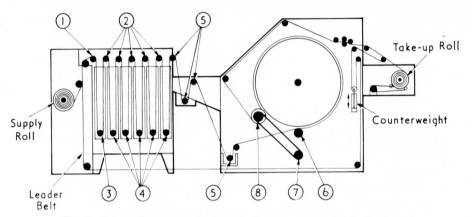

Fig. 42 Schematic diagram of a Pakopak Prosser using endless leader belts

belt rollers and therefore driven by them. To maintain good tracking, Pako advise that some flat driven paper rollers may have to be replaced by crowned idler rollers, but this kind of modification is made in an empirical manner when the machine has run in and tensions of both belt and paper can be reliably assessed.

The idler and belt rollers on shafts between the Prosser and the dryer are all crowned to maintain good tracking. A squeegee roller (6) is sprung lightly against the drum but must still allow leader arms to pass easily. A drive roller (8) drives the leader belts through the dryer but its speed is governed by a clutch (7) which is set so that it provides just enough tension to drive the drum while maintaining equal belt tension at both entrance and exit points of the dryer.

It is not always understood that in a properly adjusted Pako Prosser there should never be any appreciable backward strain on the leader arms as their only function is to guide and not pull the paper through the machine. The paper strands must pick-up their own drive from their own rollers.

98

Life of Leader Belt

The length of life of a leader belt in a continuous paper processing machine varies according to the way in which it is used and the nature of the solutions through which it passes. It is particularly important not to let the belt become unnecessarily dry and if a machine is not used for a long time its tanks should be filled with water to prevent the belt from drying out. A period of six months or one season is a normal life for a belt. The two ends of a leader belt can be joined together by means of a pair of stainless metal clasps which mesh and are linked with a pin in much the same way as leather machine belts used to be joined. It is also possible to drill a line of small holes in the two ends of the belt and link these together with heavy gauge nylon monofilament fishing line.

Pavelle (Colortron) 1114

The Pavelle 1114 continuous paper processor uses a pair of endless nylon belts to guide up to four paper strands through a sequence of processing tanks. This machine, which can be operated in daylight has a radiant panel pre-dryer that will dry prints to be finished with a matt surface or will deal with prints that are dried and then re-wetted before glazing—a procedure that offers several advantages over earlier methods of producing glazed prints.

The smaller Pavelle 810 machine has a single leader belt and will process two strands of $3\frac{1}{2}$ in. paper. In all other respects it is the same as the 1114.

Recirculation, Filtration and Agitation

Usually it is not considered necessary to apply any special form of solution agitation in black and white paper processing machines and dependence is generally placed on the movement of paper through the solutions together with whatever degree of agitation results from recirculation of the developer. Often a filter is included in the developer recirculating system, as for example in the arrangement provided for the Williamson machine and the Pakopak Prosser. A typical rate of flow achieved with this type of installation is between 5 and 10 gallons a minute.

Temperature Control

As with roll film processing machines there are several ways in which solution temperatures can be maintained in continuous paper processing machines. Pako, with the Pakoline and Pakopak Prossers follow their usual practice in

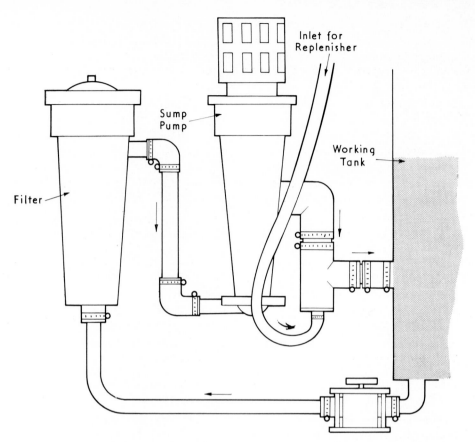

Fig. 43 This arrangement of pump and filter provides recirculation of a solution within a machine tank and permits the introduction of replenisher at a suitable point

providing water jackets or cells on the sides of the stainless steel developing tanks, and the temperature of the water as it is pumped through is closely controlled by a separate Pakotemp.

The small Williamson machine can also be coupled to a Pakotemp, or alternatively, tempered wash water already used in the wash tanks of the machine can be fed through tempering cells in the developer tanks before being run to waste down the drain.

Kodak sometimes arrange for tempered water from a mixing valve to be passed through a water jacket built around the developing tanks and then to over-flow it into an exit spray wash at the outgoing end of the machine, finally feeding it in counter-flow through the two wash tanks of the machine. Wash water should always flow against the direction of travel of the material being washed—because this is the most economic way of using the water.

Some paper processing machines, the Kodak (Britain), Kennington, Hostert and Pavelle machines among them, incorporate thermostatically controlled heating elements in their solution and filtering circuits.

Replenishment Methods

As we saw when considering film processing machines, there are several ways of replenishing photographic solutions, but the problem is made more complicated when the number of strands being processed on a continuous machine and the widths of the strands are both changing.

In some cases, the machine operator, as well as being responsible for starting and stopping the flow of replenishing solutions, is also required to decide the rates of flow that are necessary, depending upon the number and widths of the strands being processed. For example, Kodak's recommendations for the Model 4A black and white paper processor are given in this table:

Replenishment rates for single-weight Kodak unicontrast paper processed at 4 feet per minute

CHEMICALS	3 STRANDS $2\frac{1}{4}$ or $3\frac{1}{2}$ inch	2 STRANDS $2\frac{3}{4}$ or $3\frac{1}{2}$ inch	1 STRAND $2\frac{3}{4}$ or $3\frac{1}{2}$ inch
Dektomat	80 cc/min	55 cc/min	30 cc/min
Stopomat	60 cc/min	50 cc/min	30 cc/min
Fixomat	200 cc/min	160 cc/min	90 cc/min

Pakomat Prossers incorporate a large measure of automation in their replenishment system by an arrangement that causes each strand of paper as it enters the processor to trip a micro-switch which in turn actuates a Visi-Flow replenishment system to start the automatic replenishing cycle. During the time paper is being processed, valves in the Visi-Flow dispense pre-set volumes of replenishment solutions into the circulation filtration system, but as the end of each paper strand enters the processor, the replenishment cycle is automatically turned off.

Some black and white paper machines like the Model 3 processor made by Kodak in England, still use a "chicken-feed" type of constant level device to replenish by replacing the solution that is lost by carry-over. Certainly there is a very direct relationship between the volume of developer carried out of a developing tank and the area of paper processed in it, but this form of replenishment can only be used confidently when both the material to be processed and the chemistry are supplied by the same manufacturer.

On black and white paper processors it is common for solutions other than

the developer to be replenished by hand at convenient intervals, following periodic tests for pH, speed of fixing, silver concentration and so on. It is not sufficient to depend solely upon maintaining a constant level in stop and fixing baths, since roughly the same volume of liquid from the preceding tank enters these baths as is carried out of them by the paper.

Glazing

It is probable that the practice of glazing photographs grew out of a need to find a more satisfactory way of drying prints than simply hanging them up on lines or laying them out on racks. Glazing was originally carried out by squee-geeing wet prints emulsion side down on to clean glass; by which simple means it is possible to obtain a perfectly glazed print. Perhaps it was the resulting improvement in effective tone range that subsequently caused the almost universal adoption of glazing as an accepted part of photofinishing—even though there has been evidence from time to time that unglazed prints might be equally acceptable to the customer.

In Europe for instance, a relatively large proportion of semi-matt prints are still sold to discriminating amateurs who seem to prefer them unglazed. Furthermore, all colour prints made from amateur colour negatives during the first few years of negative-positive finishing, were sold in the unglazed form, and it is not at all clear why it was subsequently considered necessary to glaze them.

Print glazing is often a serious source of trouble for the photofinisher because many different kinds of fault can occur, including sticking, flecking, creasing and edge lifting. Pako who have been making dryers and glazers for fifty years or more have summarised their advice on glazing in these terms:

1 To force-dry prints with heating they must be correctly processed and the heat and machine speed during drying must be co-ordinated.
2 Over-heating of the drum causes discoloration, cockling, or buckling of the edges, an orange-peel effect in the body of the print or fleck marks and dull spots. Gelatine emulsion dries more rapidly than the paper back, thus curving the print in the direction of the paper grain. This sets up stresses and strains in the paper which are exaggerated by the forced drying.
3 Running the dryer too fast causes the prints to stick to the drum when they are not properly dry after completing one cycle around the drum.
4 Improper processing causes most of the other defects which appear on dried prints.

In their earliest form, drum dryers were heated by gas, but as electrical power became more generally available, resistance heaters were used either to heat the air inside the drum or to heat hot water or oil to be circulated through the drum.

In essence, a high pressure glazer or ferrotyper takes paper that has been previously dried to a moisture content of between 6 and 9 per cent and then re-wets it by the application of steam immediately prior to rolling it under very high pressure into contact with a polished drum.

Ferrotypers or calenders can be used as separate glazing units or on line—taking paper strands directly from a processing machine. However, it is always necessary to dry the processed paper before it is fed on to the high pressure glazer. On continuous processing machines this pre-drying step is now usually done by passing the paper strands through a drying chamber where radiant or even radio frequency energy is applied to both sides of the paper.

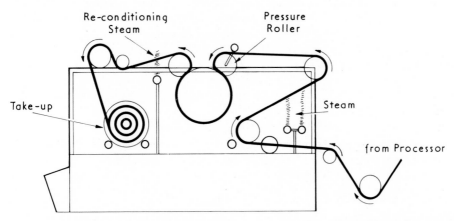

Fig. 44 When paper is to be glazed 'on-line' with a paper processor, a pre-drying stage generally preceeds re-moistening by the application of steam just prior to contact with the glazing drum

There is some evidence to show that by pre-drying and rewetting processed paper—certainly black and white paper—the glaze that results is superior no matter whether an ordinary drum or a high pressure ferrotyper is used. In particular, any tendency for the paper to stick to the glazing drum is greatly reduced and edge lifting is virtually eliminated. Another benefit that results from using high pressure ferrotyping together with an associated final print steaming or humidifying stage, is that this treatment prevents prints from becoming curled and brittle when surrounding humidity is low.

Most drum surfaces, whether for high pressure ferrotypers or larger rotating dryers, are chromium plated, and for colour papers Pako insist upon the use of stainless steel as a base for the chromium plate.

Print Cutting

When prints were made on cut-sheet paper, a large proportion of them had

103

Feeding water through a drum does of course, involve the use of watertight couplings to the centre of a rotating shaft.

In Britain, Ilford made a glazer to work in conjunction with the Kenprint Processor, running at five feet a minute on each of two tracks. The drum unit is in effect a water jacket of welded construction supported by tubular spokes. Integral pipes connect the water jacket to the hub of the unit. Water is heated to the required temperature (approximately 85°C) in an insulated (5 kW) heater tank and circulated by pump through a gland on one end of the hub of the drum. The water then circulates around the drum jacket and leaves via a similar gland in the other end of the central hub. From this point the return to the heater tank is by way of a flow indicator and a thermometer. There is a

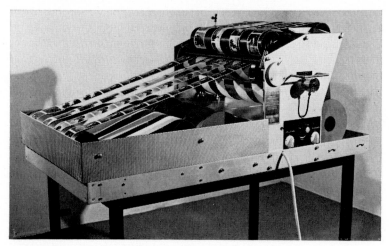

Fig. 45 Simplex (Hostert) high-pressure glazers can be used in-line with a four-strand paper processing machine equipped with a pre-dryer

small tank located above the glazing drum and the expanding water is therefore forced out of circuit and into this expansion tank, where it remains until the water cools again.

High Pressure Ferrotyping

After half a century of using chromium plated or stainless steel drums for drying and glazing prints, finishers were offered an alternative procedure usually described as high pressure ferrotyping or calendering. Kodak were first (1962) to offer photofinishers the equipment necessary to employ the new method, but the technique of using very high pressure and a relatively small hot drum, had already been used by Keller in Switzerland for calendering mass produced prints for view-card and similar applications.

104

uneven or unsquare borders because of the difficulty any printer operator has in accurately positioning paper sheets into the printing position—particularly when working at speed. As a consequence, many prints had to be trimmed on all sides in order to square them up, and as a further consequence, prints that should have been the same size, were not.

When continuous roll printing became available finishers could for the first time limit their trimming to a single separate cut between adjacent prints. For

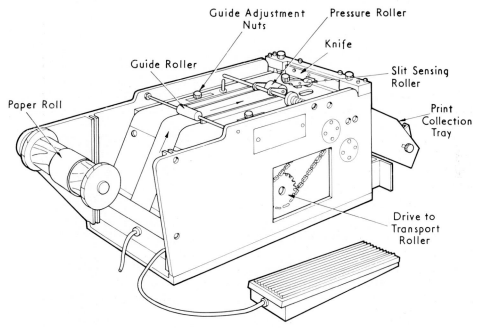

Fig. 46 One of the first automatic print cutters—the Pakoline cutter—worked with rolls of paper that had been marked with short slits cut centrally between successive prints at the time of exposure

this to be done automatically, an indexing mark of some kind has to be impressed on the paper at the time each exposure is made. As has been seen in the previous chapter, print cutting marks can take the form of a slit, a graphite mark on the back of the paper or a photographic mark on the emulsion side.

PAKOLINE CUTTER One of the first automatic print cutters was the Pakoline cutter intended to work in conjunction with a slit forming device attached to the Pakomatic printer. This cutter works on a purely mechanical basis and rolls of prints that have been through a printer fitted with an incising knife are fed through the cutter by a rotary feed roller, power driven through a friction clutch. The paper is held in contact with the feed roller by a spring loaded pressure roller, and as the paper moves towards the cutting knives, the centre of the print is

105

depressed by a spring loaded roller. When a slit reaches this depressor roller the area of paper adjacent to the slit is forced down so that the downward curved edge of the slit catches on the lower knife blade. The friction driven transport roller then slips and the paper stops moving until the cam operated lower knife is driven upwards to cut off the paper at the slit. After cutting, the lower knife is retracted and so disengages the leading edge of the paper, and the strip moves forward again until the next slit engages the knife, which by then has returned to its starting position. The Pakoline cutter normally chops prints at rather more than sixty a minute.

AUTOMATIC CUTTING WITH MARKS Although it is possible to fit Pako or Baron type slitters to most Kodak and Agfa printers and all Pako roll printers, this form of paper indexing has not gained increasing acceptance and Pako as well as most other finisher equipment manufacturers now make automatic paper cutters that depend upon the detection of either graphite or photographic marks.

The Kodak companies have generally preferred to fit their printers with graphite markers and to provide paper roll cutters using conductive (graphite sensitive) pick-ups. But the Eastman Kodak Model 5K cutter can be purchased with a photo-electric pickup if required, and in fact both forms of sensing can be incorporated in the cutter and the choice made by means of a changeover switch. This facility could be useful to a finisher who finds himself with a variety of printers, some giving graphite and some producing photographic marks. In Britain the Kodak Model 2 automatic print cutter is used in conjunction with Kodak's Model 1 graphite markers.

Agfa's Cutomat also depends upon a graphite mark, but the mark can be on either edge of the paper strand because the cutter is equipped with two sensing heads.

EFFECT OF VARIATIONS IN HUMIDITY One of the problems that is met fairly frequently when differences in conductivity are to determine cutting strokes is that in conditions of high or variable humidity, or in cases where a roll of paper has not been uniformly dried, spurious cutting can result. It is important therefore to ensure that all paper rolls bearing graphite marks are dried fully and uniformly and not allowed to collect moisture again before being cut, which can easily happen if the rolls are handled with wet or moist fingers. The cutter must be located in a dry room, where the relative humidity will not exceed 60 per cent and if it is ever moved from a cold room to a warm one, a watch should be kept for any signs of condensation.

Variations in humidity will not affect the operation of a print cutter that depends upon the photo-electric detection of an indexing mark, but the contrast between the mark and the paper surface itself will have to be great enough to avoid the risk of spurious cutting resulting from too high a sensitivity setting in

the sensing circuit. The operational sequence of a typical photo-electrically operated paper cutter begins when a mark on the edge of the paper showing sufficient contrast against its background is detected by a photo-cell which then triggers a relay to brake the paper drive and operate the cutting knife. Upon the completion of the cut a single relay releases the paper drive brake and turns on a magnetic clutch to resume paper drive.

Some cutters using photographic marks are designed to chop out a sliver of paper from between two adjacent prints in order to remove all evidence of the indexing mark, the Kenprint cutter is typical of this type. When slivers of paper accumulate as a result of this form of chopping, it is necessary to prevent them from collecting around the cutting knife by reason of their static electrical charge.

Various means have been used to remove the static charge—Agfa merely attaching short strands of earthed metal tinsel to brush across both surfaces of the prints as they emerge from the cutting blade. The Kenprint cutter incorporated a row of six high voltage decharge points to create an ionised atmosphere around the cutting area.

NORD PAPER PRINT CUTTER The photo-electric probe of the Nord print cutter does not operate by the volume of light it receives but by a rapid change in light. The circuit can respond to a change in intensity that occurs in as little as 1/20,000th of a second. When an indicating mark on a paper roll enters the slit of light formed by the Nord anamorphic optics, the circuit fires instantly, and does not have to wait until the entire mark has passed through the probe. Yet firing can occur only with a moving mark, so that no stationary mark or transitory change in voltage will affect the trigger circuit. The probe on the Nord cutter will work by reflection from any type of mark, either graphite, ink or photographic, on either the back or front of the paper. Prints are cut on the Nord machine by a spring loaded self sharpening rotary blade that travels laterally across the width of the print roll just like the rotary print trimmers that are now used in place of guillotines.

REFERENCES

[1] USP 1,624,781.
[2] USP 2,362,587.
[3] BP 381,636.
[4] BP 357,597.
[5] BP 18,852.
[6] USP 2,770,179.
[7] BP 855,747.
[8] BP 18,852.
[9] BP 577,430.
[10] BP 847,230.
[11] BP 836,513.
[12] BP 922,166.
[13] BP 357,597.

V COLOUR NEGATIVE PROCESSING

A multi-layer colour negative film is a remarkable product of modern industrial technology, but one that remains valueless until it is processed and printed. If processing is faulty in any way then it will be difficult, if not impossible, to obtain as good a colour print as the exposure warranted.

In colour processing both the film and the chemical solutions employed are more complex than those used in black and white work and consequently the composition of solutions, their pH, their temperature, the way they are agitated, the way in which the film is transferred between solutions and the way in which the film is dried—all affect the quality of a processed colour negative more seriously than they would a black and white film.

Difficulties of Making Films Compatible

In their earliest commercial forms both Kodacolor and Agfacolor were straight-forward unmasked colour negative materials. But this did not mean that they were manufactured or could be processed in the same way. In fact they were incompatible from the outset. Nevertheless, there has always been a feeling among some photofinishers that manufacturers of colour negative materials should be able to produce films that would perform satisfactorily in some commonly accepted processing chemistry in just the same way as black and white films of any manufacture can be processed in any one of many different developers. The problems associated with any attempt to make one colour negative compatible in processing and printing with the film of another manufacture are therefore worth describing.

The colour couplers employed by Agfa have very large and complex molecules which tend to remain immobile within their respective emulsion layers—an essential pre-requisite of any coupler that is to be incorporated in an emulsion at the time the film is coated. The couplers used by Kodak on the other hand, are prevented from wandering out of their appropriate layers by being en-capsulated in tiny resin-like particles which, while being permeable to suitably compounded processing solutions, do not dissolve to release the couplers.

It is also true of colour couplers that the hues of the dyes they generate upon development depend very much upon the structure of the colour developing agent that is used in conjunction with them. Each manufacturer designs his colour materials with particular combinations of couplers and development in mind, and any substitution of the latter is therefore likely to impair the performance of the film.

From these differences alone it will be realised that it cannot be expected that two such dissimilar films could be correctly processed in the same solutions.

108

Colour Masking Methods

This problem of incompatibility was made yet more difficult when first Kodak and later other manufacturers including Agfa, decided to improve the colour reproduction capabilities of their films by introducing coloured masks. The dyes which are used in subtractive colour processes never completely fulfil theoretical requirements, and colour masking is a way of combating the shortcomings of available dyes.

There are several ways in which coloured masking images can be formed in a colour negative as part of the processing operation. The couplers in Kodacolor are coloured at the time of coating, but their initial colour is destroyed and replaced by the subtractive image forming dyes as part of the colour development operation.

Before their amalgamation, Gevaert and Agfa had both evolved methods of forming coloured masking images in their colour negative materials. As *Koshofer* has reported—

> From the spring of 1963 Gevaert in Belgium have manufactured their Gevacolor-Mask films. Here the mask is produced by a so-called "mask former" contained in the cyan layer from the beginning. In a special alkaline bleach bath, this additive oxidises the residual, unused colour coupler into the mask dye. It must also be mentioned that Agfa Leverkusen, too, manufactured a similar type of film, the Agfacolor CN17 M sheet film, for a short time. This film, which had been introduced at the 1963 Photokina exhibition, had a yellow mask in the magenta layer like the negative films by Ilford. This layer contained an osazon coupler from the beginning, reacting during the colour development with the oxidation product of the developer to form a colourless substance in the exposed portions of the emulsion. In the bleach bath it was oxidised automatically into the masking dye in the unexposed portions. Difficulties arose concerning the keeping qualities of this emulsion, and Agfacolor CN17 M sheet film was withdrawn from the market in 1964. However, a new type has recently been marketed experimentally in the US, it is based on the same principle but is masked in both the cyan and magenta layers. Agfacolor CN17 S (S for special) is an interesting combination of two masking principles. As opposed to its CN17 M predecessors, a yellow mask only is produced by the Agfa masking method, whereas a red mask in the cyan layer is produced by the Gevaert principle.

This outline of masking methods will further indicate just how difficult it would be for different film manufacturers to produce colour negative materials that would be compatible in processing.

Processing Equipment

Roll film colour negatives are usually processed on rack and tank (dunking machines) of the same general type as those used for black and white films, but the increasing use of 126 cartridge films is resulting in film of that size being processed on continuous motion picture type machines. Because of this trend, more attention will be given to the kind of machine required and the associated problems such as film joining, than to the older methods of film processing.

DUNKING MACHINES Any dunking machine that is to be used for colour negative processing requires more solution tanks and more of the solutions need to be replenished, re-circulated and agitated than is necessary in black and white film processing.

One of the smallest and cheapest installations that can adequately deal with colour negative processing could be based on Pavelle's FPT2 processing tank. These tanks are intended for applications where the quantities do not justify an automatic processor. The tanks can be supplied in complete sets for any

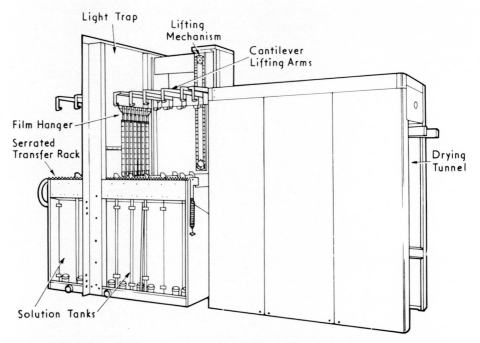

Fig. 47 The Model 34KO Pako film processor can develop 300 Kodacolor films per hour and dry them continuously in the associated drying tunnel

chosen colour process. Tanks and circulation units are made of rigid PVC and can process twelve films at one time. Roll sizes and 20-exposure 35 mm. films are suspended full-length, but 36-exposure 35 mm. films have to be looped. The films, attached to normal double clips and weighted with bottom clips, are suspended from a circular holder. Each chemical tank is supplied with a circulation unit containing a heater/thermostat, and in the case of the developer, a precision contact thermostat. Cooling units and solution filter units are available and the developer tank has provision for nitrogen burst agitation. Replenishers are fed from calibrated plastic bottles into the circulation units and not directly into the film tanks.

From this it can be seen that provided a reliable operator is using this hand tank line, quite satisfactory results should be obtained.

Moving up the production scale, machines intended for an output of between 75 and 100 films an hour are exemplified by the Pavelle FM200, the Wainco Viscount (K75) and Pako Models 35KO and 35AG-2.

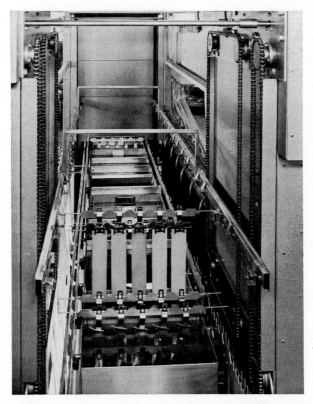

Fig. 48 By permitting changes to be made in the horizontal movement of film hanger rods, this Donka processing machine can be used for processing two different types of film

Although these machines operate on basically similar principles, there are differences between them. For example, the Pavelle and Wainco machines have rigid PVC tanks with external heat-exchange tanks for temperature control, while the Pako machine typically uses stainless steel tanks with built-in tempering fed from a Pakotemp unit. The Pako 35KO (Kodacolor) and 35AG-2 (Agfacolor) machines also provide uniform agitation in all tanks except the wetting agent. The system includes air pump and automatic gas burst timing and this shows full recognition of the importance of agitation in colour film processing.

111

FILM TRANSPORT METHODS The film transport mechanism of the Pako and Wainco machines are basically the same and they both use tanks which vary in size according to the time required in each solution. The Pavelle machine uses an adjustable timer which is set to suit the time or a simple fraction of the time required in the developer, there being no progression of the films through the tanks except by reason of the up and over motion that is applied to the main lifting carriage at regular intervals. This means that if the cycle time is set at five minutes and the time of development required is ten minutes then one rack of films is lifted from the developer and replaced in the same solution one step further along the tank. After ten minutes the rack is transferred from the developer into the stop bath where it stays for five minutes.

In order to minimise the time taken to transfer films from one position to the next, Pavelle have shortened the operation to about thirty seconds from about twice that time. This is done by lifting the films rapidly and then, almost at the top of their travel, causing the driving motor to slow to half speed while the films are moved laterally and then to speed up the motor again so that the films are lowered quickly into the tanks. If the motor did not change speed while the films were moving across the top of their travel, they would begin to swing and might not be deposited in their correct positions when lowered again.

Donka of Breda in Holland patented[1] a single track automatic dunking machine in which a normal type of mechanism is used to lift the film racks out of the solution tanks, but the horizontal movement is provided by an adjustable and independently driven sliding carriage which allows the film racks to be moved any desired distance, skipping solutions as required.

Even the best roll-film dunking machine gives trouble sometimes, if only as the result of occasional lapses on the part of the machine operator. An incorrectly loaded or badly located film hanger bar can cause serious trouble if any of the films suspended from it catch up at any point in their passage through the machine.

As a partial safeguard against this kind of danger, Fox-Stanley in the US, have designed their Filmalarm system to monitor jams or drape-overs at tank dividers, as well as nitrogen pressure and developer temperature. The system has a built-in alarm with provision for remote alarms. Signal lamps indicate whether the problem area is in the dark section, at the light trap or somewhere in the light section. The temperature sensor triggers a signal lamp whenever the temperature of the solution is too high or too low, while both the aim point and the temperature differential are adjustable.

In Britain Pavelle make a remote indicating temperature monitor having six channels and reading temperatures by means of glass probes designed to fit into the top of processing tanks or recirculation units. All six channels are continuously monitored and connected with the alarm system, but at any time the temperature of any probe can be read on a meter type thermometer by using a six-position selector switch.

112

MEDIUM-SIZED AND LARGER MACHINES The medium sized colour negative processing machine capable of 150–200 rolls an hour is represented by the Simplex (Carl Hostert) Standard Model C22. As with the Pako 35KO and 35-AG-2, film hangers for the Simplex machine can be prepared in white light, the film rolls being clipped to grooved hangers so that darkroom operations are reduced to attaching weighted bottom clips to the free ends of the films and placing hangers on to the loading end of the machine.

Solution control on the Simplex machine is achieved by constant circulation and filtration through pumping and tempering units that are attached to the

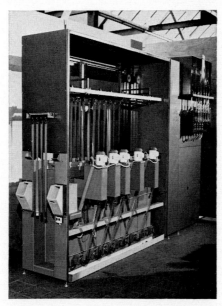

Fig. 49 The Simplex (Hostert) Standard Model C22 roll-film processing machine has circulating pumps for all working solutions and is capable of handling between 150 and 200 rolls an hour

sides of the appropriate solution tanks. This system, which allows the easy removal of pumps, heaters and filters for cleaning and replacement, is becoming more generally adopted in both film and paper processing machines.

Larger automatic rack and tank machines are made by Refrema, Pako, Hostert and several other manufacturers, but these do not differ in principle from their smaller counterparts.

The Model K607 Refrema has a capacity of 60 film hangers an hour, each carrying seven films—a total hourly capacity of 420 films. When intended for processing Kodacolor in C22 chemistry, Refrema machines incorporate five complete units for the re-circulation, filtration and tempering of developer, stop-bath, hardener, bleach and fixer. All units except the bleach are fitted with

113

stainless steel heater, cooling coils and thermometer bulbs. A combined replenishment system is provided for all five solutions.

Problems of Handling Incompatible Films

One of the things a photofinisher has to decide in most countries outside the US, is how many different colour negative processes he should attempt to service. In Germany where the share of the colour negative market is probably divided fairly equally between Agfa and Kodak, there has been some tendency for each finisher to concentrate on one process, leaving the dealer to distribute his work between two different finishers. Whether this kind of arrangement will persist is not clear, but certainly there are many finishers, both in Germany and elsewhere, who feel that they should offer a comprehensive service to their dealers. In some countries, for example in Britain, this may mean handling two types of negative film, but in others, it can mean processing three or more non-compatible films.

Sometimes, the finisher has compromised by processing a "second" film with makeshift or inadequate equipment, so that poor quality results. Often a hand tank line has been used because the volume of films to be processed did not warrant investment in an automatic processing line. Wherever this has happened it has generally been to the disadvantage of the manufacturer of the minority film because any shortcoming in final print quality resulting from unsatisfactory film processing or printing, are almost always attributed by the customer to the poor quality of the original film. This of course has made it even more difficult for manufacturers to win an economically viable share of the colour negative market. The situation is unique to colour processing, and has no parallel in black and white work, where all films can be handled in the same way.

Manufacturers of processing equipment have not been unaware of the finisher's problem and several roll film processing machines have been designed to handle two different types of film at the same time.

DUAL TRACK MACHINES The Kennington machine was originally intended for processing Kodacolor and Ilfocolor. This machine comprised two sets of tanks arranged in parallel with a common central film transport mechanism.

The distribution of tanks and solution sequence was of course different on the two sides of the machine, but the total film transfer time had to be the same. Therefore, whichever film type required the shorter treatment times, had to have longer times in less important solutions such as stop-bath and wash tanks.

A twin track processing machine similar to the Kennington is made by San Marco for processing Kodacolor and Agfacolor negative films at the rate of 45 films an hour for each type. Since the lifting carriage and arms of the San Marco Combi-Programm machine are common to both processes, the distribu-

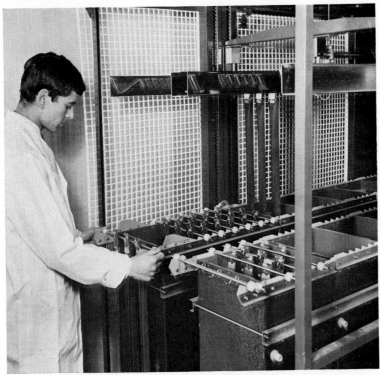

Fig. 50 Kennington 'dual-track' colour negative processing machines were originally intended to handle Kodacolor and Ilfocolor films at the same time. Many of the machines were subsequently modified to suit other combinations of films

tion of solutions and tanks in each line must be arranged to fit the transfer pattern of the machine. This also means that when films require more treatment time in a solution than represented by the basic transfer cycle, they must be lifted from and replaced into the same solution for as many times as necessary to complete the required time in that bath.

The Combi-Programm machine can be used to process a colour negative film together with black and white film, but the output of black and white films is restricted to 45 an hour, and much of the black and white tank line becomes superfluous.

Hostert has also made a dual track dunking machine called the Automata Bi-Color 220 in which both Agfacolor and Kodacolor films can be processed simultaneously.

Continuous Processing Machines

Reversal colour films for amateurs have been processed on continuous (motion-picture style) processing machines since 1936, but the records seem to indicate

115

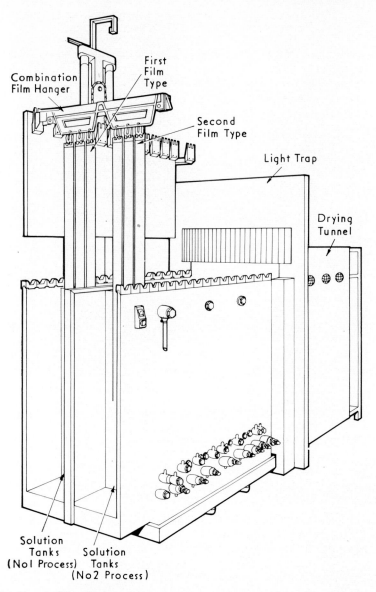

Combination Film Hanger

First Film Type

Second Film Type

Light Trap

Drying Tunnel

Solution Tanks (No1 Process)

Solution Tanks (No2 Process)

Fig. 51 San Marco's "Combicolor" dual-track colour negative machine uses divided film hangers, carrying three films each of two different types. While the dwell times of the two kinds of film will be different in their respective solutions, the overall processing time has to be the same

that Ilford Limited were first to join 35 mm. amateur colour negative films into long rolls before processing them on a continuous machine. This was in 1960, when Ilford launched their Ilfocolor 35 mm. film in conjunction with a proof-

116

strip or contact print. This marketing idea and the processing and printing system that evolved around it has been described by Coote, Neale and Large.[2]

When planning to process 35 mm. and 126 films on the same continuous machine, it must be remembered that although both films are 35 mm. wide, they differ in certain significant respects. Thirty-five millimetre camera film has perforations along both edges and the image width is only one inch, leaving 3/16 in. clearance on each side of the picture area. The 126 film on the other hand is perforated along one side only and as the image width is $1\frac{1}{8}$ in., the images extend almost to one edge of the film. Abrasions on the base side of 35 mm. film in the area of the perforations resulting from frictional contact with rollers in a processing machine are not critical because they are outside the picture area, but any abrasions of this kind would be serious on 126 film. Therefore the type of drive used for processing 126 films must not produce this form of damage.

One aspect of continuous film processing that worries photofinishers more than anything else, is the risk of film breaks while processing. Many finishers are understandably apprehensive about the loss and damage to film that results whenever a break occurs while a continuous film processor is running and is full of work.

Some photofinishers are so concerned with these risks that they prefer to forego the advantages that can result from joining films into rolls at the commencement of handling and instead prefer to join them after processing but before printing.

Perhaps some finishers forget that Kodachrome Double-8, Super-8 and 35 mm. reversal films are always processed on fast running continuous processing machines and that the damage to films processed in this way is almost certainly less as a percentage than the damage that results when films are processed on rack and tank machines. The finisher might also gain confidence by considering the attitude of any motion picture or television film processing laboratory, where the original negative film with which they are entrusted is always extremely valuable and usually irreplaceable. In such laboratories one film break in a year is exceptional.

Film Joining

It is obviously extremely important to join films quickly and reliably if a system of continuous film processing is to be successful.

The type of join used by Kodak in their Kodachrome processing stations is known as a heat-seal splice. When the service began in the mid thirties, a short length of gelatine coated film was placed across the butted ends of two films and both pressure and heat were applied until the gelatine of the patch merged with the emulsion on the two films to join the three parts together giving a splice that was as strong as the film itself.

117

More recently Kodak have been using a paper based waterproof heat-seal tape with an identification number stamped on to the relevant side of the join by an automatically actuated number perforator which also punches the same number on the order docket or return label.

The Automatic Film Splicer for 126 film preparation and splicing developed by Standard Photo Service Inc. in the US, includes a joiner using Kodak heat sensitive paper based tape. The tape is $\frac{3}{4}$ in. wide and contains an opaque material which automatically triggers an end-of-order marker system on the Kodak 2620 colour printer. The other two elements of the Standard system are an automatic cartridge opener and a 126 film identification perforator. The cartridge opener is pneumatically operated and automatically opens and discards the film cartridge while the spool of film is retained in position ready for the operator to insert the end into the perforator where the following operations are performed simultaneously.

1 The correct amount of film is cut off the trailing end of the 126 roll to permit the in-pitch splice.
2 An extra pawl hole is perforated in the film to permit automatic advance through the gate of the 2620 colour printer or any other printer with an automatic pawl advance.
3 Both film and order envelope are perforated with numerical identification.

UNICORN FILM JOINER One of the earliest semi-automatic darkroom operated film joiners was the Unicorn tape splicer made by the Hollywood Film Company in the US and by Photomec in Britain. This machine is based on disclosures in a patent by *Baumbach* and *Enklemann*.[3] The Unicorn splicer uses pressure sensitive Mylar tape one inch wide and ·002 in. thick, and operation of the splicer is quite simple. The two film ends are placed in positioning guides and clamped there. At the push of a button a motor driven mechanism wraps tape round the trimmed ends of the films. No corners protrude from the tape so there is little risk of the join catching up on anything during its progress through either processing or printing machines.

GRYPHON SPLICING MACHINE A similar type of film splicing machine using tape, is the Gryphon Model 855. This splicer is less fully mechanised than the Unicorn and is not motor driven. Instead it is operated by a series of mechanical movements initiated by three levers.

In outline the operating principle of the Gryphon splicer is as follows:

The first lever rotates the tape disc backwards until it adheres to the end portion of the tape, anchoring it in place. The trigger blade locks the disc in position and holds it under spring tension. The second lever retracts the tape carriage assembly, causing the proper length of tape to be pulled from the roll. A catch holds the carriage in position until it is released by operation of the

118

disc return mechanism. The third lever operates the razor blade arm causing the blade to cut the tape. The back-up spring mechanism causes separation of the tape. Pressure on the trigger then allows the tape disc to snap forward bringing the cut tape, adhesive side down, across the film ends and along the tape carriage to return to its starting position.

The Gryphon Model 855 splicer normally uses tape one inch wide and it can be set to produce wrap-around or edge-to-edge splices, but in the former case the over-lapping ends of the tape must be turned over and pressed down

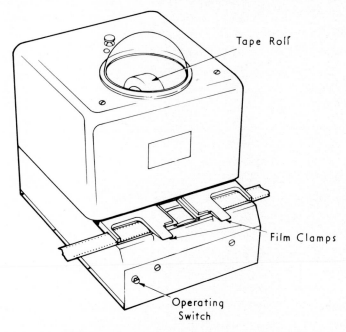

Tape Roll

Film Clamps

Operating
Switch

Fig. 52 Wrap-around tape splices made on the Unicorn Joiner can be run safely through continuous
film processors of the friction-drive type

manually. Another Gryphon Model, the 855S is intended for joining processed films prior to automatic printing, and this machine uses half-inch tape, the splice extending only to within 1/32 in. from each edge of the film, leaving edges clear for passage through close tolerance film guides.

Film Identification

When films are joined end to end before processing, there is no longer any possibility of maintaining a physical link between individual films and their order dockets in the way that is possible with the double-clip system used with deep-tank processing. Instead, both film and order docket or envelope must be

119

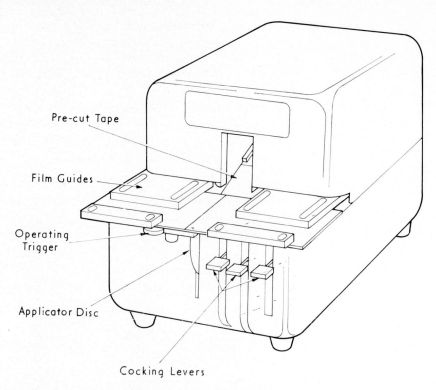

Pre-cut Tape

Film Guides

Operating
Trigger

Applicator Disc

Cocking Levers

Fig. 53 This semi-automatic film joining machine, the Gryphon Model 855, can be used to make either wrap-around or edge to edge splices, but in the former case, the ends of the tape must be folded into position by hand

given a number, and this number must in some way be imprinted on both the film and the order. The method first used by Kodak in the thirties to identify Kodachrome, double 8 mm. and 35 mm. amateur films after continuous processing, was to simultaneously perforate a serial number on the end of the film and on the customer's return address label or order envelope.

Perforated numbers are still used by some independent finishers and they have the merit that they cannot be destroyed or rendered illegible by any type of processing solution. The Kodak automatic film splicer has already been mentioned and this uses heat-sealed tape for joining and identifying purposes—a perforated number being impressed on the relevant side of the join.

Automatic film identification perforators are also made by Photomec and by Standard and both models simultaneously trim the tail of the film and perforate a four digit sequential number through both film and order docket or envelope. The Standard machine goes further and perforates an extra pawl hole in 126 films to permit automatic advance through the gate of the Kodak 2620 colour printer.

120

Perhaps the only disadvantage of perforated numbers is their relative illegibility when compared with normally printed numbers. The sole purpose of putting identification numbers on film is to avoid cross-overs, and it could be argued that any numbering system that is open to the slightest risk of misinterpretation will nullify the purpose of the exercise. Certainly many photofinishers prefer to use the twin-check system for film identification because the numbered labels are very easily read.

Twin-check adhesive labels are supplied in continuous rolls with parallel pairs of sequential numbers that can be dispensed automatically, the labels being applied manually to both film and order.

One possible objection to any form of adhesive label or adhesive film joining system is that there is some risk of the adhesive seeping or squeezing from the edges of the patch and transferring to image bearing film elsewhere in the roll. This danger has led some photofinishers to wind paper interleaving between the layers of film at the take-up point of joining or processing machines.

Estimates vary about the rate at which film can be joined and numbered, but an average would seem to be about 300 films an hour—hardly enough to feed a quite small continuous film processor such as the Photomec Type 359. Larger machines running at higher speeds would of course need five or six joining stations to enable processing to be continuous.

If to these aspects of film preparation one adds the initial task of cartridge opening and film removal, it can be seen why considerable effort is now being devoted to the automation of all aspects of film preparation.

Driving Methods of Continuous Processing Machines

No matter how securely films are joined into a long roll before processing, if the machine on which they are processed is badly designed or badly maintained, film breaks will occur and customers films will be spoiled. It could be argued that of the two factors, a machine that never creates excessive film tension is more important to a finisher than having a joining machine that produces joins as strong as the film itself.

TYPES OF DRIVE In motion picture laboratories there are two basic forms of film drive for processing machines. One depends upon sprockets engaging in perforations and the other drives by friction and can therefore handle unperforated films.

Sprocket-driven machines are not really suitable for photofinishing purposes because the frequency of joins is high, and it would be essential to phase the perforations through each join—making additional perforations where necessary. Furthermore, because amateurs sometimes damage their films while loading and unloading their cameras (except with 126 cartridges), there is

always a risk that perforations will not remain properly engaged with the machine sprockets. There is therefore a growing tendency for finishers to use friction drive machines for all continuous film processing.

Friction drive machines can be separated into top-drive and bottom-drive types. Typical of the top-drive machines are those made by Photomec in England and Hills in the US, while some of the machines made by Arnold & Richter in Germany and Pako in the U.S. depend upon bottom drive.

Fig. 54 The spring loading on this film roller is overcome whenever tension in the film loop exceeds a predetermined value. Whenever film tension does counteract the spring and pull the roller into contact with the continuously rotating drive roller, then more film is fed into the section, and tension is reduced. When this happens contact between film roller and driver roller is broken and drive ceases temporarily while tension again builds up

Tension Control of Individual Loops

Ideally the tension in each loop of film in a continuous processing machine should be controlled independently of all the others. A machine that does this was patented by *Terraneau*[4] of George Humphries, and versions of it are still used by motion picture processing laboratories in London and Hollywood and by finishers who have installed Photomec processing machines.

The way in which tension is regulated in each single loop of a Humphries type machine is basically simple, but will be best understood by reference to the diagram. Each film loop is carried by a roller that is pivoted on a counter-weighted arm in such a way that when the tension on the loop increases the roller is pulled downwards slightly until its knurled flanges touch the surface of a continuously driven rubber covered roller. Contact between the rotating

122

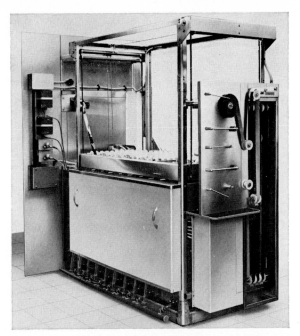

Fig. 55 There is a film elevator or reservoir at the feed-on end of the Photomec continuous Kodacolor film processor. Both 126 and 135 films can be run through the machine after being spliced into continuous rolls

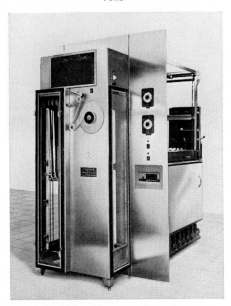

Fig. 56 A similar film reservoir is provided at the take-up or dry-box end of the Photomec continuous processor, so that rolls of film can be removed without stopping the machine

roller and the flanges of the film spool serves to drive the film spool in the opposite direction of rotation and so progresses the film through the machine.

A pacer or "come-along" drive at the output end of the machine positively governs the speed at which the film emerges from the machine while the diameter of the individual counter-balanced film spools all through the rest of the machine is precisely chosen so that when these spools are all turning, rather more film is fed forward than is required by the pacer roller. This means that the film in the machine frequently becomes slightly slack and this in turn allows the counter-weighted arms to move the film carrying spools out of contact with the rubber covered driving rollers and so temporarily interrupt the forward movement of the film at that point. Quickly, the slack film will be taken up, tension will again increase and the film spool will again be drawn down into contact with the drive roller. The movements described are very slight and very frequent so that when the machine is running the rocker arms are constantly oscillating as they engage and disengage the rubber driving rollers.

The Photomec Type 354 continuous film processor is intended for 35 mm. and 126 films and employs a top-drive based on the Humphries rocking-roller principle, so that the tension of each loop is controlled separately. The machine is intended to process either Kodacolor films in C22 chemistry or Kodak Internegative film in its appropriate developer. Alternative threading of C22 Internegative developer racks enables the change-over to be made quickly and simply.

The speed of the Photomec machine is four feet a minute for either camera film or internegative, and all the facilities required for good processing are included in the design.

Houston Photo Products in the US make a machine using the same driving principle as the Humphries and Photomec machines, without requiring weighted or spring loaded arms for rocking rollers. The film spools used by Houston are

Integral
Plastic
Springs

Fig. 57 This form of spring-centred film roller can be used in a top-drive film processing machine in place of spring-loaded or weighted rollers.

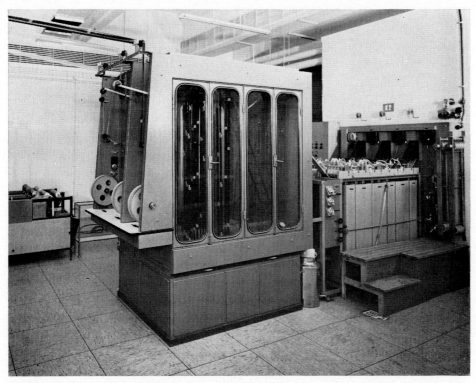

Fig. 58 A three-track Refrema continuous processor for 126 colour negative films. This machine has a combined output of 700 Kodacolor films an hour

moulded entirely from plastic material but incorporate, as part of the moulding, an internal convuluted spring between the central bush and the outer film carrying part of the spool. These spring rollers have been patented[5] by Eastman Kodak, and described by *Feichtinger* and *Witherow*,[6] and they serve exactly the same purpose as the rocking rollers on a Humphries type machine.

Top and Bottom Drive Machines

The Refrema continuous processor is a twin- or triple-track machine with a speed on each film track of nine feet a minute and a combined output of 700 Kodacolor films an hour. The driving principle is a combination of both top and bottom drives with the bottom shafts driven via immersed nylon chains from sprockets on the upper shafts. None of the film spools are locked on to the shafts, but all tend to rotate because all shafts are driven. The usual "come-along" roller is located at the output end of the machine.

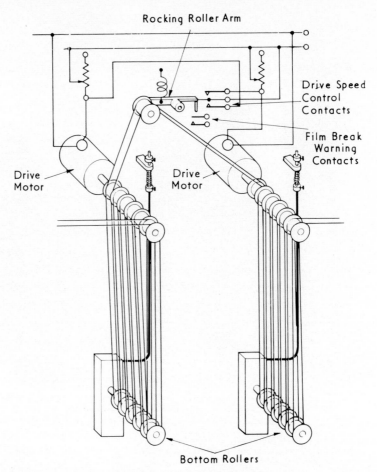

Rocking Roller Arm

Drive Speed
Control
Contacts

Film Break
Warning
Contacts

Drive
Motor

Drive
Motor

Bottom Rollers

Fig. 59 Control of film tension in an Omac processing machine, is achieved by means of a rocking roller arm which governs the speed of each roller shaft according to the tension at any point in the film path

The Hills High Speed Colormatic Model C machine is intended for the C22 process and will handle 35 mm. or 126 films at the rate of 13–15 feet a minute. This is a top-drive machine with the top spools frictionally driven by reason of laterally applied spring pressure.

There are several ways in which the relative position of a "floating" bottom roller assembly can be made to control the speed of the following driven top roller assembly to increase or decrease the rate of film removal, and therefore the tension, in each tank. *Capstaff*[7] of Eastman Kodak describes one way in which this can be done mechanically, and Carl Hostert (Simplex) has devised a machine in which any vertical movement of the lower roller assembly serves to increase or decrease the speed of the motor driving the following top roller shaft.

126

The Italian firm Omac, make machines in which the tension on the film as it passes from one film rack to the next is used to move a spring loaded arm that in turn controls the speed of the motor driving the next roller shaft.

Continuous film processors in which drive is imparted to the film by the lower immersed rollers are usually known as bottom-drive machines. These are typified by machines made by Arnold & Richter, Pako, Houston and Dynacolor. But since the primary purpose of all these machines has been to process reversal colour films such as Kodachrome, the principles underlying them will be considered in the chapter on reversal processing.

Process Variables

The variables affecting colour negative quality are basically the same whether film is processed in a rack and tank or on continuous machines, although the means of control are sometimes different. The problems are summarised by Kodak in their recommendations on the control of quality of Kodacolor films processed in C22 chemistry:

> Possibly the most common cause of deviations from normal density and colour balance is the exhaustion of the processing solutions as a result of inadequate or incorrect replenishment, although errors in the chemical mixing, agitation, wash water or film handling may also cause or contribute to such faults. Contamination of solutions is also a frequent cause of trouble.

PROCESSING TIME Treatment times in an automatic rack and tank or dunking machine should be measured from the moment the rack is deposited in one tank until the same hanger is deposited in the next solution.

With a continuous processing machine the average speed of the film through the developer can vary slightly when a friction drive is used so that it is important to time the film visually through the developer before relying on the built-in tachometer. Generally, in colour negative processing, the time of treatment is critical in only one solution, and the required time of development can be achieved either by electrically adjusting the speed of the driving motor or by mechanically altering the output shaft of a gear box—often a variable drive such as the Kop Variator. This method of speed adjustment will of course affect the times in all solutions.

It is also possible to alter the treatment time of the film by reducing or increasing the length of film contained in any solution. One way of reducing the length of film in a solution is to by-pass some rollers and therefore run the machine with fewer loops on any particular rack. This gives a fairly coarse adjustment and a better way is to alter the position of one of the shafts on which the film rollers rotate, so as to shorten or lengthen a group of loops on a particular film rack.

DEVELOPER TEMPERATURE In the same way as it is necessary to know the precise time of development provided by a processing machine, it is also important to check the developer temperature periodically with a precision thermometer before depending upon the type of dial thermometer built into most machines. It is equally important to ensure that the temperature reading that is obtained, truly represents the developing solution as a whole and that it is not unrepresentative because of inadequate recirculation or even because circulation has not continued long enough to produce complete mixing.

The limits within which the temperature of the developer must be maintained when processing colour negatives are set by most manufacturers as $\pm 0.25°C$ or $\pm \frac{1}{2}°F$. The other secondary solutions—stop-bath, bleach, fixer and wash water should be held within $\pm 1°C$ or $\pm 2°F$.

METHODS OF TEMPERATURE CONTROL Most rack and tank or dunking machines now have auxiliary or blister tanks attached to the sides of working tanks and heat exchangers of one kind or another are incorporated in these auxiliary tanks together with a pump for recirculation.

Pako and Hills continuous film machines both use water jacketed machine tanks and supply the jackets with water pumped from tempering units—usually two separate units to take care of the difference in temperature between developer and secondary solutions.

The Photomec 354 continuous film processor has integral low voltage heating elements in all solution tanks, with an adjustable indicating thermometer regulator in the developer tank.

Houston continuous film processing machines employ a combination of methods for temperature control. The developer solution is controlled by the immersion heater in the recirculation line and cooling coils in the solution tank. The stop-bath is controlled by temperature transfer from the wash water. The water temperature is in turn controlled by a mixing valve.

Solution agitation

Throughout the first ten years of competitive colour processing there was a growing realisation by both Kodak and independent finishers that variations in the degree of agitation during development were a frequent cause of faulty processing. In a paper by *De Vuyst, Drago* and *Hotler*[8] of the Eastman Kodak Company, it was reported that an analysis of a trade survey in 1967 had "emphasised the importance of agitation in Kodacolor film processing".

One finding of the survey showed that 29 per cent of the finishers surveyed had "some form of low agitation problem".

Pako have also reported (1960) that "The major cause of improperly processed colour film is unquestionably poor control over agitation". Pako's

128

colour Filmachines now incorporate grids in the bottom of each working tank to provide a controlled pattern of nitrogen or air agitation.

It has taken a long time for photofinishers to realise that maintenance of an adequate and consistent level of solution agitation is as important as the control of temperature in processing.

Agitation of a developing solution is essential to disturb the boundary layer that exists adjacent to the film—whether or not the film is moving relative to the solution. Throughout the period of development, the boundary layer of solution is enriched in bromide and depleted of developing agent relative to the body of the developer, and unless fresh developer is supplied to the surface of the film, development is slowed down overall and differentially as between the image forming layers of a colour film.

Agitation generally affects contrast more than speed in colour negative development, and when the level of agitation falls too low, the resulting drop in contrast cannot be regained by any other means. If time, temperature or replenishment are increased, the result is a high fog level (D min) and usually mismatched curves, all of which will cause poor print quality.

Although there are several ways in which solution agitation can be achieved, some of them are really only suitable for adoption in large scale motion picture type processing machines, and consequently photofinishers have come to depend upon bursts of nitrogen gas to provide the necessary solution disturbance. Fortunately, it has been shown that provided a certain level of solution movement is achieved at the developer/film interface, little or no change in sensitometric performance results from further increases in the amount of agitation. This means that it is important to arrange for sufficient solution movement to take place for the process to be operating on the plateau of the agitation/contrast curve: changes in agitation will then have less photographic effect.

It is a problem to know just how effective gas burst agitation is in a used C22 developer that has become quite coloured and dark. Certainly Kodak decided in 1967 that their previous recommendation of two gas bursts per minute was insufficient to ensure optimum development and they increased the recommended frequency to 12 bursts per minute.

With the recommendation for a higher frequency of gas bursts there came advice to alter the duration of each burst to one second, thereby allowing the solution some four seconds to settle down.

The pressure of nitrogen used to produce gas bubbles in the developer must be sufficient to provide a well distributed pattern without causing film entanglement. The pressure must never be sufficient to cause spattering of the developing solution on to films waiting in the feed-on position or in the adjacent solution tanks.

HUMIDIFYING NITROGEN TO AVOID TUBE CLOGGING. Before 1968 photofinishers who had been using submerged distributor tubes to release nitrogen gas

bubbles into the developing solution, found that the holes in the tubes invariably became clogged after a relatively short service. It was thought that the blockage resulted from dirt in the pressure line or in the developer itself, and frequent cleaning of the tubes resulted. However, it was finally discovered that after each burst of nitrogen, developer fills the holes of the distributor tube forming a meniscus on the inside of the tube due to capillary action. With each succeeding burst of nitrogen a film of developer is left inside the tube surrounding the hole. As this film of developer evaporates a crystalline deposit forms on the inside of the tube around the hole. In other words, the distributor holes were being blocked from the inside by deposits of developer constituents and not by foreign particles or dust.

With this understanding of the cause of distributor blocking it was a relatively simple matter to humidify nitrogen supplies in order to prevent the evaporation of the developer around the holes of the distributor. A satisfactory humidifying

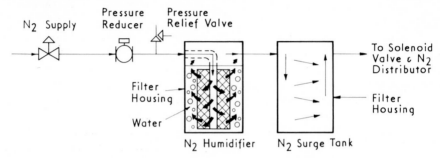

Fig. 60 An ordinary solution-filter can be used in a nitrogen supply line to ensure that the gas carries moisture with it to avoid crystallisation of chemicals around the holes in the distributor tubes

procedure is to use an ordinary commercial filter such as a Cuno and reverse the flow path so that the nitrogen is introduced through the centre of the filter and is dispersed in fine bubbles through water surrounding the cartridge. The diagram indicates one possible arrangement of this kind.

AIR AGITATION Gradually, as the significance of nitrogen agitation came to be fully appreciated, finishers began to consider the benefits that might result from introducing air agitation in secondary processing solutions such as bleach and fixing baths, and even in washing tanks. It was soon found that almost any solution treatment can be made more uniform and efficient by introduction of gaseous agitation.

Most colour negative processing machines are now designed so that air can be used for agitation in all solutions except developers—where air of course would cause serious oxidation.

Any air used for agitation in processing solutions can be obtained highly compressed in cylinders in the same way as nitrogen, or it can be compressed on

130

site. If a compressor is used then it must be of a kind that will produce oil free air, such as the carbon vane type.

PAKO AGITIMER The Pako Agitimer takes nitrogen from a high pressure cylinder and air from a rotating carbon plate compressor to two separate surge tanks from which bursts of the two gases are fed into the appropriate machine tanks.

Air is automatically injected by water pressure into the flow of washing water supplied to the Hostert Automata film processing machine and as a result the volume of water required to provide adequate washing is significantly reduced.

Recirculation of Solutions

Adequate recirculation of processing solutions in any processing machine is now recognised as an essential requirement for good processing. As we have seen in black and white film processing by means of dunking machines, the tendency is for auxiliary tanks to be attached to the sides of working tanks and for heat exchangers, pumps and sometimes filters to be incorporated into these auxiliary tanks. This relatively simple arrangement is compact and avoids some of the difficulties that result from a more complex system of pipes connecting the machine to remote storage solution tanks. On the other hand, certain advantages result from having a relatively large volume of working solution contained in a reservoir located adjacent to the machine and connected by pipes and flowrators to the machine. The larger volume in circuit tends to give more consistent processing quality because the process "hunts" less as a result of short term changes in activity. Recirculation rates can be observed by means of a flowrator and adjusted accordingly.

REFERENCES

[1] BP 956,425.
[2] NEALE, D. M., COOTE, J. H. AND LARGE, A. A. "Electronics and Economics in the Handling of Ilfocolor 35 mm Colour Negative Film". *J. Phot. Sci.* Vol. **11**, pp. 355–364.
[3] USP 3,011,936.
[4] BP 497,864.
[5] USP 3,679,765 and USP 3,380,678.
[6] FEICHTINGER, C. A. and WITHEROW, L. R. "A New Demand-Drive System for Processing Machines Using Spring-Centered Spools". *J.S.M.P.T.E.* Vol. **78**, September, 1969, pp. 712–717.
[7] USP 2,210,880.
[8] VUYST, DRAGO AND HOTLER. "The Importance of Agitation in Kodacolor Processing". *Photo Marketing*, November, 1968.

VI. PRINTING COLOUR NEGATIVES

Judging by the volume of patent literature on the subject, the problems surrounding the design and operation of automatic colour printers intended for use in photofinishing, are both numerous and significant, and in this chapter some of the reasons will emerge.

If as we have seen, it is difficult to estimate the optimum printing exposures required for a wide range of black and white negatives from amateur cameras, then it is virtually impossible to visually evaluate the quantity and quality of light required to produce saleable colour prints from amateurs' colour negatives.

In fact, for any given combination of negative and print material, optimum conditions for exposure must initially be found by trial. Once established, one might suppose that these same conditions could be used to print all other negatives exposed on the same type of film. But in practice, prints made from a wide range of negatives representing different batches of negative material, having different exposure, storage and processing histories, but printed under uniform exposure conditions, would certainly vary in colour balance over an unacceptable range. This is the essential problem at the heart of all forms of colour printing from colour negatives.

Control of Variables Affecting Colour Balance

Hunt[1] has listed the factors that can influence the colour balance of prints made from a colour negative, these are:

1 Intensity of scene illuminant.
2 Colour of scene illuminant.
3 Scene subject matter.
4 Camera lens transmission colour.
5 Lens aperture, exposure time and film speed.
6 Film colour balance.
7 Latent image keeping properties.
8 Negative processing.
9 Printing settings.
10 Paper speed and colour balance.
11 Paper processing.
12 Colour and intensity on print illuminant.

This is a formidable list of variables that serves to explain just how much more difficult it is to make satisfactory colour prints from colour negatives than to make prints in black and white.

Eastman Kodak began selling Kodacolor films in 1942, and it seems reasonable to assume that initially colour prints were made at Rochester by somewhat empirical means.

However, it was not long before attempts were being made to introduce greater control and automation of the printing process. First came the 1598 printer with which variations due to film speed and colour balance together with negative processing, were monitored by impressing a standard reference patch exposure on the end of each customer's film before it was processed. After processing, the colour densities of this reference patch could be measured and then each negative on the film was punched with a series of small holes along the edge, the size and location of the holes indicating the direction and degree of colour correction required to adjust the transmitted colour of any particular negative to a standard. When each negative was printed, the code perforations automatically determined the correction filters that were required in the printing beam, while the response from a photo-cell was used to adjust the intensity of the printing beam by means of a neutral continuous wedge so that a uniform time of exposure would result.

According to *Hunt*, this method, which must have been the very first attempt to print amateur colour negatives by semi-automatic means, was moderately successful but "still rather variable".

Principle of Integration to Grey

In 1938, *Pitt* and *Selwyn* of the Kodak Research Laboratories at Harrow in England, had shown[2] that the overall colour of the average outdoor subject is very nearly grey and that different subjects do not depart markedly from the average. These findings have subsequently been interpreted and it is now more usually stated that the colours of most outdoor scenes will integrate to grey. The whole of present day automatic colour negative printing now rests on this fact.

In order to make use of the *Pitt* and *Selwyn* findings a colour printer is required which, once it has been adjusted to produce a correctly balanced print from a standard or reference negative will thereafter photo-electrically monitor the red, green and blue light that is transmitted by any other negative and automatically terminate the red, green and blue exposures when each of them has equalled the exposures that were given to the correctly balanced reference print.

In 1946, *Evans* of Eastman Kodak patented[3] this concept of arranging for the same doses of red, green and blue light to reach the print material whatever the density or colour balance of the negative. In fact the integrated colour of the printing light may not be grey, but the integrated colour of the print after processing will be grey or very nearly so. Claim 1 of the *Evans* patent reads—

133

Method of printing a multi-color transparency on to a photographic printing material whose sensitivity lies in three different regions of the spectrum which comprises uniformly illuminating said transparency with light which contains energy in said three regions of the spectrum, integrating the light transmitted through the transparency, measuring the color of said integrated light, determining the color and amount by which said integrated light departs from light which will print as grey on said printing material, adjusting the intensity of the printing light so that when integrally passed through said transparency which has the same printing characteristics as light which prints substantially as grey and then focussing and printing said transparency on to said printing material with the said last mentioned light.

Eastman Kodak 1599 Printer

In the preamble of a patent[4] disclosing the principles of the Kodak 1599 printer, *Tuttle* and *Brown* explained that:

The customary methods of making colour prints in a multi-layer printing material from an integral tri-pack color negative involves the following steps. First, a processed negative is sent to an expert for judging and this step requires the services of an expert who can judge color negatives and tell what combination of filters is required in a color printer to correct for discrepancies in the color balance or overall hue of the negative in order to obtain a color print having colors rendered correctly therein. The expert puts a code on the margin of each negative judged and each code informs the printer operator what combination of filters to insert into the printing beam in the exposure. Since this judging step is time-consuming and fatiguing it is customary to judge only one negative, usually the first, on each roll of film and the code applying to this negative is used for printing the entire roll.

The practicability of this procedure is dependent on the fact that all pictures on the roll are exposed at approximately the same time, or at least under the same lighting conditions, so that any deficiency as to correct color balance or overall hue, which might appear in one picture due to improper exposure, should apply to all pictures on the roll. While this condition might be true on average, it will be obvious that it does not hold true for all pictures and it is quite possible that different pictures on the same roll will be exposed on different days and under quite different exposure conditions.

According to the present invention, the total negative transmission for each of the three primary colors (red, green and blue) is integrated and measured individually and the printing source is adjusted until the intensity of each of the transmitted primary colors is equal to a pre-selected value. The color-sensitive printing material is then exposed for a given time to each of the transmitted primary colors with the intensities so adjusted. While the exposures with the three primary colors is preferably made successively right after integration, measurement and adjustment as to intensity to the transmitted printing beam, the three could be integrated, measured and adjusted as to intensity individually and then the exposure by the three could be made simultaneously. This of course, would necessitate using three separate printing sources. It will thus be seen that by the preceding method each and every color negative is integrated and measured rather than only one on each roll as is commonly done with previously known methods.

Hunt[5] has clearly described how the 1599 printer works:

The negative is illuminated by a diffuser and an array of small lamps whose luminance can be varied; in early models this was done by means of a Variac transformer, but later

models use a saturable reactor. The diffuser has the dual function of making scratches and other negative defects far less noticeable than would be the case if the beam were specular, and it also spreads some of the light sideways, on to the monitoring photo-cells. The paper is exposed successively to red, green and blue light by means of filters situated adjacent to the lens. A bank of barrier-layer photo-cells, each one covered by a red, a green, or a blue filter, receive light from the negative and produce three photo-currents which are compared one at a time with that from another barrier-layer photo-cell illuminated by a comparison lamp. The difference between the two photo-currents is amplified and used to adjust automatically the voltage on the array of small lamps until the two photo-currents are equal; an exposure for a fixed time is then given for each colour in turn.

The sequence of operations is thus: insert the negative and activate the printer; the red filter moves into place but is covered with a dark shutter that remains in place for 0·3 seconds while the intensity is adjusted correctly for the red exposure; the dark shutter is removed from the beam, the red exposure of about half a second is given, and the exposure is terminated with the dark shutter; with the dark shutter in place the green filter replaces the red, the lamp voltage is re-adjusted, and an exposure of about half a second is given; in the same manner the blue filter replaces the green, the lamp voltage is again re-adjusted, and an exposure of about half a second is given. The lamp voltage adjustments are all made during the dark shutter time of 0·3 seconds.

That the 1599 printer was an outstanding success can be judged from the fact that these printers were still being used in Kodak's Rochester plant some twenty years after they were first introduced! Presumably the 1599 will become obsolete only when the requirement for printing roll film size negatives diminishes to an uneconomic level, and 126 cartridge films are printed from joined rolls on printers like the 2620.

Variable Time Exposures

It will have been noticed that the *Evans* patent was confined to the use of variable intensity printing. Some years later Agfa patented the alternative method of integrated colour printing by means of variable time exposures. The British patent[6] protecting this procedure was filed in 1955 and its first claim reads:

> A process for producing a photographic colour print from a colour transparency, said process comprising three exposures of the printing material to light of three primary colours each of said exposures being controlled by a photo-electric regulating device which includes a photo-electric cell and is influenced by printing light rays coming from the colour transparency during the exposure of the printing material and each exposure being interrupted by said regulating device after a pre-determined quantity of printing light of the corresponding colour has fallen on to said photo-cell.

Later in their claims Agfa define a system of printing with three separate light sources to be used simultaneously for red, green and blue exposures. This was the method Agfa used in their Colormator printer when it was introduced around 1960.

135

Limitations of Integrating-to-Grey System

Hunt has pointed out that:

> By taking each negative as the arbiter of the exposure given to the paper, correction is made not only for the exposure level, for the colour balance of the negative material, and for its processing (items 1, 5, 6 and 8 from his list), but also for the colour of the scene illuminant, subject matter, camera lens transmission colour, and latent image keeping properties (items 2, 3, 4 and 7). This results in a marked improvement in the consistency of the colour balance of the prints made from the majority of amateurs' negatives.

However, the concept of integrating to grey is known to fail in varying degree with abnormality of colour distribution in the subject photographed. This means that of all the prints produced as a result of complete integration to grey (100 per cent correction), some 10 to 20 per cent may be unacceptable because the monitoring system of the printer has been misled by some particular distribution of colours in the negative. A white cat on a red carpet is a well known example. But a much more likely and equally serious subject failure for colour can result from a landscape scene that includes a relatively large area of bright green grass in the foreground. Any white clouds in the sky of such a picture will usually be rendered predominantly magenta.

As earlier writers have noted, this limitation of an integrated transmittance system has somehow come to be blamed on the subject, and is now referred to as a "subject failure". The term "subject anomaly" as used by *Bartleson* and *Huboi* would seem to be more logical.

Increasing Print Output

In any constant-time printer a thin negative must take just as long to print as a dense one, which necessarily means a lower output. The 1599 printer therefore incorporated triple negative carriers so that the operator could change one negative while the machine continued to make exposures from another. The printer was designed to expose three rows of prints along a single, wide web of paper, each print being the product of three consecutive exposures through printing filters—a procedure known as additive printing. By working in this manner more than 1,000 prints an hour could be exposed by a skilled operator.

SUCCESSIVE ADDITIVE EXPOSURES Prior to 1956 the printing of Kodacolor negatives was retained by Eastman Kodak, and very little, if any, colour negative processing or printing had been done by independent finishers—with the one exception of Pavelle Color Inc. in New York. Pavelle had printers available when Kodacolor processing was released, because in 1956 they had been working with Ansco on the test marketing of Ansco's Plenacolor negative film, and had devised integrating printers based on the variable-time principle.

Fig. 61 Eastman Kodak Type 1599 colour printers require cut negatives and employ three carriers two of them being either loaded or unloaded while the third is in the printing position

Fig. 62 Rolls of colour paper exposed on 1599 printers are eleven inches wide and carry three parallel rows of prints that are separated after being processed and examined

The Pavelle printers made successive additive exposures, and in order to reduce the time required for the overall exposure cycle, the voltage on the exposing lamp was automatically adjusted to a level that was governed by the density of the negative being printed. This device, together with a swivelling negative carrier to facilitate handling, made it possible to obtain 400 to 500 exposures an hour from roll film negatives.

Light from a 500 watt projection lamp passed through two heat absorbing glasses and proceeded through a sequence of three printing filters mounted in a rotating disc. The light was then reflected by a solid mirror and directed downwards through a condenser lens on to the negative. The negative in turn was imaged on to the paper plane, at bench level.

A small proportion of the image-forming light was reflected via a partially reflecting mirror and a lens to a pair of diffusers which in turn transmitted light through one or other of three filters to a photo-multiplier. The printing filter disc and the reading filter disc were mechanically synchronised through bevel gears.

In use, once the exposure start button was depressed, the lamp voltage was raised from its low standby value to operating voltage, and the green exposure commenced. When the green exposure ended—as a result of photo-tube response—the film discs rotated to the blue filter position, while the blue exposure was made. Finally, the filters were changed again, for the red filter exposure to be made.

Because the photo-multiplier was temperature sensitive, a heater and fan supplied a thermostatically controlled flow of air past the tube. Furthermore, in order to compensate for other changes in photo-multiplier sensitivity during printing, a standardising lamp was included, and the photo-multiplier was exposed to light from this lamp during the dwell periods between every set of three component exposures.

CONCURRENT EXPOSURES THROUGH INTERFERENCE FILTERS In 1957, Technicolor, who had diversified in the US by taking over Pavelle Color, designed and constructed a constant-time additive printer with a very high operating speed.[7] To avoid the loss of time involved in making consecutive exposures, each print was exposed concurrently through red, green and blue interference filters. The exposure time for any negative was 0·5 second while the cycle time, including negative and paper transport was 1·2 seconds. The negatives, all of which were on size 620 roll film, were spliced after processing into 500-ft. rolls and then fed through an encoding machine where a skilled operator graded and framed each negative for printing by punching a control hole in the edge of the film.

The grader also punched a series of holes in the opposite edge of the film if he considered that correction should be made for either colour or density. Colour control in the Technicolor printer took place before the printing light reached the negative being printed, but was dependent upon the light coming

138

through the latter. A beam splitter diverted a fraction of the light in the projected beam to three analyzing photo-cells sensitive to red, green and blue light respectively. These cells, through associated exposure circuits, controlled the intensity of the red, green and blue light beams by means of servomotors which opened or closed sets of mechanical vanes.

The separation of the printing light into the primary colours was effected by means of dichroic reflectors. Thus the first reflector, in conjunction with a front surfaced mirror, split the light into two parallel beams: blue and red-green. A pair of dichroic reflectors directed the green component of the red-green beam

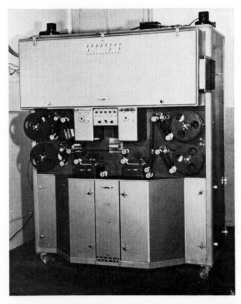

Fig. 63 Technicolor's experimental high speed colour printer used two 500ft joined-up rolls of 620 size negatives and made 5,000 exposures an hour on paper seven inches wide

to the blue beam. A further reflector and two mirrors then re-combined the parallel beams.

This somewhat complex light path thus contained sections of red, green and blue light respectively; and in each of these sections the photo-cell controlled vanes to adjust the intensity of the individual beam. The reconstituted beam was therefore no longer "white", but contained reduced amounts of one or more of the primary bands and reached the colour negative in this form. Essentially the same system is now used on the Bell & Howell motion picture release printer.

The Technicolor printer was a double-track machine. When fed with two 500-ft rolls of encoded negatives and loaded with a supply of seven-inch wide

paper, it was set to work at the rate of 5,000 exposures an hour without the attention of an operator.

Because of their cost and complexity, neither the Kodak 1599 nor the Technicolor High-Speed printer was made available to the photofinishing industry.

FIRST COLOUR PRINTERS FOR PHOTOFINISHERS The first colour printer to be offered for sale to independent photofinishers was the Eastman Kodak Velox Rapid printer Type IVC, a modified version of the early black and white roll-head printer that had been the work-horse of the finisher in the US. The IVC

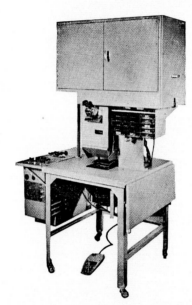

Fig. 64 Eastman Kodak's Roll Paper Printer Type IVC was the first colour printer to be made available to the independent finisher in the U.S.

machine, like the Pavelle printer, but unlike Kodak's 1599, was a variable-time printer making a sequence of three exposures through red, green and blue filters for each print. Here again, a beam splitter diverts a sample of the light transmitted by the negative to photo-cells, one of which is sensitive to red and the other to blue and green light. The exposure circuits then interpose red, green and blue filters in succession into the printing beam between lens and paper, the duration of each exposure being determined by the outputs of the photo-cells working in conjunction with a capping shutter.

As *Tuttle* and *Brown* pointed out in their patent, it is possible to make all three additive exposures simultaneously, either in the manner devised by Technicolor in their High-Speed printer or by using three separately filtered light sources and recombining them. Agfa's first printer, the Colormator N76/90

140

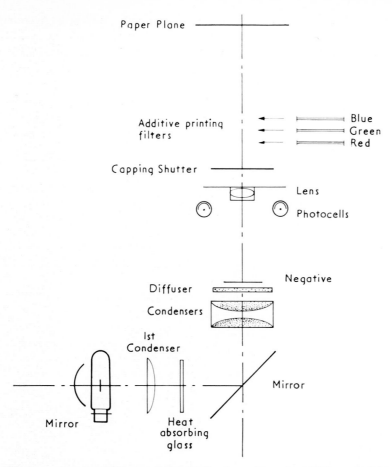

Paper Plane

Additive printing
filters

Blue
Green
Red

Capping Shutter

Lens

Photocells

Negative

Diffuser

Condensers

1st
Condenser

Mirror

Mirror

Heat
absorbing
glass

Fig 65 Schematic diagram of Eastman Kodak IV-C printer. Uses the additive principle, making successive exposures to red, green, and blue through filters above the lens. The photocells below the lens, shown here diagrammatically, are in fact three pairs of cells with the appropriate colour filters permanently over them.

was introduced in 1959 and incorporated a triple source lamphouse of novel design. Light from the three lamps is filtered and recombined by means of a crossed mirror system. The duration of exposure of each of the three beams is controlled by a rapid action louvre shutter.

Additive and Subtractive Printing Methods

All of the printers described so far have been of the additive type—that is to say the light used for exposure has been made up from filtered red, green and blue

141

rays. During the first decade or so of development of colour negative films and papers and the printers that were necessary to exploit them, it was generally accepted that slightly better saturation and contrast could be obtained by exposing prints additively through primary coloured filters, than by printing with "white" light modified with dilute subtractive filters.

As the performance of films, papers and printers have improved, the difference in quality obtainable with the two methods of exposure has lessened, and because additive printing of any kind is more wasteful of light than white light

Fig. 66 Triple-source lamp houses are used in all the colour printers designed by Agfa, although the latest versions do not always use the additive method of exposure provided by this lamp house from a Colormator N76/90 printer

printing, it was not surprising that by 1960 a number of faster operating white light printers had begun to appear.

Exposure on a subtractive termination printer commences with "white" light and continues just so long as is required for one or other of the three integrating circuits to be satisfied. Thereafter, supposing the red exposure is completed first, a complementary coloured (cyan) filter is rapidly interposed in the exposing light beam. Then, when the next of the remaining two channels have been satisfied—say the green—a magenta filter is added to the cyan filter and only blue light continues to reach the paper. Finally, when sufficient blue exposure has been given, all light is stopped by the introduction of a capping shutter.

142

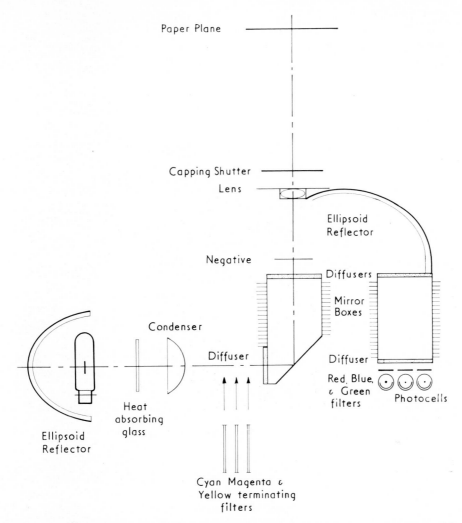

Fig 67 Schematic diagram of Kodak S-I printer. White light printing with subtractive termination. Light for the photocells is collected by a large ellipsoid reflector and diffused by a secondary mirror-box. The main mirror-box provides diffused light at the negative plane. The terminating filters are in the lamphouse, so are effective on both the printing paper and the reading cells

Subtractive Printers

KODAK S1 PRINTER The first subtractive printer to be used commercially was the Kodak S1 designed by *Hunt* of the Kodak Research Laboratories at Harrow in England. The S1 printer was used by Kodak in 1957 and made available to the British finisher in 1958.

143

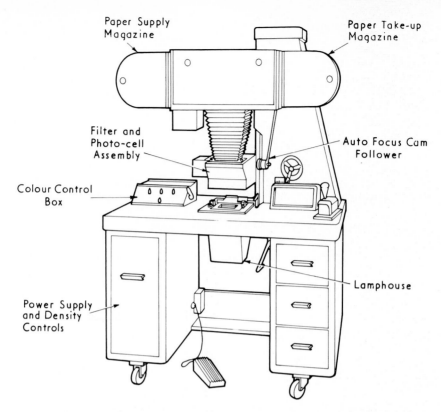

Paper Supply
Magazine

Paper Take-up
Magazine

Filter and
Photo-cell
Assembly

Auto Focus Cam
Follower

Colour Control
Box

Lamphouse

Power Supply
and Density
Controls

Fig. 68 The Pakotronic 5C printer was the first colour printer to be introduced by Pako. It was intended for operation in daylight and could take paper rolls of any width between $2\frac{1}{2}$ and 5 inches, and handle negative sizes from 24 \times 36 mm to $2\frac{1}{2} \times 4\frac{1}{4}$ inches

In the S1 printer, exposure commences with unfiltered light from an incandescent source which allows all three red, green and blue exposures to proceed at the same time. The predetermined amounts of each of the component exposures are obtained by automatic insertion of subtractive filters at the appropriate times. In other words, when the required amount of red light has reached the print material a cyan (minus red) filter is inserted into the exposing beam so that only green and blue light continues to reach the printing plane. When the green exposure is sufficient then a magenta (minus green) filter is inserted into the beam as well. Similarly, when the channel monitoring blue light has been satisfied, a yellow (minus blue) filter is used to terminate the blue exposure. The filters are controlled by photo-cells which analyse and measure the integrated light coming through the colour negative.

In principle, nearly all modern integrating colour printers now operate in this way.

144

KODAK S3 PRINTER. In an attempt to produce a lower priced, albeit lower speed printer that would enable finishers in Britain to take their first step into negative-positive printing, *Hunt* devised the S3 printer, which was semi-automatic in operation and employed the same principles of colour adjustment as he had already used in his colour enlarger.

Photocells, grouped on either side of the lens, viewed the illuminated negative to assess the relative proportions of red, green and blue light. These values were then compared and the resulting differences were indicated on the twin needles of a meter. Any departure from zero readings were corrected by manual adjustment of sliding filters within the lamp house. One filter slide served to adjust the red/green ratio and the other the blue/yellow ratio. Overall exposure was controlled by a normal type of integrator. Because of the manual adjustments involved, the S3 printer could never be operated at more than about 200 exposures an hour.

EASTMAN KODAK 5S AND PAKOTRONIC PRINTERS Not long after the S1 printer had appeared in Britain, two subtractive printers were launched in the US—Pako's Pakotronic 5C in 1958 and Eastman Kodak's 5S in 1959. Much of the thinking behind the Pakotronic can be found in a series of patents granted to Pako,[8] while the 5S is described in some detail in Eastman Kodak's patent by *Brown*.[9]

The 5S printer differs from the S1 and the Pakotronic in one important respect; its measuring photo-cells are positioned between the negative and the subtractive terminating filters, whereas the cells are between the filters and the paper on both the other printers.

At first glance, the significance of this difference may seem slight, and in order to understand why the location of the terminating filters relative to the negative and the photo-cells is very important, it is necessary to consider once again the concept and the limitations of any integrating exposure systems.

Combating Limitations of Integrating Systems

In 1947, *Smith* of Eastman Kodak applied for a patent which was intended to constitute an improved method of operating the 1599 printer. In this patent *Smith* explains that integrating to grey produces satisfactory prints from most negatives, but:

This method tends to produce over-corrected prints from negatives in which one or more colours are in exceptional prominence. For instance, if this method is used to print from a negative bearing an image of a scene which includes a girl in a red dress standing in front of a red barn, the reproduction of this red would be thrown so far in the direction of cyan that the print would be wholly unsatisfactory. Similarly, a negative of a seascape which is predominantly blue will appear much too yellow in the print.

145

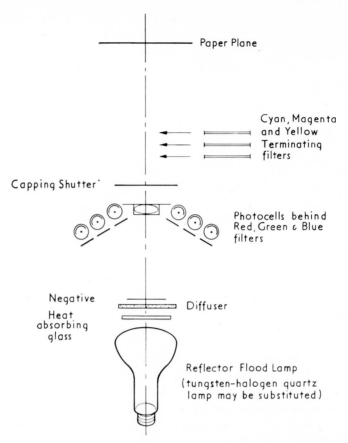

———————————— Paper Plane

Cyan, Magenta
and Yellow
Terminating
filters

Capping Shutter

Photocells behind
Red, Green & Blue
filters

Negative

Diffuser

Heat
absorbing
glass

Reflector Flood Lamp
(tungsten-halogen quartz
lamp may be substituted)

Fig 69 Schematic diagram of Eastman Kodak 5-S printer. White light printing with subtractive termination. In this design the reading cells are before the terminating filters, and the cells continue to see all colour components of the light even after one or two channels have terminated. The printer must be set up for dead-heat termination on a standard negative, by a basic filter pack

Smith's proposal to minimise this type of wastage when using the 1599 printer was to dilute the light coming from the negative being printed with some light coming direct from the printer light source, and then, after pre-setting the intensities of the three tri-colour exposures, exclude the diluting light from the transmitted printing light when exposing the print.

Of *Smith's* proposed method of modifying the degree of correction in order to compensate for negatives that depart significantly from average, *Bartleson* and *Huboi*[11] said:

The device described directs light from the variable-intensity printing source on to the monitor. The result of this diluting is to reduce the effective monitor response to the negative transmittance. It should be noted, however, that as the negative's integrated transmittance is lowered, both source flux and diluting light intensity are raised. It may be

146

seen, then, that the diluting light intensity becomes disproportionate to the integrated transmittance signal so that the end result is not a linear departure from full correction but is nonlinear.

A few years later, with the advent of the 5S printer, a different approach to this same problem was disclosed by *Letzer*,[12] who re-defined it in these terms:

> In photographic colour negatives the colour balance, i.e. the ratio of red, green and blue, integrated transmittance is determined by several factors. The most important of these can be enumerated as:
>
> 1 Illuminant quality (colour temperature).
> 2 Improper or prolonged storage of the film.
> 3 Manufacturing and processing variations of the film.
> 4 Over and under exposure, when the red, green and blue sensitive layers of the film do not have matched contrast.
> 5 The colour balance of the integrated reflectance of the subject area (colour subject failure).

Letzer points out that in order to produce saleable prints a printer must incorporate accurate correction means to deal with variations in negative density and colour balance. Unfortunately, automatic printers which operate at 100 per cent density correction level, also operate at high levels of colour correction and therefore produce an undesirable proportion of unacceptable prints because of subject anomalies (colour subject failures).

Attempts have been made to train operators to detect negatives having predominant colour, but besides slowing down production, this method of operation is not very effective because it is difficult to see differences in overall colour on a negative that is already strongly coloured as the result of yellow/orange masking images. In his patent *Letzer* continues—

> When a tri-colour printer other than one modified in accordance with the present invention has been adjusted to give full overall density correction, this usually ensures that the printer is fully compensating not only for overall density variations between negatives, but is also compensating for variations in red density level, for variations in green density level, and for variations in blue density level. In other words the printer is also operating at "full colour correction". This means that the printer is providing prints of equal colour balance (integrating to grey or a hue near grey) regardless of the colour balance of the negatives. Accordingly, the printer is not capable of accurately printing (colour subject failure) negatives or those having a wanted predominant hue. Therefore, experience has shown that full overall density correction printers tend to produce low levels of waste due to exposure error, but high levels of waste due to incorrect colour.
>
> In order to understand why this is so, one must consider how a negative comes to have abnormal colour balance. One of the major causes of this is the colour of the overall scene of which the negative was made. If one takes a picture of a white house against a blue sky, the negative produced will not have the same colour balance as another negative taken closer to the same house with less blue sky. When these two negatives are printed in a full overall density correction printer, the abnormally high blue density of the first negative (from the area representing the blue sky) will cause the blue printing time to be relatively longer than the blue printing time of the second negative. Thus the first negative will produce a print with a much yellower house than the white house in the print made from the second negative.

147

Letzer's solution to this problem was to locate the measuring photo-cells of his printer (the 5S) between the negative and the terminating filters—in fact they are clustered beneath the lens where they collect scattered light from the negative, while the terminating filters are located above the lens as in the old IVC printer.

The improvement in the yield of saleable prints that comes from the under-correction that results from this particular disposition of filters and photo-cells, can be explained by comparing the two types of subtractive termination printers.

In subtractive printers such as the S1 and the S4, as well as the S4P, Colortron and the Pakotronic, the photo-cell monitors are positioned beyond the subtractive filters. In other words the cells "see" the terminating filters and will compensate for the fact that these filters absorb some of the light they should transmit, by extending the residual exposures whenever one or two of the filters remains in the printing beam for an extended time. When a printer of this type is adjusted to provide a high degree of overall density correction to deal with factors 1–4 listed above, then it will necessarily have a high colour correction level.

Letzer describes the imperfections of available subtractive filters in terms of their "non-image absorbancies" and continues:

> The present invention concerns making use of and controlling the non-image absorbancies of the filters in a time modulated colour subtractive printer in order to provide when necessary, a lowered colour correction level while maintaining a nearly full correction for overall density variation of a population of negatives to be printed. This combination of corrections produces a high yield of acceptable prints affected by "colour subject failure", factor 5 above, as well as those affected by factors 1–4, also listed above.
>
> In order to build both of these optimum levels into a colour printer, one must first make a printer capable of differentiating between the two types of abnormalities and then provide a method of handling these abnormalities differently.
>
> This desired result can be accomplished with a variable-time subtractive printer modified so that the monitoring cells are placed in the system ahead of the subtractive filters, and therefore, do not compensate for the non-major absorbancies of the filters, the printer operates at a lowered colour correction level when necessary.

Letzer also points out that the printer must be adjusted initially so that negatives of normal colour balance print in nearly equal red, green and blue times—in other words the printer should be set up so that the terminating filters operate in "dead heat" when printing negatives of normal colour balance within the accepted exposure range of the negative material. He then continues:

> Let us consider negatives of abnormal colour balance. Going now back to the two negatives of the white house, the second negative (without much blue sky) would be expected to have near normal colour balance, and therefore will produce a good print. The first negative, however, has a relatively high blue density (excess yellow in the negative) and will receive a longer blue exposure in a full overall density correction printer. This is because the blue light reaching the photo-cell is attenuated and as the photo-cells are operating on an integrated light effect, the time of the blue exposure is then lengthened. However, the

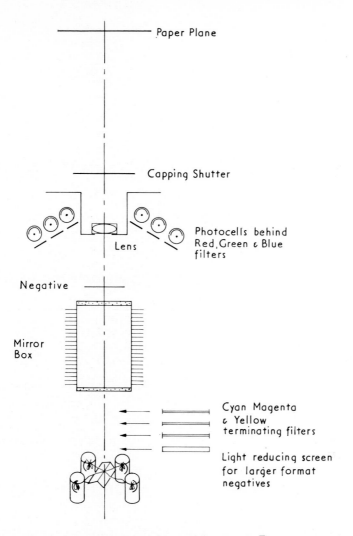

Paper Plane

Capping Shutter

Lens

Photocells behind
Red, Green & Blue
filters

Negative

Mirror
Box

Cyan Magenta
& Yellow
terminating filters

Light reducing screen
for larger format
negatives

Fig 70 Schematic diagram of Kodak Limited S4 and S4P printers. These machines use white light printing with subtractive termination, the terminating filters being in the lamphouse and so before the reading cells. Four integral-mirror lamps provide illumination reflected into the mirror-box which gives fully-diffused light at the negative

magenta filters come into the beam at the end of the green exposure (which is of normal duration) and the cyan filters come into the beam at the end of the red exposure (which is also of normal duration) and the blue intensity striking the print material is reduced by the blue absorption (non-image absorbants) of these two filters for the remaining duration of the blue printing time. This causes less yellow dye to be formed in the print and the house remains whiter than it would have been had the magenta and cyan filters been perfect cutting filters, and had no non-major absorption for blue light, or had this non-image absorption of these two filters been fully compensated for. Had the monitoring photo-cells

been placed between the subtractive filters and the colour print material, as for non-colour printers of this type, the blue intensity to the blue monitor (as well as to the print material) would have been lowered during the residual blue exposure and this residual exposure time would have been lengthened accordingly so that the house would appear more yellow in the print.

Finally *Letzer* explains that:

> By careful design of the subtractive filters their non-major or secondary absorptions can be varied to obtain a greater or lesser degree of under-correction. Tests along these lines have indicated that the minimum reduction from full correction that will produce a significant improvement in print yield is about 20%—meaning that the printer would then operate at an effective 80% correction level. On the other hand, it has been found that the lowest practicable level of colour correction for amateurs' negatives may be about 40% with each colour.

Other Methods of Lowered Colour Correction

In a patent[13] describing the Pakotronic 5C printer, Pako comment on the problem of dealing with colour subject failures when printing with a subtractive termination printer in which the filters are located between the negative and the photo-cells:

> An important feature of the present invention is that we use filters that are not of the full cut-off type, but which instead pass definite amounts of white light admixed with coloured light. This provides two important advantages. Due to the imperfections present in filter dyes, full cut-off types introduce serious amounts of neutral density which serve only to reduce the light intensity and prolong the time of the modifying exposure. Further, filters which cut-off all light of one primary will serve to over-correct negatives of the subject failure type.

Some of these points are difficult to reconcile with *Letzer's* view.

On the Colormator N2B/S automatic printers which operate subtractively, Agfa provide a switchable choice between operating at full colour correction or at a lowered correction level which they describe as a "facility for correcting sensitivity to dominants". When one of these printers is being worked in the under-corrected mode, any partial exposures that extend beyond the time required for the first channel to terminate, are shortened variably, thereby reducing a tendency to produce an off-balance print.

This method of lowering correction does of course entirely depend upon the printer having been carefully set up with a standard negative to give partial exposures that are matched or terminated in "dead-heat".

For obvious reasons, the principles and practical application of lowered colour correction in automatic colour printing are extremely important to all photofinishers. If a degree of under correction, such as that achieved so simply in the 5S printer, can produce a high yield of saleable prints, some may wonder why the same principles are not adopted for more printers. The reason for this

seems to be that variations due to manufacture of colour negative film—factor 3 in the list already given, is less serious in the US, where the S5 printer was designed, than in most other countries. This is another way of saying that Kodacolor films manufactured in Rochester and processed by photofinishers in the US, tend to yield more uniform negatives than are so far obtained in other parts of the world—except perhaps in Switzerland and some Scandinavian countries who import their colour materials from the US.

Certainly it has not so far proved possible for British photofinishers to improve their yield of prints by operating printers at substantially lowered levels of correction, although there is little doubt that the trend towards under correction will continue just as rapidly as improved manufacturing and processing performances allow.

Negative Classification

The less fully corrected a colour printer is, the more care must be taken by the printer operator to recognise the different kinds of subject illumination normally used by amateur photographers. It is for this reason that low correction printers like the 5S always provide subject classification buttons to enable the operator to differentiate between "indoor" or "outdoor" negatives—a difference that would generally be accepted and automatically compensated by a fully corrected printer.

Subject classification was most important in the early days of colour negative printing, when amateurs used clear flash bulbs rather than the blue bulbs they use today.

Density and Colour Corrections

Because no system of colour negative printing can yet produce first time saleable prints from every negative, colour printers all incorporate some means for overriding the built-in integrated response of the monitoring system. Usually this is done by means of a series of correction push buttons. These correction facilities are usually divided into groups—one channel governing density, and three other channels affecting the colour of a print.

The correction for density is made in just the same way as for black and white printing—if a print seems to be too light, then the reprint is made after depressing a plus 1, plus 2 or plus 3 density button, according to the estimated error. Conversely, a dense print is remade at a minus 1, minus 2 or minus 3 setting.

Corrections for colour balance are usually estimated in terms of colour

151

correction buttons, generally arranged in groups of three, representing a progressive degree of correction in terms 'of the three primary and three complementary colours. There is a contradiction in this approach that has presumably arisen because it has been found easier and more satisfactory to train operators to apply a "blue" correction when remaking a print that looks too blue, than to think of the print as requiring less blue.

In the early days of colour printing, attempts were made to deal with the problem in a logical manner by pressing a minus blue button to produce a print containing less blue, but perhaps this unnecessarily complicates the task when training print examiners and printer operators.

Not all printers have push buttons to feed in corrections. Pako for example employ rotary adjustable settings for colour corrections, and unlike most push button arrangements, the Pako colour adjustments are not self cancelling.

Typically, density correction adjustments are arranged in increments of 0·075 log exposure units, while the adjustments provided by colour correction buttons are usually more closely spaced, with increments of 0·05 log exposure units.

The circuitry of most printers allows the additive use of combinations of correction buttons in order to increase the effective range of adjustment. When combinations of colour buttons are used on such printers, some density shift may be noticeable and furthermore, if the correction results in a wide departure from "dead-heat" exposure termination, unpredicted shifts in colour can result from complicated slope affects.

Agfa have patented[14] circuits which allow colour corrections to be made without any resulting changes in overall density, and Gretag claim that the density and colour correction channels on their 3112–6 printers are free from "cross-talk".

Slope Control

If it is assumed that in a colour negative material the relative speed balance and curve conformity of the three colour sensitive layers remains constant throughout a range of, say, three stops under and three stops over-exposure, and if it is further assumed that a constant-time variable intensity printer is being used, then there would be no reason to expect prints made from the under exposed negatives to look any different from those made from the correctly exposed or over exposed negatives. This is undoubtedly one of the reasons why Eastman Kodak based their early colour printers on the constant-time, variable intensity principle. But *Hunt* has pointed out that:

> A very efficient and convenient way of varying exposure is to alter the time, the intensity being kept constant. In these circumstances, however, prints of uniform density may not be produced because of reciprocity failure of the paper; and, in a colour printer, because

152

the reciprocity characteristics of the paper may be different in the three layers, the resulting prints may lack uniformity not only in density but also in colour.

As *Hunt* further says—

Because such variations are more serious in colour than in density, it has been found desirable in most colour printers to provide means for adjusting the relative colour balance of prints made from thin and dense negatives.

This form of adjustment—known as slope-control—was described by *Pieronek*, *Syverud* and *Voglesong* in 1956[16] with particular reference to the earliest form of the Kodak Type IVC colour printer which they described:

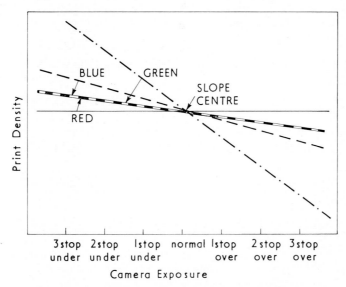

Fig. 71 By comparing print densities (of each component image) with negative exposures, the extent of mismatched colour and density can be anticipated

The Kodak Colour Paper Printer Type IVC has been developed from the Velox Rapid Printer. Several important changes had to be made to the black and white printer to fulfil the additional requirements for colour printing. The proper printing balance for different film types and illumination conditions are selected with the "film type" push buttons. The monitoring and timing circuit provides an automatic correction for colour and density variation in the negative. The printer is also equipped with an empirical adjustment referred to as "slope-control".

The monitor and timing system must correct for variations of density and colour in the negative. It is further necessary that the degree of correction be the same for each of the three printing exposures. One may test the response of a monitoring system by printing a set of negatives representing the latitude series, i.e. some scene spanning the useful exposure range of the negative material.

A colour printing system may be visualised with these different degrees of correction— one for each complementary pair of negative and paper images. When such a system is mis-matched and then adjusted to print normally exposed negatives properly, then under-

153

and over-exposed negatives will produce poorly balanced results. This can be displayed graphically by plotting print densities in terms of identical colour images against negative exposures.

The adjustment or reduction of the degree of mis-match is referred to as slope-control, and adjustment for optimum performance for all three colour component images greatly increases the yield of saleable first-time prints. However, it should be realised that a slope control system and its particular adjustment on a given printer depend upon the characteristics of the colour paper being used as well as certain other factors, and it may therefore be necessary to readjust the slope-control settings on a printer from time to time.

In his paper on slope control in colour printers, *Hunt* deals very fully with all the factors affecting slope control. Briefly these are:

1 *The reciprocity characteristics of the colour paper*. This is generally the most serious cause of difficulty in maintaining correct colour balance throughout a range of negative densities. In black and white printing it is well known that if exposure is multiplied by 10 to compensate for a reduction in intensity to 1/10th, then the resulting prints do not generally match. With colour papers the reciprocity characteristics of each emulsion layer can be different, and when compensation is not made for this, variations in colour balance are inevitable.

2 *The shape of the characteristic curve of the negative material*. This *Hunt* explains by considering two extreme cases. If a negative is very under exposed, the printing exposure time depends almost entirely on the colour of the unexposed area of the film, because the monitoring photo-cells are more effected by the light areas of a negative. On the other hand, when a negative is greatly over exposed, the monitoring is still effected by the lighter areas of the image, but the colour of the higher densities in the negative largely determine the colour of the lighter areas of the print—often the most important part of a picture.

3 *The relationship between the colour response of the filtered photo-cells and the layer responses of the colour paper*. Ideally the photo-cell/filter response would exactly match the sensitivities of the three emulsion layers of the paper, but in practice this is very difficult to achieve because whereas emulsion colour sensitivity normally falls sharply on the long wave-length side, filter absorptions are generally steeper on the short wave-length side.

In the S1, S4 and S4P printers, the method employed for slope control is to make the voltages through which the integrating condensers have to charge, dependent on the duration of each colour exposure. This is done by switching from one voltage to another through suitable resistor-capacitor circuits during the course of exposure.

A similar method is used to deal with the problem in Eastman Kodak's 5S printer.

154

When considering the problem of slope control in relation to their Pakotronic printer, Pako say[17]—

> The printer will produce corrected prints from negatives of various densities corresponding to a considerable range of over and under exposure. However, due to imperfections in the materials in use, a shift in both colour and density occurs in printing greatly over-or under-exposed negatives, and we have invented a means for compensating for such grossly under-and over-exposed negatives during printing. Prints from such negatives exhibit a colour shift in one direction if under-exposed and in the opposite direction if over-exposed. Using the registered Trade Mark "Kodacolor Type C" material, this colour shift is towards green with over-exposed negatives and towards the green complement, magenta with under-exposed negatives, requiring shortening of the green component exposure for under-exposed negatives and lengthening of the green component exposure for over-exposed negatives. In each channel adjustable response is provided in series with the summing condenser so that when the photo-cell current passes through the resistor a voltage appears across it and this voltage is added to the voltage of the charge on the condenser. Hence, whenever a thin (under-exposed) negative is being printed a large signal will be applied by the resistor and with a dense (over-exposed) negative the signal will be small. If the negative is very thin, then voltage may be strong enough to produce half the required firing signal, so that the summing condenser need only supply the other half. Consequently, the firing voltage is reached sooner with the help of this added voltage and this shortens the exposure whenever a very thin negative is printed. With a normal negative a medium signal is added to the voltage of the summing condenser. While with a dense negative the added voltage is negligible, and the full time is required for the summing condenser to produce the firing voltage.
>
> The value of the added voltage produced by the resistor is dependent upon the setting of the adjustment of said resistor. The medium signal corresponding to a normal negative would introduce a shift to green, but this is now overcome by re-adjusting the green channel biases upward until the combined resistor voltage and summing condenser voltage produces a good print.

These means of compensating for reciprocity effects are not as satisfactory as a method which effectively pivots the three reciprocity characteristics around a mid-point representing the exposure time of a normal negative, because then the three slope characteristics can be adjusted to deal with both under and over exposed negatives without affecting the colour balance settings required for a normal negative.

In 1969, Pako announced a slope control modification for all Pakotronic printers which was said to "improve uniform density in printing from negatives over-exposed or under-exposed as much as two stops" and to "boost color compensation range from both under-exposed and over-exposed negatives".

Certainly it is a shortcoming of many slope control systems that slope adjustments that produce good colour balance may not produce satisfactory print densities. Only on the Gretag printer can the colour and density slope adjustments be made independently.

Slope Control in Agfa Colormator

Agfa's approach to slope control has been similar to that adopted by Pako and in their instructions for setting up the Colormator N2B and N4B, Agfa say:

> All three (slope) potentiometers should first be left in the zero position and a print made from each negative of the series 4–10 (three stops under to three stops over plus the properly exposed negative). If these are printed in sequence, after development we shall see that the colour density of the series fluctuates. The settings of the potentiometers should then be altered in accordance with the following table:

Print from underexposed negative No. 10 too	Print from overexposed negative No. 4 too	Turn potentiometer No. 83 for
blue yellow	yellow blue	blue in + direction blue in − direction
green magenta	magenta green	green in + direction green in − direction
red cyan	cyan red	red in + direction red in − direction

> Prints are then made from negatives 4–10 at various settings lying in the required direction. The setting at which no colour distortion occurs should be chosen for operation, care being taken to avoid over-correction. Under unfavourable conditions a colour cast may occur at this optimum setting even with the normally exposed negative—but this cast will then be consistent on the entire strip of prints. This means that calibration will have to be readjusted slightly after setting the slope control, and the exposure cycles determined during calibration can be used for the purpose.

Here again we see the difficulty that results from pivoting the slope characteristics about one end of their curves rather than about a mid-point represented by a properly exposed negative.

Size Compensation

All photofinishers would prefer to work from a single size of negative—and that preferably square! Perhaps this ideal state will come one day—certainly the rapid adoption of 126 cartridge film has meant that considerably more than half the negatives handled in the US are now of this size and the trend is the same elsewhere. In the meantime, negative sizes are varied—particularly in Britain—where film sizes have been influenced at different times by camera

manufacturers in the US (828, 127 and 126), in Germany (35 mm. and Rapid), and in Japan (half-frame 35 mm.). This wide variety of sizes makes it difficult for a finisher to set aside a printer to deal with a single size of negative—the most efficient way of working. Consequently, most colour printers are designed to accept a wide range of negative formats and this means that they must be equipped with means for negative size compensation.

Most printers use either manually or automatically selected compensating circuits to suit each different negative size. The S4P for example has sixteen size compensation channels, all of which are selected automatically when a

Fig. 72 In order to make the most efficient use of the available light, the Colormator N4B printer is fitted with interchangeable mirror tunnels—one for 135 (24 × 36mm) and 126 negatives and the other for larger sizes up to 6 × 9cm

negative carrier is placed in position. A different procedure was adopted with the S1 printer where different sized light integrating mirror boxes are available for positioning beneath the negative carrier. Adjustment of overall print density with change of negative size is effected by changing the neutral density filter located over the top end of the mirror box supplying light to the photocells.

Light Sources and Lamphouses

When compared with black and white negatives of a given size, masked colour negatives require much more light—particularly blue light—to print them at desirable commercial speeds. Because of this, a great deal of work has been done on the design of more efficient ways of illuminating colour negatives for projection printing.

The simplest way of illuminating a negative is to use a lamp with a diffusing envelope, placed quite close to the negative and cooled by an efficient flow of

157

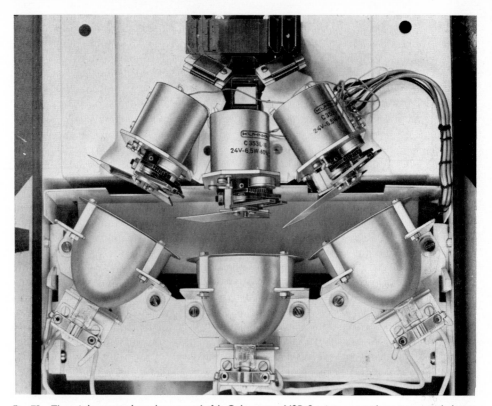

Fig. 73 The triple-source lamp house on Agfa's Colormator N2B-S printer uses three tungsten halogen lamps in reflectors arranged to direct three beams of primary coloured light into a mirror tunnel. Solenoid operated blade shutters are used in place of the earlier louvre type

air. In effect, the early Pakotronic printers and the Eastman Kodak 5S, 8S and 11S printers work in this way. The 5S, does in fact, have two lamps incorporated in its lamphouse (one of them is a reflector flood and the other a normal lamp). The lamps can easily be interchanged on a swivelling mount to suit the size of negative being covered.

One of the earliest attempts to try something new was seen in the Kodak S1 printer, which incorporates a mirror tunnel. Light from a 1000 watt projection lamp is fed via a condenser into the bottom of the mirror box to be reflected on to a diffuser at the top of the tunnel. This system produces uniform negative illumination of quite a high intensity and similar mirror boxes are now used in conjunction with tungsten halogen lamps on the Kodak S4P and the Agfa Colormator N2B-S and N4B printers.

Agfa, who have continued to employ triple source lamphouses since they first introduced the Colormator N, have done so largely because, by using three lamps simultaneously they were able to compensate for much of the light loss

158

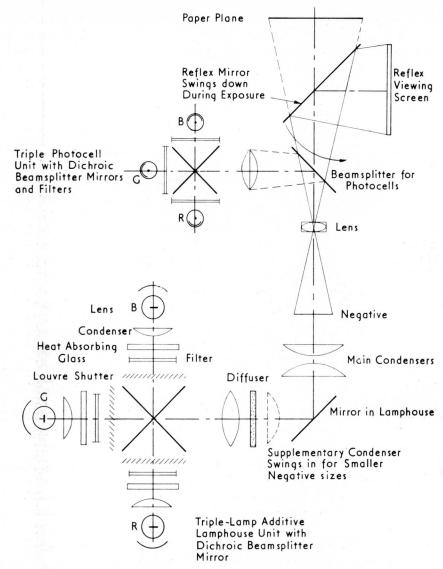

Paper Plane

Reflex Mirror
Swings down
During Exposure

Reflex
Viewing
Screen

B

Triple Photocell
Unit with Dichroic
Beamsplitter Mirrors
and Filters

G

Beamsplitter for
Photocells

R

Lens

Lens B

Condenser

Heat Absorbing
Glass

Filter

Louvre Shutter

Diffuser

Negative

Main Condensers

G

Mirror in Lamphouse

Supplementary Condenser
Swings in for Smaller
Negative sizes

R

Triple-Lamp Additive
Lamphouse Unit with
Dichroic Beamsplitter
Mirror

Fig. 74 By using three lamps to provide simultaneous additive exposures Agfa were able, with their
Colormator 76/90 printer, to achieve acceptably short exposure times

associated with additive printing. Even when they decided to abandon additive printing, as in the Colormator N2B-S Automatic printer, they have still maintained the triple light source, mixing unfiltered light from the three tungsten-halogen beams in a mirror tunnel.

Because the yellow-orange masking density of most colour negatives absorbs

159

a great deal of blue light, sources rich in blue have often been considered and used for colour printing. The lamphouse designed by Ilford Limited[18] incorporated a mercury vapour lamp and a tungsten lamp. The mercury vapour source supplies the blue and green light at high efficiency, and the tungsten lamp the red light. A simple optical combining system is used to collect light from the two sources to illuminate the diffuser before the negative.

PAKOTRONIC ILLUMINATION SYSTEM The introduction of a tungsten-halogen source in a new high efficiency lamphouse on the Pakotronic 75-3WCC printer introduced in 1967 resulted in exposures with an average duration of 0·5 second —a considerable improvement on earlier Pako colour printers. However, an average exposure of half a second implies considerably shorter exposures from thin negatives and this in turn presented a problem that was peculiar to Pakotronic printers. In all previous models the three exposure channels had been served by a single photo-cell operating in conjunction with a distributor cup or drum rotating at 1400 rpm and having three filtered windows let into it. The monitoring system works as follows[19].

> When the red filter in the rotating cup is in front of the beam splitter, the photo-tube sees only red light and the cam in the red channel closes a set of contacts to allow the photo-tube signal to go to the red timing circuit. In the same way, while the green (or blue) filter is in front of the beam splitter, the photo-tube sees only green (or blue) light and its signal is sent to the green (or blue) timing circuit.

Clearly, the accuracy of this method of integrating depends to a large extent upon the exposure time of any negative being printed. If we assume an average exposure of 0·5 second, then the rotating drum would distribute signals at the rate of about twelve an exposure, but if we then assume that many thin negatives might only require one third as much exposure, there would be time available to distribute only four signals an exposure, and the sensing accuracy of the monitoring system would become inadequate.

For these reasons, the much shorter exposures achieved with the Pakotronic 75 and 77-3WCC printers rendered the old system of monitoring unsatisfactory, and as a result, a new colour sensing system was devised. The new arrangement uses an X dichroic beam splitter feeding three separate photo-multipliers so that all three colours can be measured simultaneously.

Although they do not appear to have based any of their commercially available printers on them, Pako have a number of patents relating to a method of exposure that can best be described as "white-light plus successive primary top-up".[19] In terms of the specification:

> A system which uses the initial wide band "white" light exposure to complete the requirement of one or more of the three primary colours and partially to complete the requirement of the remaining colour(s) and in which there follows the sequential exposure to narrow band primary colours required to complete the remaining colour requirements.

160

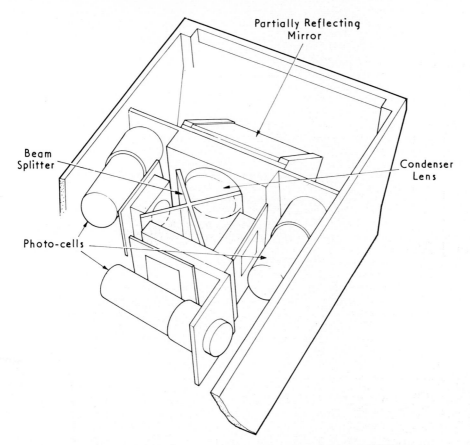

Partially Reflecting
Mirror

Beam
Splitter

Condenser
Lens

Photo-cells

Fig. 75 This form of photo-cell layout was first used by Pako on their Pakotronic 77-3WCC printers, to replace their earlier system using a single photo-cell within a rotating filter drum

In related patents Pako explain a problem that results from using the white light plus primary light system of exposure:

> Automatic exposure control in photographic colour printers is normally effected by means of photo-cells with which narrow band (primary colour) filters are associated. When such an exposure control system is used in carrying out the "white" exposure plus sequential primary exposure method of colour printing, the light extended upon each photo-cell always passes through the associated narrow band filter even though for part of the exposure time the light which is being monitored is wide band printing light. In other words the photo-cell sampling means will not normally distinguish between the wide band and the narrow band coloured portions of the total exposure. It is found that printing errors are in part due to this discrepancy.

Pako proposed to circumvent this difficulty by automatically adjusting the sensitivity of the three channels at the moment of change from "white" light to "primary" light exposure.

161

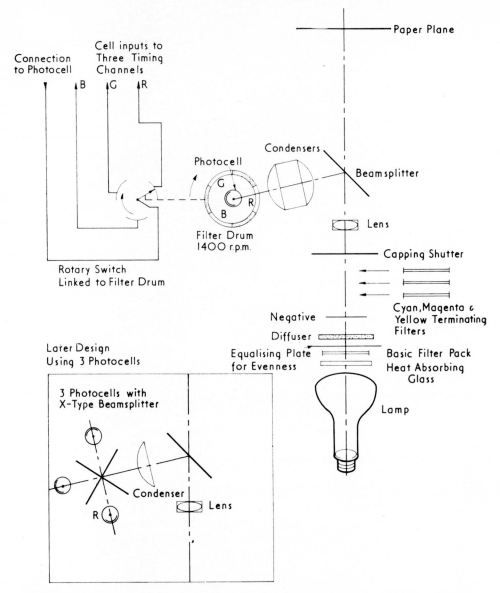

Connection to Photocell

Cell inputs to Three Timing Channels

↓B ↓G ↓R

Rotary Switch Linked to Filter Drum

Photocell

Condensers

Beamsplitter

G
R
B

Filter Drum 1400 r.p.m.

Lens

Capping Shutter

Cyan, Magenta & Yellow Terminating Filters

Negative

Diffuser

Basic Filter Pack

Equalising Plate for Evenness

Heat Absorbing Glass

Lamp

Later Design Using 3 Photocells

3 Photocells with X-Type Beamsplitter

Condenser

R

Lens

Fig. 76 Early Pakotronic colour printers used a single photo-cell enclosed within a rotating triple-filter drum. More recent machines incorporate three cells and a crossed mirror beam-splitter

The Color Automat series of printers made by Mullersohn in Germany at one time used white light main exposures topped-up by sequential additive exposures, although it does not seem that they found it necessary to deal specially

162

with the change in effective sensitivity that results when exposures are switched from white light to primary coloured light.

EASTMAN KODAK 5S-3-K In order to achieve extra production from their 5S, 8S and 11S series of printers, Eastman Kodak in 1967 introduced their 26000 lamphouse to provide high light output with negligible change in colour temperature or brightness throughout the long life of a quartz-iodine lamp. The light level at the negative plane with this lamphouse is 26,000 foot candles.

DUAL LAMP PRINTER An Ilford printer[21] incorporated two tungsten lamps. At the commencement of an exposure, the light from one lamp passes through a cyan filter which transmits both green and blue light to the negative, while the light from the other lamp passes through a magenta filter transmitting both red and blue light. When the photo-cell monitoring the red exposure has received its quota of red light the magenta filter is changed for a blue filter. The exposure then continues to the combined light through the cyan and blue filters until either the green channel or the blue channel is satisfied. Should the green exposure be completed first, a blue filter immediately replaces the cyan filter so that blue light continues to reach the negative from both sources until the blue channel has been satisfied. If, on the other hand, the blue exposure is completed before either the red or green exposures, then a yellow (minus blue) filter is interposed in the combined beam so that red and green exposures may continue as required. Upon the termination of the last of the three exposures, a capping shutter operates to intercept the common beam.

Lamphouses working in this way were used by Ilford on the printers they constructed to produce proof-strips and enprints from their 35 mm. colour negative film.

Gevaert Patents on Overlapping Sensitivities

Gevaert, who marketed a commercial colour printer for only a brief period around 1960, have been nonetheless involved in the problems of automatic colour printing because they have manufactured colour paper for photo-finishers for many years. Two of the few patents[22] they have obtained in this field deal with the problem of overlapping sensitivities of the three emulsion layers of a colour paper—particularly the overlap that generally exists between the blue and green sensitive layers. The problem and the proposed solution are stated as follows—

In order to achieve high fidelity colour reproduction it is desirable not only to effect independent exposure control of the printing light colours to which the different light sensitive layers of the print material respond, but also to avoid or restrict exposure of the print material to light of wavelengths which are within a spectral band to which the light

163

sensitive layers of the print material are sensitive. In colour sensitive materials and in photographic colour printing, the spectral sensitivity ranges of the blue and green sensitive layers overlap so that there is a common sensitivity band centred at about 490 μ.

To solve this problem Gevaert proposed to use a blue filter mounted in a filter unit which also comprises a yellow filter, the latter being initially located out of the light beam. When sufficient blue light has fallen on to the positive material, the filter unit is displaced so that the blue filter is removed from the light beam and replaced by the yellow filter.

Colour Quality of Printing Light

In any printer designed to give simultaneous exposures, whether through tri-colour filters or through cyan, magenta or yellow terminating filters, it is important to arrange for all three print exposures to end almost in dead-heat when producing a good print of a subject having no particular colour dominant.

There are three quite different reasons for requiring all three print exposures to last substantially the same time when normal negatives are being printed. First, if the part exposures were regularly out of balance, say, always longer for the blue channel to be satisfied, the output of the printer would be lowered because of the extra time taken to await the termination of the blue exposure from every negative.

Secondly, and more important, some printers—such as the 5S—depend on the extended part exposures that result from colour subject failures or colour dominants as a means of providing an automatic measure of under correction. This scheme would be nullified if a part exposure was extended for any reason other than that the negative represented a colour subject failure. In other words, if unequal part exposures resulted from normal negatives, then the 5S under-correction system would no longer work.

Furthermore, those printers—such as the Colormators and the Pakotronics—which depend upon the duration of exposure to govern slope corrections must necessarily be based on the assumption that all three part exposures will last substantially the same time when a print is being made from a negative of an average subject.

Gretag claim that it is not necessary to have "dead-heat" exposures with their 3116 printer, but while this may be true in terms of unimpaired quality, print output will always be greater when print exposures tend to be equal.

To provide a close check on the relative times of the three partial exposures, Agfa recommend keeping a triple timer connected to the three channels and running throughout a reasonably long period of printing. In that way, after work is finished at the end of a day or a week, the three totals on the timer will provide a realistic guide to the relative range of the average print exposure—and

164

if necessary, adjustments can be confidently made on the basis of such evidence.

It is also undesirable to have one or more partial exposures extended unnecessarily because of the deterioration in print sharpness which tends to occur on printers where the projected image passes through gelatine filters.

Finally, any unnecessary extension of printing exposure causes rapid fading of filters when they are located before the negative, as for example in the S1 and S4 printers.

In some printers the overall adjustment of the colour of the negative illumination is made by means of a basic filter pack. Quite often this is made up from gelatine filters located just below the negative, the pack generally includes a heat absorbing glass that is itself bluish-green in colour and therefore helpful in balancing the relatively low blue content of tungsten light. Fading of cyan filters used in basic filter packs is a frequent cause of trouble in colour printers because the change in density need only be slight to cause some negatives to require disproportionate printing time through the cyan terminating filters—with resulting distortions in colour rendering.

It should be realised that whenever one or other of the three part exposures is longer than the others, it must only be because of some colour dominant in the original scene and never because the effective quality of the basic printing light has changed.

There are several ways in which the shortcomings of gelatine filter packs can be avoided. For instance, when each part exposure is supplied by a separate lamp as in all the Agfa Colormator printers, then it is a simple matter to independently adjust the relative brightness of red, green and blue light by means of perforated metal plates than can be moved so as to cover more or less all the individual beams of light. The primary coloured red, green and blue filters used in the Colormator N2B-S are interference coated, so as to reflect a good deal of the light that would otherwise need to be absorbed, with a consequent improvement in the performance and permanence of the filters.

Adjusting Exposure Duration on Pavelle HS Colortron

The relative durations of the three partial exposures on the Pavelle HS printer are adjusted in a rather ingenious way that requires neither additional filters nor adjustable apertures. The lamphouse of a Colortron HS printer contains a diffusing box into which light from two 24 volt 200 watt reflector lamps is directed through two apertures. These two apertures are normally unobstructed, but at the termination of each part exposure one or other of the subtractive coloured filters is automatically swung into position over the apertures.

In order to adjust the colour quality of the light emerging from the integrator so as to ensure dead-heat exposures from normal negatives, any one or two of the subtractive terminating filters can be set so that in their at-rest position they

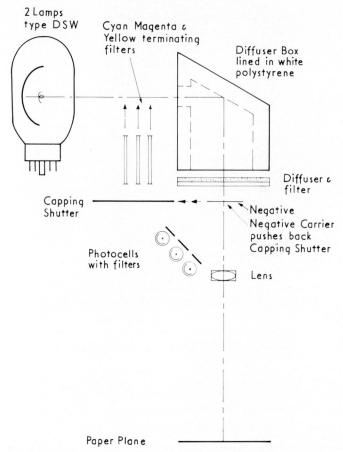

2 Lamps
type DSW

Cyan Magenta &
Yellow terminating
filters

Diffuser Box
lined in white
polystyrene

Diffuser &
filter

Capping
Shutter

Negative
Negative Carrier
pushes back
Capping Shutter

Photocells
with filters

Lens

Paper Plane

Fig. 77 The Pavelle HS colour printer uses a pair of 200 watt integral-mirror lamps to illuminate a white lined integrating box from which fully diffused light reaches the negative

partially cover the light apertures and therefore modify the integrated colour of the basic printing light.

Pako have also patented[23] a mixing box in which light from its filtered sources (two red, two green and two blue) was integrated before emerging as high intensity continuous light immediately below the negative position. The lamphouse described seems never to have been used commercially on Pako-tronic printers.

Monitoring Stability

One of the problems associated with early automatic colour printers was the instability of their monitoring systems. Clearly, if the same exposure times are

166

not given when the same negative is printed repeatedly at intervals at least as long as hours, then the whole printing operation becomes erratic and both the quality and the economics of the business must suffer.

Neale, *Coote* and *Large* have stressed the importance of photo-cell stabilization; and with this in mind, the electronic circuits in the Ilford 35 mm. proof printer and En-printer were designed to give high precision exposure control. It was intended that neither the long term nor the short term drift should produce an exposure variation of more than one per cent in any one channel: red, green or blue.

In the patent by which the procedure is protected, *Neale* points out the difficulties he is trying to overcome:

> One of the elusive causes of inconsistency (in colour printers) has now been identified with variations of spectral sensitivity response of the photo-cell or photo-cells with temperature history, i.e. the history of the variation in temperature with time to which the photo-cell has been subjected prior to that time at which the sensitivity is being examined. Changes in spectral response led to errors in assessment of the relative red, green and blue light fluxes transmitted by the colour negative. Known types of automatic printers use photo-cells in temperature controlled enclosures in an attempt to eliminate this source of instability.

Several printers do in fact incorporate thermostatically controlled heaters to ensure that the temperature of their monitoring photo-cells remain constant. The early Pavelle, Eastman Kodak 5S and Agfa's N2B-S are among them. A heater, a blower and a thermostat are usually fitted for this purpose and warm air at a controlled temperature is blown around the cell assembly whenever the printer is operating. In addition, the 5S has a stand-by switch that ensures that the photo-cells are exposed to light from an auxiliary lamp. It is usual to leave printers switched on continuously or at least overnight throughout the working week in order to obtain better stability.

Solid State Circuitry

There is little doubt that the introduction of solid-state circuitry brought about a considerable improvement in the stability of integrating colour printers. Even old Eastman Kodak IVC printers can be modernised in this way.

In 1968, *Sager* of Cyro-Dyne Systems, introduced the 102–1000 Printer Control Console for use with the IVC printer, thereby bringing this long established machine up to date once more. The Cyro-Dyne conversion kit eliminates all electro-mechanical components, including motorized timer, cam switches and control relays, while all vacuum tubes and thyatrons are replaced by solid-state computer type logic circuits.

GRETAG PRINTERS The Gretag subtractive colour printers use sophisticated solid-state electronics designed for ease in setting up and to give a high degree of stability.

Light passing through the negative is measured by a ring of photo-resistors located around the lens. The blue, green, and red outputs are fed to logarithmic amplifiers, while slope and other corrections are summated. The electronics can be adjusted at will to provide either full or a reduced level of colour correction, so as to produce the best possible yield of good prints from any given negative population.

Setting up the printer is facilitated by the use of logarithmetic amplifiers which permit all the various settings and corrections to be summed electronically. Slope centre settings are made simply by using an indicating meter built

Fig. 78 The Gretag 3116 colour printer incorporates advanced electronic circuitry that results in extreme stability. A novel feed-back system ensures that the brightness of the printing lamp is held at a precisely determined level at all times

into the machine, while precise times are ascertained with an electronic digital timer.

Another special feature of the printer is that the three colour channel voltages resulting from a particular negative can be determined without the necessity for going through the printing cycle. Exposures are controlled by charging a capacitor in each colour channel circuit.

Unwanted absorptions of the three subtractive terminating filters are compensated electronically by a "matrix" circuit which cross-links the three timing channels. For example the exposure to blue light is terminated by the blue channel timer inserting a yellow filter into the beam. However, this filter also absorbs some green and red light, and to offset these unwanted absorptions, the

168

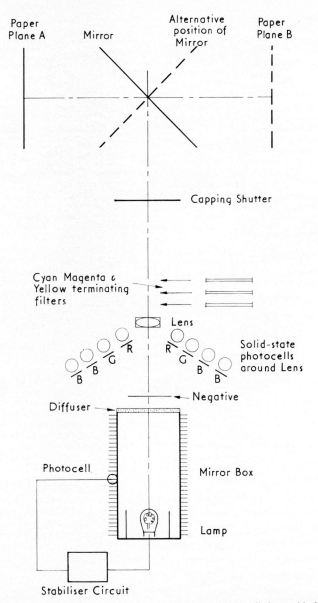

Paper Plane A Mirror Alternative position of Mirror Paper Plane B

Capping Shutter

Cyan Magenta & Yellow terminating filters

Lens

Solid-state photocells around Lens

R R
G G
B B B B

Negative

Diffuser

Photocell

Mirror Box

Lamp

Stabiliser Circuit

Fig. 79 The Gretag 3000 series of colour printers use solid-state photo-cells located before the lens, and a stabilising circuit controlling the light output of a 650 watt tungsten-halogen lamp. Two paper tracks are provided and one or the other can be selected for use by moving a mirror through ninety degrees

levels of the other two channels are automatically modified to give the appropriate increases in the green and red exposure.

The Gretag printers include a constant intensity circuit for the printing lamp,

169

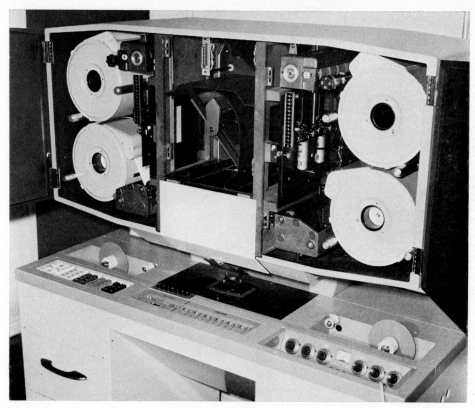

Fig. 80 Gretag colour printers are designed for two paper tracks, both providing vertical exposure planes. Either track may be selected for use by rotating a mirror through ninety degrees. Paper can be changed in one track while the printer continues to operate

which is held at a predetermined brightness level by a control amplifier linked to a photo-resistor in the lamphouse. This system, besides facilitating setting up, also ensures stability of the slope centre settings, even after a change of lamp.

The accuracy of repeated exposures is very high. Short term reproducibility is claimed to be \pm 0·02 (print density) and long term \pm 0·04. As an example, with a total exposure time of 0·03 seconds (300 milli-seconds) the reproducibility of the circuit is \pm 12/1000th sec.

The Gretag printer can be set for any degree of correction, and the amount of correction has no influence on the value of colour correction or density correction buttons. Slope-control is wide range and slope-centre is set on a built-in meter.

Gretag claim that with their printer it is not important to set it up for 1:1:1 part exposure ratios and that a basic filter pack is therefore unnecessary. This particular feature is rather difficult to understand until it is realised that the

Gretag 3112 printers incorporate very advanced electronic circuitry—all solid state—and working in a unique way. The light intensity is stabilized, and the negative density, as read by each photo-cell is applied, with all necessary corrections, as a voltage on the timing capacitor.

As a second part of the operation, though almost instantaneously in fact, the exposure is initiated. During the first phase however, an electronic matrix is fed with the three voltages on the timing capacitors of the respective colour channels. Within the matrix, the three channels are cross-linked so as to modify the exposure times as required to correct for the deficiencies of the termination filters.

Layout of Printers

The early commercial types of automatic colour printers used layouts that were quite similar to those that had previously been developed for black and white printing. For example, the IVC printer made by Eastman Kodak and the S4

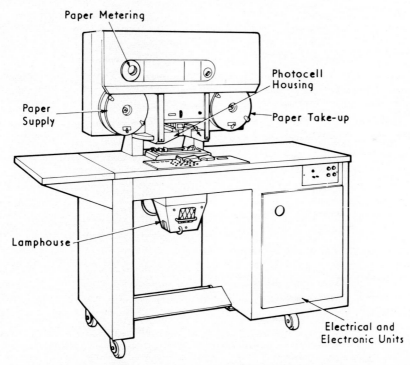

Fig. 81 S4 and S4P colour printers were designed by Kodak Limited and are used by many finishers in the U.K. The S4 is a 'white' light, subtractive termination printer similar in appearance to the Kodak Auto-Velox black and white printer.

171

and S4P printers made by Kodak in England are quite similar in outward appearance to the old Eastman Velox Rapid printer in the one case and to Kodak's British made Auto-Velox printer in the other.

Similarly, although Pako made their Pakotronic printer a daylight loading machine, they still maintained many characteristic features of their Pakomatic black and white printer—in particular the use of one lens for all degrees of enlargement from any negative size.

Mullersohn in Germany use a forty-five degree reflecting mirror to keep the paper plane vertical in both their black and white and colour printers—with the exception of the Automatic 35 mm. printer.

The Gretag 3112 printer is novel in layout in that it incorporates two paper tracks, both providing vertical paper planes. Either track can be selected for printing by rotating the reflecting mirror through ninety degrees. Because of this twin track facility, paper can be changed on one side while the printer continues to operate on the other.

DOWNWARD PRINTING BEAM MODELS One of the first manufacturers to break away from the conventional arrangement of the principal components of a colour printer, was Pavelle (Colortron) in Britain. First, in their en-Printer and their Mini-Printer and then in the HS Colortron range, they chose to direct the projected beam downwards on to a paper plane below bench level. This had been done before by Pavelle Color Inc., who made colour negative printers for their own use as early as 1950.

Eastman Kodak's 2620 printer also has a downwardly directed printing beam, but in this case the designer also incorporated a viewing screen on which the operator can see a magnified image of the negative that is next to be printed.

Prior to the introduction of the 2620 printer, the only colour printers with negative viewing screens were the Agfa Colormators—all of which provide a reflected image of the negative being printed up to the moment exposure commences.

Pako broke with their tradition when they introduced the Mach I colour printer in 1969. The Mach I, which has a layout that is very similar to the 2620, is intended for printing either 126 negatives only or 135 negatives only. This printer employs the same layout as the Kodak 2620 and the earlier Color-tron machines—with the lamphouse aiming downwards to a paper carriage within a bench cabinet beneath the negative carrier. The Mach I takes 1000-ft daylight loading paper magazines that can be wheeled into their operating positions on castors and never have to be lifted. The negative is illuminated by a 200 watt quartz-bromine lamp located close to a diffuser and close to the negative itself. Separate lamp assemblies are required for use with 126 or 135 negatives. As with the 2620 printer, a reflex image of each negative is visible prior to its reaching the printing aperture. No in-pitch perforation is necessary

172

Fig. 82 The Pavelle (Colortron) H.S. series of printers use a downwardly directed printing beam and a dual source lamp house in conjunction with subtractive exposure termination

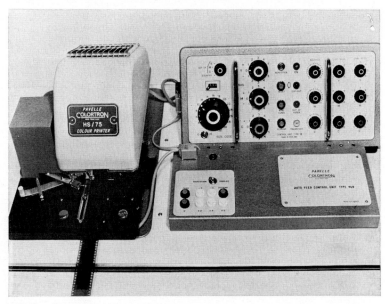

Fig. 83 HS/78 Pavelle printers can incorporate an automatic negative feed for use either with 135 or 126 negatives

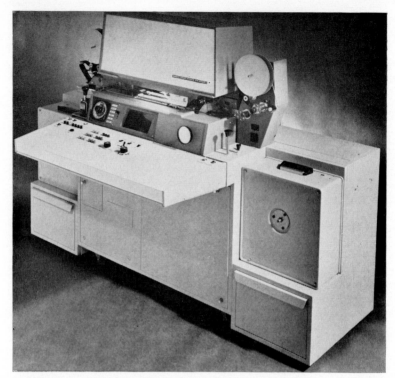

Fig. 84 A negative pre-viewing station is provided on the Eastman Kodak 2620 colour printer to enable the operator to decide upon any corrections required while the preceding negative is being printed

between adjacent rolls of joined 126 negatives. Both paper transport and negative transport have been speeded up to minimise "dead" time, and Pako claim that the Mach I printer can expose 4000 prints an hour.

Speed-up Kit for 2620

When a printer is expected to make between 3000 and 4000 exposures an hour, every possible fraction of a second must be saved by shortening exposure times and by reducing "dead" time due to paper and negative transport. These considerations led Kodak to modify their 2620 printer by means of a "speed-up" kit, enabling output to be increased from around 2000 up to 3000 exposures an hour. The improvement is mainly due to using a more efficient printing light source and to making both picture and optical cutter mark exposures simultaneously rather than in succession.

Value of "Ring Arounds"

Measurement of exposures by means of a timer permits accurate reproduction

174

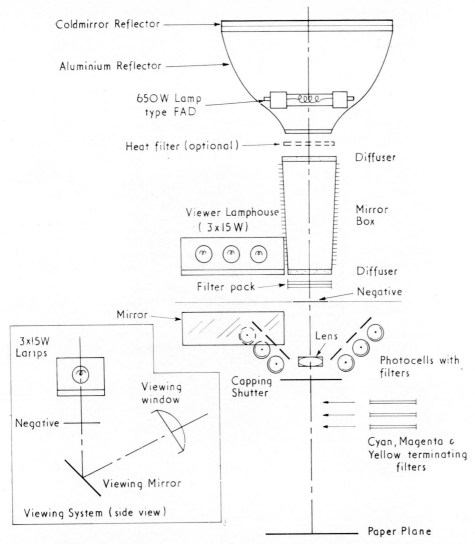

Coldmirror Reflector

Aluminium Reflector

650 W Lamp
type FAD

Heat filter (optional)

Diffuser

Viewer Lamphouse
(3 x 15 W)

Mirror
Box

Diffuser

Filter pack

Negative

Mirror

3 x 15 W
Lamps

Lens

Photocells with
filters

Negative

Viewing
window

Capping
Shutter

Cyan, Magenta &
Yellow terminating
filters

Viewing Mirror

Viewing System (side view)

Paper Plane

Fig. 85 Schematic diagram of Eastman Kodak 2620 printer. Uses white light printing with subtractive termination. Layout uses lamphouse above, paper plane below, for convenient viewing of negatives about to go into printing gate. Unusual lamphouse has tungsten-halogen lamp in reflector, topped by cold-mirror which reflects light down through hole in bottom of bowl and to negative via diffusing mirror-box

and adjustment of conditions, but this alone will not teach what conditions of exposure are required for a printer to produce the greatest number of saleable colour prints. This can be decided only as the result of careful examination of many prints, made under normal production.

But before any assessment can be made, it will be necessary to establish the

175

printing conditions required to make a good print from a standard or reference negative.

It is a fact that if a number of reasonably well balanced colour prints are examined separately in isolation, then many more of them will be considered satisfactory than if they are assessed as a group. This fact serves to illustrate that it is necessary to use the "ring-around" method of testing when setting up a printer, either initially, or after any major change.

A "ring-around" is simply a procedure devised for obtaining a group of colour prints, the colour balance of which will be sufficiently diverse to straddle

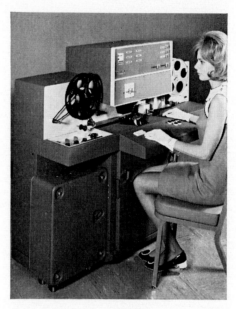

Fig. 86 The 1,000ft. paper magazines used on Pako's Mach I colour printer can be wheeled into position and brought into operation without being lifted

the optimum result obtainable from a reference negative. The procedure can be well illustrated by taking the recommendations for setting up an S4P printer:

By making a series of practical "ring-around" tests it should be possible to locate the exact setting for the paper in use by selecting the print from each test which is nearest to the correct colour balance.

These series of tests are designed to produce groups of colour prints which cover a wide range, medium range and close range of differences in colour balance.

The first test to be made is the wide range 9/3 test, which comprises nine combinations of three colour buttons at the three button correction level: Make one exposure at "normal" density at each setting. When processed this will produce a strip of nine prints which cover a range equivalent to two density buttons light to two density buttons dark and six colour buttons bias towards each of the primary and complementary colours.

176

In other words, unless the printer or the paper batch is a long way off balance, the results of the "ring-around" must straddle the area of correct adjustment.

Inspect the prints closely and choose the one which is nearest to a reasonable colour balance. Determine at which setting this was printed, then adjust the sensitivity of the three integrators so that a "normal" print made with no colour correction corresponds to the selected improvement.

On the S4P, this adjustment is easily made because there is a fixed relationship between the correction button values and the click settings of the three integrator sensitivity adjustments.

Having established an approximate sensitivity setting for the printer, a more comprehensive test should now be made.

A 27/2 medium range ring-around involves making 27 exposures at the two button correction level.

From the results of this test, again select the best print for both colour and density. Further adjust the five sensitivity switches as necessary to produce the improved result at the normal setting.

Having achieved a close approximation of the final colour balance required, a final close range test is suggested which should enable any final adjustments to be made to produce a perfect balance.

This final 13/1 test is a series of thirteen test prints that are closely grouped around the normal setting at one colour-button level.

Before a commercial colour printer is delivered to a customer it is set up to produce satisfactory prints from a standard negative on to a typical batch of colour paper. When the photofinisher comes to use this machine, it is possible that he will be using the same type of colour paper as was used for the factory tests of the printer, but it is very unlikely that it will be from the same batch. Furthermore, his paper processing conditions will almost certainly differ in some respects from those used by the printer manufacturer.

Before commencing the series of tests that have to be made before the printer is adjusted to give optimum performance, a set of standard or reference negatives must be available. The number of reference negatives supplied by printer manufacturers varies—partly because the greater the number of negative sizes a printer is capable of handling the more reference negatives are required. But the minimum requirement is three negatives, all of which must have been properly processed. One of the negatives should have been correctly exposed while one each of the others should be under and over-exposed by two stops. The correctly exposed negative then becomes the standard while the three together form a slope-set. Some manufacturers of printers supply a slope-set with seven test negatives, representing three stops under and three stops over exposure.

177

Built-in and Plug-in Timers

Besides reference negatives it is necessary to have a plug-in electronic timer that can be connected to the printer if a timer is not incorporated. Most printer manufacturers recommend the frequent use of an accurate timer in the setting up and control of printer performance and some colour printers have built in triple timers.

Eastman Kodak have produced two types of triple-channel timers: the 5S, a dial type intended originally for service with the 5S, 8S and 11S range of printers, and the model 1K electronic digital timer required for accurate timing of Kodak's 2620 printer, the extremely short exposures of which must be timed to the 1/1000 second.

Agfa's early printers were set up with a plug-in timer, but their N2B Automatic printer includes a built in triple exposure timer so that the precise exposures of each channel can be read simultaneously.

A timing clock and adaptor pack are available for use with all Pakotronic printers. The clock times exposures with an accuracy of 1/100 second, and with the adaptor, can be used to check print exposures or total times.

The Kodak (UK) S1 and S4 printers depend upon a timer for all setting up and control purposes, but with the S4P came a change of policy in that correction button adjustment was made reproducible and the results of a ring-around could be transferred directly from button values to click-stop potentiometer settings. However, a single channel timer is built-in to the S4P printer and is used to set slope-centre values.

Special Purpose Printers

Besides the standard type of projection printer designed to produce single prints in a variety of sizes, there are a number of other forms of multiple image or package prints that can be made, either by using a special purpose printer or by adaptations of existing equipment.

Message Printing

Probably the first photofinisher produced photographic greeting cards were made in the US, where they have now become big business—particularly before Christmas each year. The usual style of card is a combination picture and message; the picture printed by projection in the normal way and the message printed by contact at a printing position adjacent to the picture exposure aperture.

Several standard types of black and white and colour printers can be adapted

178

to print messages from suitably prepared same-size negatives, which can often be purchased carrying stock sentiments, from suppliers such as Eastman Kodak.

Not all printers are designed to allow the addition of a message printing unit, but most Kodak (US), Pako and Mullersohn printers can be adapted for the purpose.

Agfa produce a greeting card printing accessory for use on most of their printers—both Colormators and Variograds. But in their case, the picture negative and negative bearing the message are located alongside each other in a slide mounted at the negative plane and the two images are projected in succession on to the paper, which is moved automatically between the two exposures.

Package Printing

A package print is a print which bears more than one image of the same subject —usually, but not necessarily, in more than one image size. Package printing seems to have begun in the US, and probably the idea was first used as an aid in marketing pictures of children taken in school.

There are several ways in which a "package" of prints can be produced, but one of the first was used for black and white printing by *Bremson* of Kansas City.

BREMSON PRINTER The Bremson printers incorporate a motorized lens turret carrying three sets of lenses, chosen according to the combination of images required on each print unit. That is to say, a three unit package might comprise a single full-size image on paper $3\frac{1}{2}$ in. wide, a second unit divided into four quarter size images and a third unit bearing nine "postage stamp" images. This package would thus contain fourteen pictures—made in three exposures—on a length of paper equivalent to three normal prints. There are 120 possible packages available and the choice and sequence of image combinations can be selected by a switch which simply determines where and for how many exposures the lens turret will stop during one revolution.

PAVELLE HS78P The Pavelle HS78P also uses a rotating lens turret to produce package prints. With this printer a programme can be set up to make either one or two exposures using one or more of six lenses that can be mounted either singly or in clusters. As with the Bremson printer, the turret has to make a full revolution for each package and the total cycle time is usually between six and ten seconds for a three unit package.

KODAK AUTOMATIC PACKAGE PRINTER When Eastman Kodak introduced their package printer, they used a different approach to the task, and designed

179

interchangeable optical multiplier units to accommodate any of four negative sizes—35 mm. unperforated, 35 mm. perforated, 46 mm. and half-frame 70 mm. The multipliers do, as their name suggests, form multiple images through a system of beam splitters—the precise layout of each one depending upon the disposition of images required. As with the Bremson printer, the choice is between one, four and nine images per unit, but the choice of multipliers enables prints to be made either across or along the length of the five inch paper. Unlike the Bremson and Pavelle printers, Kodak's package printer exposes all three units at the same time.

NORD PACKAGE PRINTER The package printers made by Nord in the US, employ yet another method of producing a variety of image sizes on the same length of paper. In a Nord printer each lens set is inserted and withdrawn from

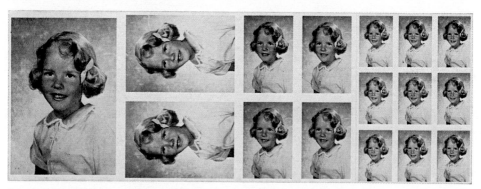

Fig. 87 Nord printers incorporate a rotating optical system to allow wallet size ($2\frac{1}{2}'' \times 3\frac{1}{2}''$) prints to be included in the same package as all the other regular sizes, without repositioning the negative

its operative position by an air-cushioned solenoid-operated lens panel. This means that each print unit is exposed separately, but instead of using a rotating turret to change lenses, one lens panel is automatically slid into operating position while another panel is withdrawn to an off-centre storage position together with other alternative lens combinations.

The Nord printer can be programmed to make any combination of various sized prints to form a complete package. Any standard package can be chosen by merely pulling out one multi-way plug and inserting another. A spot reader is included in the Nord printer to enable any selected area of the picture to be used to determine exposure. Furthermore, the printer operator can vary the size of the measuring spot to cover a tiny area of a chin, cheek or forehead, or an area as large as the entire face.

In Europe, Agfa-Gevaert distribute the Nord printer under the name Programator, and Mullersohn have produced the Tetra-Skopar four lens cluster for use in their printers.

180

Other Applications of Package Printers

Package printers are not used exclusively for school pictures, and the idea has been adopted in the photofinishing of amateurs' films. The Film Corporation of America for example have built their direct-mail photofinishing operation on a "triple-print" offer; triple-print simply meaning a unit of 6 × 4 in. paper on which with a single exposure, one 4 × 4 in. and two 2 × 2 in. prints are produced. By these means, an amateur photographer who has exposed a 12 exposure cartridge of 126 film obtains three prints from each negative for a lower price than he could through normal photofinishing channels.

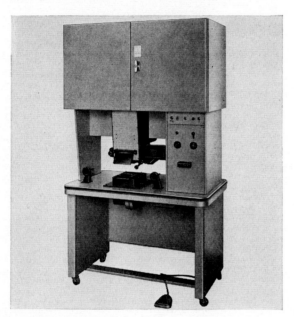

Fig. 88 The Nord 8 × 10 Automatic Programming Printer incorporates optical facilities for locating a comparison light spot on any area of the negative image in order to accurately determine print exposure

In a patent[26] granted to the Film Corporation of America, their purpose is explained:

The market at which the present invention is especially directed is that of the commercial developer who receives the roll of exposed film from the amateur photographer, either by mail or from the film store, and who returns the roll of negatives as well as prints of the individual frames after the processing has been completed. The market of the present invention is addressed to an especially competitive field which must be highly automated and produce great efficiency of operation with minimum rejections.

It is therefore an object of this invention to provide a photographic projection printing apparatus which will simultaneously produce from each single frame of an exposed roll a plurality of prints of various sizes without advancing the print paper.

181

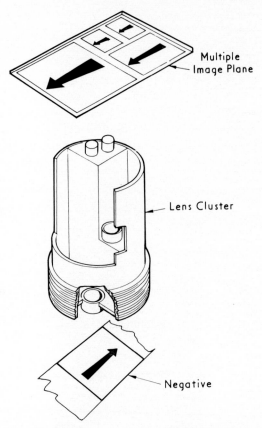

Fig. 89 By using a 'cluster' of lenses of different focal lengths it is possible, with a single exposure, to produce a variety of combinations of images at the printing plane

A somewhat similar type of package print offer was introduced to the photo-finisher by *Bremson*, whose Bonus Print System[27] provides, at one exposure, one normal size print, one small print and by a second, contact, exposure at the message printing station of the printer, adds one "trade-mark" print indicating the name of the finisher or dealer. This form of marketing is intended to boost individual dealer/finisher business.

INTEGRATION REQUIREMENTS When prints are made from portrait negatives or from other long runs of negatives that have been exposed under uniform conditions on the same length of film, nearly all the variables that usually make colour integration necessary are absent. As a result, it is sufficient for one or two sample negatives along the roll to be test printed to find an optimum colour balance. Thereafter, the whole run of negatives can be printed with the chosen filter pack. Package printers intended for this class of work do not need to

182

include colour integration facilities. Furthermore, it is usual to control the overall white-light exposure by selecting and assessing a representative area of each portrait so as to reproduce faces at about the same density.

Whenever any form of package printing is used in conjunction with amateurs' negatives, colour and density integration again become essential.

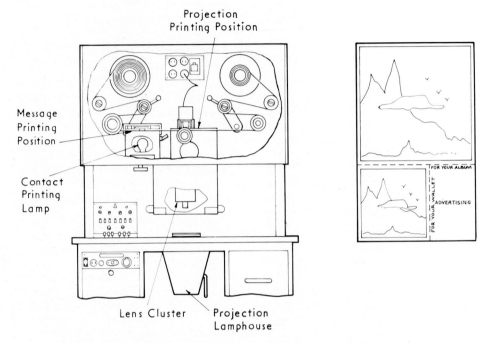

Fig. 90 By combining a 'message' printed by contact, with a 'package' of two or more prints from a negative, a 'bonus' print can be offered a customer together with some advertising for the finisher or dealer

Making Transparencies

Most photo-finishers already have a demand for transparencies to be made from colour negatives, and as the use of colour negative film increases, it seems probable that this demand will persist or even increase.

The material most used for direct printing from colour negatives is Ekta-color Slide Film. This film is supplied in 100-ft. rolls suitable for such printers as the Homrich, the Pakopy, or the Kodak Film Magazine Model 35P. The film can of course also be printed by contact from the original negatives, although this is difficult when the negatives have been cut into short lengths or individual frames.

The advantage of printing Slide Film on a modified colour printer is that the

183

colour negative is integrated, both for colour and density, in the same way as if a paper print were being exposed.

In the absence of colour integrating facilities, corrections can be made by means of subtractive colour filters, added to or subtracted from whatever basic pack is found necessary to produce a balanced transparency from a properly exposed and correctly processed colour negative.

FILM ORIENTATION It is important to remember that colour slides made from colour negatives are often intermixed with original colour reversal transparencies when they come to be projected. The printed slides should therefore have the same emulsion orientation as the camera exposed transparencies if loss of projection focus is to be avoided. This requirement means that when a colour negative is to be printed by projection on to Slide Film, the base side of the negative must face the emulsion side of the Slide Film. When contact printing, a small, distant printing light source is desirable in order to maintain definition in these circumstances.

PROCESSING Ektacolor Slide Film is processed in C22 chemistry, but the time of development should be extended by four minutes beyond the time required for Kodacolor films. Otherwise, processing conditions are the same for both types of film.

Enlarged Colour Prints

As in black and white work, a finisher has to fulfil a demand for colour prints that are larger than the standard en-prints or jumbo prints usually made at the first time of printing an order. Several enlarger-printers are now available for use with colour paper up to 11 inches wide.

KODAK 8S AND 11S PRINTERS Typical of these enlarger-printers are Eastman Kodak's Model 8S and Model 11S, both of which are merely larger versions of the well established 5S machine. Besides being used for the production of 11 × 11 in. and 11 × 14 in. enlargements from negative ranging in size from 126 size to 4 × 5 in., the 11S can also be used for making 8 × 10 in. enlargements printed across 10 in. wide paper, thereby permitting a 20 per cent increase in paper processing production. Additional paper masks can be used for printing on to 10 in. or 8 in. papers.

PAKOTRAN 8/11 Pako's equivalent to the 11S is the Pakotran model 8/11, on which paper widths of 5, 8, 10 or 11 inches can be accommodated for printing from negatives ranging from 126 size to 4 × 5 in.

Colour enlargement and integration on the Pakotran is normally carried out in much the same way as for Pako's Mach I printer, but a facility for printing with white light (not intergrated for colour) is available by using a selection switch. This is often useful because it allows printing of a continuous run of

184

negatives of uniform lighting and processing history, to be balanced initially with filter packs and for production thereafter to be unaffected by any colour subject failures. Portraits of school children, or wedding pictures often print more successfully and economically without the use of colour integration.

AGFA AND PAVELLE MODELS In Europe, Agfa make the N4B printer for the semi-automatic production of colour prints up to 7 × 5 in. on 5 in. wide paper, while Gretag's printers accept roll paper up to 8 in. wide.

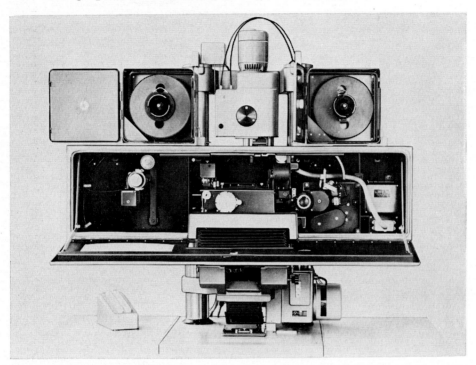

Fig. 91 The Colormator N4B printer is intended for the semi-automatic production of colour prints on any of four paper widths up to 5 inches, and from any negative size between 18 × 24mm and 6 × 9cm. Magnification can be adjusted continuously between 1:1 and 6:1, using a single lens

Pavelle's HS78 subtractive printer accepts 8 in. wide paper and is therefore suitable for making 10 × 8 in. or 8 × 8 in. prints from amateur negatives. Their Miniprinter Type M4/8 is also used by many finishers as a low cost but versatile enlarging printer. The Miniprinter, which employs sequential additive exposures, can be made more useful by means of an optional plug-in repeat printing unit for making unattended print runs from one negative. Whenever unintegrated, fixed filtration is required for printing negatives taken in identical lighting conditions, the integrating photo-cell of the Miniprinter is replaced by a resistor; the filter wheel remains stationary during the exposure of each print.

185

Enlarger-printers of the type described above are being used by most finishers to deal with the majority of their enlarging orders, but there usually remains a proportion of special work that must still be done on an orthodox type of enlarger. As with black and white enlarging, this work tends to be an expensive activity, requiring above average skill and therefore always inviting simplification and improvement.

In the earlier days of colour printing with enlargers it was usual to adjust the colour of the exposing source by means of various combinations of low density subtractive filters, known as filter packs. Although this rather laborious procedure is still used to some extent, it is preferable to use a colour head or lamp house that provides some form of built-in continuous adjustment of the colour of the light reaching the negative that is to be printed.

AGFA COLOUR HEAD One of the first colour heads to be designed was made by Agfa to fit on to their Varioscop enlarger, although it was soon adopted for use on many other types of equipment. The colour of the illumination provided by the Agfa Colour Head is adjusted manually by means of three rotating knobs which in turn operate cams to move cyan, magenta and yellow filters more or less completely across the beam of light from the projection lamp. The effective density of each of the three filters depends upon the extent to which it interrupts the light beam. Heavy diffusion is used to mix the light adequately before it reaches the negative.

PAVELLE (COLORTRON) 400 ENLARGER This white light enlarger handles negatives up to 4 × 5 in. and uses diffused light from two 200 watt projector lamps. The light from the two sources is mixed in a diffusion box to give even illumination over the whole negative area while continuously variable non-fade dichroic filters are inserted in the light path to modify the colour of the exposing light.

A control unit forms part of the Pavelle 400 enlarger and is used in conjunction with an exposure probe on the base board. Pavelle claim that the effective light level of the 400 model is 8 to 10 times greater than it is with conventional diffusion type enlargers.

SIMMON CHROMEGA. Another firm that has spent a great deal of effort on the development of a satisfactory colour head is Simmon Omega Inc., who first of all worked on sequential additive methods but soon switched to the design of white light printers. The earliest Chromega colour enlarger fed light from opposing housings into a centrally disposed integrating sphere. The light from the two housings passed through adjustable colour filters and was thoroughly mixed within the sphere. This arrangement provided a high level of perfectly uniform

186

and highly diffuse illumination that was particularly effective in minimising dust and scratch marks on any negative.

In 1969, Simmons announced an important improvement in the design of their colour enlarger in the form of interchangeable light-integrating spheres to serve more efficiently the requirements of different negative sizes. Perhaps this design feature owed something to the similar practice of using interchangeable light-integrating boxes on some types of photofinishing printers.

The Super Chromega enlarger uses two 150 watt tungsten-halogen lamps, the light from which is directed by elliptical reflectors into an integrating sphere. Three geared, graded subtractive colour filter discs are actuated by control knobs to provide an effective density correction range from 0–180. Three interchangeable integrating spheres are available for 35 mm., $2\frac{1}{4}$ in. square and 4×5 in. negatives. When using the appropriate sphere for printing 35 mm. negatives the Super Chromega is about nine times faster than the earlier Chromega enlargers.

Exposure Assessment

The assessment of exposure requirements for colour negatives is particularly difficult in the context of photofinisher enlarging. Straightforward colour integrating procedures are unlikely to succeed, because of the widely varying processing and storage histories of the negatives involved; while the standard of quality expected of the larger, more expensive print is usually higher than that expected of en-prints.

Many analyzers and computers have been designed for either integrated or spot reading and are intended to provide control or guidance in determining optimum exposure conditions for any negative, but the successful interpretation and application of any of these methods still largely depends upon the skill of the operator.

VIDEO ANALYZERS In custom photofinishing, as opposed to photofinishing for amateurs, there is growing evidence that video-analyzers are being used to determine visually the exposure conditions required by colour negatives *before* they are printed. Currently the cost of this type of equipment prohibits its use for printing from amateur negatives, but in the future it does seem likely that such analyzers will become cheaper and much more widely used.

COLOUR PRINTERS—PRINCIPLES OF OPERATION

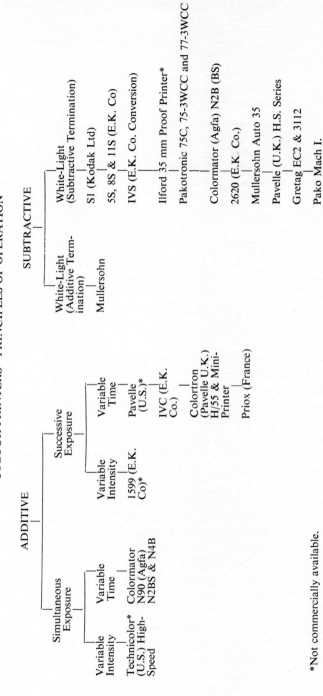

ADDITIVE

- Simultaneous Exposure
 - Variable Intensity — Technicolor* (U.S.) High-Speed
 - Variable Time — Colormator N90 (Agfa) N2BS & N4B
- Successive Exposure
 - Variable Intensity — 1599 (E.K. Co)*
 - Variable Time — Pavelle (U.S.)*; IVC (E.K. Co.); Colortron (Pavelle U.K.) H/55 & Mini-Printer; Priox (France)

SUBTRACTIVE

- White-Light (Additive Termination) — Mullersohn
- White-Light (Subtractive Termination) — S1 (Kodak Ltd); 5S, 8S & 11S (E.K. Co); IVS (E.K. Co. Conversion); Ilford 35 mm Proof Printer*; Pakotronic 75C, 75-3WCC and 77-3WCC; Colormator (Agfa) N2B (BS); 2620 (E.K. Co.); Mullersohn Auto 35; Pavelle (U.K.) H.S. Series; Gretag EC2 & 3112; Pako Mach I.

*Not commercially available.

REFERENCES

1 HUNT, R. W. G. "Printing Colour Negatives". *J. Phot. Sci.* Vol. 11 1963 pp. 109–120.
2 PITT, F. H. G. AND SELWYN, E. W. H. "Colour of Outdoor Photographic Subjects". *Phot. J.*, March, 1938. Vol. **78**, pp. 115–21.
3 USP 2,571,697.
4 USP 2,521,954.
5 HUNT, R. W. G. *The Reproduction of Colour.* Fountain Press, 2nd Edition, 1967.
6 BP 805,891.
7 GUNDLEFINGER, A. M., TAYLOR, E. A. AND YANCY, R. W. "A High-Speed Color Printer". *Phot. Sci. & Engineering* Vol. **4**, 1960, pp. 141–150
8 BP ǀ908,340; and 945,953; and 6946, 595–600
9 USP 3,062,096.
10 BP 662,789.
11 BARTLESON, C. J. AND HUBOI, R. W. "Exposure Determination Methods for Colour Printing: The Concept of Optimum Correction Level". *J.S.M.P.T.E.* Vol. **65**, pp. 205, 1956.
12 BP 956,462.
13 BP 945,593.
14 BP 879,729.
15 HUNT, R. W. G. "Slope Control in Colour Printing". *J. Phot. Sci.* Vol. **8**, pp. 212–219, 1960.
16 PIERONEK, V. R., SYVERUD, W. R. AND VOGLESONG, W. F. "Printing the Colour Negative" *J.P.S.A.* Vol. **3**, November, 1956, pp. 145–156.
17 BP 945,593.
18 Application No. 3857/61.
19 BP 945,593.
20 BP 945,596.
21 BP 952,889 and 952,890.
22 BP 965,799.
23 BP 949,773 and 949,774.
24 BP 988,092.
25 NEALE, D. M., COOTE, J. H. AND LARGE A. A. "Electronics and Economics in the Handling of 35 mm Ilfocolor Negative Film". *J. Phot. Sci.* Vol. 11, 1963.
26 BP 1,108,716.
27 BP 1,186,250.

VII. COLOUR PRINT PROCESSING

Just as colour negative processing requires greater care and the observance of narrower tolerances than are necessary for processing black and white films, so colour paper processing is more demanding than black and white paper processing.

As with colour negative films, colour print papers are not usually compatible in processing—one with another. This is primarily because of the different colour couplers that are used by various manufacturers but also because of the different processing treatments preferred by them. For example, some types of paper require separate bleaching and fixing stages while others are treated in a combined bleach/fix bath.

Early Cut-Sheet Processing

When independent photofinishers first began to make prints from amateurs' colour negatives, they worked either with cut sheet paper or with relatively short lengths of roll paper wound spiral fashion, in processing reels. In fact, in Germany, Agfa used to sell colour paper in two contrast grades, and finishers processed their cut-sheet prints in racks in much the same way as they developed cut-sheet films.

Some automatic processors are made to take cut-sheet colour paper in a variety of sizes. Agfa's Labormat K24 for example takes individual prints up to $11\frac{3}{4} \times 9\frac{1}{2}$ in. and all intermediate sizes. This machine automatically releases the prints from their clips on the completion of the wet processing cycle.

For a while, some finishers—particularly in Europe—used rotating drum type print processors. Typical of these is the Autopan (originally Holmüller) machine on which a wide variety of print sizes can be treated in a programmed sequence of temperature controlled solutions.

But in due course finishers realised that if the price of colour prints was to be reduced to a level that would induce growth of the market, paper processing would have to be made more efficient, and for this to happen continuous roll processing would be essential.

Shortened Processing Times

One of the difficulties that faced finishers in the early days of negative/positive colour work was the long processing times required by all colour papers of that period. Times of almost an hour in the wet section of a processor meant that

the output of processed prints was very low in relation to the investment in machine and space, and furthermore, the production cycle was lengthened so that service times became extended. This problem soon attracted the attention of colour paper manufacturers who, during the past decade, have steadily reduced the times for processing their papers to hardly more than a quarter of the original requirement.

At first the improvements resulted from more efficient and therefore faster processing at higher temperatures. Over the years developer temperatures were increased from 68° to 85°F. But another improvement was made when resin coated (RC) non-absorbent paper base came to be used for colour prints. These resin coated or polythene laminated base papers allow much shorter washing times because the fibres of the paper itself do not absorb treatment chemicals and washing is therefore much easier.

Another feature of resin coated papers that is important to finishers is that they dry with an acceptably glossy surface without having to be glazed or calendered.

Because colour papers, like most other kinds of paper materials are coated with at least three superimposed emulsion layers, the colour balance of a print depends critically upon the relative rate and extent of development as between the three layers. Colour development—the first stage of colour paper processing—is therefore the most important step in the processing cycle and all the variables that have been considered in relation to colour negative processing apply in principle to the processing of colour paper.

Process Control

There is one way in which colour paper processing is different from colour negative processing. Whereas a finisher can reprint any roll of paper that may have been incorrectly processed, he can do nothing about badly processed negatives. But if a finisher falls into the habit of changing his printing conditions in order to offset some out of control condition in paper processing, then he is likely to find that he gets into further difficulties. Unfortunately, some finishers do unwittingly fall into this trap and make changes in printing conditions to rectify problems that are caused by drifts in paper processing performance. It is therefore most important to maintain separate control of paper processing by using control strips that have been exposed on a sensitometer and not on a printer. By these means it is possible to separate the influence of printing from that of processing and ensure that changes are not made for the wrong reasons. These points are considered in greater detail in Chapter XI.

Despite the reduction in processing times that has been explained, it remains a fact that for a given output, continuous colour paper processors tend to be larger than machines for processing black and white paper, but in other respects

the same type of machine serves for both purposes. As we have seen in black and white paper processing, many finishers prefer machines using endless leader belts of the kind that Pako first introduced in their Pakoline and Pakopak processors. Similar machines are now made by Agfa and Hostert in Germany, San Marco in Italy, and Pavelle and Kodak in Britain.

The available endless belt machines now cover a very wide range of capacities from the small Pavelle 810 processor with an output of only two feet a minute to the largest Hostert ECP48 machine running four strands of $3\frac{1}{2}$ in. paper at a combined output of some 40 ft. a minute.

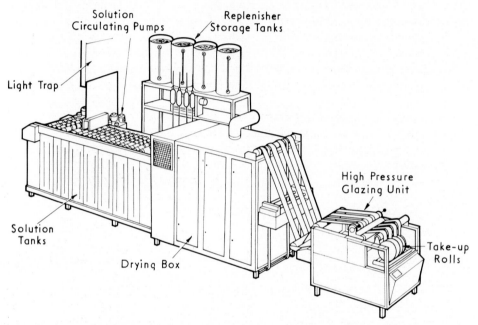

Fig. 92 The Hostert four strand colour paper processor pre-dries the processed paper in a drying cabinet before it reaches the high-pressure glazing unit

Pako offer a range of Pakopak machines with capacities varying between 30 in. a minute using two strands and 144 ins. a minute running four strands, when processing Ektacolor C paper at 85°F. Because of the flexibility of their design Pakopak processors are also available for handling Agfa/Gevaert paper and paper made by the 3M Company or by Fuji.

Until Kodak Limited announced their Contimat machine in 1968, all Kodak paper processors had depended on the use of expendable or one-time paper leader for threading, but the Contimat (now called Ektaprint Processor) uses an endless leader belt and was the first machine of its kind to allow exposed paper to be attached to a "stationary" threading band to facilitate loading. This facility for stopping a section of the endless band for a short time to allow

192

attachment of the leading end of an exposed roll of paper is achieved in much the same way as an elevator or reservoir of film is used at the feed-on end of a continuous film processing machine.

EKTAPRINT PROCESSOR The Ektaprint processor is designed for daylight operation, and as with Agfa's machines, this is made possible by the use of light-tight cassettes. The machine accepts any paper widths up to 12 in. and the total output when running four strands of $3\frac{1}{2}$ in. Ektacolor paper is 20 feet a minute—or 4000 en-prints an hour.

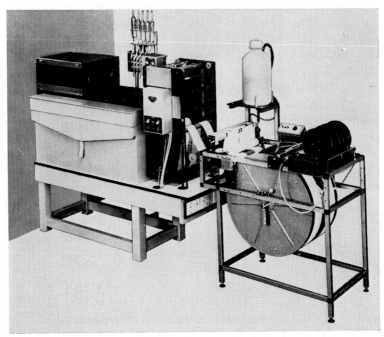

Fig. 93 With an output of two or three feet a minute, the Pavelle 810 paper processor is intended for the smaller finisher

At one time Agfa used plastic transport chains to lead paper strands through their processing machines, but the Labormator range now depend upon endless flexible nylon belts to which clips are attached in the usual way. The Labormator N4200T is a four strand processor designed for processing Agfacolor paper in full daylight. This facility of working in daylight is consistent with Agfa's policy of offering cassette loading for all their printers and processing machines. The N4200 is also available for darkroom operation for those finishers who do not wish to have or cannot utilise the daylight operating facility.

193

The N4100 machines will take four strands of $3\frac{1}{2}$ in. wide paper on two endless leader belts and has a combined output of about 10 ft. a minute, handling Agfacolor paper with a processing and drying cycle time of 22 minutes.

In the case of the daylight machine, a roll of exposed colour paper in its casette, is transferred directly from an Agfa Colormator printer to the processor and attached to the leader belt in daylight. Thereafter the automatic processing cycle takes place in daylight. Pilot lights indicate the tracks on which

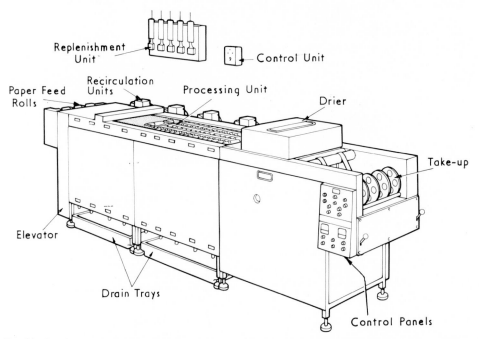

Fig. 94 Besides being the first Kodak machine to depend upon endless leader belts instead of expendable paper leaders, the British made paper processor incorporates means for attaching paper arms while the machine continues to run at 5 feet per minute

paper is running. Between two and three feet of excess paper is required at the leading end of each printed roll in order to thread the paper into the machine.

Ilford Paper Processing Machines

Although they were never made available to other photo-finishers, in 1960 Ilford Limited designed and constructed paper processing machines of a novel type.

Whenever photographic material is to be processed in roll form for a relatively long treatment time and at high speed, long lengths of the material travel through

194

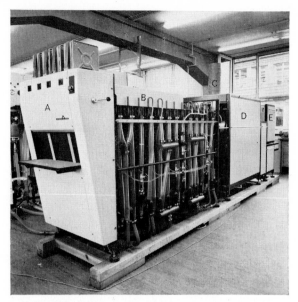

Fig. 95 The Labormator N4200T is a four strand Agfacolor paper processing machine for operation in full daylight. Paper drive is by means of endless leader belts and the machine incorporates a pre-drier and a high-pressure glazer

Fig. 96 Cassettes holding rolls of exposed paper are attached to the feed-on end of the Labormator N4200T, and after the leading end of the paper has been attached to a clip, and the clip attached to the leader belt, the paper is automatically fed onto the machine

195

the machines at any one time. Consequently, undesirable tension can easily build up and cause the strand to break. In order to limit the tension on the paper strands at any point in the machine, Ilford used the rocking-roller or Humphries driving principle described in connection with continuous film processing machines. The Ilford machines can handle two separate strands of paper up to a width of seven inches each; but because it was not possible to transport the paper through a helical path, each of the two strands follows a sinusoidal track straight down the length of the machine.

Not every loop of paper in the Ilford machine passes over a rocking roller; instead, each tank is large enough to take a rack of four loops of paper, and

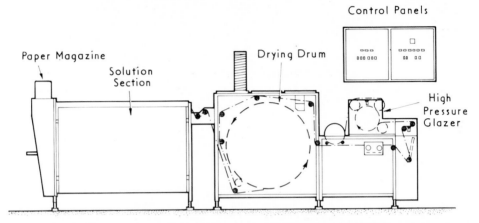

Fig. 97 Agfa's N4200T Labormator colour paper processor can be operated in full light, and paper from Colormator printers is transferred directly to the machine in light-tight magazines

only where the paper leaves one rack to enter the next does the web pass over a spring loaded rocking roller. The principle of the drive is the same as on the Humphries or Photomec film machines. Whenever the tension in a loop of paper increases, the rocking roller is pulled down into contact with a continuously rotating rubber covered roller so that the paper roller is then driven fast enough to create slackness in the succeeding loops of film. The flanges of the spring loaded roller then lift away from the rubber covered drive roller and stop the progress of the paper until tension builds up again in that section. These machines were used by Ilford to process both paper based and pigmented acetate base print materials at output speeds of 40 feet per minute.

Eastman Kodak Paper Processors

The paper processing machines made by Eastman Kodak have all depended upon the use of paper leader and their capacity ranges from a single module

unit (Model 4C3) having a combined output of $4\frac{1}{2}$ ft. a minute with three strands of $3\frac{1}{2}$ in. material to a three module machine (Model 4CT-K) with a combined output of 25 ft. a minute on three strands with a solution temperature of 85°F.

The relatively high speed Model 4CT-K has been equipped with a tendency drive system to provide more uniform transport and to improve tracking. The so-called tendency drive results from rotating all top shafts throughout the machine—as compared with driving one shaft in each section as had been done

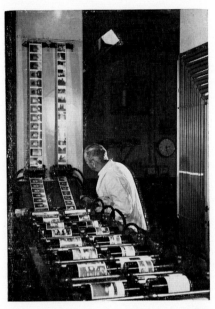

Fig. 98 When they were first used (1960), the paper processing machines designed by Ilford Limited for their own use, were larger and faster running than any commercially available machine. They incorporated tension control features that were borrowed from motion picture laboratory practice

before. The paper rollers are not pinned to the rotating shafts, but are urged to rotate by reason of their frictional contact with the shafts. A pacer roller determines the precise rate at which the exposed paper is fed into the machine, and machines intended for driving RC (resin coated paper) need little or no over-drive to account for expansion of the paper web during processing.

Another feature of the Eastman Kodak processors is that the developer is re-circulated via a tempering unit (Model 40A) and back into the machine tank. This makes the provision of adequate solution movement a great deal easier.

VARIABLE FACTORS IN PAPER PROCESSING Paper processing can be conveniently divided into three stages—the all important developing step, treatment in the secondary solutions and drying or glazing.

197

Fig. 99 The tension on the paper strands in each processing tank of the Ilford machine is controlled by a rocking-roller drive that senses the demand from the following tank

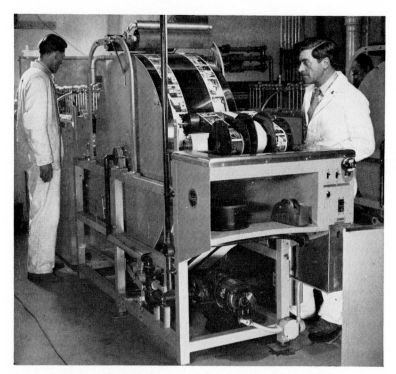

Fig.100 A three-strand Kodak designed colour paper processing machine running two print strands and one leader. The prints are being dried without glazing

198

A valuable practical article on colour paper processing has been written by *Bulloch*[1] of the Philip A. Hunt Chemical Corporation.

Naturally, the development stage of the process normally receives the greatest amount of attention, and in large labs the developer chemistry is analysed at least once a day. But as we have seen in earlier chapters it is not enough for photo-finishers to know that the chemical composition of a solution is correct, it is equally important to know about the physical conditions under which the solution is being used. Times of treatment and temperature of the developer are quite easy to ascertain, but they should be measured on the machine itself. So often it is assumed that because no deliberate change has been made, the time of development will not have changed, but a bottom roller can sometimes creep up without being noticed and the paper is then processed for a shorter time than is required.

TEMPERATURE CONTROL The temperature tolerances usually allowed for colour paper processing are the same as for colour negative processing, i.e. $85°F \pm \frac{1}{2}°$ in the developer and $85°F \pm 2°$ in all other solutions.

SOLUTION AGITATION As with colour negative processing it was rather slowly realised that the solution movement suitable or acceptable for black and white paper processing was inadequate for colour paper processing. Many early types of colour paper processing machines certainly did not provide adequate developer movement. For example, later models of the British made Kodak Model 2 are fitted with improved developer circulation units which increase the circulation rate to six gallons a minute.

This greater solution movement gives higher contrast and brighter prints. In particular it increases the contrast of the blue sensitive, yellow dye forming layer of Ektacolor paper.

Because the degree of movement of developer past the surface of the colour paper is so important, some kind of regular check is necessary to ensure that solution is being re-circulated at the required rate. It is not always sufficient to ensure that the re-circulating pump motor is running, because this alone does not indicate whether the impeller is broken or the filter clogged. The only really satisfactory arrangement is to have a flowmeter in the output line from the pump to the developing tank from the processing machine; then a valve can be used to adjust the flow to the required rate.

To provide the vigorous circulation needed for efficient agitation and filtration of developer and all the other solutions in the sequence, Pako fit their Pakopak machines with vertically mounted sealless sump pumps with a capacity of eight gallons a minute through a filter.

Hostert machines also use sump pumps housed in small auxiliary tanks attached to the sides of the appropriate machine tanks. Agfa, however, with their Labormator machines, used re-circulation assemblies located remotely and

connected by feed and return pipes to the machine tanks. Each of the four sump pumps used on the Labormator gives a flow of $4\frac{1}{2}$ gallons a minute.

Solution Replenishment

All manufacturers of colour papers publish precise information on the rates of solution replenishment that should be used when processing their material. Sometimes, the required rates of replenishment are given in terms of cubic centimetres per square metre, but this is not as convenient as knowing the rates in terms of volume per unit length of paper processed—assuming a uniform width of paper.

Some paper processors incorporate detectors to determine when a strand or strands of paper enter the processing machine so that the replenishment system can be started automatically. This is easily done on any machine using endless leader belts because the beginning and end of each paper strand can be sensed by a microswitch. But when paper leader is used in the same line of track as exposed print material—as in most Kodak machines—the responsibility for starting and stopping replenishment is placed on the operator. This is evidenced by Kodak's instructions:

> Turn on the developer replenisher when paper reaches the developer solution. Do not turn on the replenisher before this time or over replenishment will result. Similarly, do not turn on any of the other replenishers until the paper actually reaches and enters the working solution.
>
> The same procedure should be followed when the last strand of paper is going through the processor. As the paper leaves the developer tank turn off the developer replenisher. Similarly turn off the other replenishers as the paper leaves the respective washing solution.

There are many different ways of arranging for the insertion of replenishing solutions into a working bath. Perhaps the simplest is that adopted by Kodak; each replenisher supply tank is connected to its corresponding machine tank via flowrator and a flow of solution is obtained by mounting the replenisher storage tanks at least seven feet above the base of the processing machine. With this type of direct flow, manual control system of replenishment, it is very important for the machine operator to fully close the valve controlling the flow of replenisher because it is comparatively easy to fail to notice that a small but continual flow of replenisher is entering the developer tank when the machine is shut down.

This system is not completely straightforward in operation because a slight adjustment of the metering valves is required during processing as the liquid level changes in the replenisher supply tanks. Initial calibration of the flowmeters is simply done by allowing each solution in turn to run into a measuring cylinder for some predetermined time. After the valve has been adjusted to give the required flow rate in cubic centimetres a minute, either an indicating slide or

a piece of adhesive tape is used to mark the position of the float in its tube. This calibration can be done to suit the requirements of one, two or three strands of paper so that the one meter tube bears three different marks.

AGFA LABORMATOR REPLENISHMENT SYSTEM Agfa's system of replenishing on their Labormator machines is discontinuous. Impulses are transmitted by a timer in the control cabinet and these are further controlled by microswitches which detect the presence of paper in any of the tracks at the feed-on end of the machine. The impulses have a constant duration of three seconds and the volume of replenisher fed to the circulation system can be varied between eight and approximately eighty cubic centimeters by adjusting the valves which govern the rate of flow from the replenisher containers to the machine tanks.

Adjustments are made empirically by feeding the output from the replenisher supply tube directly into a measuring cylinder. When available height does not allow gravity feed, the pressure needed to move replenisher from storage containers to machine tanks is obtained from a small motorised compressor supplying air at about seven pounds a square inch to enclosed solution containers. The compressed air is isolated from the surface of the replenisher solutions by means of floating lids and the possibility of air reaching the working solutions if the replenisher tank should run dry is prevented by a floating valve in the outlet from the replenisher reservoir.

Cordell Engineering in the US markets a nitrogen pressurised chemical delivery system as well as a pressurised replenishment system. The replenishment installation consists of the basic elements—the master control unit, located either on or near to the processor—and a rack to house special pressurised containers in which the replenishers are stored. The containers can be as far as 100 ft. away from the processing machine they serve, and they can be either above or below the machine level. Using half-inch bore PVC piping, the approximate unrestricted rate of flow is about 32 ounces a minute.

The advantages of a pressurised replenishment system are that no allowance has to be made for the changing level of solution in the replenisher storage tanks, and if nitrogen is used for pressurising, solutions are prevented from oxidizing during storage.

PAKO VISI-FLOW SYSTEM In their Pakopak colour paper processors, Pako recommend the use of Visi-Flow replenishment valves. These allow the visual observation of replenishment in much the same way as with flowmeters, although the Pako system is intermittent and depends upon a timer to provide impulses at regular intervals. The impulses are used to open electro-magnetic solenoid valves which in turn allow replenisher solution to flow by gravity into a glass tube on each Visi-Flow unit.

The volume of solution that enters each tube depends on the diameter of the tube and the height to which the solution is allowed to rise in the tube. This

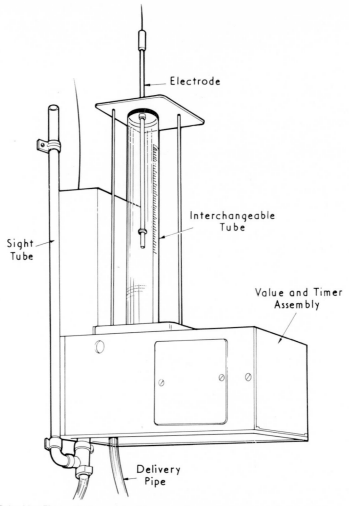

Electrode

Interchangeable
Tube

Sight
Tube

Value and Timer
Assembly

Delivery
Pipe

Fig. 101 The Pako Visi-Flow solution replenishment valve operates at regular timed intervals, but the volume of replenisher dispensed depends upon the diameter of the metering cylinder and the adjustment of the sensing electrode within it

variable is adjusted by means of changes in the position of the upper one of a pair of electrodes located in the tube. As soon as the liquid level rises sufficiently to short a low voltage across two electrodes, the resulting impulse is used to close the solenoid and prevent any further flow of replenisher into the tube, while at the same time the drain valve opens to allow the solution in the tube to drain into the machine tank.

The next filling and discharging cycle is controlled by a timing clock and a set of rotating cams. The cams in the timer are set so that the cam actuated

202

switches remain closed long enough for the Visi-Flow units to fill and then completely drain. When the cam operated switch re-opens, the relay and drain solenoid de-energise to close the drain valve. The system is then ready for the next cycle—provided there is still paper entering the processor to keep the replenisher microswitch closed.

There are cams for each of the paper tracks on a Pakopak processor so when more than one strand of paper is running through the machine at the same time, the Visi-Flow unit carries out a replenishment cycle whenever the cam actuated switch related to any paper track is closed—provided that paper is holding the feed-on microswitch closed. The cams are staggered so that only one cam-operated switch is closed at a time and each replenishment cycle must be completed before the next switch is closed, in order to give the Visi-Flow tube sufficient time to drain.

CONDITION OF REPLENISHMENT SOLUTIONS Quite apart from ensuring that the correct amount of replenisher is fed into the working solutions to offset changes due to processing exposed paper, there are one or two other factors to be considered if replenishment is to work entirely satisfactorily.

As we have seen, most paper manufacturers base their replenishment recommendations on a given speed in inches, feet or metres a minute for a paper of a certain type, weight and width. Whenever any change is made to one or more of these factors the replenishment rate may have to be re-adjusted.

The temperature of replenisher solutions should be kept at about 70°F in their storage tanks. When four strands of paper are being processed on a fast running machine, as much as a litre of developer replenisher can be added to the working solution every minute, and if the replenisher has been allowed to get much colder than the working bath, then obviously the temperature of the working developer may fall despite the continuous introduction of heat through the thermostatic control system.

Floating lids should be used on all replenisher solutions to reduce evaporation and consequent change in concentration.

Washing Methods

One of the most important steps in paper processing is the wash which follows the stop-fix treatment. This is because any trace of developer that is carried over into the bleach causes a pinkish stain with Ektaprint C. If the rate of flow of water in the wash that follows the stop-fix bath is insufficient, it is likely that traces of developer will remain in the paper—particularly if the condition of the stop-fix is marginal. For this reason alone a careful watch must be maintained over both the temperature and flow of water at this stage.

For a machine handling three or four strands of $3\frac{1}{2}$ in. paper at a combined

output of about 10 ft. a minute, a flow of between two and three gallons a minute will be normal for each of the washing stages of a four bath process.

Flowrators can easily be fitted into the water supply lines to the machine tanks, and the little expense involved always proves worthwhile.

The last wash before drying is also important, because insufficiently washed papers are a frequent cause of poor glazing and of prints sticking to the drum. Furthermore, chemically contaminated paper does not dry properly and the dyes forming the images are more likely to fade.

The economics of washing photographic materials is of increasing importance to finishers as the cost of water rises almost everywhere in the world. Most paper processing machines make the fullest possible use of incoming water by having the flow in adjacent wash tanks arranged to run counter to the direction of travel of the paper. It is also possible to greatly improve the efficiency of washing with a modest flow of water by using compressed air to continuously disturb the water layer that is in contact with the two paper surfaces.

Of course when resin coated papers are generally adopted washing is easier, and the consumption of water much less.

Drying and Glazing

The drying of colour prints passed through a number of phases during the first decade of independent colour finishing. At first, continuously processed prints were dried without glazing and a semi-matt surface resulted. Then some finishers decided to glaze their colour work, and because the prints were thought to look better that way, all other finishers followed suit.

The methods used for glazing colour paper on large drums straight from processing are much the same as those required for the continuous glazing of black and white papers. Chromium plated stainless steel proved to be the most satisfactory drum surface with which to work and the temperature of water circulated through the drum is generally controlled at about 200°F. As with all forms of glazing, the gloss on the finished prints can only be as good as the surface on which the paper is glazed.

Then around 1965, because of the uncertainty and difficulties associated with glazing colour prints straight from the wet processing stage on to a hot drum, a change in technique was introduced. The colour paper was pre-dried after leaving the last washing stage and then re-wetted—on the surface only—immediately prior to being rolled under very high pressure on to a small polished drum maintained at quite a high temperature. This pre-dry—re-wet system improved the finished appearance of the prints, minimised any tendency to stick to the glazing drum and eliminated edge lift. Pre-drying can be done by passing the paper, emulsion out, round a regular heated drum, by passing the paper in loops between hot air impingement panels or, as with the Hostert

204

Automata machine and the Ilford machine, the strands of paper can be transported over rollers enclosed in a hot air drying cabinet in much the same way as film is dried on a continuous film processing machine.

KODAK PRESSURE FERROTYPER Apart from Keller in Switzerland, who make high pressure calendering machines for viewcard publishers, Eastman Kodak were first to offer a pressure ferrotyper to the photofinisher. The Kodak model 1M was introduced in the US in 1963 and operates in the following way. The

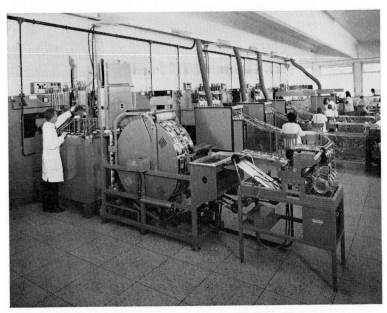

Fig. l02 A group of Kodak colour paper processing machines operating in a German laboratory. The three strands on each machine are pre-dried and linked directly to Kodak High Pressure Ferrotypers

paper, processed and dried either emulsion out on a drum or through an air impingement dryer, is fed into the ferrotyper after passing over a steam tray. The moistened emulsion surface of the print roll is passed between a rubber coated pressure roller and a hot (240°F) chromium plated drum and then over a second steam tray before being re-spooled. The extremely high pressure between the rubber roller and the drum (1500 to 2000 lb.) produces prints with a highly glazed surface from edge to edge.

Other manufacturers, including Hostert and Agfa in Germany and Wainco in England, subsequently produced versions of the high pressure ferrotyper or calender. The large, four strand ($3\frac{1}{2}$ in.) type 55 machine made by Simplex (Carl Hostert) has a production rate equivalent to almost ten thousand $3\frac{1}{2}$ in. square prints an hour.

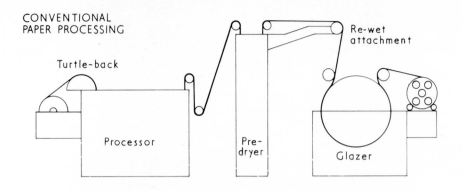

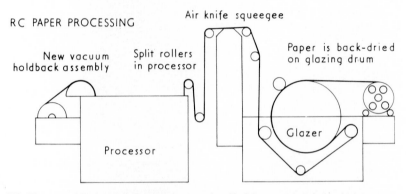

Fig. 103 These two diagrams show the changes that Kodak recommend should be made to a Kodak paper processing machine when it is to be used with Ektacolor RC paper

It is not essential to use very high pressure and high temperatures to obtain advantages from the practice of pre-drying paper prior to glazing. For low output machines a quite satisfactory procedure adopted by Eastman Kodak, Kodak Limited and by Pavelle (Colortron), among others, is to pre-dry the paper between hot air impingement panels and then glaze the prints by re-wetting their surface before running the roll on to a small but otherwise normal type of glazing drum.

Resin Coated Papers

Following a lengthy period of rumour and anticipation Eastman Kodak announced their RC (resin coated) water resistant photofinishing papers in October, 1968. About Ektacolor 20 RC material, Eastman say:

206

Kodak Ektacolor 20 paper is designed for processing in Kodak Ektaprint C chemicals. It offers the immediate advantages of rapid drying to a high gloss without the usual ferrotyping procedures. Although increases in processing speed are not now recommended, it is anticipated that the water resistant base feature will permit faster processing in the future.

Of the modifications required in processing the new paper they say:

The characteristics of the resin coated paper base make it necessary to modify all continuous paper processors by the addition of tendency drives, to splice with $1\frac{1}{2}$ in. wide Kodak film splicing tape. Print marking on the base will require either ribbon or soft disc (graphite) markers; reflective rather than conductive pick-ups will be required to operate print cutters.

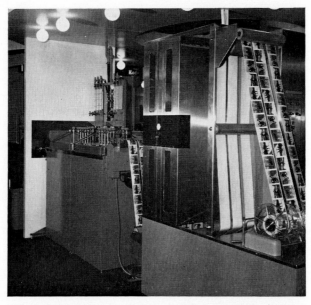

Fig. 104 When resin-coated (RC) papers are processed, there is no need for glazing, and drying is most easily done in an air impingement cabinet such as this one attached to a Kodak processor

PROBLEMS WITH RESIN COATED PAPERS Quite soon after these early observations were published, further changes and recommendations became necessary.

Because RC paper behaves more like film than paper-based material, its expansion when wetted in the processing machine is quite limited, and with top roller drive machines such as Kodak supply, tension easily builds up to cause surface damage on processed prints. In an attempt to alleviate this trouble, Kodak fitted eccentric top rollers that are roughly pear-shaped in section. This type of "lumpy" roller apparently improves tracking and limits the tension on RC paper.

In a further attempt to minimise friction and thereby reduce tension, all

207

bottom rollers of the Kodak machines were fitted with small stainless steel ball-races.

There seems little doubt that as waterproof papers become more widely adopted, photofinishers will be able to shed many of the problems that have been so long associated with print glazing operations. In fact there would seem to be no reason in future to use a drum dryer of any kind—but rather to dry paper in a drying cabinet by means of impinging air in just the same way as film is dried when it is processed continuously. Savings in consumption of current for heating alone will greatly help the economics of photofinishing—because a high pressure glazer often consumes 5 or 6 kilowatts.

Eastman Kodak have an impingement drying cabinet available, made for them by Houston, and this can be linked to any of the Eastman Kodak paper processors. If a drum drier has to be used with RC paper, great care must be taken to dry the back of the strand before it goes on to the drum, otherwise trapped moisture may result in sticking between the turns of the spooled up paper roll.

Optical Marking for Print Cutting

Although some graphite markers can be successfully used with RC papers intended for automatic cutting with photocell detectors, it is likely that in future most printers and print-cutters will be equipped to produce and read photographic marks on the emulsion side of the paper. This system has several advantages and only one disadvantage: the cutting mark must either remain visible in one of the print margins or it must be chopped out with a consequent waste of paper, which can amount to 2 per cent of total consumption.

Kodak's Model 5RD-K Roll Paper Cutter, when fitted with a dual reflection pick-up, can be used either for cutting rolls with graphite marks on the back of RC paper or optical (photographic) marks on the emulsion side.

REFERENCE

[1] BULLOCH, DAVID, K. "Troubleshooting Ektacolor Paper Processing". *Photographic Processing*, August/September, 1967.

VIII. NEGATIVE AND PRINT HANDLING SYSTEMS

The opportunities to establish efficient systems of colour printing and handling have improved as standardisation of negative sizes proceeds and the most recently proposed systems have all been concerned with 126 and 35 mm. films.

Technicolor Roll Film Printer

The system and equipment designed by Technicolor (Hollywood) in 1957 was intended for printing 620 size roll film negatives at the extremely high rate of 5000 an hour on two parallel tracks. In a paper[1] describing the system, the authors outline the shortcomings of both standard illumination and variable-time printers as well as white-light/subtractive termination printers, which of course are affected by reciprocity law failure in colour papers and suffer from production slow-down when printing over-exposed negatives.

Technicolor's printer dealt with most of these disadvantages and had the following salient features, some of which were subsequently adopted for the Bell & Howell Panel printer now used in motion picture laboratories:

1 The printer was completely automatic (requiring no operator) and had a capacity of 5000 prints an hour.
2 Lamp intensity and therefore colour temperature was maintained constant.
3 Exposure time was maintained constant, thereby eliminating reciprocity law failure and electronic devices for compensation.
4 The integrated negative transmission control was a completely null system, independent of electronic or photo-sensitive drift and dependent only on the constant emission of a voltage-regulated reference lamp.
5 Under-correction was applied photometrically, retaining the null control features.
6 Density subject failure corrections were applied photometrically, again retaining the reliability of the null system.
7 Customers' negative strips were spliced into 500 foot rolls. These rolls were then fed through separate encoding machines where operators framed the pictures for printing by punching a 1/16 in. diameter control hole in one edge of the negative and one or more of a series of 1/30 in. diameter holes in the opposite edge for density and/or colour subject failure correction.
8 The printer had two complete printing paths in order to utilise a single strip of 7 in. wide paper.
9 In each path, the negative was automatically advanced rapidly and framed accurately by means of the control hole (7 above) which actuated the photo-electric clutch/brake drive.

209

P.T.E.—O

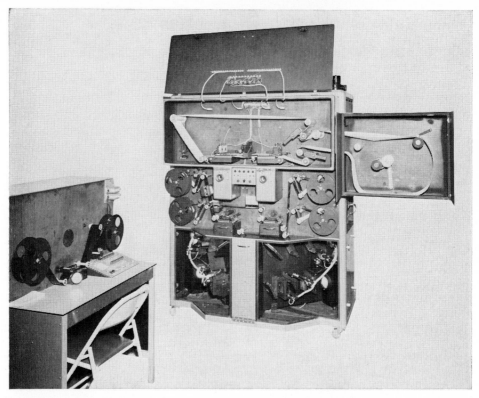

Fig. 105 The experimental high speed printer made by Technicolor in 1957 incorporated many advanced features. Two 500ft. rolls of pre-spliced and pre-coded 620 size films were printed in parallel on to seven inch paper, giving a combined output of 5,000 print exposures an hour

10 Insertion of density and colour subject failure correction was accomplished electro-pneumatically by means of the pre-coded holes (7 above), utilizing the binary system.
11 Two rolls of prints were made through offset and positive apertures on to 7 in. wide Kodacolor paper, using a paper transport of conventional design.

From this it is evident that Technicolor were first to splice together processed amateur colour negative films before printing them on an unattended printer. The printer designed by Technicolor was almost certainly the fastest operating printer ever to be used in photofinishing. The printer was built in Hollywood and then used in Technicolor's New York laboratory, but it is not clear just how long it remained in service.

Ilford Colour Printing Methods

Another, somewhat similar approach to the problem was devised by Ilford

Limited in 1961/62, although in this case the system was confined to 35 mm. amateur negatives made on Ilford colour film (126 cartridge film did not appear until 1965). The thinking behind the Ilford system has been explained in the paper[3] already referred to:

Ilford Limited did not enter the colour negative market until 1960. This relatively late entry encouraged a scrutiny of established photo-finishing methods. As a result it was deduced that the economics of existing colour printing methods could be improved by attention to the following points:

1 The printer yield should be made as high as possible.
2 The printer should be made as free from drift as possible so that any given negative would print in the same colour balance from hour to hour and day to day. All printers examined seemed to be subject to some degree of drift and some were particularly unstable. Economically, printer drift is probably more serious than a lowering of printer yield.
3 High speed printers were needed, capable of well over 1000 prints per hour over long periods. This implies automatic negative feed and this in turn implies the use of only one size of negative on a given machine.

Although Technicolor in America had developed a twin-track printer, each side of which was designed to handle up to 2500 roll film negatives per hour, a rather different approach was preferred. Ilford Limited had developed a fast colour printer for card-mounted 35 mm transparencies. With the rapidly increasing popularity of the 35 mm camera in mind, it was felt that automatic handling methods could best be applied to this format. Accordingly the existing design was developed to handle colour negative materials.

Concurrently, with this study of printing economics, thought was given to the best way of handling 35 mm colour negatives. Hitherto this had followed the pattern of roll film photofinishing. Films received are given an identifying number before being developed. Processed films are briefly examined either before printing or by the printer operator, who must reject negatives that are obvious failures such as under exposed or fogged frames; as well as negatives which are out of focus or show severe camera or subject movement or extreme exposure errors. Unfortunately, it is not always easy to judge which of the border-line negatives may still be of interest to the customer despite technical faults. As in modern art, the distinction between medallist and muddler is not always immediately obvious.

Conventionally, films still in strip form are printed on machines typically producing 500 and 600 prints per hour. The prints are processed in roll form, inspected, and unacceptable prints marked with corrections, to be applied at second printing. Quite often several attempts are required before a satisfactory print is obtained from a difficult negative.

First, second and third attempt prints must be finally cut and collated with the negatives so that the customer receives one good print from each good negative. Surplus prints are discarded and an invoice is prepared, charging the customer (through the dealer) for the number of good prints provided. From this it will be seen that a typical order, requiring one re-printing cycle, passes through sixteen stages if one includes handling by the dealer on the forward and return journeys.

Weaknesses of the conventional system were seen as follows:

1 The photofinisher has to decide on behalf of the customer which negatives shall be printed. In making these decisions the photofinisher must continually weigh on the one hand the customer's possible reluctance to buy a poor print from a technically deficient negative, and on the other hand the customer's natural desire for a return on the money already spent on negative and processing.

2 Re-printing difficult negatives takes time and money. Technically poor negatives tend to give prints the customer does not require anyway. So the system is often needlessly slow and expensive.

3 Invoicing can be done only when printing is finished. This introduces a further delay in returning to an impatient customer a set of prints with which he may not be pleased.

4 The repeated handling of the negative entails a serious risk that even before it reaches the customer it may gather dirt and scratches. In 35 mm the considerable enlargement in printing makes these defects more obvious.

This summary may be a little unfair to a system which has been worked successfully by many photofinishers in this country and abroad. It was to provide a better system however, that the Ilfocolor 35 mm colour service was introduced. Eight distinctive features of the Ilfocolor service were:

1 The customer posted the exposed film direct to the processing station. There was therefore no delay involved in returning film via the dealer.

2 After processing, one-to-one "contact" prints were made from every exposed negative. This strip of prints was returned to the customer so he could decide for himself from which negatives he would have enlargements made. Although "contact" prints were made on a machine using photo-electric corrections, no re-printing was attempted at this stage. Consequently, the contact prints did not necessarily represent the best possible results from every negative. It was found that slight colour casts did not have a serious effect on the appearance of small prints, and customers experienced no difficulty in allowing for the improvement which could be introduced when an enlargement was made at a later date.

3 Negatives were cut and card-mounted in the manner already established for 35 mm colour transparencies. This largely protected them from scratches and finger marks. For the customer's convenience the negative mounts were numbered to correspond with numbers on the contact prints.

4 Contact prints and negatives were posted directly to the customer who was thus able to assess his results with the minimum delay. As the cost of processing, contact printing and mounting was included in the selling price of the film, there was no delay in invoicing.

5 The customer returned selected negatives for enlargement printing. As they were card mounted, they could be handled efficiently in a completely automatic machine.

6 The photo-finisher was relieved of the necessity for deciding which negatives should and should not be printed.

7 As customers tended to select only the better negatives for re-printing, and often confidently ordered several prints from each negative, a very high print yield was maintained.

8 The price of an order was known in advance. There was therefore no delay due to final invoicing.

Ilfocolor Proof-Printer

The Ilfocolor proof printing machine was designed to handle negatives still joined in the 250 foot lengths in which they had passed through a friction-drive continuous processing machine. On a semi-automatic machine notches were cut in one edge of the film to indicate the positions of individual pictures, because not all 35 mm. cameras give a precise eight perforation film advance. A notch was also cut in the opposite edge of the film to indicate the start of each new order. As the negative roll passed through the printer, sensing

212

fingers detected the edge notches and initiated the appropriate operations. The picture position notch caused the negative feed to stop with the picture correctly located in the printing gate. Provided AND logic circuits indicated that other operations had been completed following the previous cycle, printing of the negative began. The cold cathode numerical indicator tubes indicated the number of the negative and a reduced image of the tubes was photographed on to one edge of the print strip. The numbering circuit was re-set to one by the start of order notch.

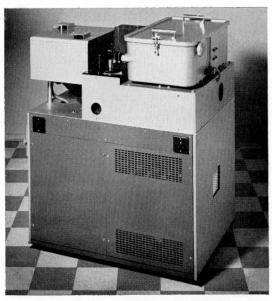

Fig. 106 Ilford Limited used a specially designed printer to produce 'proof-strips' from 35mm Ilfocolor negatives. The negatives were joined before processing and when processed were notched for frame and end of order location before being fed through the proof printer unattended

AUTOMATIC MOUNTING After proof printing, the negative roll passed to an automatic mounting machine in which the film was cut into individual frames and sealed in 2 × 2 in. card mounts. The mounts were numbered to correspond with the number already printed on the proof print strip. The feed and numbering operations in the mounter were again controlled by the notches on the film.

AUTOMATIC EN-PRINTER A high output automatic en-printer was used to print customers' re-orders and the mechanical feed of the printer was based on a card mounted transparency printer previously made by Ilford Limited and described by *Coote* and *Jenkins*.[3] Briefly, the printer comprised a magazine into one end of which the negatives were loaded by an operator. The feed mechanism removed negatives from the other end of the magazine at a rate dictated

by the machines requirements. The printer produced single prints faster than the operator could comfortably feed in negatives; on the other hand, while multiple prints were being made from a single negative, the operator was able to increase the number of negatives awaiting printing.

On a conventional colour printer, the output is retarded considerably and operator errors are often caused by the need to push buttons to indicate the number of prints needed or the colour and density corrections required on individual negatives. In the Ilfocolor 35 mm. system this wasted time and source of error were eliminated. The requisite information was carried on the card mount in the form of binary coded perforations. As each negative moved into the printing aperture, the information was read out by photocells, decoded and fed into the appropriate circuits automatically. This feature considerably reduced the cost of multiple prints and a sliding scale of print prices was introduced to encourage multiple print orders.

In the event, the growth of 35 mm. film usage which had been anticipated by Ilford Limited did not fully materialize—largely because in 1965 the introduction of cartridge loading cameras changed the face of amateur photography.

Impact of Cartridge Film on Photofinishing

Within a few years of the introduction of 126 cartridge film, it became apparent to independent finishers that this particular type of film has many features to facilitate systematic handling. Several of the causes of failure with roll films are completely eliminated with 126 cartridge films. For example, there are no fogged film edges due to loosely wound spools, no risk of over-lapped frames or double exposures and little risk of physical damage due to faulty film transport within the camera. These are all very useful advantages to the customer in that he is likely to obtain more good pictures from each film and this in turn means better business for both the dealer and the finisher.

The finisher also benefits from several other features of 126 size film. First, he can process the film on a continuous processing machine—if necessary together with (but not mixed with) normal 35 mm. films of the same emulsion type. Secondly, he can feed the processed negatives automatically through printers with the certainty that pictures will be correctly framed. Thirdly, and very important—the blank frame surrounding each negative prevents any spurious light from getting around the negative image proper to upset the photo-electric monitoring system of the colour printer.

The proportion of 126 cartridge film increased steadily from the time of its introduction in 1965, until in most parts of the world it was around 40–50 per cent of most finisher's intake of films by 1969/70. Many photofinishers began to consider the advantages that could result from using continuous processing and printing techniques for these films.

214

The principal film manufacturers have encouraged this kind of thinking by recommending handling procedures for 126 and 35 mm. film. In 1967, Kodak in Britain announced a system:

The whole concept of which is based on the use of continuous film processing, automatic printing, continuous paper processing, automatic paper cutting and automatic film cutting.

KODAK SYSTEM The way in which Kodak suggest the finisher should operate can be indicated by a workflow diagram, and the new equipment made available for the system mainly comprised the Kodak H126 Cutter Perforator, the Kodak Automatic Film Splicer, and the Kodak Automatic Film Cutter Model 20R.

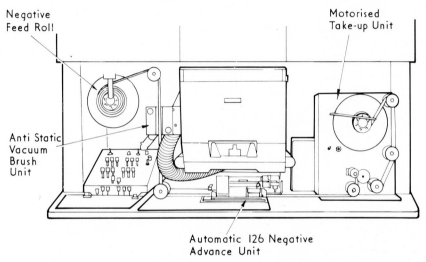

Fig. 107 The Berkey automatic 126 negative feed assembly for a 5S colour printer comprises a negative feed unit, an anti-static cleaner, the negative advance mechanism and a motorised take-up unit

For a while Kodak Limited sponsored a version of the Photomec 35/126 continuous processor, but later they decided not to be specific in their recommendations on continuous film processors.

AGFA AUTOPRINT SYSTEM Agfa, who were rather late in accepting the revolutionary influence of 126 cartridge film on both consumer attitudes and photofinishing techniques, nevertheless launched their 35/126 Autoprint system at Photokina in 1968. The system is an extension of an earlier procedure devised by Agfa in 1966, for the more efficient handling of 35 mm. colour films of all formats including Agfa's own Rapid sizes.

In neither of their systems have Agfa recommended the continuous processing of negative films, but merely post processing, sorting, joining and notching

215

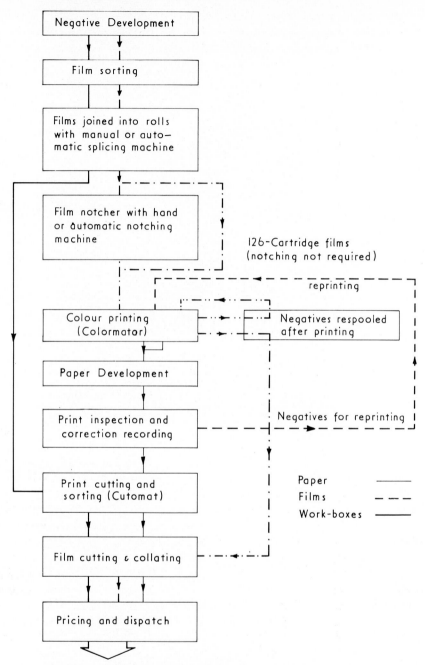

Fig. 108 A work-flow diagram representing the Agfa Autoprint System

(35 mm.) before handling on Autofeed printers—particularly the N2B-S and N2B Automatic machines.

Economics of Joining Film After Processing

It might seem surprising that it should be considered economically sensible to join films after processing and before printing, rather than to join them before processing on a continuous machine. But in practice there are several reasons why post-process splicing may be considered preferable.

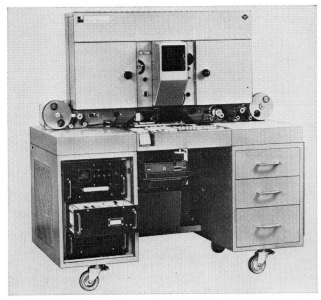

Fig. 109 Equipped with automatic negative feed for either 135 or 126 films, the Agfa Colormator N2B Automatic printer uses a triple source lamp house and subtractively terminated exposures. For reprinting, the Autoprint system involves the use of a synchronised correction value list, which is located on the left of the central operating panel.

One of the new problems in photofinishing has resulted from the disproportionately long time that is required to prepare films in joined rolls ready for continuous processing. The 126 cartridge, while extremely simple for the photographer to use, is a nuisance when the time comes to remove the film from the cartridge and then separate film from backing paper before identifying it in some way and then joining it to the end of the preceeding film on the continuous roll. Nearly all these operations must be carried out in the dark and they must be done very carefully.

The time an operator requires to prepare each film varies with the skill and experience she has, but often the output does not exceed 200 films an hour.

By using "daylight" or "safelight" conditions for cartridge opening and by loading hanger bars with the film/paper rolls from 126 cartridges, it is possible, with an overhead delivery system such as Refrema have designed, for one darkroom operator to strip away backing papers and attach weighted clips to say 500 films an hour at the feed-on end of a dunking machine.

It can be seen therefore that there is something to be said for deferring the joining of films until after they have been processed, thereby avoiding any risk of film breakage on a continuous processor, and leaving the joining operation to be done in white light.

Operation of Agfa Autoprint System

The range of equipment associated with the Agfa Autoprint system includes film splicers, a film re-winder, and film notcher (for 35 mm. formats), automatic

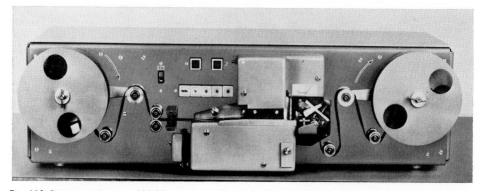

Fig. 110 Since negatives on 135 films are not always uniform in size or spacing, it is necessary to cut frame locating notches in the edge of the processed film before it is used on automatically fed printers. The Type 7543 notching machine made by Agfa is intended for this purpose

film transport for printer, a correction value printer and a print inspection bench that allows simultaneous examination of the colour print and its relevant printing data.

After development on a dunking machine, the films are sorted into negative sizes and formats and then spliced together before being fed into the automatic holder. This automatic feed had to be made extremely versatile because of the wide range of negative formats that have been based on film 35 mm. wide.

Agfa's negative feed is designed to handle 24 × 36 mm., 24 × 24 mm. and 18 × 24 mm. negatives in either of two ways. If the feed in the camera is uniform the automatic negative transport can be set to move exactly the required number of perforations between each printing exposure. That is, either eight, six or four perforations. Naturally, the first negative of each roll has to be

218

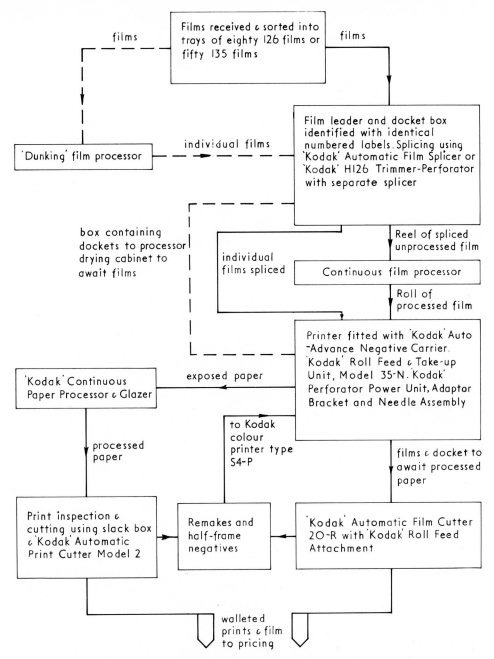

Fig. 111 Work-flow recommended by Kodak for handling 135 and 126 colour negative films

manually positioned in the printing aperture. Agfa do not say what proportion of cameras can be relied upon to produce uniform negative movement, but they do point out that the film transport is uniform and reliable with Rapid cameras.

Alternatively, the roll of spliced 35 mm. film can be notch-scanned—in much the same way as was done by Ilford for their proof-printing system in 1962. Agfa seem to suggest that preparatory notching is really the best way of automatically locating 35 mm. negatives for printing. They say—

> The system of notch-scanning is the most rational and convenient method of operation.

And that:

> One big advantage of the negative notching system is that unsuitable negatives are left unnotched and are thus automatically passed by in the automatic negative carrier at the time of printing.

But of course, the easiest negatives of all to print are those on 126 cartridge film, because, as Agfa say:

> The perforations of the frames being scanned by means of a mechanical feeler, a preliminary notching of the negatives is not necessary.

RE-PRINTING METHOD In accordance with the practice of so many European finishers, Agfa's Autoprint system includes facilities for recording all relevant printing data on the back of each print and a special type of Roll Monitoring Unit displays by reflection the data relating to each print as it is being examined. For this system an Agfa Correction Factor Printing Unit is used in conjunction with the Roll Monitoring Unit to print on a strip of paper the correction factors found necessary for prints that need re-making. The re-print can then be made on the printer from the information contained on the strip, without the necessity for handling envelopes and prints.

The correction factor printing unit is a bench type instrument—rather like a small adding machine, with twelve number or symbol keys and six operating keys. Up to nine numbers or symbols can be set in one line of information relating to each print. The first three places from the left are intended for the order number, the next two for the negative and the last four places are used to include correction factors from plus one to plus five or minus one to minus four.

It is obvious that the successful operation of such a system depends entirely on the reliability of both the print examiner who makes out the list of corrections and the printer operator who must interpret them in the strictest sequence.

Gretag 3000 System

At Photokina in 1968, Gretag of Regensdorf in Switzerland announced their 3000 System, based on recognition of the fact that—"in a forty-eight hours service only four hours are required for processing".

220

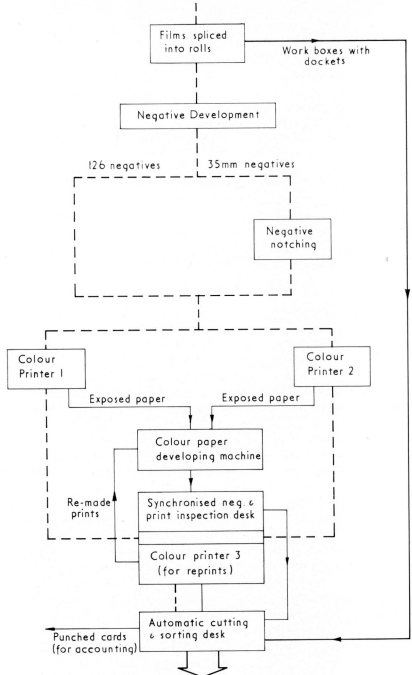

Fig. 112 Outline of the Gretag 3000 System

The 3000 System is designed for 126 and 35 mm. films in which the key to the procedure is a proposal for streamlining the production of prints that must be re-made because they are not saleable after initial printing.

In the Gretag system a print inspection table is synchronised so that as a roll of prints is being inspected and corrected so a corresponding roll of negatives (still joined after processing and after first printing) is being fed through an adjacent printer in synchronisation with the print roll. This means that corrected prints can be exposed at exactly the same time as the first print is being assessed —the print examiner operating the printer by remote control.

As an insurance that the print and negative rolls remain in synchronisation, Gretag have suggested that a video image of the negative in the printer gate should be visible to the print examiner at all times. The workflow pattern proposed by Gretag makes it clear that neither negative nor print rolls must be cut until all makeovers have been printed. The result, Gretag claim, is that instead of a large percentage of orders being completed in twenty-four hours with an untidy residue taking longer and costing disproportionately more to complete, all orders can be finished more economically in forty-eight hours.

Tape-Controlled Systems

Punched-tape systems controlling the printing operation in photofinishing, date back at least to 1958 when Hamilton Tait of Edinburgh were using a punched-tape control system to feed printing information into some of the earliest types of colour printers. Ilford also used punched-tape to feed order requirement and correction information into their high-speed colour transparency printer.[3]

D-MAC In 1968 a system called D-mac was announced by D-mac Ltd., of Glasgow, Scotland, and owes much to the ideas of *Iain Tait* who claims that by using D-mac a 10 per cent increase in production can be attained without increase in material costs.

The new system is designed to handle 120, 127, 126 and 135 negatives and broadly follows the principles originally employed by Hamilton Tait. Spliced rolls of processed colour negative film are viewed by the pre-grader who estimates any corrections required in density or colour and records them on computer tape together with the number of prints required and a synchronisation mark. In addition a small spark discharge hole is pierced into the edge of the film to enable its subsequent automatic location in the printer gate.

A tape reading facility must of course be added to whatever colour printers are to be employed. The roll of film and the tape are synchronised at the start of printing but thereafter printing proceeds automatically without an operator. A checkout comparator forms the third element of the D-mac system, and this again uses the tape to control the cutting of the film, trimming of the processed

222

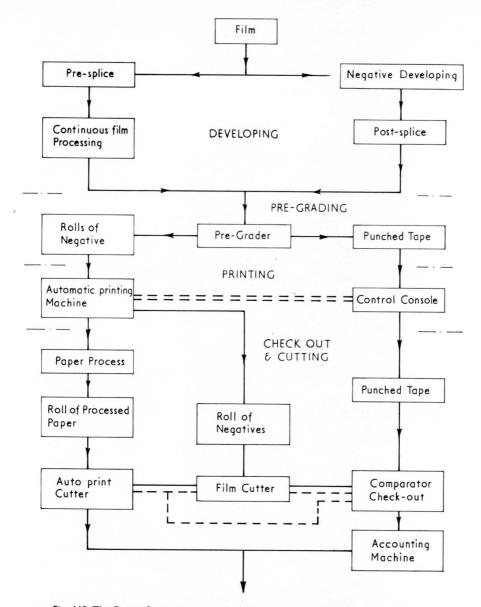

Fig. 113 The D-mac System uses punched tape as an essential part of its operation

prints and the final count of pictures passed out. It is also quite conceivable to extend the use of the tape to incorporate automatic invoicing.

Perhaps the only weakness in a system of this kind is that it must still depend upon the skilled subjective judgment of the operator who feeds in the correction

data on the basis of his examination of the original negative. If, as seems practicable now, the same examiner could be provided with a positive colour video image—at least he would be quickly able to identify and correct obvious density or colour subject failures, with the probability of a much higher rate of success than is ever possible by direct judgement of colour negatives.

Video Analyzers

The possible uses of a video analyzer or simulator in photofinishing have not

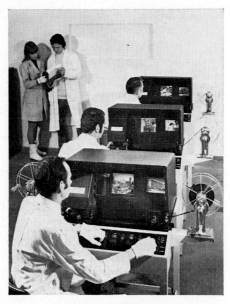

Fig. 114 These Eastman Type 1635 Video Color Analyzers are being used to grade colour negatives before printing on motion picture printers

yet been fully evaluated, but both Hazeltine[4] and Kodak have developed effective video equipment for grading or timing colour negatives used in motion picture or television production.

MOTION PICTURE GRADING It is general practice in motion picture printing for a grader or timer to estimate the printer light settings in terms of exposure and colour balance that will be required to correctly print every scene in a film. When the optimum printer settings have been found—often by repeated trials— the whole film is printed continuously and the required light changes are made automatically from scene to scene. A motion picture printer has no integration facilities—the changes in brightness and colour of the printing light being

224

effected either by use of a synchronised perforated band carrying an appropriate sequence of filters that are automatically inserted in the printing beam or by the automatic adjustment of the level and relative proportions of red, green and blue light as in the Bell & Howell additive printer.

To use a colour video facility in conjunction with an integrating printer it would be necessary to add integrating circuitry to the video analyzer so that the simulated colour image appearing on the screen would accurately represent the print that would result from an integrating printer. With such an arrangement it should be possible for a grader to predict the corrections required for any subject failure at least as accurately as a print examiner can predict the corrections required for make-over prints, but with the advantage that subsequent printing could be made fully automatic.

Bearing in mind the trouble and expense involved in making and collating make-overs it might well prove worthwhile examining negatives in roll form on a video analyzer before printing and to print the examined negatives on an automatic unattended printer controlled by a synchronised punch tape.

A continuous roll of processed 126 size negatives could be fed semi-automatically through an analyzer and something like 90 per cent of the images appearing on the video screen would obviously be satisfactory, but whenever a subject failure came up the grader would recognise it immediately and could introduce the required corrections just as quickly as if he were examining and correcting prints. In fact, the corrections could be fed into tape by means of

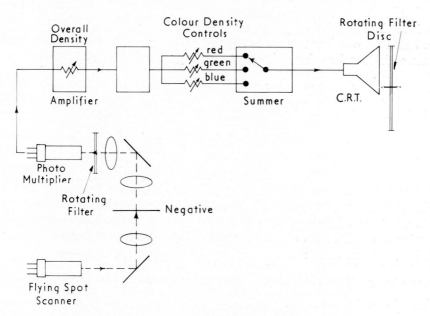

Fig. 115 This schematic drawing shows the operating principle of the Ferrex Colorverter vidio analyzer

P.T.E.—P

push buttons on exactly the same values as used on any operator controlled printer.

Alternatively, there may one day be printers in which colour video facilities are incorporated so that the printer operator can see exactly when any correction is required for a negative immediately prior to printing it.

EASTMAN 1635 VIDEO COLOUR ANALYZER Although it is primarily intended for service in motion picture laboratories, the Eastman 1635 Video Colour Analyzer[5] would seem to be adaptable to photofinishing requirements, as would the Colorverter made by the Ferrex Corp. in the US.

Negative and Print Handling

Although it has tended to attract more attention than most other aspects of colour negative work, the printing stages of the negative-positive cycle are not the only ones that require systematic handling. When the prints have all been exposed and processed they must be examined, cut from the roll and then mated with their negatives, which must also be cut so that the order can be charged and dispatched—or re-made as necessary. These operations are difficult to streamline, but because they are so important they have received increasing attention in recent years.

In 1967, Kodak Limited proposed a photofinishing system for 135 and 126 films based on continuous processing and printing of joined films, and their recommendations for print and negative cutting were divided into two methods:

> In the first arrangement the paper cutter and film cutter are on different levels and are operated by one person. In the second arrangement the two cutting machines work back to back and each is operated by a separate person. In either arrangement the prints should be examined and marked for correction prior to cutting—preferably by using the "slackbox" principle which provides a reservoir or buffer supply of prints between the print examiner and the cutter.

FOX PHOTO CUTTING SYSTEM Fox Stanley Photo-Products Inc., photofinishers themselves, have studied the cutting and packaging of negatives and prints with special reference to 126 films. They now offer equipment for operating the Fox Photo Cutting System. The thinking behind the system is explained in these terms:

> Those who are splicing 126 Kodacolor film whether presplice or post-splice quickly found, however, that there was another part of the system that was suspended in an even greater vacuum. This was completely at the opposite end of the handling system—cutting and packaging the prints and negatives.

226

Negatives either had to be manually cut and then directed to the print cutter and packager, or each individual roll of film had to be manually cut apart at the splice with the print cutter handling the order from then on. At best, you were only slightly less efficient than with continuous methods and at worst, the inefficiencies of the multiple handling were staggering.

Then was born the continuous 126 film cutter. The idea was really not original because it was patterned to function similar to a paper cutter that cuts the prints and stops itself at the end of the customer order. Briefly, this is what happens to each roll of film. Since the operator does not actually have to handle the film—merely picking it up after being cut—it quickly becomes obvious that she could do something else along with it. Thus was born the system of one operator simultaneously cutting and packaging both prints and negatives.

To properly utilize the system a work station is needed that spreads out the prints on a moving conveyor.

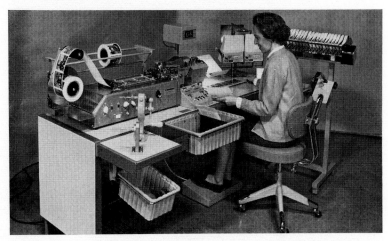

Fig. 116 A Fox-Stanley cutting and pricing station enables a single operator to continuously handle the negative and prints coming from a Kodak 2620 printer

Fox Stanley tried out the first of their integrated negative and print cutting work stations in one of their own finishing plants and soon found that when operated by an efficient girl, one station was capable of continuously handling the output from a 2620 printer. Further refinements have been added including a large digital counter to display the number of prints made for each individual order.

An interesting psychological advantage emerged from the use of an integrated work station—it was found that a good operator takes pride in the additional responsibility she is given and even though she is actually doing more things she readily accepts this because she has complete control over the whole job. This change in mental attitude results in a reduction in errors—particularly those resulting in cross overs—because a mis-match of prints and negatives becomes more obvious when they are both handled at the same time, directly from two cutters.

REFERENCES

[1] GUNDELFINGER, A. M., TAYLOR, E. A. AND YANCEY, R. W. "A High Speed Colour Printer" *J. Phot. Sci.* Vol. **8**, 1960, pp. 161–170.

[2] COOTE, J. H., NEALE, D. M., and LARGE, A. A. "Electronics and Economics in the Handling of 35 mm. Ilfocolor Negative Film" *J. Phot. Sci.* Vol **11**, pp. 355–364.

[3] COOTE, J. H. and JENKINS A. P. "A Machine for High Speed Printing from 35mm Colour Transparencies". J. Phot Sci. Vol **8**, pp 102–105 1960.

[4] BP 845,154.

[5] DREYFUSS, A. W., WAZ, E. M. and WOODLIEF, T. "Design Aspects and Performance of a New Video Color Analyzer for Motion Pictures". B.K.S.T.S. Motion Picture Technology Conference, 1969. Paper No. 308.

228

IX. PROCESSING REVERSAL COLOUR FILMS

So far only negative/positive processes have been considered, and these have now grown to represent the most important part of many photofinisher's intake of work. Nevertheless, it is an historic fact that reversal colour films were available to amateur photographers long before colour prints. The earliest forms of colour transparencies were all based on the additive screen-plate system, and plates or films of this type were made by Lumiere, Agfa, Finlay and Dufay. Of these early processes only Dufay ever operated a photofinishing service in anything like the modern sense, and their activities in Britain were cut short at the outbreak of war in 1939.

Black and white reversal processing has had no significance in the photo-finishing of still pictures, but the home-movie business, first established in the twenties, was based on the direct reversal of 16 mm. black and white film. Later, in the mid thirties, the advent of what came to be known as the sub-tractive multi-layer process marked a tremendously important turning point in the history of colour photography and of photo-finishing.

Advent of Kodachrome and Agfacolor

The first and most important change came in 1935, when Eastman Kodak launched 16 mm. Kodachrome for amateur movie making. Kodak, who had already established their Cine Kodak System, had considerable experience of selling and servicing black and white reversal films for amateur cinematography and knew very well that they would have to offer a processing service for their new colour film. This they did by setting up facilities in Rochester, Los Angeles and Chicago.

Very shortly after the introduction of Kodachrome in the US, I. G. Farben in Germany introduced their equivalent subtractive reversal colour film, which they called Agfacolor Neue to distinguish it from an earlier Agfacolor additive screen-plate process. Agfa, like Kodak, also decided to undertake the pro-cessing of their new film, although in fact its processing was much simpler than that of Kodachrome.

Substantive and Non-Substantive Films

Kodachrome, and several other films of the same type that were introduced later by companies such as Ilford in England, Fuji in Japan and Dynacolor in the US, require that the colour forming substances (couplers) from which the component image dyes are formed should be contained in three separate

229

developing solutions. The ways in which these three different colour developers are used in sequence to produce appropriately coloured dye images in the three layers of a film, vary in detail and are usually quite complicated.

Agfacolor and Anscochrome as well as many other films based on the early work of I. G. Farben, represent another group of colour materials which depend upon the presence of colour forming substances in the emulsion layers from the time the emulsions are coated. Such materials merely require initial development in a black and white developer, followed by re-exposure and a single stage of colour development to simultaneously form the correct colour component images in all three emulsion layers. Ektachrome films also belong to the substantive coupler group, although the way in which Ektachrome couplers are confined to their individual emulsion layers is different from the method employed by I. G. Farben, and adopted by so many other manufacturers.

Because of the basic difference between the so-called substantive (Agfacolor and Ektachrome) and non-substantive (Kodachrome) processes, it can be seen that while the user may well be able to process films of the subtantive type, it is virtually impossible for him to process film of the Kodachrome type.

In the US, Ansco, who had been associated with I. G. Farben before World War II, also worked out a reversal colour film of the substantive type which they launched in 1942 under the name Anscochrome. At certain times during its history, Anscochrome has been the fastest colour film available, and unlike Kodachrome and Agfacolor, it has always been available in a variety of cut sheet and roll film sizes for user processing.

Kodachrome processing is practicable only on continuous processing machines in 35 mm. or narrower widths, which implies an expensively equipped installation. Eastman Kodak therefore decided that they needed a substantive type reversal colour film that could be sold in cut-sheet and roll film forms and be processed by the user. The film they introduced to fulfil these requirements in 1946 was Ektachrome, and from that time onwards independent photofinishers throughout the world found that they were involved in reversal colour film processing.

Processing Methods

Because there is no printing step involved in reversal processing and the original film becomes the finished photograph, the investment involved in undertaking the work can be quite modest and many finishers have started processing Ektachrome with three gallon tanks in a sink line.

Naturally, as the popularity of colour transparencies increased—particularly during the decade from 1955–1965—many finishers found it worthwhile to install a deep-tank line either for manual or automatic operation.

230

A typical deep-tank set for manual transfer is the Eastman Kodak Model 10E Processor; while Pako in the US adapted their Filmatic machine to suit the requirements of reversal processing in the form of Models 35EK and 26EK automatic dunking machines. In Britain, firms such as Wainco and Pavelle (Colortron) have machines for Ektachrome processing, while in Europe, Hostert, San Marco and Donka all offer machines for reversal film processing.

Prior to the introduction of the Ektachrome E4 process, which will be described later, all colour reversal materials required an exposure to light after first development in order to render the residual unused silver halides developable in the colour developer that is then used to form the positive dye images.

When processing in spirals, the re-exposure step in reversal processing is something of a nuisance and the spirals used must either allow re-loading of wet film or have transparent ends to allow adequate re-exposure before colour development.

On manual deep tank transfer installations such as Kodak's Model 10E, re-exposure is carried out by placing each rack of films in a light chamber for sufficient time to ensure uniform and sufficient fogging. In automatic machines such as those made by Pako, Refrema, Colortron and Wainco, each rack of films is fogged as it is transferred from the wash prior to colour development into the colour developer itself. Usually the source of fogging light consists of a bank of ten or more fluorescent tubes, but some machines—the Wainco for example—fog the films by means of electronic flash.

Ektachrome Processes

The original Ektachrome processing chemistry did not incorporate any replenishment system, but later as the demand for deep-tank processing increased, a batch replenishment system was designed, and this was used both by photofinishers and professional photographers. In 1958 further changes were made and continuous replenishment was introduced; then in 1959 modifications were made to offset the effects of iodide build-up from High Speed Ektachrome film.

One of the big problems of the E2 processing chemistry resulted from variations in transfer time—particularly extended transfer times—which gave rise to green run-down streaks. For these reasons among others, the E4 process was introduced in 1968 to make processing stable whether operated by replenishment or not. The new process differed from E2 chemistry in several important respects:

1 Pre-hardener and neutralizer solutions precede first development.
2 The new colour developer contains a fogging agent which renders re-exposure to light unnecessary.

3 The E4 process operates at a higher temperature—86°F (30°C) for machine processing. This gives a wet processing time of 47 minutes against 67 minutes for E2.

Gehret[1] has commented on these differences in some detail and points out that:

> To improve the mechanical resistance of emulsions destined for Process E4 treatment at 30°C, it is necessary to treat them in a pre-hardening bath containing—in addition to formaldehyde—2,5 dimethoxy tetrahydrofuran (DMTF) a liquid whose vapour is very aggressive in its action on the respiratory system and eyes.

Commenting further on the process *Gehret* observes:

> Re-exposure to light (reversal) before colour development, has been discontinued: reversal is effected by chemical fogging of the emulsion during colour development. Its solution contains an organic chemical—tertiary butylamino borane (TBAB)—which enables all parts of the emulsion which have not been developed by the black and white first developer to react to the colour developer. TBAB is very toxic and must be handled with the greatest care to avoid contact with the skin and respiratory organs.

This problem of irritant vapours is sufficiently serious for Kodak to strongly recommend installation of fume extraction facilities on every possible type of processing set up from three gallon sink lines upwards, not forgetting chemical mixing areas.

The wet section of the dunking machine made by Wainco for the E4 process has a plastic roller blind to cover the open side of the machine so that an exhaust fan can more effectively extract the fumes rising from the pre-hardener.

From these comments it will be seen that while the E4 process is a considerable improvement on earlier Ektachrome chemistry, it did bring some new problems with it.

FORCED DEVELOPMENT WITH EKTACHROME It is a well known and valuable characteristic of Ektachrome film that its effective speed can be increased by means of modified processing. As much as two stops increase can be obtained without serious loss of quality by extending the time of first development by six minutes. One stop increase may be obtained by a first development extension of three minutes. So important is this flexibility for some specialist finishers, that Pako have introduced a developer "push" system for use with their 35EK Filmachines. The system depends upon collars being added to film hanger rods in certain configurations that will operate pre-positioned microswitches in such a way as to control an extra dwell time in the first developer. A choice of six additional times allow effective speed increases of up to two stops in one third stop increments.

AGITATION The correct application or omission of agitation is very important in the operation of the E4 process. When Ektachrome films are being processed in E4 chemistry using spiral reels, it is recommended that only manual

232

agitation should be used—not gas burst. When automatic dunking machines are used, agitation should consist of a two second burst of nitrogen every 30 seconds for both first and colour developers. The only other solutions for which gaseous agitation is required are the bleach and the fixing baths. Gas burst agitation is specifically not recommended in the pre-hardener, neutralizer, second-stop or stabilizer.

REPLENISHMENT Kodak's recommendations for replenishment of E4 solutions are based on the area in square feet of film processed. However, as with any other process it is made clear that the precise replenishment rate for the more critical solutions such as colour developer, must be arrived at by practical trial because the requirement will vary with the type of machine and with the volume and regularity of throughput. Broadly, if colour balance moves towards yellow-green, then too much replenishment of the colour developer is probably occurring, while if results become purplish then it is probably due to under replenishment of the colour developer. Adjustments of ± 5 per cent to the rate of replenishment are usually sufficient to rectify any drift.

Kodachrome Processing

Ektachrome was not the first colour film to be processed by means of a chemical fogging. Kodachrome II was introduced in 1961 and required a new chemistry known as process K12. The new process included a chemical fogging step to replace the previous requirement for exposure to light before the development of the magenta image.

The K12 process is one of a long line of different processing procedures that have been worked out by Eastman Kodak since the introduction of Kodachrome in 1935. It is well known that *Mannes* and *Godowsky*, two independent research workers, who also happened to be musicians by profession, joined the research laboratories of Eastman Kodak in the early thirties and were responsible for devising the Kodachrome process in its earliest form.

It has been said that at the time, even *Mees* did not fully realise just how complicated the new process was. In all, 30 treatment stages were required to process Kodachrome film by the controlled penetration method originally employed.[2] In effect, a composite three colour image was created step by step from the bottom layer upwards. First, the latent colour separation negative images in all three emulsion layers were developed in a black and white developer and then bleached in a bath which removed the silver but did not attack the silver halide. Then the residual, unused halide in each layer was treated in a colour developer containing a cyan colour coupler so as to form combined silver and cyan dye images in positive form in all three layers. Next, the outer two cyan dye images were destroyed by using a bleach bath to a

233

controlled depth before re-developing these same positive halide images in a colour developer containing a magenta coupler. Then, using the controlled depth bleach technique once again, the magenta dye image was removed from the outermost layer before finally re-developing the image in this layer in a colour developer containing a yellow colour coupler. At this stage the film contained a cyan image in the innerlayer, a magenta image in the intermediate layer and a yellow image in the outer layer, together with metallic silver in all three layers. These residual silver images were finally removed in a ferricyanide bleach to complete the process.

In 1942, *Mees* disclosed that this lengthy and difficult process had been modified, although it has been suggested by *Koshofer*[3] that the simplified process had in fact been in operation since 1938—only two or three years after the introduction of Kodachrome.

The modified processing procedure depended on the fact that the differential colour sensitivities of the three emulsion layers were retained after first development, so that selective re-exposure could be employed to deal with each of the image layers in sequence, thus avoiding any necessity for the tricky techniques of controlled penetration.

Before 1955, all Kodachrome films, 35 mm., 16 mm. and 8 mm.—were processed in Kodak's own laboratories—the only exception being the processing station in Stockholm which was owned and operated by Hasselblad for many years before Kodak took over. But in 1955 Eastman Kodak signed the famous Consent Decree by which they gave an undertaking to the United States Government that they would make Kodachrome (and Kodacolor) processing techniques available to independent photofinishers in the US, and to sell their colour films without the cost of processing being included. One of the first finishers to take advantage of the new processing opportunity was Pavelle Color Inc. of New York, who quickly installed continuous machines for processing 35 mm. and Double 8 mm. Kodachrome. Several other large independent photofinishers soon followed suit and have been processing Kodachrome in the US from that time.

K12 PROCESSING METHOD The processing used in 1955 was designated K11, but when Kodachrome II film was introduced in 1961 the chemistry and procedures were altered and designated process K12. This presented something of a problem to the independent laboratories, because they had to run both processes in parallel for some years because of the backlog of film requiring K11 chemistry.

Kodak's outline description of process K12 goes as follows:

The exposed material is first treated in a pre-hardener bath which renders the emulsion tough enough to remain intact during the remainder of the process. During washing to remove the pre-hardener solution, the anti-halation backing on Kodachrome film is washed and buffed from the support. The material is then developed in a black and white

developer which produces black and white negative silver images of the original scene colors in each emulsion layer. The original spectral sensitivities of the different emulsions are retained during pre-hardening and black and white development so that the remaining silver halide in each emulsion layer is still sensitive to colored light in the same manner as before development. A blue object in the scene is developed to a black and white negative image in the blue sensitive layer, a green object is developed to a black and white negative image in the green sensitive layer, and a red object in the red sensitive layer. This is all done in a single black and white developing step.

When the first development has been completed, the film is washed to remove the developer and is re-exposed to red light through the support. The two outer emulsions are not sensitive to red light and thus the red light re-exposure is effective only in the bottom emulsion. Following the red re-exposure the material is developed in a cyan color developer which deposits a positive black and white silver image and simultaneously a positive cyan color image in the red sensitive layer only leaving the blue and green sensitive layers essentially unchanged. Cyan is the complementary color of red; hence, the positive cyan image formed in the red sensitive layer corresponds to red objects in the scene photographed and is in addition to the negative and positive silver images. The cyan image "subtracts" red light from the viewing or projection light, hence the term reversal subtractive color processing.

The cyan color developer is then washed from the material and the material is then re-exposed to blue light from the emulsion side. Since the yellow filter layer is still intact in the film, no blue light penetrates to the two bottom emulsions and therefore only the top, blue sensitive layer is re-exposed. The re-exposed blue sensitive layer is then developed in a yellow color developer which deposits a positive black and white silver image and simultaneously a positive yellow color image in the blue sensitive layer. Yellow is the complimentary color for blue and hence subtracts blue light during viewing.

The yellow color developer is washed from the film. After washing, the film is treated in a magenta reversal bath and developed in a magenta developer to produce a positive magenta color image in the green sensitive layer (magenta is the complementary color of green) as well as a positive silver image. After washing the magenta color developer from the material, all silver is bleached to convert both positive and negative silver images in each layer to silver halide, which is removed in the fixing bath. The yellow filter layer is also converted in the bleach to a form which can be removed by fixing. At this point there is no silver left, and the scene photograph is represented in the film by three separate dye images. The material is then washed and dried.

Re-Exposure Printers

There are two re-exposure stages in the K12 process—cyan "printing" and yellow "printing". The magenta image is formed in the middle emulsion layer after that layer has been chemically fogged by treatment in a magenta reversal bath containing potassium borohydride.

The "printers" or re-exposing sources used in Kodachrome processing are positioned so that the film passes continuously through them while it is being transferred from one solution tank to the next. The cyan printer is positioned between the wash tank after the first developer and the cyan developer tank; while the yellow printer is located at the cross-over between the cyan spray wash tank and the yellow developer tank. On some types of Kodachrome processing

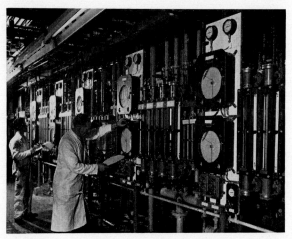

Fig. 117 There are many solution variables to be controlled in the Kodachrome process and as a result, a complex system of pumps, filters, flowmeters and temperature recorders is required

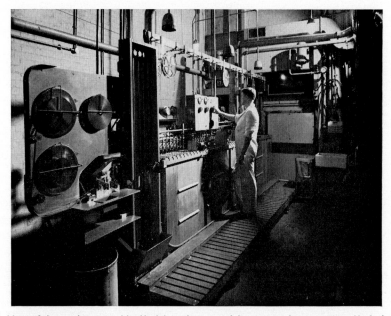

Fig. 118 Most of the machines used by Kodak in their own laboratories for processing Kodachrome are based on the Capstaff driving principle. Note the re-exposure lamp controls midway along the wet section of this machine

236

machines—those used for 8 mm. film for example—the speed of the film may be 100 feet a minute or more; consequently, quite a powerful source of fogging light is required. A typical lamp in a printer used on a machine running at 35 feet a minute would take 7·5 amps at 20 volts, and an integrating bar would be used to guide the light on to the film through either a red or blue filter.

Accurate re-exposure is an important factor in the reversal processing of Kodachrome, so film transport through the processing machine must be smooth and uniform. Any variations in film speed—known as hunting—could give rise to visible variations along the length of the finished film.

Coupler Recovery

Because they are costly, it is common practice in Kodachrome processing stations to recover the cyan and magenta coupling agents from used developers. The procedure is to treat the spent solution with carbon dioxide gas to reduce the pH to approximately 8·0, at which point the couplers precipitate and can then be centrifuged and washed before being used to compound fresh developers.

The ferricyanide bleach solution in the K12 process is rejuvenated by oxidising the ferrocyanide in the used solution back to ferricyanide. Potassium persulphate is used as the oxidising agent and the treatment is carried out in a batchwise manner, using solution collected from the bleach tank overflow.

Film Driving Methods

When Kodachrome processing was released to the independent photofinisher in the US, one of the first problems the finisher faced when he had decided to make the investment, was where to obtain a suitable friction-drive continuous processing machine. As we have seen in the case of the continuous processing of 35 mm. and 126 colour negatives, it is extremely important to limit the driving tension used to transport long lengths of frequently joined film through a continuous machine.

Capstaff Tendency Drive

Kodak themselves use machines designed by *Capstaff*[4] who had first worked on the problem in 1923 when he designed the machines used for processing 16 mm. black and white Cine Kodak reversal film. *Capstaff* later designed a more sophisticated friction-drive machine, the principles of which came to be known as the Capstaff "tendency drive".[5] This is the type of machine Kodak uses in most of the Kodachrome processing stations throughout the world.

In a Capstaff machine, the film carrying racks are linked individually to a constant speed drive belt by pulleys which act as clutches. The arrangement is such that the floating bottom spool assembly of each rack acts to control the drive imparted to the following rack. As the "floater" of one rack rises or falls the speed of the film on the following rack decreases or increases respectively.

Film is fed into the machine by a metering roller called a "pacer", the shaft of which is driven by the same constant speed belt that drives the racks. It is possible for the individual rack drive to speed up so that film is advanced faster than it is being metered into the first tank by the pacer roller. This is known as overdrive, and it compensates for the gradual expansion of the film which occurs in the solution tanks, at the same time keeping development constant.

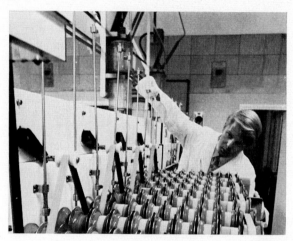

Fig. 119 Omac continuous processing machines incorporate moving arm speed controllers between each pair of film racks. By changing motor voltage, these arms govern the film speed and therefore the tension in any section of the machine

In normal operations, the clutches continually slip in slightly varying degrees as each floater automatically seeks the level that will cause film to be driven out of each tank at the same rate as it enters.

HOSTERT AND OMAC There are other ways in which the relative position of a bottom roller assembly can be made to control the speed of the following driven top roller assembly to increase or decrease the rate of film removal (and therefore the tension), from each tank.

Hostert in Germany has devised a machine in which any vertical movement of a lower roller assembly serves to increase or decrease the speed of the motor driving the following top roller shaft.

The Italian firm Omac, make machines in which the tension on the film as it passes from one rack to the next is used to move the spring loaded arm which in

238

turn controls the speed of the next top roller shaft. The principles of this form of film drive have been discussed by *Chatwin*.[6]

BOTTOM DRIVE MACHINES Continuous film processors in which drive is imparted to the film by the lower, immersed rollers are commonly known as bottom-drive machines and were probably originated by *Spoor Thomson*. They are now typified by the designs of Arnold and Richter (Arri), Pako (Cine-Strip), Houston and Dynacolor (3M Co.)

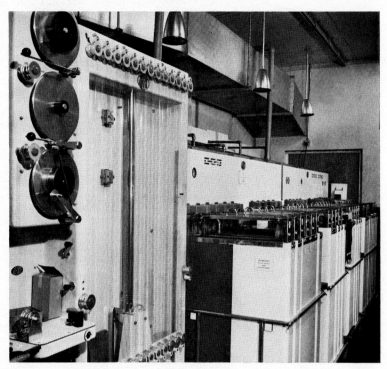

Fig. 120 Some of the first machines used by independent photofinishers to process Kodachrome were made by Arnold and Richter in Munich. These bottom-drive machines often operate at more than 100 feet per minute when processing 16mm or 8mm film

The principle underlying the bottom-drive machine is simple, in that it depends upon each loop of film picking up drive from rotating bottom spools whenever the tension on the loop is sufficient to pull it up into good contact with the spool. Drive to the lower shafts of a processing machine is usually achieved through positively driven vertical shafts with bevel gears at both ends. The way in which the film spools pick up their drive from the continually rotating bottom shaft varies according to the machine design.

On the Arri machines most spools run freely on the shaft and pick up a

239

limited amount of drive when the film is under tension, but a few spools are pinned so that they rotate at shaft speed. Obviously the cumulative effect of these two forms of drive—which may be adjusted differently at different points along the machine—governs the tension at which each section operates. Naturally, both the speed and rotation of the fixed spools and their working diameter must be arranged to provide a slight overdrive so that the tendency is for each bottom spool to serve as a driving clutch by its contact with the loop of film. When tension becomes too great in any particular loop it tightens the grip of the film on the bottom roller of the preceding loop and this in turn results in more film being fed into the tight loop. Conversely, when a given loop of film becomes slack it will fall away from the bottom spool and lose its drive until tension again becomes normal.

In practice it is usually found that only some of the bottom spools need to be locked to the rotating shaft, the other spools merely being allowed to pick up frictional drive from the shaft whenever the film loop tightens sufficiently. If all bottom spools were to be locked to their shafts, too much over-drive would result, and this would cause an intermittent movement of the film that is known as hunting.

Adjustment of Treatment Times

Although the manufacturer can provide the nominal times of treatment in the required sequence of processing solutions for any of his films, adjustment of these times is necessary to compensate for small but significant local differences of one kind or another. Solution times can be adjusted in three ways:

1 By changing overall drive speed (in which case all treatment times are affected).
2 By changing rack threading—for example by skipping some loops.
3 By adjusting the positions of the lower roller shafts.

In general, the last of these three methods is the most useful, provided that the lower shaft is never raised to a point where the angles of the film loops become great enough to cause strain.

Houston Inc. make machines using the bottom drive principle, but do not lock any spools to the driven bottom shafts. Instead, two-piece spools are used, an inner drum being keyed to the shaft, and an outer part of the spool being supported by the film loop. Film drive therefore results from frictional fluid contact between the bore of the outer spool and the surface of the rotating inner bush. These special two-part film spools are sometimes called "wobble rollers" —although this is something of a misnomer.

More recently Houston have designed top-drive machines incorporating the

240

spring-centred rollers patented by Eastman Kodak and described by *Feichtinger* and *Witherow*.[7]

PAKO CINE-STRIP PROCESSOR. As the number of independent Kodachrome laboratories increased, and the demand for continuous processing of 35 mm. and 126 colour negative films also became apparent, Pako entered the field with their series of Cine-strip Processors. These machines are available in a number of forms, to take film of various widths, and quite often two sizes of film (e.g. 35 mm. and Double 8 mm. or Super 8) on two sides of the same machine—

Fig. 121 Pako Cine-Strip processors are made for use with 35mm, 8/8mm and Super 8 films. The method of film transport has been changed from time to time, but can generally be described as bottom-drive

thereby using a common main drive. Early Cine-Strip Processors used bottom-drive with "wobble rollers" in much the same way as Houston, but later machines incorporate a continuously over-driven bottom roller against which the knurled flanges of the suspended lower film spools are pulled whenever any loop of film tightens sufficiently.

In a bottom-drive machine a pacer roller is usually fixed to a driven shaft at the output end of the dry box, and as the diameter of this pacing spool is less than the film spools on the bottom shafts, throughout the rest of the machine, the linear speed of the film fed from the pacer roller is less than the linear speed that would result if all the bottom spools were positively driven. In effect, the film tension throughout the machine—which is generally around

241

150–200 grams—is governed by the difference in diameter between the pacer roller and the rollers on the bottom shafts.

There is some risk with a bottom-drive system that film loops may become too slack and cause trouble under conditions of vigorous solution agitation by flapping and suffering damage. Dynacolor[8] overcame this difficulty by adding guide tubes to the racks in their machines in order to restrict the amount of movement that could result from the combination of slack film and vigorous solution movement.

Dynacolor Processing of Kodachrome

The Dynacolor Corporation, now a subsidiary of the 3M Company, entered the field of colour film manufacture and processing in 1949, sometime before the release of Kodachrome processing to independent finishers. However, because the Dynachrome film and its processing were so similar to Kodachrome I material and the K11 process, it was a relatively easy decision for Dynacolor to make when they decided to undertake Kodachrome processing in the several plants they operate throughout the US. Because they had commenced their operations before Kodachrome processing was freed, Dynacolor had already designed and built their own processing, film joining and mounting equipment.

Agfacolor Processing Laboratories

By the end of the fifties, Agfacolor reversal films were being processed in a large number of countries throughout the world. Some of these labs were owned and some licensed by Agfa. Not all of them could handle Double 8 mm. film because, despite the comparative simplicity of the process itself, this film requires continuous processing equipment and cannot be handled satisfactorily on a small scale. Wherever continuous processing machines were justified, either Arnold and Richter or Omac equipment was generally used.

Pre-Splicing

Whatever the process, amateur films must be joined together before they can be fed on to a continuous processing machine. In the earliest form of continuous film processing, pre-splicing was done by means of metal staples or eyelets, and this method is still used by some finishers for joining narrow gauge films such as 16 mm. and 8 mm.

EYELET SPLICING The Eyelet Tool Company make an automatic film splicing machine to use either a small brass or silver plated eyelet that does not leave a

242

rough or jagged projection, an important consideration when film is to be wound in rolls before and after processing. Berkey market a "white-light" Double 8 mm. and Super 8 mm. pre-splicing machine which enables an operator to make up to 180 joins an hour in the light. Using a pre-determined tear-off point, film leader is removed and the roll spliced to the preceding roll or to machine leader. A light-proof cover is then closed and the film is automatically transported on to an "in-dark" take up reel. A sensing unit on the film track stops the film transport immediately at the end of each roll. Then the light-proof cover is slid open and the cycle is complete. At the conclusion of film splicing, the master roll is removed to a light-tight can by means of changing-bag armholes in the "dark" box.

HEAT-SEALED SPLICING Amateur movie films permit ample overlap at the join between one customer's film and the next, but when 35 mm. still camera films are concerned, and more than the normal number of exposures have been squeezed on to a standard length, there is too little spare film to provide an adequate overlap and because of this, tape or heat sealed joins are usually employed.

In early days of the process, Kodak joined Kodachrome films by means of a heat-sealed patch of film about $\frac{3}{4}$ in. wide, but more recently they have used a paper-based splicing tape which, on the application of heat and pressure, seals a patch across the two butted ends of adjacent films. The procedure is as follows:

> The films to be spliced are placed, emulsion side up, on the film stage. A solenoid valve is actuated which provides air pressure to swing a pivoted arm containing a heated platen into position over the film. At the completion of this movement, a second solenoid valve actuates a downward stroke of the platen. A hardened steel insert in the platen shears off the patch of splicing material. At the completion of this down stroke of the platen a timer controlling the dwell (1·5 seconds) of the heated (350°F) platen shuts off the air supply from the second solenoid and the platen is raised by means of an internal spring. At the completion of the up stroke of the platen, the machine is recycled in readiness for the next splice.

The total time required to make each splice on the Kodak machine is between four and five seconds. A similar machine is made in England by Photomec.

TAPE JOINING An alternative method of pre-splicing involves the use of pressure sensitive tape. The first tape splicing machine designed specifically for joining film prior to processing was the Unicorn Automatic Film Splicer made by the Hollywood Film Company. The Unicorn splicer[9] can be used for joining either 35 mm. or 16 mm. films and the join is made automatically by wrapping Mylar tape completely round the two ends of the film. When completed, the splice is claimed to be the strongest part of the film roll, provided that the recommended tape has been used. It is also claimed that despite the fact that there are no perforations in the spliced area, very few film perforations are

covered and the joined film can be handled satisfactorily on sprocket driven as well as friction driven machines.

A manually operated semi-automatic tape splicer is made by the Gryphon Corporation in the US, and this machine can produce either edge to edge or wrap-around splices using one-inch pressure sensitive tape.

FILM IDENTIFICATION In order to return each film to its owner, some method of identification is necessary. Kodak use a sequence of perforated numbers—the perforations being made simultaneously in the end of each film and in the customer's return address label. Standard Photo in the US and Photomec in the

Fig. 122 The Photomec Heat Seal Pre-splicing machine uses a patch of 3/4 inch temperature sensitive tape applied over the butted ends of two adjacent films

UK both offer systems for thermal splicing in conjunction with automatic film numbering by perforation.

The "twin-check" system of identifying customers' films is often used instead of perforating the films with numbers that are not very easily recognisable. When numbered self-adhesive labels are applied to films, care must be taken to see that the adhesive does not ooze from the edge of the label and off-set on to other films wound in the same roll. The same precaution applies when tape joins are being made.

Post-Processing Operations

When 35 mm. reversal colour films have been processed, it is usual to cut the

244

films into separate frames and to mount each one in a 2 × 2 in. card or plastic mount ready for projection. *Mees*[10] once said:

> The use of miniature colour pictures was greatly accelerated when the Kodak Company mounted all the customers' pictures in cardboard frames as part of the processing service.

Certainly, in Britain and in the US, almost all users of 35 mm. colour reversal film expect to find their transparencies mounted when they are returned from processing. However, for many years in Germany and certain other Continental countries, Agfa simply return processed Agfacolor films in their original lengths and customers bought their own mounts from dealers. This practice

Recessed Area

Adhesive Area

Fig. 123 Kodak card-mounts for transparencies require heat sealing, but have a recessed area within which the frame of film is free to expand and contract

seems now to have changed, and Agfa are mounting transparencies in the ordinary course of processing.

CARD-MOUNT PRODUCTION. The mounts made and used by Kodak are of the heat seal type with a spacing frame sandwiched between the two outer halves of the mount. Thus the heat sealing area does not extend towards the picture aperture sufficiently to trap the transparency itself, because the inner frame forms a kind of nest in which each piece of film is placed. This precaution is necessary in order to allow the transparency to expand without buckling when it is subjected to the heat of projection.

The vast quantities of mounts required by Kodak processing stations through-

245

out the world led to the need for very high production speeds, and mount making machines have been devised that are capable of making 240 mounts a minute.[11]

In the early fifties in the US, the only colour transparency film available, other than Kodachrome, was Anscochrome—much of which was processed by Pavelle Color Inc. in New York. While he was working at Pavelle, *Seary* invented a heat seal card mount that did the same job as the Kodak mount but was cheaper to produce. The Seary mount[12] located the transparency by means of a series of small tabs embossed in one side of the card mount surrounding the

Fig. 124 Eastman Kodak make semi-automatic mounting machines for use in their own processing stations. As with all amateur pictures on 135 films, the location of each frame cannot be relied upon so the operator of this machine must always be ready to reposition the film before cutting off any transparency

picture aperture. But when folded and heat sealed only the area outside the locating tabs was sealed—thus leaving the transparency space in which to expand and contract as in the Kodak mount.

MOUNTING MACHINES At first, quite simple manually operated heat sealing presses were used for mounting processed transparencies, but as the popularity of 35 mm. reversal film grew through the fifties so the requirement for mounting increased, and with this expansion came the need for faster and more automatic mounting machines.

246

If the spacing of all amateurs' transparencies were uniform along the lengths of the films on which they were exposed, it would be possible to devise fully automatic mounting machines to operate at very high speeds, but in practice, the frame spacing of many films is irregular. This is sometimes due to the design of the film transport in certain cameras and sometimes because the film is not always wound on properly by the amateur. In either case, the resulting film cannot be fed automatically through the film transport mechanism of a mounting machine, but must always be checked and where necessary adjusted by a skilled operator, who must never cut any transparency from its roll until the image is properly positioned.

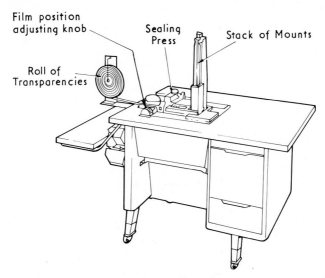

Fig. 125 The American version of the Seary automatic mounter is used with cardboard mounts, but models made by Seary-Michelbach in Germany can be used with hinged type one-piece plastic mounts

Apart from the machines used by Eastman Kodak, several independent companies designed and built automatic mounters. One of these was *Seary*, who together with his partner *Michelbach* has been producing these highly specialised machines for more than a decade. The basic engineering concept of the Seary-Michelbach machine is described in the relevant patent[13], but by the time Seary machines came to be sold in Europe, particularly in Germany, the vogue for plastic mounts had begun and the necessary modifications to the American version of the mount were made by *Kleinschmidt* of Seary-Michelbach GmbH.

Since 1956, *Byers* of Portland, Oregon has also been designing and manufacturing automatic mounters, and the so-called Bypak Auto-Mounter sold by Pako was in fact designed by *Byers*.

In the early sixties Perutz[14] in Germany decided to introduce moulded plastic mounts as an aid in selling their reversal colour film. At that time Agfa were not mounting Agfacolor film and Kodak were using the paper or card mounts they had always used. The new type of mount called for a new design of mounting machine, and one was designed and made by Colorclip—a machine which took two separate halves of the mount and combined them with a transparency in between.

Whether the use of plastic mounts greatly influenced the sales of any particular colour film is difficult to say, but certainly the vogue started by Perutz has persisted in Europe, and all Agfacolor transparencies are now returned mounted in plastic mounts.

Fig. 126 This one-part plastic mount is hinged so that it can be handled in much the same way as a card mount in suitably modified machines such as the Seary Automatic Mounter

Agfa have designed some of their own mounting equipment, but they also use mounting machines made by Jost of Essen using two part mounts in much the same way as Colorclip.

GEIMUPLAST An interesting approach to the troublesome problem of efficient high speed film cutting and mounting was introduced in 1966 by Peter Mundt KG. This new system requires the use of an ingenious type of mount in conjunction with a relatively simple mounting machine. The mount, which can best be understood from a diagram, is made from two moulded plastic parts ultrasonically welded where required. In use, two pins in the mounting machine spring open one edge of the mount so that the end of the transparency film can be inserted, then, with the film partly in the mount, the frame is cut off and the

248

piece of film is pushed into position, wholly within the mount. Removal of pressure from the opening pins is sufficient for the mount to spring back into the closed position without further sealing. Mounts are supplied stacked ready for use in "sticks" of 500.

Pako are agents for the Geimuplast mounter in all countries other than those in the European Common Market, and they sell the system under the name Pakon.

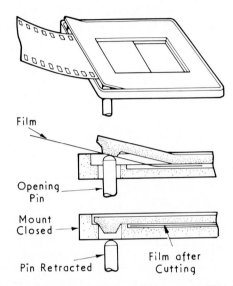

Fig. 127 Peter Mundt introduced the Geimuplast mounting system in 1966. These diagrams show how the mount is sprung open to insert the transparency

MILLS-DYCEM MOUNTERS The British made Mills-Dycem MK IV Automatic Slide Mounter handles all 135 and 126 hinged type mounts (not two-part) whether they require heat or are self-sealing. A numbering and dating unit is supplied as standard, and the output is claimed to be 3000 slides per hour—no doubt with film bearing perfectly spaced images, intended for duplicate transparencies.

HAND OPERATED MOUNTERS We have already seen that the introduction of Ektachrome film brought many finishers into reversal colour film processing for the first time and that some of them operate the process on a relatively small scale. Consequently, these same finishers need low capacity hand operated slide mounting equipment, of which there is a wide choice.

Among the hand operated slide mounting presses available commercially in the US, are the Kodak Model 1, the Seary Model 2, Byers 3U6 (also sold by

249

Pako) and the Slide Sealer made by the Heat Seal Company of Hollywood. In Britain, Kodak Limited make their Slide Mounting Press for heat sealing transparencies in Kodak Ready-Mounts. This press, like most others, has interchangeable jaws, enabling it to mount 135, 126 and super-slide transparencies, all of which go into 2 × 2 in. mounts.

Eastman Kodak's Model 3K is a semi-automatic machine with an output somewhere between a simple hand operated press and a fully automatic mounter. In this machine, the framing adjustment is made with an overriding knob while mounts are advanced automatically into position one by one under each transparency. The film cutting knife is also power driven so that much less effort is required of the operator.

Economics of Slide Mounting

The economics of slide mounting have not always been properly understood, and it is as a result of this more than anything else that half-frame and other non-standard film formats have failed to retain a share of the market that some camera manufacturers expected they would have.

Any film manufacturer who is also providing a pre-paid processing service for reversal colour film, must assume that the film will be used in a camera that produces the nominally accepted number of exposures of a standard size. In other words, either 20 or 36 frames (36 × 24 mm.) on a cassette length of 35 mm. film. If the film is used in a camera which allows twice as many exposures on the length of film the manufacturer will be quite happy to process it, but not at all ready to mount twice as many frames for the same amount of money. This problem has never been properly solved, and as a result the popularity of half-frame cameras has declined. Perhaps the Japanese camera manufacturers did not realise how well established the practice of pre-paid processing had become in the Western world.

Splitting and Spooling Double 8 mm. Film

When Double 8 mm. film has been processed it must be split, joined and spooled ready for projection before it is returned to the customer. The operations involved in forming a continuous single width of film from a double width camera film are described in a Kodak patent[15] dealing with equipment designed for the job:

> After the film is processed, the photo-finisher slits the 16 mm film into first and second 8 mm strips, each having a start end and a finish end, attaches the start end of the first strip of one reel and the finish end of the second strip of another reel, and winds the strips thereon.

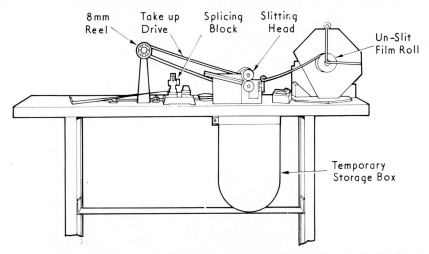

8mm Reel — Take up Drive — Splicing Block — Slitting Head — Un-Slit Film Roll

Temporary Storage Box

Fig. 128 A layout proposed by Kodak for a slitting and joining bench suitable for finishing double 8 films after processing

After the strips are completely wound on the reels, the photofinisher takes the free ends of the strips from the reels, which are the finish end of the first strip and the start end of the second strip, and splices them together. The photofinisher then unwinds the first strip

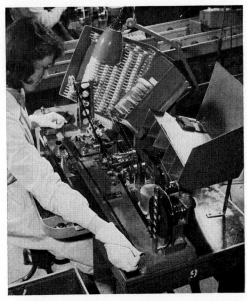

Fig. 129 This operator is slitting and splicing the two halves of double 8 cine film. The processed roll is on her right and the rotary slitting knife is immediately in front of her, while the splicer is near her left hand

from its reel on to the other reel so that the entire length of 8 mm film is now wound on to a single reel, having the finish end of the second strip attached to its hub. The finished end of the first strip and the start end of the second strip spliced together, and the start end of the first strip free. The photofinisher then splices a leader to the start end of the first strip and the film is ready for packing for shipment back to the customer.

While this may seem a lengthy way of explaining what is to be done it does serve to show that this sequence of operations cannot be carried out in much less than a minute, and to achieve that time, skilled operators using well designed equipment will be required.

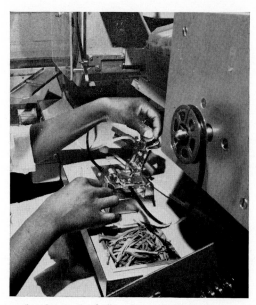

Fig. 130 No slitting operation is required after Super 8 film has been processed, but a length of projection leader has to be spliced to the leading end of the film

Super 8 and Single 8 Systems

While it is very unlikely that Double 8 mm. equipment will become outmoded as quickly as once was thought possible, it is certain that the consumption of film in Double 8 mm. form will steadily decline. But the photofinisher who wishes to be in the 8 mm. processing business cannot ignore Super 8 and therefore has to face up to the prospect of running two formats for several years to come. This outlook would be encouraging if it were more obvious that the size of the market was increasing.

Fuji, who introduced their well conceived system of Single-8 film in easy load cartridges at about the same time as Kodak launched Super 8, have never had

252

more than a few processing stations equipped to handle their film. This obviously restricts the spread of the system, and in turn discourages any independent finishers from investing in it.

REFERENCES

[1] GEHRET, C. H. "Processing Ektachrome E4". *B. J. Phot.* Vol. **116**, 25th April, 1969, pp. 396–397.

[2] USP 2,113,329.

[3] KOSHOFER, GERT. "30 Years of Modern Colour Photography". *B. J. Phot.* 29th July, 1966. pp. 644–649.

[4] USP 1,690,616.

[5] USP 2,210,880.

[6] CHATWIN, T. H. "Friction Drive for Motion Picture Processing Machines". Brit. Kinematography Sound & Television. July, 1968, pp. 220.

[7] FEICHTINGER, C. A. and WITHEROW, L. R. "A New Demand-Drive System for Processing Machines Using Spring-Centered Spools". *J.S.M.P.T.E.* Vol. **78**, Sept., 1969, pp. 712–717.

[8] USP 2,967,473.

[9] USP 3,011,936.

[10] MEES, C. E. K. *From Dry Plates to Ektachrome*, 1961, published by Ziff-Davies Publishing Company.

[11] BP 749,236.

[12] USP 2,495,142.

[13] BP 920,683.

[14] BP 960,447.

[15] BP 968,123.

X. PRINTING FROM COLOUR TRANSPARENCIES

There have been periods in the history of colour photography when it was thought that the best way of obtaining colour prints for the amateur photographer would be to start with a colour transparency. The most obvious advantage of working in this way is that the customer is able to assess the results of his exposures more quickly and cheaply than by having prints made from colour negatives.

But despite the undoubted attraction of this method of working, there are several technical reasons why in general the photographer is not likely to obtain results that are as good as he would get if he simply used colour negative film when exposing his pictures.

When a colour transparency is converted into a colour print, colour saturation is lost because of the inevitable reduction in gamma involved, while colour reproduction is degraded as a result of the imperfect spectral sensitivities and dye absorptions of the dyes used in colour films and papers. These dye deficiencies can largely be overcome by the inclusion of coloured masking in a colour negative material, but masking dyes cannot be employed in a colour transparency film that is intended for direct viewing or projection.

To the true snap-shot photographer another disadvantage of using a reversal colour material as a camera film is its limited exposure latitude when compared with a modern colour negative material. For most amateurs, greater exposure latitude means more good results per roll of film and is therefore a very important factor in determining his choice of procedure.

Despite these limitations the fact remains that because the popularity of colour slides is so great, a demand for colour prints from transparencies continues and even though it may not now increase, photofinishers will be required to fulfil it for a long time to come.

There are two basic methods of making colour prints from transparencies; by printing on to direct reversal colour print material and by making intermediate colour negatives for printing on to colour negative/positive paper. Both methods have their place in photofinishing and the choice usually depends on the volume of work, although in the past it has sometimes depended simply on the availability of one or other of the special materials required.

Even film manufacturers operating finishing services have used several different methods of making prints from transparencies at different times. Around 1940 the Kodachrome process was used by Eastman Kodak for making colour prints on white-pigmented acetate film base. These prints had no white borders and were recognisable by their rounded corners. Later Eastman Kodak adopted the internegative system of making prints from transparencies, and in

the US this procedure continued for some years. But finally Kodak changed once again to direct reversal material.

Anscocolor Printon

In 1943 Ansco produced a reversal colour material called Printon, the emulsions of which were coated on a white pigmented film base just like Kodak's Mini-color (Kodachrome) prints of that time. A film base was often used for early direct reversal print materials in order to minimise the risk of mottle arising

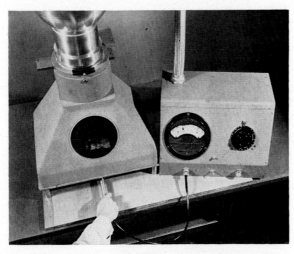

Fig. 131 In 1945, Pavelle Color Inc., were using a pre-grading system to determine correct exposures from colour transparencies onto Ansco's direct reversal Printon material

from the lower image forming stratum of the emulsion reflecting any unevenness that might be present on a paper surface. Direct reversal colour print materials can be made satisfactorily on a paper base, but in the early attempts to make these materials it was safer to use pigmented film base.

PAVELLE'S PRINTON PROCESSING EQUIPMENT Unlike Kodak, Ansco decided not to establish a processing service under their direct control, but to assist Pavelle Color Incorporated to operate the process in New York. Thus Pavelle became the first of the large independent colour photofinishers with a modern laboratory equipped with special purpose colour printers and large, high-speed, continuous print processing machines. The processing equipment made by Pavelle was extremely advanced for an independent finisher of the time, and some of it has been described by *Kohlman*.[1] The Pavelle[2] colour printers were used in conjunction with a grading or coding device in which each transparency

255

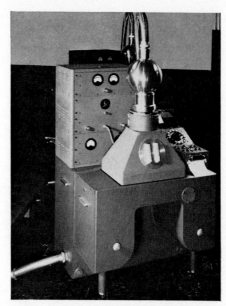

Fig. 132 The Pavelle printers were operated in white light, and they incorporated automatic density integration

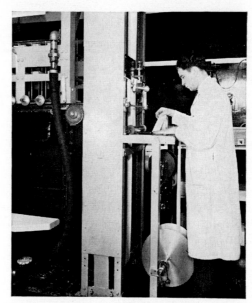

Fig. 133 Exposed rolls of Printon material were spliced together at the feed-on end of Pavelle constructed processing machines

256

was evaluated. A ratio or coding value was obtained by relating the total light transmitted by each transparency to the light transmitted by what was judged to be the most important subject area. The area selected for local measurement was located by observations of a projected image and by means of a movable photo-cell probe, while integrated light from the whole transparency was collected by a second photo-tube via a reflecting prism. The two readings were fed into a zero-centre meter and any deflection was translated into what nowadays would be called plus or minus corrections.

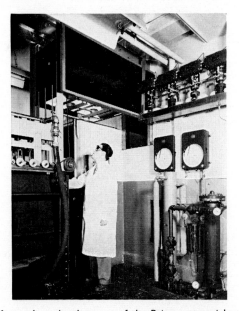

Fig. 134 Re-exposure before colour development of the Printon material was made in an overhead light-box located between the dark and light sections of the machine

COLOUR CORRECTIONS The comparative measurements made by Pavelle were useful in that they improved the yield of prints having acceptable density, but any corrections for colour balance were determined by visual evaluation by the grader. Here of course is the distinction between printing from colour transparencies and printing from colour negatives. There is little that can be recognised in a masked colour negative, whereas a transparency is completely recognisable and should normally be reproduced as accurately as possible when printed. Whenever colour corrections are necessary because of some obvious off-balance condition in a transparency, it is usually fairly easy to decide in what direction and to what extent the correction is required.

257

In Britain, Ilford Limited, who were making a non-substantive 35 mm. reversal colour film called Ilford Colour D, entered the amateur colour print field in 1952, using a silver dye-bleach material rather than one depending on colour development. Like Kodak and unlike Ansco, Ilford decided to operate their own photofinishing service and because no suitable equipment was available they designed and built printers and processing machines of their own.

One feature of any silver dye-bleach material that presents a problem to the photofinisher is its extremely low sensitivity. This low speed results from the fact that complementary coloured dyes are mixed with each of the three emulsions, so that, for example, the blue sensitive layer contains a yellow dye throughout its thickness.

In order to achieve reasonable production rates on the printer they made for exposing this slow material, Ilford found it necessary to use a Xenon arc as a printing light source—a somewhat revolutionary approach at that time. In an attempt to automate the printing operation as far as possible, Ilford eventually designed and constructed a printer[2] incorporating a $2\frac{1}{4}$ kilowatt Xenon arc and an automatic transparency feed device. This printer was capable of making between 1000 and 1200 exposures an hour, despite the abnormally low speed of the print material.

The Ilford printer was designed to be worked by two operators—one of them feeding card-mounted transparencies and information into the printer, and the other removing the printed transparencies and replacing them in their individual envelopes. There are two kinds of basic information required about each transparency before it is printed: the film type or brand and the number of prints required. To convey these two pieces of information into the printer it was decided to use five-hole punched tape—the first line of each pair of holes controlling the correction filters and the second line operating a uni-selector to control the number of prints exposed.

In use, an operator sitting at one side of the machine commenced work by inserting a transparency into the gate of a magazine that was capable of storing up to 200 transparencies. A transparency could not be accepted into the magazine until the requisite two pieces of information had been punched in the tape. The reading from the first of each pair of holes in the tape was used to control solenoid operated filter flags for film type correction, while the second line set up a uni-selector to control the number of prints that were to be made. The duration of exposure of each print was determined in the usual manner by integrating a fixed proportion of light transmitted by each transparency.

PRODUCING WHITE BORDERS If no special steps are taken when making direct reversal prints from transparencies, the margin surrounding the finished print is black because of the absence of exposure. Both Kodak and Pavelle had trimmed

258

off these rather funereal borders and sold their Minicolor and Printon prints without borders of any kind. Ilford decided to provide a white border and consequently had to arrange for a second exposure to fog the print surround without affecting the image area. This was done at a separate, second exposure position at which an opaque metalised glass plate protected the centre image area while allowing the surrounding borders to receive a flash exposure sufficient to completely fog all three emulsion layers.

COLOUR CORRECTION OF PRINTING LIGHT For reasons that have already been given, it is usual practice when printing from colour transparencies on to reversal colour print materials, to make colour corrections—either to compensate for batch to batch differences in the print stock or for differences between individual

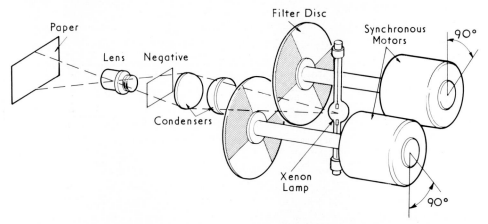

Fig. 135 This arrangement of synchronously rotating filters used in conjunction with a Xenon lamp, allows continuous adjustment of the colour of a printing light source by suitable rotation of either or both motors

transparencies—by using suitable combinations of low density subtractive filters. But by these means it is often difficult to obtain precise correction without a wide choice of filters having very small density differences. Even when satisfactory correction is achieved, filter fading further aggravates the problem. On the Ilford printer, these problems were largely overcome by using a Xenon light source in conjunction with a system of rotating filters.[4]

The output of light from a gas discharge lamp, when energised by alternating current, rises to a maximum brightness and then fades almost to extinction in every half cycle of the current supply. If a filter sector disc having alternate coloured and clear areas is rotated by a synchronised motor running at a speed that is related to the cycle frequency of the source, then the colour of the integrated light transmitted by the filter depends on the phase relationship between the lamp and the filter. When the phase relationship between the light source and the disc is altered, different areas of clear and coloured filter are present in

259

the beam during the peak output of each pulse of light from the lamp. In the extreme positions it can be arranged that either a coloured or an uncoloured sector is centrally in the beam during the peak brightness of each half cycle.

The phase relationship between the light output from the Xenon source and the sectors of the rotating filter disc can be changed by rotating the body of the motor about its axis by means of a worm engaging in a gear surrounding the motor casing. Usually two motors driving two filter discs in two of the three subtractive colours are required to adjust the colour of the source to suit any particular batch of printing material.

This system of correction works over a wide range of adjustment when discs are used with relatively dense coloured sectors, but in practice an adequate range of extremely precise adjustment can be obtained by using two discs having coloured areas of approximately twice the static density required to balance any particular batch of material. The discs can be easily made from dyed gelatine coated film, and a selection of them can be held available in a variety of densities of all three subtractive colours. Although the discs fade like any other filters, the useful area of filter is much greater and in any case, re-positioning of the motors can compensate for considerable change.

Adjustment of the colour of illumination by means of the rotating filters was carried out with the aid of a built-in photocell unit. This meter enabled ratio readings to be taken sequentially through red, green and blue filters while an additional reading made without filters over the photo-cell allowed white light readings to be made for setting the brightness level.

Kodak Reversal Colour Prints

A year or so after the introduction of the Ilford reversal colour print service, Kodak Limited in Britain launched a photofinishing service providing colour prints from 35 mm. colour transparencies. The direct reversal colour print material used by Kodak was initially made in France by Kodak Pathé and was the first reversal colour print material to be coated on a paper base. Being a substantive colour coupler type of material it was processed in much the same way as Ansco's Printon. But while Printon was available to independent finishers, the Ilford and the Kodak reversal print materials were not. This remained the position for some years, and in fact before they finally made reversal colour print material freely available, Kodak offered the finisher a colour internegative film with which he could make intermediate negatives from transparencies before using the negatives to make prints on negative/positive colour paper.

INTERNEGATIVES To the smaller photofinisher the advantages of using internegatives are considerable. The exposed film can be processed in modified

260

C22 chemistry (using a separate developer) and thereafter, the colour inter-negatives—which are masked like Kodacolor camera film—can be printed on a normal integrating colour printer adjusted to suit the particular characteristics of the internegative material. By working in this way there is of course no problem in producing white borders. Furthermore, the masking dyes in the internegative material enable a considerable degree of automatic colour correction to take place—something that is not possible when prints are made directly on to a reversal print material.

Nevertheless, the theoretical benefits of using a masked internegative material are only fully realised if the material is carefully exposed and processed. This is particularly true of Kodak's Internegative film which is a very sophisticated product having no less than six emulsion layers as well as various isolating and filter layers. Each pair of emulsion coatings comprises a normal and a high contrast layer of the same sensitivity.

The purpose of an internegative film when printed from a transparency is to produce effectively the same densities in the internegative as would have been produced on a negative exposed in a camera to the original subject. In order to come near to doing this, a material is required that will increase in gamma as exposure increases. This ensures that the lowered gamma that results from increased exposure of a transparency film is offset by the built in characteristics of the internegative film. However, because the gamma of the internegative is so sensitive to exposure, the exposure given is dependent upon the correct judgement of the contrast as much as the density of the original transparency.

CONTRAST CORRECTION WITH INTERNEGATIVES The particular tone scale of Kodak Internegative film allows considerable control of the overall reproduction by variation of exposure when the internegative is made. Increasing exposure places more of the transparency image on the upper, contrasty end of the inter-negative scale—making possible the production of a normal print from a flat transparency. Conversely, decreasing exposure when making the internegative reduces overall constrast of the resulting negative and this in turn results in a normal print from a contrasty transparency.

It is quite possible to modify the colour balance of the colour print while exposing the internegative, but in practice, unless the transparency is seriously out of balance or is a potential subject failure, it is preferable to leave the correction to the integrating system of the colour printer.

In general, internegatives require a different printer setting than original camera negatives and are usually printed on a channel set aside for the purpose.

Internegative Printers

Internegatives can be exposed either by contact or by projection, but because most transparencies reach the finisher in mounts of one kind or another, it is

P.T.E.—R*

more convenient to project them on to internegative material without removing the transparencies from their mounts.

Eastman Kodak make a Slide Film Kit for use with their IVC and IVS colour printers. The kit comprises a 35 mm. film magazine taking 100 feet of film, together with a relay assembly which provides a pulse to automatically wind on the necessary length of film between exposures. The film magazine is mounted at the paper plane of the colour printer and can be used for either internegative or print film.

The simplest way of setting up a printer for exposing internegatives is to use the Kodak Internegative Test Kit, comprising a standard transparency, a standard internegative made from the transparency and a reference print made from the standard internegative. The exposure time for internegative material should not be less than one second and an average time would be two seconds using the N (normal) density setting on the printer. The +2 and −2 density buttons will provide suitable changes in exposure times to effect corresponding changes in contrast when required.

PAKOPY AUTOFOCUS PRINTER The Pakopy printer made by Pako is specially designed for making internegatives from transparencies, although it can also be used for making duplicate colour transparencies. The Pakopy is an autofocus projection printer using a 90 mm. lens to image the original transparency on to film contained in a 100 foot capacity magazine. Flatness of the original transparency film is achieved by sandwiching the picture area of the film between glass—while the transparency remains in its mount. Three separate adjusting timing circuits are provided in order to best utilize the contrast control that is a feature of Kodak Internegative film. The three basic exposure times are: 0·75 secs., 1·5 secs. and 3 secs., and these three exposure times are maintained regardless of degree of magnification by using an appropriate supplementary neutral density filter mounted in a manually rotated filter disc. A blower-cooled lamphouse contains four 200 watt projection lamps, the light from which is integrated in a mixing box.

Pako claim that one operator can expose 500 internegatives an hour with the Pakopy which can be used with film magazines accepting 35 mm., 46 mm. (127) and 2·423 in. (120) film widths.

Homrich Printer

Another 35 mm. projection printer designed for internegative and duplicate transparency production is made by Homrich of Hamburg. The standard magazine on the Homrich printer takes 400 feet of film, although a larger magazine holding 12,000 feet can be used for quantity production—particularly of duplicate slides. Any length of film can be exposed and removed

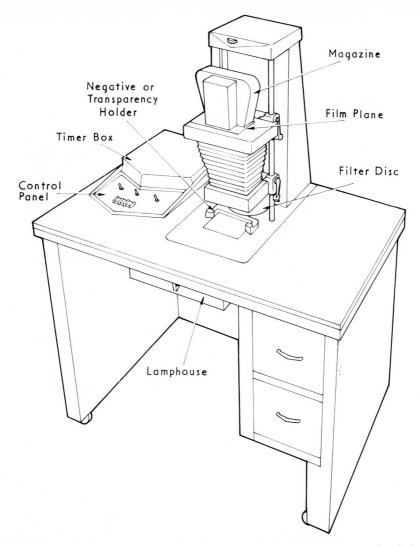

Negative or
Transparency
Holder

Magazine

Film Plane

Timer Box

Filter Disc

Control
Panel

Lamphouse

Fig. 136 Designed especially for making internegatives from colour transparencies, Pako's Pakopy printer can also be used for the production of duplicate transparencies. The Pakopy permits the use of mounted transparencies—provided they are not already between glass

at any time. The "camera" fitted to the Homrich printer has a mirror reflex and a focusing magnifier working on an extremely fine-grained ground glass screen.

The lens position can be adjusted in all directions in the horizontal plane, while the negative carriers can be rotated to allow correction of horizons. These latter adjustments are of somewhat academic interest to the photo-

finisher, who cannot usually afford the time to deal specially with individual transparencies, but they are useful when producing long runs of duplicates from the same original.

The standard light source is a 150 watt opal tungsten lamp, but an Agfa Colour Head can be fitted in its place. Film transport is motorized and while the film is moving the pressure plate is raised and the film is supported only by guide rollers.

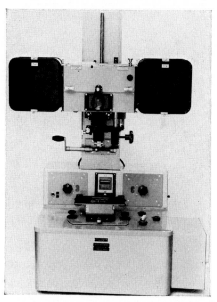

Fig. 137 The Homrich printer can be used to produce either 18 × 24mm or 24 × 36mm internegatives or duplicate transparencies from original negatives or transparencies of all sizes from 18 × 24mm up to 9 × 12cm

ORIENTATION OF FILMS When making internegatives, the emulsion side of the transparency should face the lens. When printing the internegative on to paper, the emulsion side of the negative should face away from the lens. By working in this way both original negatives and internegatives can be printed on the same printer without refocusing.

Processing Kodak Internegative Film

A special colour developer is available and should be used if internegative film alone is to be processed. The working developer is prepared by converting Kodak Internegative Replenisher by dilution with water and the addition of

264

Internegative Starting Solution. C22 solutions are used for the remainder of the process.

In practice, some photofinishers process their Kodak internegative film in their standard Kodacolor C22 chemistry, and this is reasonably satisfactory so long as the proportion of internegative film does not exceed about 20 per cent of the throughput of Kodacolor camera films. When the C22 developer is used, the time of development of internegative film is less than that required for Kodacolor films.

It should be remembered that the effective contrast of Kodak internegative material is controlled by varying exposure time and not by altering development. Internegative control strips and a test kit for determining correct filter pack and exposure conditions are available from Kodak.

Direct Reversal Prints

Despite the advantages that the intermediate colour negative offers a photo-finisher, the fact remains that finishers with a large demand for prints from transparencies, including the major manufacturers' laboratories like those operated by Agfa and Kodak, seem to prefer to make their prints on direct reversal colour paper. There are at least two contributing reasons for this preference for direct printing. First, when the volume is sufficient, the economics of the method are more attractive than the alternative of using intermediate negatives, and secondly, a print made by direct exposure from a transparency is usually sharper than one made via an internegative.

There are two principal types of paper available—Agfacolor Reversal Paper CU111 and Kodak's Ektachrome paper—now produced on a resin coated paper base and designated RC.

PRINTERS FOR DIRECT REVERSAL Commercially available equipment for printing directly from transparencies on to reversal colour print materials are relatively straightforward in design and often are virtually the same machines as those produced for printing colour negatives—less their colour integrating facilities.

Typical of the printers available are Agfa's Colormator U, Eastman Kodak's Type IVb-3 and modified 5R, Pako's Pakotronic, Pavelle's A65R, Muller-sohn's Color Automat and Gretag's 311 series.

COLORMATOR U The Colormator U2BH Type 7601 accepts paper in 250 foot rolls, either 3 or $3\frac{1}{2}$ in. wide—and produces prints from either 24 × 36 mm., $1\frac{5}{8}$ in. square or $2\frac{1}{4}$ in. square transparencies. As with other Colormator printers, the U2BH is made in two versions—for light-room operation and for daylight operation. The daylight version requires light-tight feed and take-up paper magazines while the light-room printer requires a darkened room or cubicle for

loading and unloading paper, although the printer can otherwise be operated under brightly lit workroom conditions.

The U2BH incorporates a ground glass viewing screen on which a full size image of each transparency can be seen prior to exposure.

In order to avoid any necessity for removing transparencies from their mounts, the Colormator incorporates a self-centering slide holder which grips any kind of mount between V shaped clamps so that the plane of the transparency film itself remains in the correct position regardless of the thickness of the mount.

Border exposure units are available to suit either square or rectangular print formats. These are printing boxes incorporating rows of small low voltage lamps arranged along all four sides of the print area. A potentiometer controls the voltage and the brightness of the lamps so that the borders of the prints can always be adequately exposed.

EXPOSURE CALIBRATION Exposing conditions should be adjusted in two steps. First the basic level of exposure should be determined and then the colour of the exposing light should be adjusted by printing a ring-around series from a well balanced reference tranparency.

Basic exposure can be found by making a series of tests while varying the voltage supplied to the lamp. The resulting prints will almost certainly show some colour cast, but a reasonably accurate setting of the lamp voltage is possible by simply judging print density.

With the lamp set at the chosen brightness, a range of different filter packs must be tried in order to arrive at a correctly balanced print from the standard transparency. In assessing the adjustments that must be made to reach the required filter pack, it must be remembered that the addition of either one or two different subtractive filters to a pack results in the addition of this same colour to the print. In other words the opposite to what happens in negative-positive colour printing. There is never any need to have subtractive filters of all three colours in the same pack—because the combination of cyan, magenta and yellow filters results in the addition of grey—and therefore one or other of the filters is superfluous.

COLOUR CORRECTION When a print of correct density and satisfactory colour balance has been made from the reference transparency, the printer is set up for the straightforward production of prints from most other transparencies of the same brand. However, it must not be assumed that when transparencies of a different manufacturing type appear to be correctly balanced by visual inspection, prints made from them will also appear correct in colour. Some types of reversal colour film need colour correction even though there is no visual evidence to indicate the fact.

There are other reasons for introducing colour correction—as for example

when a transparency is obviously off balance because of some error in exposure or because of some fault in its processing. In the Colormator U printer, two ranges of density and colour correction buttons are provided; the density corrections being fed into the timing circuit and the colour corrections being made by introducing solenoid operated filter "flags". There are six buttons to each colour correction channel, and although they control subtractive coloured filters, the buttons themselves are coloured primary red, green and blue. Agfa have chosen this arrangement because the operator can then continue to think in terms of negative-positive practice; so that when a slide has a green predominance, a green key is pressed and this in turn introduces one of the magenta filter flags to produce a less green print. In the same way, a bluish looking transparency prompts the operator to depress one of the blue correction buttons, which in turn activates a yellow filter.

The exposure times of both picture and margin exposures can be precisely measured by plugging in the Agfa digital timer.

5S SERIES PRINTERS It is possible to equip the Kodak 5S series of printers with attachments for making prints from transparencies on Ektachrome paper. White borders 7/32 in. wide are flashed with a contact printing attachment similar to that used for message printing. Colour corrections are made by means of solenoid operated filter flags in much the same way as on the Agfa Colormator.

Reversal Paper Processing

Reversal colour paper processors are generally quite similar to other paper processors except that the processing sequence involves both black and white and colour development stages, and between the two there is a re-exposure step during which the residual silver halides are fogged so that they can be colour developed to form the necessary component positive colour images.

Agfa's Labormator U475 four track continuous processor is intended for use with Agfa's reversal colour paper, and is typical of the type of installation required for large volume production of direct reversal colour prints. The machine is quite like others in the Labormator range, having a combined capacity of about ten feet a minute ($2\frac{1}{2}$ feet a strand), but with more tanks and replenishment units than are required for negative-positive print processing. In addition, the Labormator U has a re-exposure section in which all four paper strands are fogged prior to colour development. A minimum light intensity of 2500 lux is necessary over a period of one minute. This exposure can be achieved by using 20-watt fluorescent tubes positioned not more than 12 inches from the surface of the paper strands.

The reversal colour paper made by Agfa is coated on a normal paper base,

267

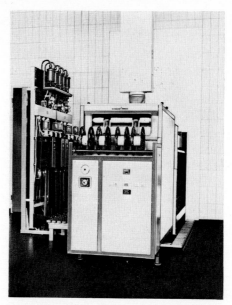

Fig. 138 The Labormator U475 processor is designed for use with Agfa/Gevaert direct reversal color paper. Four strands of $3\frac{1}{2}$ inch paper can be processed at a combined speed of ten feet per minute

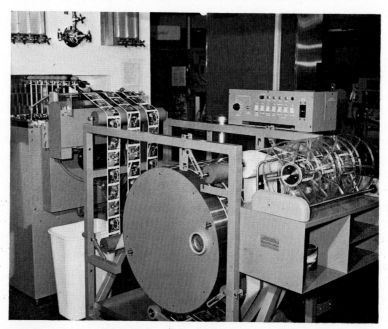

Fig. 139 Before the resin coated Ektachrome Reversal paper reaches the drying drum of the Kodak processor, the back of each strand is dried by being passed over an 'air-knife', to remove surface water

and can therefore be glazed on a drum if required, but Kodak's Ektachrome RC paper has a sufficiently glossy surface after drying, not to need glazing.

Duplicate Transparencies

The photofinisher usually has two kinds of demand for duplicate colour transparencies. First, there is a continuous, if small, demand from amateur photographers for duplicates of their colour slides, and then there is the larger scale requirement for bulk duplicating of slides for commercial applications.

KODACHROME II One of the most convenient materials for both these applications is Ektachrome Print Film although it should not be forgotten that Kodachrome II Film (Type 5081) can be used for making duplicates of the highest quality when the quantities justify it. Kodachrome film for duplication is sold at a price including processing (but not mounting) by Kodak, provided the lengths sent for processing are always greater than 15 feet. As Kodachrome is balanced for light of daylight quality, printing equipment used for exposing duplicates can conveniently be fitted with an electronic flash light source.

EKTACHROME REVERSAL PRINT FILM For the independent photofinisher, one of the reasons for choosing Ektachrome (Type 5386) Reversal Print film for the production of duplicate transparencies is that the exposed material can be processed in Ektachrome E4 chemistry together with regular Ektachrome films.

The most suitable equipment for making exposures on to duplicating film is the same as that already described for making internegatives, the Homrich, Bowen's and Pakopy printers being typical.

Exposure times and colour balance are determined by trial, with reference to a Kodak Test Transparency or some other properly exposed and properly processed comparison transparency. Corrections for off-balance originals can be introduced by modifications or additions to the basic filter pack. But, as with prints made from transparencies, the finisher is entitled to take the view that if he reproduces the original transparency reasonably accurately, he has done what was expected of him.

REFERENCES

[1] KOHLMAN, I. R. "Alarm Systems and Visual Aids Applied to Automatic Processing Machines". *Journal P.S.A.* November, 1956, Vol. **3**, pp. 123–126.
[2] VARDEN, L. and KRAUSE, P. "Photoelectric Controls for Colour Printing" *Electronics*, Vol. **19**, 1946, pp. 110–115.
[3] COOTE, J. H. AND JENKINS, P. "A Machine for High Speed Printing from 35 mm Colour Transparencies". *J. Phot. Sci.*, Vol. **8**, 1960, pp. 102–105.
[4] BP 824,977.

XI. QUALITY CONTROL SYSTEMS AND SERVICES

In recent years the term monitoring has been more frequently used in connection with the control of quality in photofinishing. This indication of a slightly different slant on the problem has probably arisen from the fact that most film and paper manufacturers now provide well tried packaged chemistry to suit each of their sensitized products—particularly their colour materials.

The concept of monitoring rather than controlling in the sense of frequently adjusting a process was evident in 1956, when *Glass* and *Cogan*[1] of Eastman Kodak considered the problems of reversal colour film processing by both non-substantive and substantive methods. Their opinion was that whereas processes such as Kodachrome do require chemical adjustments based on frequent analysis of the many developers used, a substantive colour film such as Ektachrome

> Has built into it most of the features required for good contrast, speed and colour balance control.

So that

> If the mixing has been properly done and if the chemical kits have been properly packaged, reasonable photographic results are to be expected.

Poor Quality of Early Colour Finishing

Unfortunately, things were not really as simple as *Glass* and *Cogan* indicated, for just ten years later, *Marshall* of Kodak Limited was reporting[2] that in a survey of Ektachrome processors during 1964, no less than 45 per cent of the laboratories produced results that were out of control.

In the US at about the same time, *Zornow*, Vice President of the Eastman Kodak Company, wrote[3]:

> The findings of the consultants retained (by the MPDFA) to judge (Kodacolor) prints obtained anonymously from fifty finishers, showed only 15 per cent to be of good or excellent quality, and that only 25 per cent of the finishers sampled made an effort towards colour correction.

Clearly the situation called for action, and in the US, the MPDFA Quality Control Committee inaugurated a photofinishing quality testing programme for Kodacolor processors throughout the US and Canada. At the time this testing programme was first offered, the fifty finishers who had participated in the survey referred to by *Zornow*, had provided much disturbing, though valuable evidence. The following bar charts indicate the most important findings of the 1964 Pilot Study.

270

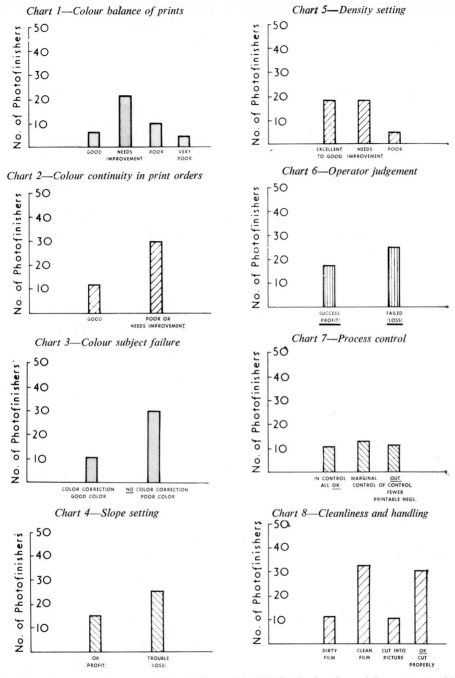

Fig. 140 These charts show some of the findings of the MPDFA Quality Control Committee in 1964

271

It should not be thought that because the photofinishing industry in the US in 1965 decided to take positive steps within its own organisation to improve the quality of the products sold by its members, that the manufacturers of sensitized materials had been indifferent to the quality of the end products that reached the public.

Both Ansco and Kodak in the US and Kodak and Ilford in Britain had introduced monitoring systems to suit their black and white films from the time that continuous roll paper printing had been introduced in the early fifties. But of course these were quite simple systems designed merely to maintain a reasonably constant black and white negative quality—a simpler task than monitoring the processing of a reversal colour film and very much simpler than controlling the combined variables involved in colour negative processing and printing and colour paper processing.

There are in fact important distinctions between the performance involved in processing reversal colour films and the more complex technical and economic considerations involved in the production of amateurs' colour prints. It costs little if any more to process a reversal colour film correctly than to process it badly, but when it comes to making colour prints, the economics of printing and processing concern every laboratory, because there is always a balance to be struck between market acceptability and the desired profit ratio. But any photofinisher taking the longer term look at his business must agree with *Marshall* when he says:

> Poor photofinishing quality is to the detriment of the whole photographic industry. Even if work of indifferent quality appears to be selling easily enough now, this is an extremely short-sighted attitude.

Quality Control Defined

Kodak has summed up the task of controlling a colour process in these terms:

> A quality or monitoring system for colour negatives, transparencies or prints requires establishment of a "reference" (standard) and systematic comparison of daily production to this reference. With transparencies or prints the monitoring system can be based partially on visual comparison to a single reference provided that the quality control personnel have adequate experience. With colour negatives visual examination would be inaccurate, whether personnel are highly trained or not.

Controlling Reversal Colour Film Processing

If we first consider the more straightforward task of processing a reversal colour film such as Ektachrome, we find that the evidence is that poor quality results are most frequently caused by the exhaustion of processing solutions as a result of

272

inadequate or incorrect replenishment. Errors in chemical mixing, solution agitation, wash water flow rates also contribute to poor results, while solution contamination is a fairly frequent cause of trouble.

Some of the faults in processing or handling reversal colour films can be identified visually, particularly if each new test strip is compared directly with a standard and not merely with the preceding strip. But visual inspection does not often detect trends or drifts as quickly as they can be discovered by measurement. Certainly the mere processing and measurement of sensitometric strips will not of itself provide any real indication of the state of a process. To be informative all measurement must be promptly recorded and carefully interpreted. All too often a junior assistant is taught to use a densitometer and plot the readings and is then expected to understand the significance of the results. This is unreasonable, for an experienced senior technician should always be responsible for interpreting and acting upon sensitometric data.

In an attempt to assist in improving the attitude of those finishers who either do not or will not understand the importance of monitoring by measurement, *Marshall* has coined the word UMPIA—as a reminder of the five stages involved:

1 *U*se control strips regularly.
2 *M*easure the appropriate steps with a densitometer.
3 *P*lot the results on a control chart.
4 *I*nterpret the plot and determine whether it is necessary to:
5 *A*ct in order to correct any out of control situation.

Control Strips

All manufacturers of colour materials that are processed by independent photofinishers supply exposed control strips to facilitate the maintenance of satisfactory production quality. The normal practice is to sell pre-exposed strips in sets of 25 or 30 together with a processed reference strip, made on the same batch of film or paper and processed under optimum conditions by the manufacturer.

The make-up of each manufacturer's strips varies somewhat according to the types and extent of the information they are intended to give. But there has been a tendency in recent years to supply simplified control strips so that they can be quickly measured and interpreted while still providing all relevant information.

The manufacturer chooses the emulsion batches he uses for control strips to be representative of the majority of films he has sold. To prevent changes in the latent image already present in the strips, they are refrigerated during storage.

Control strips intended for monitoring reversal processes often contain an

easily recognisable subject such as a portrait in addition to a scale of greys. The pictorial content of such strips does tend to make visual comparisons of control strip and reference strip more useful by augmenting the measurement of densities that should also be made. The visual evaluation of colour negatives—particularly those that are masked—is, however, extremely difficult and imprecise.

Densitometers

Although densitometers that require visual matching of two halves of a comparison field are valuable and are relatively cheap, the tendency in photofinishing is to employ photo-electric instruments. The use of a visual

Fig. 141 Macbeth's Quantalog 400 densitometer is commonly used by photofinishers for monitoring both black and white and colour negative processing

densitometer can be tiring if it is used continuously and, as this can easily lead to inaccuracy and lack of enthusiasm on the part of the operator, either unreliable or irregular measurements may result.

There are several different types of photo-electric densitometer available and the photo-finisher who is making colour prints requires an instrument that can measure both transmission and reflection colour densities.

Suitable densitometers are made by Eastman Kodak, Welch, Gretag, Macbeth, and Baldwin. The Macbeth Quantalog 400 series and the Gretag have built in illuminated digital displays and filter turrets, making these instruments extremely easy to use.

Whatever type of densitometer is used, its zero reading should be checked at least once a day, and every person using the densitometer must be made aware of the importance of its proper use and care. Obviously any error in calibration or operation of the densitometer might be interpreted as a processing change

274

and thereby lead to corrective action that was not only unnecessary but which might lead to considerable confusion and loss of production.

From this it should not be thought that the measurements that are made on a particular densitometer are likely to be absolute density measurements. But provided calibration of the instrument remains constant, measurements made on it will be perfectly reliable for the purposes of the particular laboratory. Because densitometers do vary one from the other, it is essential to measure and

Fig. 142 The Gretag D3 transmission densitometer uses solid-state circuitry, and each of the four channels, red, green, blue, and white light, has an independent zero adjustment. The measuring area may be either 1 mm. or 3 mm. diameter, and each reading is held after the sample has been removed

plot the reference strip supplied by a manufacturer before using any of the accompanying control wedges. In the same way, when a new supply of control strips is taken into service, a new reference wedge must be measured and recorded to provide a fresh start.

It is generally unnecessary for a photofinisher to plot enough density steps to provide a characteristic curve on any of the materials he is processing. In fact he can obtain a measure of all the important parameters relating to the processing of a material with only a few readings and some simple arithmetic.

The reference and control strips supplied by Kodak for monitoring Koda-color-X film merely have a high-density and a low-density patch and minimum-density (Dmin) area. Agfa provide Agfacolor control strips with many density steps, but only four of them need to be measured and used for plotting.

275

RECORDING AND PLOTTING Eastman Kodak's recommended procedure with their reference and control strips is first to evaluate the reference strip by measuring the red, green and blue densities of the three patches and recording them on a suitable record form. Then, with coloured pencils, these reference values together with the reference code number are transferred to colour process record form No. Y55. It will be noticed that the HD values are not actually recorded. but only the HD minus LD values which are in fact a measure of the contrast of the process. It will also be noticed that in the example shown, the laboratory represented processed three control strips a day when the process was running well, but put through as many as four strips in five hours when results showed that contrast was dropping.

Obviously, it is necessary to have some idea of the probable or at least possible causes of a departure from the control limits set for a particular process. To assist finishers in gaining the experience necessary to form reliable judgments, most manufacturers are now publishing more detailed information on the symptoms resulting from processing errors and the procedures required for their correction. As an example of this, Eastman Kodak in their publication *Monitoring System For Processing Kodacolor-X Film*, show graphically the effects of variations and most of the factors likely to affect the performance of Kodacolor negative film.

One of the more common causes of difficulty in colour film processing is inaccurate or inadequate replenishment. For this reason, an important part of any control system is an accurate record of the quantity (area) of film processed. When many different sizes of roll films are processed together on a rack and tank machine, a tally of the area can only be made by knowing the numbers of films of each size that are contained in each batch. Kodak provides a form (Y60) on which to record these totals.

Variations in Development Time

With Kodacolor and any other colour films it should not be assumed that variations in development time will cause only differences in the contrast of the resulting negatives. Extending development in an attempt to compensate for under replenishment can lead to mis-match of the red, green and blue curves. Departure from standard developer temperature will also result in mis-matched curves, while insufficient agitation has even more dramatic effects, as will be seen from the diagram.

An important study of the effects of variables in C22 processing has been made by *Hannavy*,[4] who varied temperature, time and agitation in turn. His findings were summed up in these terms:

From these tests we must conclude that, of the three variables tested, agitation is the most important. Second in line appears to be developer temperature and third developing time.

276

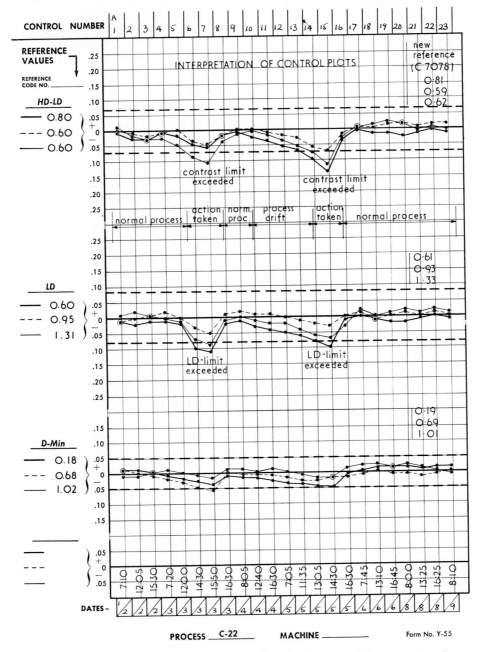

Fig. 143 This graph shows a typical sequence of results from several days processing of Kodacolor film

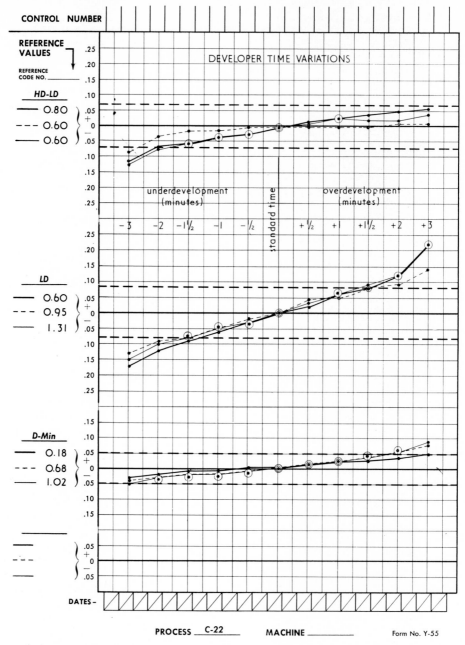

Fig. 144 These results have been obtained by deliberately departing from the recommended time of development

278

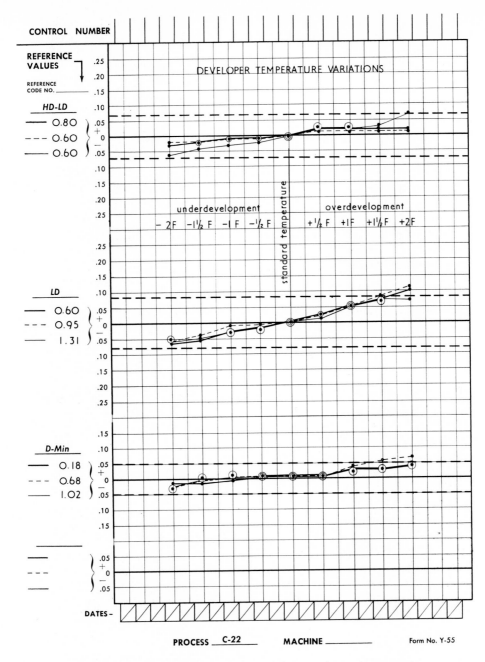

REFERENCE VALUES

REFERENCE CODE NO.

HD-LD

——— 0.80

- - - 0.60

——— 0.60

.25
.20
.15
.10
.05
+ 0
— .05
.10
.15
.20
.25

DEVELOPER TEMPERATURE VARIATIONS

underdevelopment

− 2F −1½ F −1 F −½ F

standard temperature

overdevelopment

+½ F +1F +1½ F +2F

LD

——— 0.60

- - - 0.95

——— 1.31

.25
.20
.15
.10
.05
+ 0
— .05
.10
.15
.20
.25

D-Min

——— 0.18

- - - 0.68

——— 1.02

.15
.10
.05
+ 0
— .05
.10
.15

.05
+ 0
— .05

DATES −

PROCESS ___C-22___ MACHINE _____ Form No. Y-55

Fig. 145 If developer temperature changes, these results can be expected

279

Agfa's recommendations for processing their colour negative film recognise the significance of the degree of agitation in these terms:

> Development time depends on agitation of the films in the processing system and may be varied between 7 and 9 minutes according to the results of sensitometric tests.

Because camera films carry exposures that cannot usually be repeated, the control of their processing is possibly more important than the control of paper processing—where prints can be remade if necessary. But in practice it is economically just as important for the photofinisher to process paper properly, because the success of his business must always depend on what it costs him in time and materials to give the customer satisfactory quality and service.

It is relatively easy to monitor the processing part of colour print production, but more difficult to separate the combined printing and processing operations that are responsible for print quality and yield.

Some, but not all manufacturers supply pre-exposed control strips for monitoring the processing of their colour papers. At one time, the Kodak companies held the view that the photofinisher should expose his own colour paper control strips in a sensitometer for monitoring the process alone, and on a production printer for monitoring printing plus processing. For this reason, pre-exposed prints were not available from Kodak Limited. However, Eastman Kodak do now supply process control strips and at least one of these should be processed, measured and plotted each day.

Sensitometrically exposed paper strips are intended simply to monitor the performance of the paper processing system. When it comes to the wider implications of printer plus processing results, the control strips can be made by using a production printer to expose a series of prints using a suitably devised negative. Paper manufacturers usually supply test negatives both for making paper control exposures and for setting up printers. The negatives often carry a portrait of a girl as well as a selection of specific neutral and colour density patches. Some of the models photographed by Kodak for their test negatives are printed so often by photofinishers that they have come to be known by their christian names.

ANSCO (GAF) CONTROL STRIPS The paper process control strips supplied by Ansco have six colour patches, one high and one low density patch for each of the subtractive primaries, cyan, magenta and yellow. In addition to the six colour patches, each strip has one black patch and one unexposed area intended for reading the stain (fog) level of the paper/processing system.

After the densitometer has been zeroed, Ansco recommend the following procedure:

1 Through the red filter, read the density near the centre of each of the cyan, black and unexposed patches of both the reference strip (supplied by Ansco) and the processed control strip.

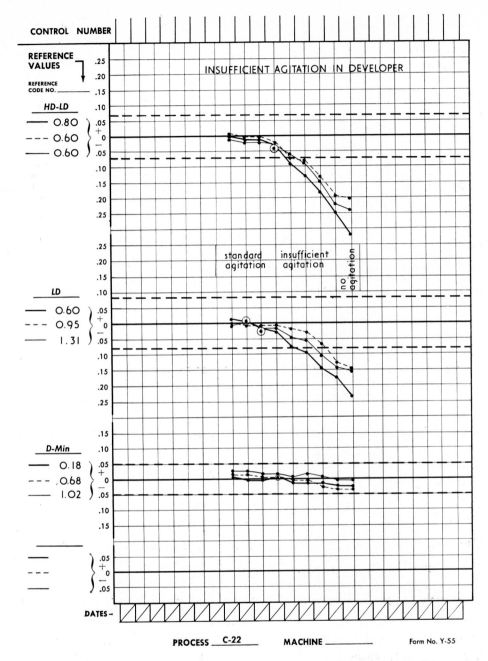

CONTROL NUMBER

REFERENCE VALUES

REFERENCE CODE NO.

INSUFFICIENT AGITATION IN DEVELOPER

HD-LD
—— 0.80
--- 0.60
—— 0.60

standard agitation insufficient agitation no agitation

LD
—— 0.60
--- 0.95
—— 1.31

D-Min
—— 0.18
--- .0.68
—— 1.02

DATES –

PROCESS ___C-22___ MACHINE _____ Form No. Y-55

Fig. 146 These results indicate how important agitation is to the process of development

281

2 Through the green filter, read the magenta, black and unexposed patches.

3 Through the blue filter, read the yellow, black and unexposed patches.

4 The difference between high and low density of each colour is an indication of contrast. For example:

	RED		GREEN		BLUE	
	Reference Strip	Control Strip	Reference Strip	Control Strip	Reference Strip	Control Strip
High Density	1·48	1·50	1·59	1·54	1·53	1·54
Low Density	·44	·42	·51	·50	·44	·52
Contrast	1·04	1·08	1·08	1·04	1·09	1·02
Unexposed	·08	·09	·11	·11	·13	·15
Black Patch	2·30	2·35	2·26	2·20	2·35	2·30

Ansco's suggested tolerance limits are: \pm 0·10 for the high density difference, \pm 0·10 for the contrast, \pm 0·07 for the low density, \pm 0·03 for the stain value and $-$ 0·20 for the black patch.

AGFA-GEVAERT PROCEDURE From a central organisation in Leverkusen, Germany, Agfa distribute both film and paper control strips. The film test strips—for either CN17U (unmasked), CNS(masked) colour negative process control comprises a multi-step grey scale with four indicated steps, marked one to four.

The density of the marked steps are arranged with the following characteristics:

Step One—Indicates combined stain plus mask density.
Step Two—Is used as an indication of speed.
Steps, Two, Three and Four are used to indicate the degree of development (gamma).

The red, green and blue density readings of the four steps are used as follows:

1 Maximum density (step one).
2 Speed steps (step two and step one).
3 Gamma I (step three minus step two) and gamma II (step four minus step three).

The results obtained from these measurements and simple calculations are compared with corresponding readings made from the processed reference strip provided and measured on the finisher's densitometer. Deviations from standard can then be plotted graphically.

282

	PROCESSING RECORD FORM, Y-60							
Date*	Number of Rolls Processed in Each Batch					Total†	Customer Order Numbers	Control Strip Numbers
	828	127	135	120 620	116 616			

*Mark dates on which solutions are mixed.
†Total units or square feet processed since solutions were last mixed.

PROCESS_____ MACHINE_____

Fig. 147 Processing record form used to estimate the replenishment required in relation to the numbers of different sized films that have been processed, and also to identify the control strips that were processed nearest to any particular bath of films

The density tolerances allowed by Agfa for green filter readings are:

1 Minimum density \pm 0.06
2 Speed \pm 0.08
3 Gamma I \pm 0.08
4 Gamma II \pm 0.08

These represent the tolerances allowed for the magenta image layer. Density readings through blue and red filters (yellow and cyan layers respectively)

should result in deviations from the reference in the same direction as the green filter readings, but may exceed the green filter deviation by an additional 0·05 density units.

Agfa acknowledge that there is some value in making visual comparisons between test strips and reference strips, provided care is taken to align the numbered steps and the two strips are examined on an evenly illuminated light box.

Of course it is useless to take a series of measurements and to plot them carefully and regularly if, when there is evidence of departure from tolerance, no action is taken. Obviously any action that is taken must be based on experience, but in an attempt to guide the finisher in the right direction, Agfa have published a table (see page 285) indicating the likely causes of some of the more usual forms of departure from acceptable limits.

It should be obvious that no radical changes to either the composition or the replenishment of any processing solutions should be made until sufficient confirmatory tests have been made to prove an out of tolerance condition. Corrective action should never be taken on the evidence of a single test strip and never, unless the quality of production prints seems to confirm that the process is out of tolerance.

MPDFA Quality Control Program

It has already been explained that in the US The Master Photo Dealers and Finishers Association decided in 1964/65 to introduce a quality control service that their members could use if they wished. The service was initiated and is operated by L. M. Dearing Associates on behalf of the Association.

Now in its fifth year, the Control and Testing Service is available in three forms whereby tests are sent and returned twice a month, once a month or every two months. The monitoring of each finisher's routine control strips is done in accordance with the recommendations of Eastman Kodak.

One of the special surveys offered by the MPDFA service is the bi-monthly supply of 126 (Instamatic) exposed picture and slope patch negatives. These permit the measurement of a finisher's departure from the quality of the statistical average, derived from prints obtained from hundreds of subscribers. Of this, Dearing Associates say:

> This computed average is the printer setting which a large cross section of our subscribers find necessary to give optimum colour and density on first printing of current Kodacolor film. This gives colour finishers a practical and up-dated means of calibrating their in-plant controls with picture tests and, more accurately, with colour densitometry. With them, finishers can adjust their aim as new calibrated sets are provided every two months. This reduces the hazards from outdated or faded printer test negatives.

RESULTS	POSSIBLE CAUSES	REMEDY
1 Results of densitometric reading are within tolerance; visual evaluation does not show any differences.	No action required.	
2 All densities above upper tolerance limits and test strip is visually darker than the master.	Over-development.	Check time, temperature, nitrogen burst agitation and replenishment of developer and intermediate bath.
3 All densities below lower tolerance limits and test strip is visually lighter than the master.	Under-development.	Check time, temperature, nitrogen burst agitation and replenishment of developer and intermediate bath.
4 Minimum density too high for all 3 colour layers in step No. 1 only.	(a) Increased temperature of developer (b) Increased temperature of intermediate bath. (c) Poor nitrogen burst agitation in intermediate bath. (d) Intermediate bath under-replenished.	Adjust temperature. Adjust temperature. Intensify agitation. Renew intermediate bath. Increase replenishment.
5 Increased magenta minimum density. Relatively high green filter reading on step No. 1.	Inadequate 1st wash.	Intensify 1st wash, check temperature and wash time.
6 Increased green minimum density. Relatively high blue and green filter readings on step No. 1.	(a) Developer contaminated. (b) Intermediate bath contaminated	Renew developer. Renew intermediate bath.
7 All colour layers in steps 2—1 low. All colour layers in 1st gradation steps 3—2 low.	(a) Temperature of intermediate bath low. (b) Decreased processing time in intermediate bath. (c) Too vigorous nitrogen burst agitation in the intermediate bath. (d) Intermediate bath over-replenished.	Keep temperature at 20°C. Adjust time to standard time of 4 minutes. Slightly decrease nitrogen burst. Decrease replenishment.
8 Steeper cyan gradation (red filter reading of steps 4—3).	(a) Increased development time. (b) Developer over-replenished.	Adjust development time. Decrease replenishment.
9 CNS test shows lower yellow minimum density (blue filter reading is relatively low on step No. 1).	(a) Bleach bath exhausted. (b) Decreased processing time in bleach bath. (c) Developer under-replenished.	Renew bleach bath. Adjust time to 6 minutes. Check replenishment.
10 CNS test shows higher yellow minimum density (blue filter reading is relatively high on step No. 1).	(a) Bleach bath over-replenished. (b) Developer contaminated. (c) Intermediate bath contaminated. (d) Poor gas burst agitation.	Check replenishment. Renew developer. Renew intermediate bath. Check gas burst agitation of all baths

Reference Negatives

The purpose of any reference or standard negative is to establish printer settings that will produce the highest possible percentage of acceptably balanced prints at first printing. It is a useful precaution to have two sets of reference negatives available—one set in use and one set in reserve or as a comparison against the set in use—which will sooner or later become damaged and faded.

It is important when using reference negatives to see that they are placed in

QUALITY CONTROL TESTING SERVICE
KODACOLOR FILM PROCESSING and PRINTING BI-MONTHLY REPORT ROLL STRIP

PLANT _____ COMPANY _____ DATE SENT _____
SERIAL NO. _____ NAME _____ DATE PROCESSED _____

	RATING					SCORE			COMMENTS
	Very Poor	Poor	Needs Impv.	Good	Excellent	Max.	Actual	OK	Description of Problem
1. PRINTING									
Color Balance						25.			
Color Problems						10.			
Density Level						10.			
Density Problems						10.			
Sharpness & Contrast						7.5			
Photo-Border						2.5			
Sub Total-Printing						65.0			
2. PROCESSING (Latest Test)									
Film Strip Control									
Contrast (8th-4th Step)						2.5			
Speed (4th Step)						2.5			
D min						2.5			
Daily Film Control						7.0			
Paper Strip Control									
Contrast (HD-LD)						1.0			
Speed (LD)						1.0			
D min						1.0			
Daily Paper Control						5.0			
Film-Paper Physical						2.5			
Sub Total-Processing						25.0			
3. HANDLING									
Cleanliness									
Film						2.5			
Printed Dirt-Framing						2.5			
Film Chopping						2.5			
Paper Chopping						2.5			
Sub Total-Handling						10.0			
4. TOTAL SCORE						100.0			
5. CUSTOMER ACCEPTANCE									

* Note: 25.0 corresponds to 100.0 on bi-weekly reports

Comparative Standings October 1965	Score	Group	Score	Group
	85-80	1st 25%	74-72	3rd 25%
	79-75	2nd 25%	71-58	Last 25%

QC-6c-65

L. M. DEARING ASSOCIATES, INC. . . . Photo - Optics - Sonics - Recording - Materials Sciences
Mail to: P.O. Box 1457 • 12345 Ventura Blvd., Suite R, Studio City, Calif. 91604 • Telephone: 213-769-2521

Fig. 148 From this Quality Report form issued by L.M. Dearing Associates, it can be seen that printer control is considered to be the most important aspect of colour print production

the negative carrier in exactly the same way every time they are used. To ensure that this always happens it is even worthwhile devoting an extra negative carrier to each reference negative.

Because it is a reminder of the many different factors that influence final print quality, it is interesting to note from their Report Form, the relative importance that Dearing Associates attach to each variable in the film processing, printing, print-processing and print finishing cycle.

It will not necessarily happen that when a printer has been adjusted so that it produces the best possible average results from a large number of different negatives, it will then give the best print from the reference negative. It is the average quality or yield of production prints that must decide printer settings. This does not mean that the reference negative is any less useful, but merely

that the routine test prints made from it should be uniform in density and colour balance, but may not represent the best result that could be obtained from that negative.

When determining the best balance for production prints it is often useful or even necessary to use a jury system, whereby the judgement of several observers is used to arrive at a norm. It is certainly well known that a print examiner who is continually surrounded by prints, tends to accept their average colour balance as normal, even though they might seem obviously off-balance to an outside observer.

When production is running, a statistical analysis of rejected prints over a reasonable period of time usually indicates whether a printer is set to an optimum aim point. If there is any predominance of one particular class of reject—in terms of either incorrect density or colour, the setting of the particular printer should be slightly altered to counteract the tendency.

However, changes in printer settings should never be made because of off-balance results from a few rolls of film, but only as the result of poor quality prints from a large number of films printed over a reasonably long period of time during which both negative and print processing are known to have been within tolerance.

Viewing Conditions

In most finishing plants it is impossible to ensure that a uniform brightness and colour of daylight will be available for print examining purposes at all times. Consequently, it is far better to provide a suitable level and quality of artificial light.

Not all those interested in the subject agree on the colour of light that should be used for examining colour prints. Some manufacturers propose light that is close to 3,900 K, and this is the rating given to the 40 watt "Avlight" fluorescent tubes sold by the Macbeth Instrument Corporation—who have worked on the problem for many years. An Avlight tube mounted over an examining bench provides a light level of around 100 foot candles, which is about what is required.

Light that is somewhere between 3800 K and 4200 K can be produced by using two 40 watt cool-white fluorescent tubes in conjunction with one 75 watt incandescent lamp.

When viewing colour transparencies exposed by amateurs, it can be assumed that the majority of results will be projected. Consequently, a projection booth of some kind should be available in the finishing laboratory so that representative samples from production can be regularly inspected and compared with reference transparencies that are considered satisfactory. To make such comparisons, matching projectors and screens will be required, and although the

287

projected images need not be very large, it will be important to ensure that the brightness on the screens is typical—say 24 foot-lamberts.

A Dilemma and a Challenge

Although more and more of the many variables in photofinishing are being brought under control by measurement, there remains the necessity for regular application of subjective judgement—the importance of which must never be underestimated.

The need for judgement to augment measurement is greater when prints are involved then it is with reversal film processing, for however well colour negative films and the prints made from them are processed, the fact remains that no system of printing has yet been devised that automatically ensures saleable results from every negative.

This then is the dilemma—if a finisher remakes too many prints his profit disappears, but if he remakes too few bad prints he loses his customers. Thus the challenge is to so control the variables involved that the highest possible yield of saleable prints results from first time printing—a goal that will undoubtedly be brought nearer and nearer but may never quite be reached.

REFERENCES

[1] GLASS, D. B. AND COGAN, J. A. "Fundamentals of Reversal Color Processing". *Phot. Sci. & Tech.* November, 1956, Vol. 3, pp. 167–174.

[2] MARSHALL, A. "The Quality of Photo-Finishing in Britain". *The Photo Finisher*, Vol. 2, May, 1965, p. 272.

[3] ZORNOW, G. B. "You Can't Sell Quality If You Haven't Got It". *Photo Marketing*, January, 1965, pp. 28–29.

[4] HANNAVY, J. M. "Control In C22 Processing—How Precise Must It Be". *Industrial & Commercial Photographer*, October, 1968, pp. 38–40.

INDEX

293